TEXTILES of SOUTH~EAST ASIA

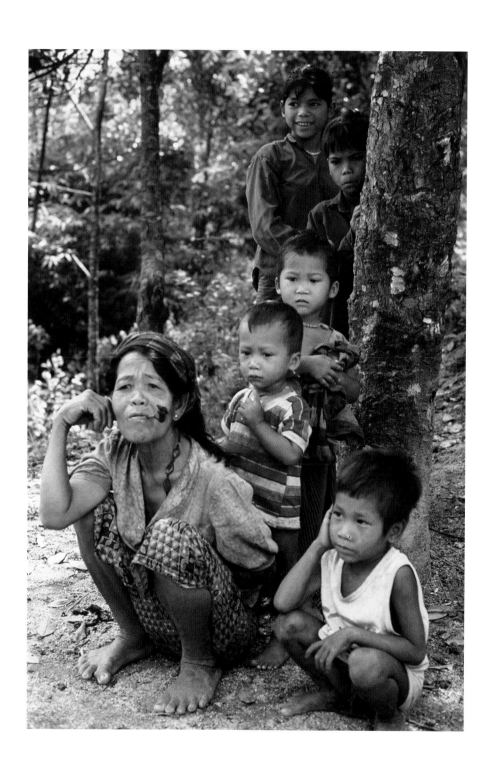

TEXTILES *of* SOUTH-EAST ASIA

ANGELA THOMPSON

THE CROWOOD PRESS

First published in 2007 by
The Crowood Press Ltd
Ramsbury, Marlborough
Wiltshire SN8 2HR

www.crowood.com

British Library Cataloguing-in-Publication Data
A catalogue record for this book is available from the British
Library.

ISBN 978 1 86126 962 1

Photo Credits
All textiles shown in the illustrations are from the author's
Worldwide Collection unless otherwise stated.

All photographs and images are by the author, except for the
following: Geoffrey Bradshaw: pages 25, 34 and 180; Timothy
Thompson: frontispiece, pages 20, 29, 81, 115, 116, 117 and 124.

Others: page 71 © Horniman Photo Archive, photo: Geneviève
Duggan; page 137 © Horniman Museum, number 2002.538,
photo: Heini Schneebeli; page 179 © Horniman Museum,
number 5.522, photo: Heini Schneebeli; page 115 © (Accession
No. 1998.170.21.3) Pitt Rivers Museum of Oxford, photo:
Charles Hose.

Frontispiece: A pipe-smoking woman from the Da Nang area in
the former de-militarized zone between North and South
Vietnam relaxes together with her young family. Photo: Timothy
Thompson, 1996

Acknowledgements

My initial thanks are due to all those unnamed people in the
countries of South-East Asia who have helped me with my
project. Next, to my son, Timothy Thompson, who diligently
takes photographic images of craftspeople, and purchases textiles
in foreign countries on my behalf. To my friend and travelling
companion, Pauline Milnes, for her patience and reliability.

I would like to thank Janice Williams for the gift of Indonesian
textiles; Alison Armstrong, Bobby Britnall, Geoffrey Bridges, Jane
Davies and Jennifer Hughes for the loan of items for
photography; also Geoffrey Bridges for the loan of transparencies
from the 1960s. Thanks to Susan Conway, Diane Gaffney and
Janet Willoughby for help and advice, also to Paul Craven and
Gina Corrigan of Steppes Travel for organizing some of my
journeys.

Grateful thanks are owed to the 'National Centre for
Sericulture', Siem Reap, Cambodia, for allowing me to take
images of the silk and weaving processes, to the Suan Pak Kard
Summer Palace, Bangkok, and Wat Phumin in Thailand. Thanks
also to the various craft workshops who invited me, without
hindrance, to take images of their employees at work.

Many thanks to Dr Fiona Kerlogue, curator, Anthropology
Department at the Horniman Museum, London, for arranging
digital images from the collection. To Geneviève Duggan for
allowing me to reproduce her photograph taken on the island of
Savu. Also to Julia Nicholson, Head of Collections and Chris
Norton, Head of Photo Collections at the Pitt Rivers Museum,
Oxford, for allowing me to use an image on display at the
'Treasured Textiles' Exhibition.

I owe a debt of gratitude to the following authors whose books
or articles, listed in the Bibliography, have proved invaluable
when conducting my research: Marie Jeanne Adams, Patricia
Baines, Jenny Balfour-Paul, Ruth Barnes, Josiane Bertin-Guest,
Karen A. Bunyaratavej, Joyce Burnard, Patricia Cheesman, Young
Y. Chung, Ann Collier, Peter Collingwood, Mary Connors, Susan
Conway, Gina Corrigan, Caroline Crabtree, Lois Sherr Dubin,
Geneviève Duggan, Maribeth Erb, Jill Forshee, David W. and
Barbara G. Fraser, Valery M. Garrett, John Gillow, Gillian Green,
Marie-Helen Guelton, John Guy, Roy W. Hamilton, Carla J.
Hassel, Ann Hecht, Michael Hitchcock, Jennifer Hughes, Ralph
Isaacs, Paul and Elaine Lewis, Gerald Moussay, Heidi Muman,
Deryn O'Connor, Rodrick Owen, Sheila Paine, Jess G. Pourret,
Jane Puranananda (editor), Hein Reedjik (editor), Pepin Van
Roojen, Khun Samen, Gösta Sandberg, Philippa Scott, Robert
Shaw, Noel F. Singer, Ruth Smith, Mary Anne Stanislaw, Christina
Summer with Milton Osborne, Anne and John Summerfield,
Anne Sutton, Janet Willoughby.

Typeset by Jean Cussons Typesetting, Diss, Norfolk

Printed and bound in China by 1010 Printing International Ltd

Contents

Acknowledgements 4

Introduction 7

1 Historical Background 11
2 Symbolism, Pattern and Design 31
3 Costume: Uncut Cloth 57
4 Costume: Closed Dress 77
5 Threads and Fibres, Spinning and Dyeing 95
6 Weaving and Loom Types 113
7 Dye Pattern Methods 131
8 Embroidery and Appliqué 151
9 Beadwork and Bead Embroidery 169
10 Thread and Fibre Crafts 185
11 Fringes, Tassels, Pompoms and Feathers 199

Glossary 216
Bibliography 218
Index 223

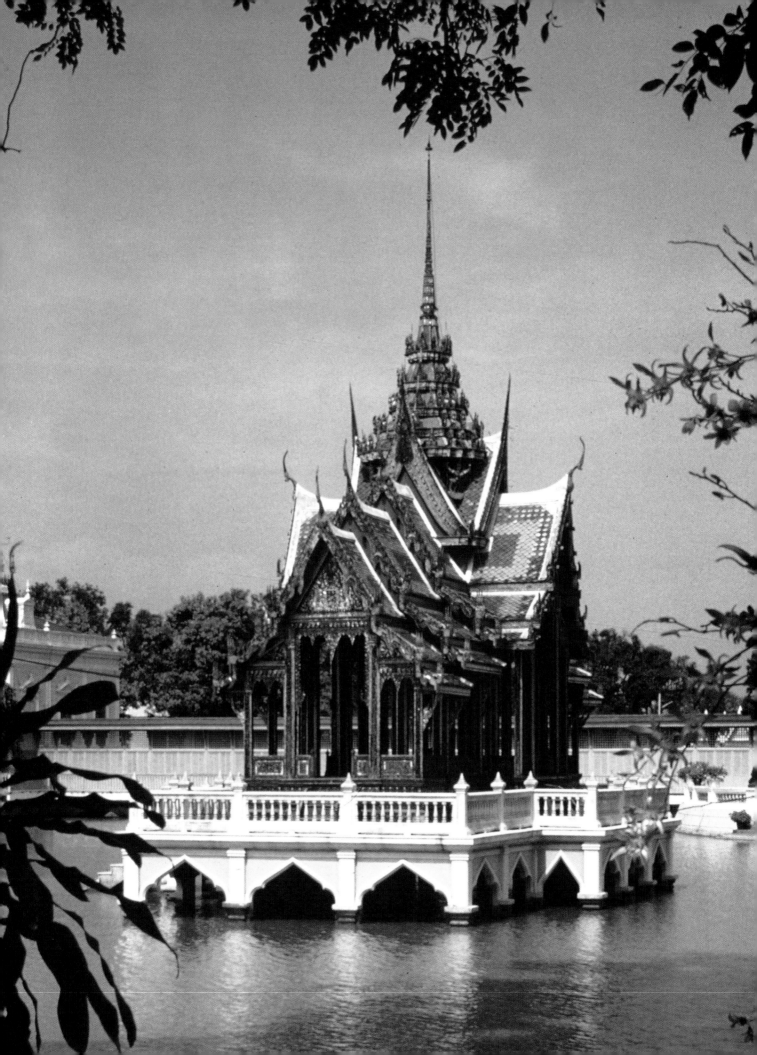

Introduction

The 'Orient' and the 'Far East' have long conjured up visions of exotic places, inhabited by decorative people with different customs and strange religions. To the European, during the seventeenth and eighteenth centuries the East was a mixture of Chinese and Indian iconography, generally portrayed on the coveted Indian chintzes, which had themselves been adapted for European taste.

Even when the colonial powers from Europe took control of much of South-East Asia, little was known of the actual area, the historical background was ignored, and archaeological discoveries were not made until a comparatively late date, in the latter part of the nineteenth century. New boundaries, defined by colonial trade and greed for natural resources, were imposed on countries not used to the concept of artificially formed locations, which took no heed of race, creed or historical inheritance. The areas once overseen by the various kingdoms and vassal states were in a continual state of flux, and the waves of migrating people from the north both disrupted and at the same time integrated with the existing societies.

Even in this context, the region that comprises South-East Asia cannot be defined as any one group of races or countries. This is due to the great differences in climate and the variations in geographical and topographical features, let alone the isolation of various areas, either by physical inaccessibility or their position as an island in one of the far-flung archipelagos. It is far easier to think of a land divided by strata, the contour lines defining the areas inhabited by the hill tribe people, the mid-areas by the farmers of dry rice and cereal crops, the lowland and river areas by the growers of wet rice. Each society developed in different ways, forming very definite cultures. In the short term, some of the lowland civilizations were more successful than others, but were less adaptable to climate change.

To a certain extent, the costume and accessories of these people can also be defined by the type of area they inhabit.

OPPOSITE PAGE:
The nineteenth-century Bang-Pa-In Summer Palace, Thailand. The Royal Library is surrounded by water to deter termites and prevent them from destroying the manuscript scrolls.

An open type of dress, based on the simple draping of woven cloth, was more suitable for the hot and humid countries of the south. Those who came from the north, or who inhabited the higher mountain regions, favoured a warmer type of garment that fitted more closely to the body. It is the diversity of the races, the differences in religious belief and the willingness to adapt to ever-changing situations, which make these people so resilient. Only in this context can the people of South-East Asia be regarded as a whole.

My first journey to the Yunnan and Guizhou provinces of South-West China during 1987 was the beginning of a fascination with the people and crafts of South-East Asia. I gradually worked southwards, with a series of visits to different countries taken over a period of twenty years, little realizing that I was following the route of many of the ethnic migrations, which had themselves originated in southern China and the Yunnan area. As a collector of textiles worldwide and a practising craftswoman, my view of South-East Asia is a personal one, based on critical observation and an analysis of the textile techniques, together with a desire to share and understand the different methods used in the various countries.

I shall always be indebted to the many textile workers who patiently answered my persistent questions, and to the guides and interpreters who helped me in my quest for information. In 1991 I was lucky to join a weaving tour of Thailand under the expert guidance of Susan Conway. She introduced us to the wonderful temple mural paintings depicting Nan La Court life in the rice-cultivation areas of northern Thailand. I shall always be indebted to her.

Some of the countries of South-East Asia are in a state of political unrest. This is not something new, but follows a continuing pattern, and sadly, may well continue for the foreseeable future. Other countries have survived brutal regimes, and I felt it a moral duty to visit the Genocide Museum and Killing Fields in Cambodia. In complete contrast was a morning spent in the National Museum in Phnom Penh, where I was happy to sketch the wrap-around skirts shown on the sculptures of the female goddesses taken from the Angkor complex. It was with even

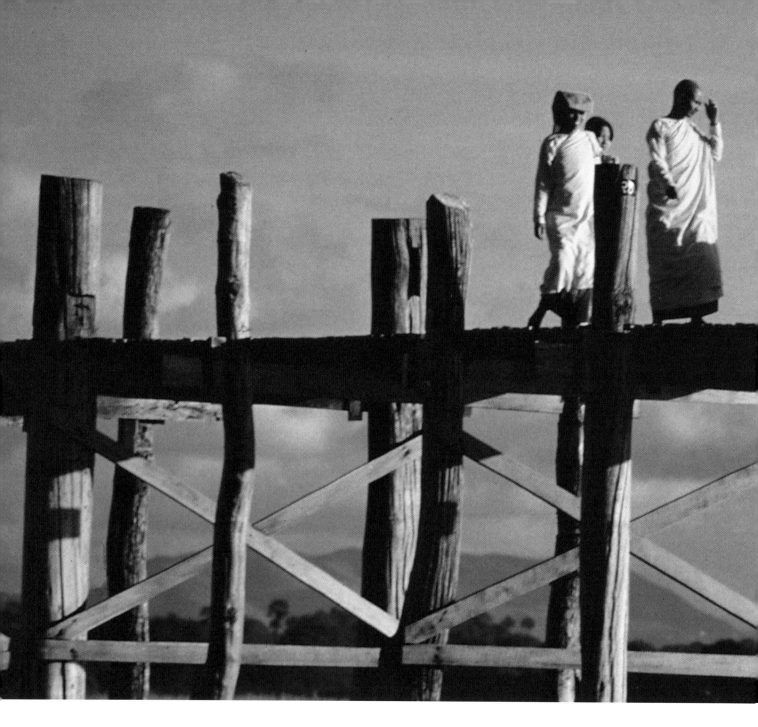

greater delight that in the Angkor temples I was able to photograph the beautiful half-relief carvings of the Apsaras, the celestial dancers, whose enigmatic smiles reminded me of the Mona Lisa.

This present book is intended to look at South-East Asia as a whole; to examine and contrast the variety of textile techniques and costume types, both in the villages and in the towns; to look at present trends and record visits to textile workshops – just as important as documenting the past; and to understand the people, their relationship with their surroundings, their religion and ancestry.

It is intriguing to compare the ways in which the crafts-people of the various countries have endeavoured to solve similar problems found in thread and fibre preparation, loom construction, dye and mordant methods, and the patterning of fabric both as weave manipulation and resist dyeing. Looms vary from country to country, but each one is designed to serve the same function: the production of woven fabric. Many of the inhabitants of these areas are not wealthy in terms of personal goods, but are rich in other ways. Time is still regarded in a different way, and craft workers will take 'time' to complete a job to satisfaction, without the slightest sign of resentment. The outcome is the reward, and the regard in which a craftsperson is held is more important than monetary compensation. How long this ethos will continue, remains to be seen.

It is not possible within the scope of this book to cover in detail all the textile techniques practised in such an encompassing area. The various sections are intended as an introduction to the different crafts, the costumes and cus-

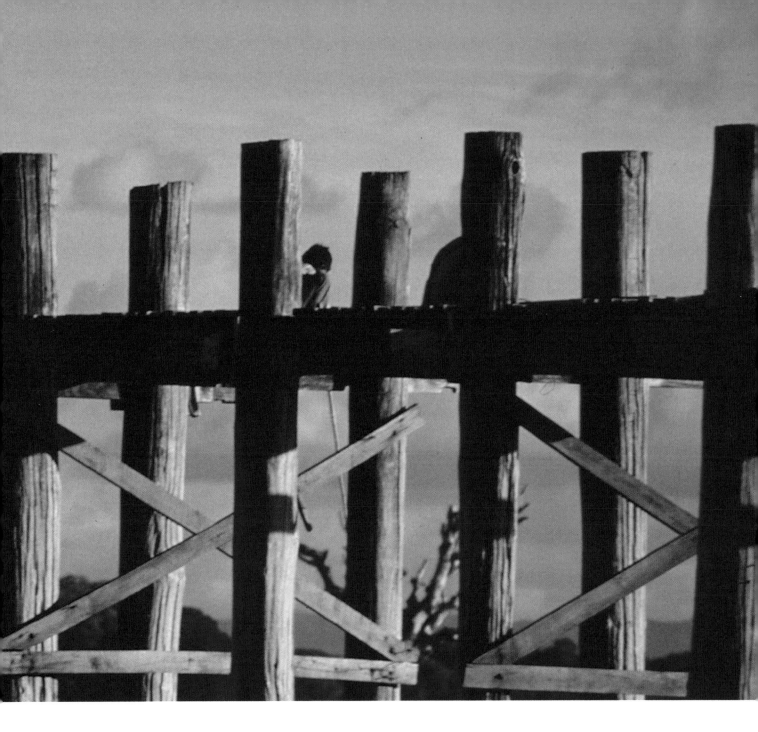

Buddhist nuns wearing pink habits cross the 200-year-old teak-wood U-Bein Bridge near Mandalay, Myanmar. 1.2km (0.7 mile) long, it spans a shallow lake that dries in winter to reveal rich agricultural land.

toms, the chosen motifs and iconography of the various tribes, and the way the people are influenced by dissimilar religious beliefs. A comprehensive bibliography is included, which covers the entire area under subject headings. Recently, various books have been published by authors who have spent many years of research in a particular country, tracing the lineage of the various ethnic and aristocratic groups, documenting their costumes and linking them to migrations. We owe them a great debt of gratitude, for these societies will not last for ever. The general textile enthusiast will find these books full of fascinating information, while the research scholar will be rewarded by reading them from cover to cover.

In trying to come to terms with the complexity that is South-East Asia, I posed myself several questions: 'What makes South-East Asia "tick"?' 'What links together these vastly disparate regions?' 'Why are they so belligerent?' 'Why are there different religions existing side by side?'

The answers were not what I had expected, and in the end, it boiled down to two main things: the first was water transport, whether by sea or by river; the other was the export trade in Chinese silk and Indian cotton.

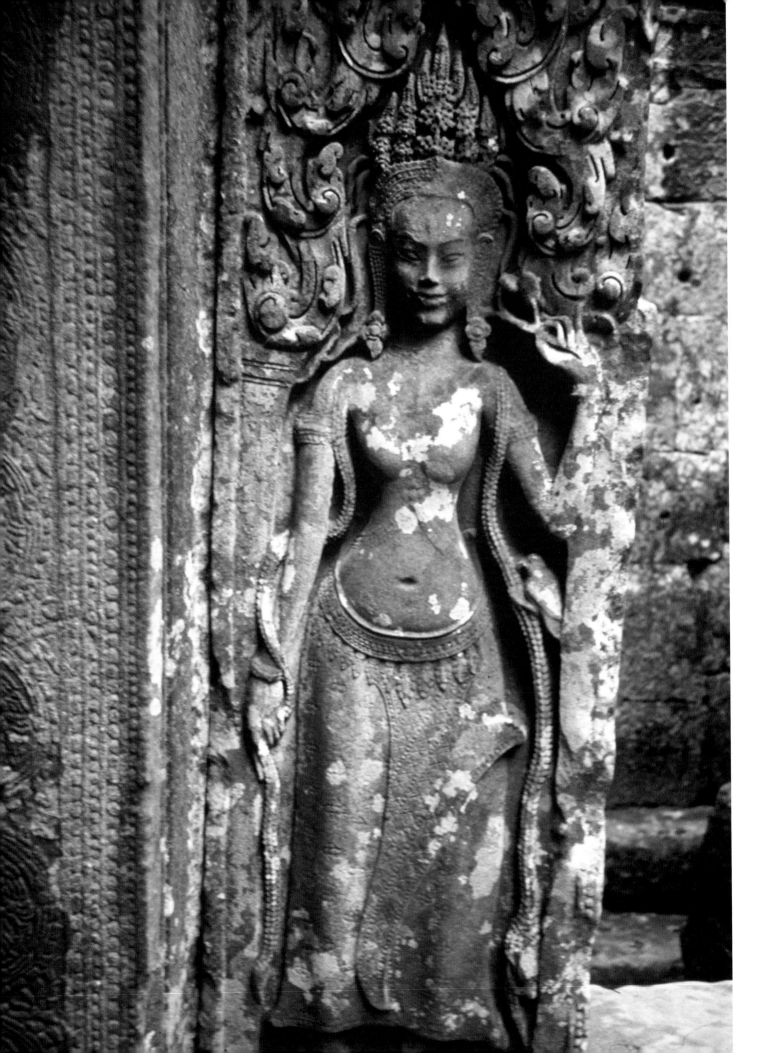

Historical Background

South-East Asia

The concept of South-East Asia as an area, whether geographical or political, is a comparatively recent one. From a geographical viewpoint, various provinces of South-West China, especially Yunnan Province and neighbouring Guizhou, are included in this book because these areas were the source of migrations over a period lasting for hundreds of years.

During colonial times much of the mainland, comprising Cambodia, Laos and Vietnam, was labelled 'French Indo-China', as though nothing existed between India and China. When the British occupied Burma, this country – together with Malaysia and Singapore – was known as 'Further India'. Only Thailand managed to evade colonial rule. The Dutch controlled the Netherlands East Indies, now part of Indonesia, and the Portuguese had colonies in the islands of East Timor. The island of New Guinea was divided in half down the centre, the western part becoming Irian Jaya. On the eastern side, Papua New Guinea was not considered part of Indonesia and is often omitted from area maps.

This mistaken labelling of the countries overseen by the European powers, together with later American influence in the Philippines, deprived the indigenous population of much of its identity. The denial of the existence of a past historical culture resulted in the inhabitants becoming virtually invisible, apart from their usefulness as traders and providers of labour in mining and in the new rubber and cotton plantations. It is hardly surprising that unrest and insurrections resulted from the insensitive divisions of land and forced movement of the people. Only when archaeologists began to unearth the amazing temple complexes at Angkor in Cambodia and similar sites in Cham, Vietnam, did scholars begin to piece together and understand the true significance of these long-lost civilizations.

OPPOSITE PAGE:
A 'devata' goddess figure in carved stone graces a niche in the late twelfth-century temple of Bayon in the Angkor complex, Cambodia.

Even when independence was finally granted to the various countries, the path was never smooth. The mixture of races, the differences in religious beliefs and practices, the ongoing migratory patterns and unstable relationships with the various foreign governments that make up the modern world, means they are still in a state of flux. In spite of all this, the separate countries of South-East Asia have managed to retain their individuality, and many have reappraised their inherited culture, giving greater importance to their indigenous crafts, and their religious and folk festivals. To an extent this is due to the promotion of tourism, in some places one of the few stable sources of income. This is not altogether a bad thing, for anything that preserves the wealth of textile knowledge in an area where the climate is not conducive to the preservation of cloth, is more than welcome.

Mainland South-East Asia

The Indigenous Neolithic Peoples

Although some of the earliest evidence of man surfaced in Indonesia and Java, various sites in mainland South-East Asia produced simple pebble tools dating from some 14,000 years ago, linked to the Hoabinhian culture, common to upland areas of Burma, Cambodia, Malaya, Thailand and Vietnam. Similar sites were found in coastal areas of Vietnam, Malaya and Sumatra. Between 9000BC and 2500BC there is archaeological evidence of a root-crop growing culture, with designs incised into pottery, which was later supplanted by a rice-growing culture. It is only when an archaeological site reveals the day-to-day life of a civilization from the long-distant past that we can begin to relate to the pre-history of any given area. Even then, a snapshot in time may tell us little of what went beforehand, or how the 'finds' can link to the future.

LANGUAGE DIFFERENCES

Nobody knows the exact origin of the earliest inhabitants, but it is thought they may have migrated south from Central Asia. In Cambodia, there is evidence of human activity as far back as 3,500 years ago, possibly early ancestors of the Khmer-speaking people who later occupied the area. The Khmer language, together with the Mon language, is one of a series that come under the heading of 'Austro-Asiatic', meaning 'south Asian', all of which have a common origin in spite of their many variations. Scholars have discovered the links between disparate languages, such as the monosyllabic, single-tone language of the Vietnamese and the polysyllabic toneless Munda language of eastern India. Vietnamese is one of the group of Mon-Khmer languages, and a thousand years of Chinese rule had a lasting influence. The experts still differ as to the viability of accepted classifications, but the general opinion is that they are all Austro-Asiatic.

In prehistoric times, the Munda and Mon-Khmer languages divided, and the Mon-Khmer languages continued to evolve over several thousand years. The study of these language variations has enabled researchers to trace the origins of many of the wandering tribes, with additional information gained from the way they dress and build their houses.

THE ESTABLISHMENT OF EARLY CULTURES

In Bangkok, the 'Cabbage Patch' Museum (a former royal summer palace, so called because lettuces were once grown in the surrounding compound) contains a wonderful collection of Ban Chiang pottery and artefacts. Named after a village in north-eastern Thailand, the site is one of the many found on the Khorat plateau, which also extends across what is now northern Laos. The Early, Middle and Late periods span a time scale from 3,600BC to AD200. Pottery spindle-whorls from the Middle–Late Period show designs of incised spirals, and these are echoed on the pottery vessels, cups and pedestal jars of the Late Period. These pottery vessels are very beautiful, and would not look out of place in a modern exhibition.

The Dong Son Culture

By about 400BC, advances in Bronze Age metal-working techniques brought the ancient Dong Son culture to the fore. The Dong Son people inhabited the Red River delta area of northern Vietnam, and are famous for their bronze drums, beautifully crafted and decorated with panoramic war scenes, and depictions of houses, musicians, animals and people. Spiral and geometric designs linked them to even earlier Neolithic cultures, and these symbolic patterns are still repeated today on ceremonial and religious textiles.

As well as making impressive stone monuments, the Dong Son people were accomplished sailors, and traded through much of South-East Asia. They are credited with the development of the Red river delta as a rice-growing area, a legacy that continues today along the Vietnamese coastal strip, with a pattern of countless rice paddies intersected by raised pathways, narrow track roads and intermittent villages.

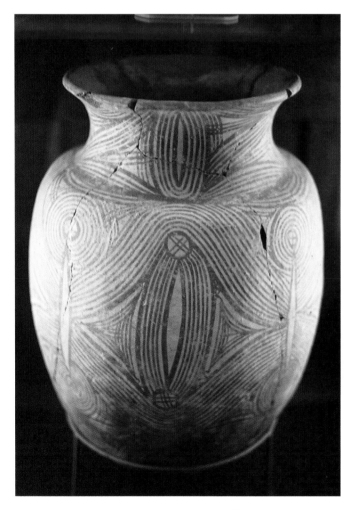

Ban Chiang culture pedestalled vessel of the Late Period (300BC–AD200), showing spiral designs in red-on-buff pottery. Suan Pak Kard (Cabbage Garden) Summer Palace, Bangkok, Thailand.

Migrations from the North and West

People migrate for a variety of reasons: war, servitude under

Finely worked wax resist on a small cloth, echoing the Dong Son spiral patterns. The cloth has been folded in half vertically before indigo dyeing, thus producing a paler reverse. Kaili area, Guizhou Province, late twentieth century.

an oppressive regime, famine and climate change, these are but a few. Migrations took place in prehistoric times as hunter-gatherers sought new territory, and later, gradual migrations took place under the swidden (slash-and-burn) methods of agriculture, as new land was constantly in demand. Sometimes migrations have happened in reverse, with communities returning to their original homeland. The patterns are complex, often repeats of themselves. The fiercely independent Karen tribes of eastern Burma (Myanmar) are still forced to migrate over the border into Thailand, as they have done so many times in the past.

Not all of the migrants have integrated fully into their adopted countries: many have kept their ethnic identities, even when dispersing further afield. It's rather like the recently revived 'lava lamps', popular way back in the 1960s, where a glutinous, coloured substance is suspended in a clear liquid – it divides, re-forms and divides again, but never mixes completely with the surrounding fluid.

The migrants moved from South-West China into the lands that now comprise northern Laos and Thailand, northern Vietnam, and the Shan states of Burma, an area referred to as 'the Golden Triangle'. Vietnam also received several waves of immigrants from south-eastern China, either by land or by sea, because boat people made their way down the coasts, or used Hainan Island in the Gulf of Tonkin as a staging post. There are even records of boat people returning to their land of origin, having lost their way or been caught in a storm. Some boat people are said to have travelled south as far as Indonesia, probably

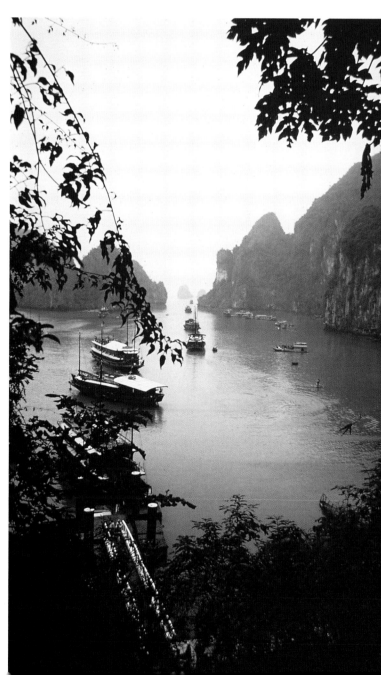

Halong Bay in northern Vietnam, now a UNESCO World Heritage site, is famous for the Karst rock islands, around which junks and fishing boats still sail. It is here that the Red river empties into the Gulf of Tonkin, providing a link with South-West China.

hopping from island to island, and it is thought this may explain the traces of Austro-Asian language found in certain areas.

Sea traders from India and Sri Lanka (Ceylon) entered Burma via the river ports, or travelled overland from Assam and settled in the new areas, where distinctive dialects are still in use. Similar traders from the east coast of India found a footing in the southern areas of Thailand and the peninsula of Malaysia. Borders were fluid, and there are records of the Thai migrating southwards into Malaysia, and at other times the Malays migrating northwards into Thailand. Sometimes the immigrants were assimilated into their new territory without too much dissent, but at other times fierce battles ensued and tribal conflict continued over several generations. Occasionally the newcomers were welcomed, as they brought new craft technology or improved agricultural and irrigation techniques.

The Influence of Yunnan, South-West China

One of the oldest hominid fossils in China was found in Yunnan Province during the 1960s, evidence of Neolithic settlements and the use of stone tools. Yunnan, the most westerly province of South-West China, extends like a peninsula, taking a bite out of northern Laos and the Shan states of eastern Burma. The entire region has a history of invasions and migrations. There were rich mineral deposits of copper, gold, iron and tin in the Red River area of northern Vietnam. It may be that the desire for these riches brought about the expulsion of much of the indigenous population at various intervals throughout the centuries. Their place was taken by insurgents from the north, who in their turn had been displaced by Mongoloid tribes or groups from Central Asia. It was an ongoing process. Some ethnic groups fled from a system of forced labour and virtual slavery, preferring an uncertain future to unending bondage.

During the third century BC a Chinese general moved south from the Yangtze river region and set up as ruler in the area of modern Kunming, and from this time an uninterrupted pattern of military occupation over the years brought a continual Chinese influence to Yunnan. When northern China was invaded by tribes from Central Asia in the fourth century there were further incursions into Yunnan, and these influxes created a population formed of many dissimilar ethnic groups with a variety of language sources; thus there are Tibeto-Burman languages and Hmong-Mien languages among the minorities groups, as well as variations in the Chinese dialects. The indigenous people who moved further south took with them these language differences, together with a wealth of costume and textile tradition.

The Muang System of Political and Military Alliances

The tribal people of the northern areas of Laos, Thailand and Vietnam cannot be divided by any political boundaries, largely because these northern tribes did not all arrive at the same time, but migrated over a period of several hundred years. Patricia Cheesman, in her book *Lao-Tai Textiles: The Textiles of Xam Nuea and Muang Phuan*, has made a study of the people and their relationship to costume, religious customs and the alterations brought about by the migrations and changed allegiances. These societies were not territorial, but were ruled by 'Muangs', the name for a group of people who owed allegiance to overlords with jurisdiction for their particular Muang, while they in their turn owed allegiance to a superior Muang. Each Muang had a particular dress code, and this was strictly adhered to; those who were forced to change allegiance also changed their dress. The size of the Muangs fluctuated as a result of famine, war, or by the addition of captured slaves.

Recent publicity has concentrated on the history of the slave trade in the Americas. However, slavery of one kind or another has always been with us: it is endemic. If a tribe needed more manpower or workers, they would engage in battle purely for the taking of slaves: the conquered were considered sub-human and therefore deserving of slavery. This is not a new concept, for even in Ancient Greece, Aristotle, writing in his *Politics*, deemed that it was a natural law for some men to govern and others to obey – a man's slaves were his absolute property. The slavery system was not always one of complete ownership, however, and a type of 'serfdom' existed where workers were in bondage, paying tribute in the form of crops, labour and military service.

GIFT EXCHANGES AND TRIBUTARY SYSTEMS

The smooth running of the Muang system depended on the 'oiling of the wheels' by the exchange of gifts. These gifts could take many forms, including precious metals, Chinese porcelain, military weapons, or prestigious woven textiles in silk and golden thread; many an alliance was sealed with the marriage of a princess or chief's daughter, bringing two rival factions together. Tribute was not in the same category as a gift: it was something demanded by a superior tribe or Muang from a lesser one. In another context, people of the Buddhist faith gained merit by presenting gifts of woven cloth and religious banners to the temples. Food was given daily to the monks, and special clothing on auspicious occasions. Other faiths had a similar system of meritorious gift exchange.

THE RESTRICTIONS OF TOPOGRAPHY ON THE LOCATION OF SETTLEMENTS

It is understandable that the migrants would seek a territory that resembled their homeland as closely as possible. As most of them came from the mountainous country of South-West China, they tended to populate the hillsides, and many continued to practise their swidden agriculture. Thus when their part of the forest had become exhausted and no longer suitable for agriculture, the whole village would be moved to another location, the forest cleared by burning, and new crops planted in the rich ash, which acted as a fertilizer. As most villages existed as a group community, it was necessary for all the elders to agree to the new location, as no single person or family could exist on their own. This meant that each community needed to reinforce their identity by performing group ceremonies and, more importantly, by wearing distinctive costume in everyday clothing, as warriors and for religious regalia.

In the mountainous areas of South-West China, rice was grown in terraces; it was irrigated by collecting spring water into high storage tanks and releasing it to the lower slopes, and this was a method taken to other areas. Those people who came from lower altitudes chose dry rice as a sustenance crop, more suited to an arid climate. If they were valley people, wet rice was grown in paddy fields with the help of irrigation channels harnessed to the river systems. These societies tended to have a firm government system under an elected or hereditary ruler, because in a hot climate, if the irrigation system was not maintained, the people would starve. Great civilizations developed from some of these early settlements, only to disappear when the system failed or climate change forced a move.

The Importance of the Great River Systems

In a society used to a network of roads and railways and easy air travel, it is difficult to understand the limitations imposed on a culture where roads and tracks are virtually non-existent, especially in the monsoon season. Although

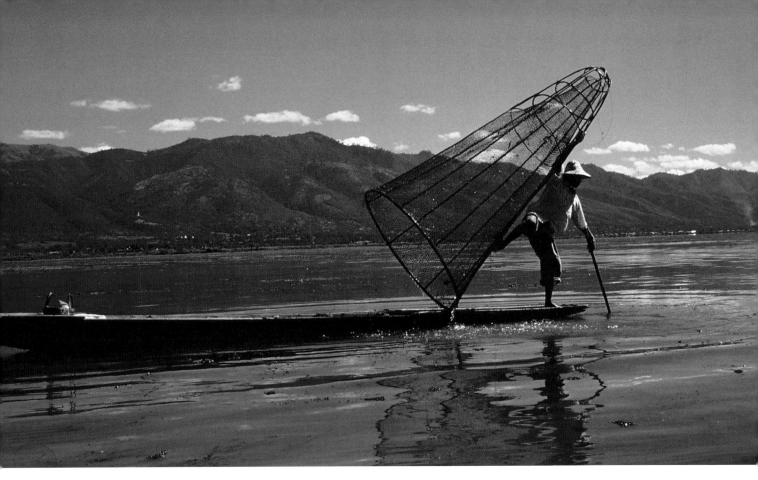

A leg-rower fisherman of Inle lake on the Shan Plateau of Myanmar poises ready to thrust his net down to the lake bed.

highways have been forced through jungle areas and mountain terrain, this is a recent development. The only alternative was water transport, with the rivers and great lakes providing easy access to the coastal sea ports, while overseas traders could take advantage of a link with otherwise inaccessible regions of the interior. An adverse effect was the advantage given to warring tribes and foreign invaders, which resulted in the building of fortified towns along the river banks and the strategic siting of the various capital cities. Tribes in areas without a viable system of water transport were cut off from their neighbours by high mountains and deep valleys. They developed in an individual way, keeping to distinctive forms of dress and inherited customs. A mistrustful attitude to outsiders resulted in frequent skirmishes, generally in pursuit of slave workers and much needed new territory.

The great river systems all flowed from north to south. The Ayeyarwady, formerly known as the Irrawaddy, and the Mekong, which has a variety of spellings according to the country through which it flows, are two of the most famous. The source of the mighty Mekong lies in the highlands of Chinese Tibet, and the river passes through Yunnan Province before flowing southwards where it forms the border between Burma and Laos, and then between Laos and Thailand. Laos does not altogether benefit from the Mekong as a transport system because the river is not navigable in the upper reaches, where boulder-strewn rapids prevent the use of any but the lightest of flat-bottomed craft. At least this prevented the French colonists from gaining a hold in the mountain regions of the north, where tribal territory only extended between the limit of each impassable rapid.

The Mekong River works its way downwards through Cambodia (formerly Kampuchea), providing irrigation for the vast rice-growing area. The Tonlé Sap is a sixty-mile-long watercourse that links the Mekong to the great lakes in the west, the source of water for the Angkor civilization. The vast quantity of silt brought downriver in the monsoon season has the strange effect of backing up the waters of the river, which vastly increases the size of the lake area. This has always been a boon to the fishermen, and sustains the rice paddyfields. After crossing into Vietnam, the river exits through the Mekong delta region into the South China Sea. This delta region has been bitterly fought over throughout history, for whoever controls the river's exit, controls the trade and prosperity of the entire area.

The Ayeyarwady is the principal river of Burma (Myanmar); it rises in the Himalayas and does not pass through any other country. The name is derived from the Sanskrit word meaning 'Elephant River', and is probably named after the Elephant Mountains in the North West. A journey down this impressive river provides a moving panorama of

life along its banks, with boat people, stilt houses and numerous temples topped with gilded stupas. Fishermen build temporary villages on the sandbanks, for the river levels drop in the dry season and fresh green vegetables are grown in the newly exposed rich silt.

In Thailand, the main river is the Chao Phraya, which comes into existence at the confluence of the Ping-Nan tributaries in the northern highlands. It flows southwards through the fertile central plain to the low-lying delta region, where annual flooding brings rich deposits to the rice fields. The sea tides run up the meandering river as far as Ayutthaya, once the former capital before the seat of government was moved to Bangkok. In the past, the river was the main transport system for moving teak logs, and even today the strings of rice barges ply their way down to the main port. Formerly, a series of canals called khlongs linked together the entire city of Bangkok, but most have been paved over to provide even more access for an increasingly frenetic traffic system.

The Red River, with its source in the mountains of Yunnan, eventually flows through northern Vietnam and exits into Halong Bay at the Gulf of Tonkin, south of China. So named because of the red silt that was carried downstream, the river provided a passage through the mountain valleys, and irrigation for rice terraces. Other important waterways include the Perfume River – named after an aromatic shrub – which flows past the historic imperial city of Hué in cen-

tral Vietnam, while a little further south, the ancient town of Hoi An lies on the banks of the Thu Bon River. Both rivers, flowing east from the high mountain chain that bisects Vietnam from north to south, provided trading facilities that made the area rich. Sixteenth-century Chinese settlers controlled the trade between China, Japan, India and the South-East Asian islands, filling warehouses with imports of silk, cotton and other goods. They built temples and wooden houses in the Chinese style, with inner courtyards and ancestor shrines.

Burma (Myanmar)

There is much contention over the naming of this country. In 1989 the authorities changed many of the place names in order to adapt to common usage. However, the Burmese language comes from the universally accepted term 'Tibeto-Burman'. The Bamar, or Burman people, are a major ethnic group, descended in pre-historic times from migrating tribes from the Sino (Chinese) Tibetan area. It was the Mon

Two boat women, wearing cone-shaped straw hats, approach the quayside of Hoi An, a port situated on the Thu Bon river, central Vietnam.

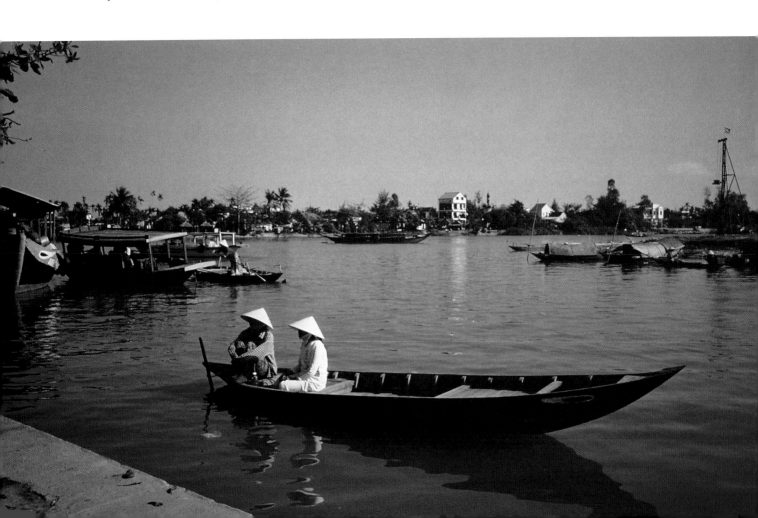

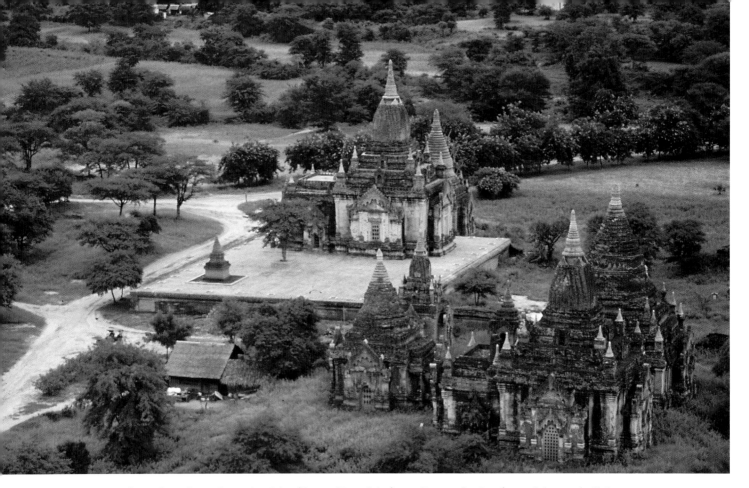

Brick temples and pagodas on the plain of Bagan (Pagan) in former Burma, the site of several thousand religious structures, built mainly during the eleventh and thirteenth centuries AD.

people, possibly coming overland from Central Asia via India, who set up a civilization over 2,500 years ago and brought Buddhism to the area. These speakers of one of the Mon-Khmer languages are credited with laying the original foundation stone of the Shwedagon Pagoda, still a much venerated shrine in the city of Yangon, formerly Rangoon. Pilgrims walk bare-foot around the golden stupa, clockwise, and gain merit with offerings to the monks.

In northern Burma the Mon were followed by the Piu, speakers of a Tibeto-Burmese language, who were great rice cultivators and controlled trade with China through the upper tributaries of the Ayeyarwady River. The 'Golden Age' of Burma is considered to be the Pagan Dynasty (now called Bagan), when parts of Burma were unified in AD 1044 and Theravada Buddhism was introduced. The Pagan kings established their superiority by building a vast complex of thousands of pagodas, temples and monasteries. The remains of this amazing city can be seen today, where the archaeological zone is now a tourist region and a tall tower gives an impressive overview of the area. The mountain-ringed plain is dotted with these brick stupas, their siting completely haphazard, like seeds broadcast from some giant hand.

A series of militant dynasties added to the existing Burmese territories, including the Shan states in the east. The Siamese capital of Ayutthaya was taken in 1767, and

intermittent fighting took place against insurgents on the China border. The invasions of the British in 1824 ended in the conquest of Burma in a series of wars that lasted until 1885. During World War II, the pro-Japanese Burmese army switched sides in 1945, aiding the British, whose rule continued until 1948 when independence was granted. The history of successive governments over the last fifty years has not been an easy one, however, and we can only hope for a better future.

THE SHAN STATES OF BURMA

The Shan people, of the Tai linguistic group, are the largest minority group in modern Myanmar, rice farming the low-land valleys of the Shan plateau in the north of the country. The original Shan people dominated much of Burma from the thirteenth to the sixteenth centuries, and also inhabited Yunnan Province in south-western China. They share the Shan plateau with aboriginal tribes, who still practise a swidden culture up in the forested hills. For several hundred years the Shan people traded with the Chinese in Yunnan and the Burmans from the west of the River Ayeyarwady. As an autonomous state, they had a system of ruling nobility and local chiefs to govern the farming communities. However, under the new constitution their power

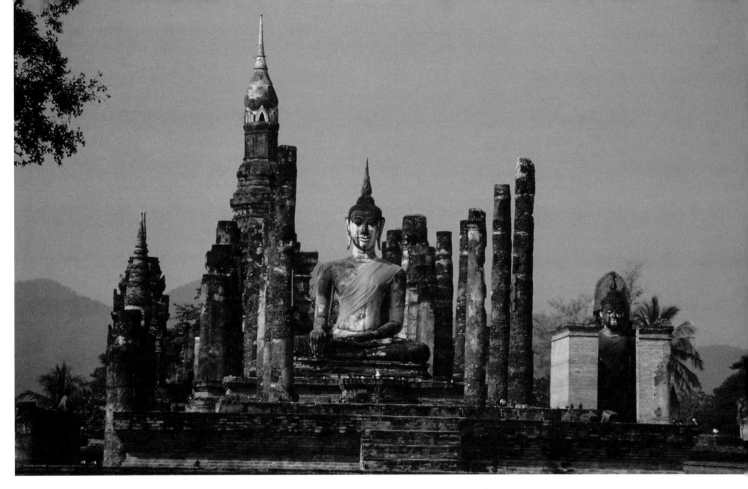

The 11m (36ft) tall seated Buddha statue in the ruins of Wat Sri Chum, at Sukhothai, the former capital of the first Thai kingdom, situated several hundred miles north of Bangkok, Thailand.

is diminished, and this has caused friction and the formation of separatist groups.

Thailand

Thailand, formerly the kingdom of Siam, shares borders with Burma in the west, Laos in the east, and Cambodia in the south-east. Present-day Thailand includes the rice-growing area of the central plain, the mountains and former teak-forest region of the north-west, the semi-arid plateau of the north-east, and the coastal subtropical region of the south. Apart from the many outside influences, each climatic region has an effect on the dress and customs of the people.

The state of Lannathai in northern Siam gained great importance as a separate kingdom; it had a sophisticated culture, depicted in the temple murals of contemporary court life – an invaluable record of a past era. The kingdom of Lanna (also called Lan Na) was established under King Mangrai in 1296, and amalgamated several small principalities. Chiang Mai, today a tourist destination, eventually became the capital. The border divides were seldom stable, and during the Burmese attacks on Ayutthaya, which lasted until 1767, Lanna was annexed by Burma and became a

vassal state, enduring impoverishment before final reunification with Siam in 1782.

The original Thai inhabitants pushed the Khmer people further southwards, and founded a kingdom in the early thirteenth century. Their first capital city, Sukhothai, meaning 'Dawn of Happiness', is now a historical park, with ruined temples showing the influence of early Khmer architecture; it is famous for the 11m (36ft) tall statue of a seated Buddha in the temple of Wat Sri Chum. The Sukhothai kingdom, which kept cultural exchanges with China, extended into Laos and down to the Malay peninsula; their sophisticated writing system eventually became the present Thai alphabet.

In 1378, Ayutthaya tribes from the south conquered Sukhothai, and a new capital was built on an island formed by the Chao Phraya and two other rivers. Ayutthaya was to become the centre not only of culture and religion, but also as the base for a vast mercantile empire. The Europeans soon realized its trade potential, and the Portuguese set up an embassy in 1511, shortly followed by their rivals, the Spanish. The Dutch and the British came in the early seventeenth century, and finally the French in 1662. The Burmese invaded the country for the second time in 1765 and completely sacked the city of Ayutthaya, but the Thais prevailed and eventually were to set up a new capital on the banks of the Chao Phraya River, near to the present site of

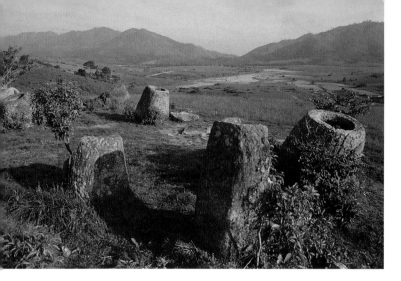

The Plain of Jars, northern Laos. Earthenware jars, or funerary urns, are scattered over the landscape for a considerable distance. Sadly, many were destroyed by bombing during the Vietnamese War. Photo: Timothy Thompson

administration system and the royal house of Luang Prabang.

The high plateau south of the former royal capital of Luang Prabang is still pockmarked with the bomb craters of the war between the Laotian communists and the North Vietnamese. The United States subjected the area to heavy bombing in the 1960s to prevent war material reaching the Vietcong in South Vietnam via the Ho Chi Min Trail; from the air, the craters form a continuous pattern covering hilltops and plains, and were never completely incorporated into the agricultural system as they are far too numerous. The bombs even damaged part of the 'Plain of Jars', where hundreds of enormous carved stone funerary jars, probably made by a megalithic Austronesian people, were discovered in the late nineteenth century by French archaeologists.

Bangkok. During the nineteenth century, King Mongkut Rama IV (featured in *The King and I*), had the sense to make treaties with the European powers, so that Thailand was the only South-East Asian country to avoid colonization.

Laos

Laos has the disadvantage of being completely land-locked – even the Mekong river only provides a transport system as far as the southern border with Cambodia. The country, which stretches south over 600 miles from China in the north, shares borders with Burma and Thailand, and is precluded from the sea along its entire length by the eastern Annamite highlands of Vietnam. Parts of the mountainous north are almost inaccessible, serviced by no more than dirt tracks, and only recently has Highway No. 13 been reconstructed from Luang Prabang to reach the Cambodian border via the capital city of Vientiane.

The isolated valley communities preserve their own traditions and dialects, often supporting a Buddhist temple and accompanying school. The hill tribes were hunter-gatherers as well as agriculturists, and had little communication with those living at lower levels. These small communities existed long before the founding of the thirteenth-century kingdom of Lan Xang: this kingdom lasted for nearly four centuries, although it was temporarily occupied by Burma in 1575, and then again in 1767, before it came under Siamese domination. The French, having colonized South Vietnam and turned Cambodia into a protectorate, sent an expedition to Laos in 1868, seeking a trade route to China via the Mekong River. Although this route proved unfeasible, in 1893 the French, who already controlled Siam, turned Laos into a French protectorate. They named the country the 'Land of the Lao', and kept the local

Cambodia: the Funan Civilization

The ancestors of the Cambodians migrated from the north, and are related to the Mon people of Burma and Thailand. In the area of today's Cambodia and the southern tip of Vietnam, they arrived to find the powerful state of Funan already well established by people who originally came from Malaya. The Funan kingdom, dating from about the first century BC, was highly influenced by Indian culture, religious beliefs and architectural styles. In the Mekong delta area, trade continued with India well into the sixth century. The Funans were conquered in AD613 by the state of Chenla, part of northern Cambodia and southern Laos, but civil war split the country in two and Cambodia declined until the foundation of the Angkor empire in the early ninth century.

Cambodia: the Angkor Empire

Jayavarman II, a Khmer prince, came under the influence of the Hindu religion and adopted the concept of divine kingship. He linked his own royalty to a cult that honoured the Hindu god Shiva, crowning himself as a *deva-raja*, or god-king, in AD802. He instituted a regime based on the Indian monarchy, and started an intensive building scheme of impressive temples, known today as the Khmer temples of Angkor. During the following centuries his successors continued to erect temples in honour of the Hindu gods; they are spread in splendour over the plain of Siem Reap, testament to a golden age that ended in 1431 when the Thais sacked Angkor. Although Angkor Wat continued in use as a shrine, many temples fell into disrepair and were submerged beneath the encroaching jungle vegetation. When Cambodia became a French colony in 1863, Angkor and

the surrounding area remained under French supervision for the next ninety years.

Cambodia gained independence in 1953 when King Sihanouk abdicated to become a full-time politician, but he was driven from power in 1970 and fled to China. Here he set up a government in exile, called the Khmer Rouge, which allowed the Communist North Vietnamese to install bases on Cambodian soil, prompting the United States to retaliate with bombing raids. In 1975 the Khmer Rouge gained control of the capital Phnom Penh, and a new government was run by Pol Pot, who instigated a reign of terror against all the intellectuals who opposed him: more than 20 per cent of the population was put to death. Pol Pot was forced to flee to Thailand when Cambodia was invaded by Vietnam, but the monarchy was reinstated in 1993 when Sihanouk returned to ratify a new constitution.

Vietnam

The Dong Son culture, which spread over much of South-East Asia, is considered to be the beginning of Vietnamese history. In 208BC a Quin Chinese general ruled over a country called Nam Viet, which stretched from southern China to the Red River delta. This minor state lasted from 207BC to the early tenth century, possibly as an independent country rather than as part of the Chinese occupation of northern Vietnam. Although the Vietnamese gained independence in 939, over a thousand years of Chinese control had left its mark, and even today the culture is influenced by Chinese art and religion, and it is embroidery rather than weaving that decorates much of their costume and wall hangings.

Vietnam is a long country, with the mountain spine of the Annamite cordillera forming a barrier from north to south, leaving only a narrow strip of fertile land against the central coast. The different areas all have a distinctive identity, the result of past divisions of the country. The northerners expanded southwards from the eleventh to the eighteenth centuries, gradually annexing more land and finally conquering the kingdom of Champa; it was the Malay people who originally founded the state of Champa in central and southern Vietnam, contemporary with Cambodian Funan. Champa survived from the second to the fifteenth century, and at times sustained a precarious co-existence with the Khmer kingdom; they, too, were highly influenced by India, Hindu teaching and culture, developing an art style similar to that of the Khmers and the mastery of carving monuments in stone. This tradition is continued in the area today, with marble quarries providing high-class stone for contemporary masons.

The temple complex at Angkor Wat, Siem Reap, Cambodia. A view taken in 2006 from a nearby static balloon shows the inner and outer courts, the surrounding moats and causeway.

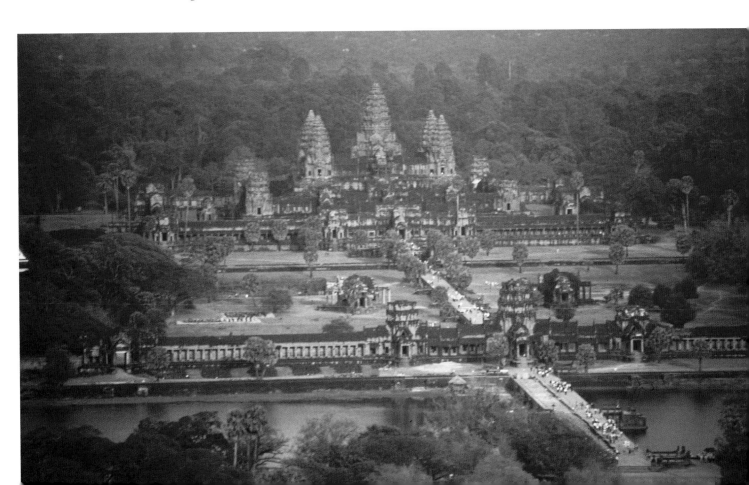

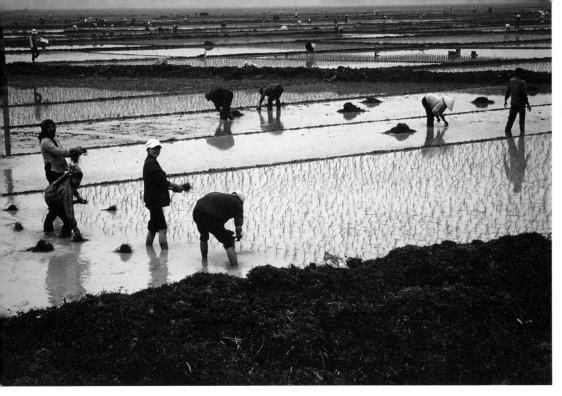

Northern Vietnam, Red River delta area. Planting spring rice in the paddyfields.

During the mid-nineteenth century, the French gained control and Vietnam became a colony, part of French Indo-China. The Japanese invaded during World War II, using the country as a base. When the war ended, the French tried to reassert their authority, but were forced to battle with northern Communists; they lost the seven-year struggle, and Vietnam was divided at the seventeenth parallel. The Unites States engaged in a war against Communist northern Vietnam that lasted from 1965 until 1973, but peace did not arrive until the whole country, unified in 1975, became the Socialist Republic of Vietnam.

Peninsular Malaya

The original inhabitants of the tropical area of the Malay Peninsula are said to have come from China and Tibet, over 5,000 years ago. Their descendants are known as the Orang Asli, and they were followed by the Malays, who settled in the coastal regions and brought farming skills and metal-work techniques. Even before 100BC Malaya was known as a source of gold and, equally important, of spices and of aromatic wood. This proved a magnet for Indian merchant adventurers, who called the country Savarnad-vipa, meaning 'The Land of Gold'. This was the beginning of a significant cultural exchange between the Indian sub-continent and the easily accessible coastal ports of the peninsula that was to last for hundreds of years. The Indians brought Hinduism and Buddhism, together with architectural styles, textile techniques and Indian forms of government.

On the south-western coast the town of Malacca (Melaka), dating from about 1400, became an important spice trade port. Facing the island of Sumatra across the narrow sea passage that came to be known as 'the Straits of Malacca', the port linked the islands of Indonesia with China and, to the west, India, the Middle East and Europe. Its perfect location brought wealth to the local rulers, who called themselves 'sultans' and held a firm control on trading. Their dealings with the Arab merchants eventually brought Islam to the country. They formed alliances with neighbouring tribes and gained ascendancy over the Straits area, defending friendly shipping against pirates, who were the bane of these lucrative seas.

But the golden era did not last for long, because in 1511 the Portuguese captured the city of Malacca, forcing the rulers to flee south. The Portuguese in their turn were taken over by the Dutch, who continued to rule the colony until 1824, when the British exchanged Malacca for Bencoolen in Sumatra. In 1819, Sir Thomas Stanford Raffles of the English East India Company had landed at the obscure fishing village of Singapore when looking for a new trading site, and was told by the local sultan that the company could purchase the site. However, the sultan was subordinate to his cousin, who was under Dutch jurisdiction. Raffles disobeyed company instructions not to offend the Dutch, and went ahead with the purchase. Although he was reprimanded, no action was taken, and in 1824 a treaty was signed by the British and the Dutch, ceding the island of Singapore to the British for a monetary payment.

British influence grew when Singapore, Malacca and the island of Penang were combined as an administrative unit called the Straits Settlements. When the British East India Company lost trade to China and ceased trading in the Malay area, the Straits Settlements were placed under the control of the governor general of India in 1851, and by 1867 became a crown colony. The integration of Malay

peninsular states followed, and the federated Malay states were formed in the early twentieth century. After the end of the Japanese occupation of Malaya during World War II, there was support for independence, and Communist guerrillas opposed the British in a campaign lasting from 1948 to 1960. The country was not called the Federation of Malaysia until 1963 when Singapore, Sabah and Sarawak were joined with the federated Malay states.

International Trade

The Spice Islands

The spice trade in the Far East had an importance to European traders that is difficult to comprehend in our present era, when refrigeration, canned and other food preservation methods all keep our food fresh for long periods. During the sixteenth century spices were used to preserve as well as enhance foodstuffs. Cinnamon came from Ceylon, and pepper from the Malabar coast in South-West India; and nutmegs and cloves from the Moluccas, the Indonesian islands off the Malay archipelago, were used as flavourings and as perfumes to ward off evil smells. The nutmeg fruit itself resembles an apricot, but with dried aril, a bright red lacy covering called mace, surrounding the inner brown seed.

The competition resulted in spice wars and trade monopolies. The English East India Company received its charter from Queen Elizabeth in 1600, two years before their rivals, the Dutch East India Company (known as VOC: Vereenigde Oost-Indische Compagnie). The Portuguese had an early dominance in the area, but lost it when the Dutch conquered Malacca in 1641, giving them control of the Malay peninsula and the surrounding area, including Bantam in Java. The Dutch held their monopoly with dogged tenacity, keeping prices high by various methods to prevent over-production. Whole nutmegs were soaked in lime to prevent them sprouting and re-seeding, a process which evidently did not affect the flavour. In the Moluccas, the Dutch resorted to burning down the native clove gardens to eliminate the production of excess cinnamon.

In retaliation the people tried to defend their crops, but were subdued and subjected to countless atrocities. Many hundreds were slaughtered, and the Dutch replaced them with slave labour and more subservient workers from other islands. The spice monopoly was broken in 1770 when the French managed to obtain from the unsuspecting Dutch, by one means or another, enough clove, cinnamon and

Images of deities adorn a Hindu temple, Malaysia.

nutmeg plants to set up plantations in French-owned islands in the Indian ocean, as well as in their colony of French Guiana in South America.

The Importance of Cotton

The search for sources of spice, precious minerals, cotton and silk opened up the whole of South-East Asia to European trade. Sailing ships were dependent on the trade winds which blew according to the monsoons, south-west from May to September and from the north-east during October to April, allowing alternating passages every six months. This led to a triangular trade, with the spice ships taking European goods to India, then picking up cargoes of Indian cotton from the Malabar coast to use as barter in the spice islands. Indian cotton was far superior to the native

cotton grown on the islands, and prized by the islanders for its ability to take dyes in the batik wax-resist process.

European Colonization and Expansion

Malaysia and Indonesia were the source of other products, such as precious metals and timber, and the Dutch trading monopoly enabled the VOC to set up the world's first stock market in Amsterdam. The prosperity of the VOC was bought at the cost of great suffering to the colonized areas and, regrettably, to the commonplace use of slave labour. While the Dutch controlled the East Indies, England gained supremacy in India. The war between the Dutch and English in 1780 weakened the VOC, and in 1795 resulted in the English taking Malacca and Dutch trading centres, apart from Java. The VOC was dissolved in 1799. The Portuguese tried to take advantage of any of the islands not already controlled by the Dutch and the British, but the islands to the east lay in the dry climate zone and were less productive.

The Silk Route

Meanwhile, the Chinese continued their long-established trade in silk and porcelain, at one time having the complete monopoly. Although much of the precious silk, either as fabric or as thread, found its way across Central Asia to the Middle East and Europe via the Silk Road, Chinese merchant ships plied a continual trade, linking China with Indonesia and the islands over a period of many centuries. During the fifteenth century, Zheng He, one of China's most famous admirals, was commander of a vast fleet of over 300 giant Chinese junks, manned by a crew of 30,000 sailors and warriors. He opened up new trade routes, and his explorations turned China into a superpower, demanding tribute from the various small states, including those on the Malay peninsula.

The Straits Chinese

Many of the Chinese merchants set up bases in the foreign ports, gradually spreading their sphere of influence. The Peranakan were early Chinese immigrants to the countries around the Straits of Malacca, which included British Singapore, Malacca and Dutch Java. They are said to be descended from a fifteenth-century Chinese princess, a gift to the Sultan of Malacca, in exchange for tribute. Her servants and royal entourage were gradually assimilated by inter-marriage into the country. But the Peranakans kept their Chinese identity and Chinese brides were imported for their sons, while their daughters were sent to China to find and bring back Chinese husbands. They practised their own ancestor religion, but otherwise accepted Malay customs. During the early nineteenth century there was an influx of further immigrants from China, and as adaptable people, they accepted English education when the British colonized Malaya. This resulted in their filling important administrative posts in local government, thus gaining further influence. Many converted to Christianity and became known as 'King's Chinese'.

The port of Hoi An in central Vietnam has long been home to a large population of Chinese merchants and traders. A woman carries her goods to the riverside market in pannier baskets.

The Kelabit people of Bario in the island of Borneo wait for a helicopter to bring supplies to their village. Situated in Sarawak, south of Brunei and close to the border with Kalimantan, Bario was a forward army base supported by a small RAF helicopter detachment, and during the 1960s was only accessible by air. Photo: Geoffrey Bradshaw

Indonesia and the Islands

The nation of Indonesia is formed from the largest archipelago in the world – and meaning 'many scattered islands in a body of water', this is an apt description, for the islands number more than 18,000. The major islands include Borneo, which is divided between the Indonesian countries of Brunei and Kalimantan, and between the Malaysian countries of Sabah and Sarawak. Sumatra is one of the largest islands, while Java is home to the capital city of Jakarta. Sulawesi lies to the west of the island group of the Moluccas, with New Guinea lying to the east, divided between Indonesian Papua (formerly Irian Jaya) and the country of Papua New Guinea. Smaller islands include Bali, Lombok, Flores, Sumba and Sumbawa, while West Timor is divided between the independent state of East Timor. The islands to the east of Bali are called Nusa Tenggara, which translates as 'South-Eastern Islands'.

Many of the islands, which are comparatively young in geological terms, are volcanic in origin, the result of the collision of tectonic plates some 70 million years ago. Islands to the west have a wetter climate than those to the east, which are influenced by dry winds from the Australian continent. On the equator, the seasons are marked by the alternating monsoon and dry seasons rather than by any marked differences in summer and winter climate. Cattle and horses are bred in the dryer savannah areas, while the tropical climate of the west supports luxuriant vegetation and wet-rice cultivation.

Early Civilizations

Java is famous as the original habitation of Homo erectus, some 500,000 years ago, while more recently on the island of Flores, a new species of hominid was discovered, Homo floresiensis, dating to about 10,000 years ago. It is thought that the first inhabitants came from Asia, spreading eastwards over the landmass, but that they did not manage to cross the deep sea of the Lombok Straits that divide the Indonesian islands. During the 1860s it was the naturalist Alfred Russell Wallace who first became aware of the difference not only in the terrestrial wildlife, but also in the people of the central islands of the archipelago. The island of Lombok is but a short distance from its immediate neighbour to the west, the island of Bali, yet Wallace observed that there were no carnivorous animals in Lombok, unlike in Bali where elephants and tigers roamed. In fact Lombok, and the subsequent islands to the east, all supported an Australian type of species and vegetation.

He correctly surmised that there must have been some past physical barrier between the two islands, possibly when the sea levels fell between islands to the west allowing the people to move across dry land, but not across the deep ocean trench that divided Bali from Lombok. In 1863 he presented a paper to the Royal Geographic Society, showing a line drawn between Borneo and Sulawesi and continuing down through Bali and Lombok. This became known as the 'Wallace Line'. Experts over the next seventy years argued as to the correctness of this hypothesis, but in the 1950s it was discovered that the 'Wallace Line' corresponded to the division of the tectonic plates in the area, giving credence to his theory. This area of the archipelago is now known as 'Wallacia'. It was Wallace who, in early 1858, while suffering from a fever in one of the spice islands, worked out his theory of natural evolution, namely that 'the fittest would survive'. As an unqualified naturalist, he wrote to Charles Darwin, outlining his theory and asking advice on publication. There is still much speculation as to the exact date that his letter arrived, but the result was that Darwin was forced to publish his *Origin of Species* sooner than he intended, and although both Darwin's and Wallace's papers were read to the Linnean Society, it was Darwin who gained acceptance as the originator of the theory.

The western tribes may have crossed the Lombok Straits about 30,000 years ago, but as yet there is no archaeological evidence to prove this. There is evidence of stone scrapers found in the caves of East Timor dating to 13,000 years ago, with similar finds in other parts of the archipelago. It was in the island of Sumbawa, immediately to the west of Flores, that the first Austronesians (South Islanders) arrived, from about 2000BC. Archaeologists link the distinctive Sumbawa stone sarcophagi to megalithic cultures in other parts of Indonesia.

People and Language

There are many ethnic groups in western Indonesia, the majority influenced by geographical location. The inland areas of Java and Bali, where the land is suitable for wet-rice cultivation, are populated by Hindus, while the coastal people of Sumatra are mainly Islamic, influenced by sea contacts. In highland areas not suitable for wet-rice cultivation, tribal groups such as the Toraja and Dayak are hunters, and practise swidden agriculture. Although most west Indonesians are of Malay ancestry, there is a mixture of races due to the gradual inflow of Arabs, Chinese, Indians and Europeans; they speak languages with an Austronesian base. Indonesia is home to two different geographic races, with Asiatic people inhabiting the west. The people of the eastern islands are of Melanesian origin,

related to the natives of Melanesia, a group of islands in the South-West Pacific.

The Part Played by the Various Religions

It was not until 200BC that there are records by Indian scholars relating to Hindu kingdoms in the islands of Java and Sumatra. This is backed up by archaeological evidence showing the influence of the Hindu religion from the first to the fifth century AD. The Hindu and Buddhist religions were to have a long-standing influence over Java and Sumatra during the period from 600AD to 1300AD. It was between the first and second centuries AD that Indian Buddhists first arrived in Indonesia, bringing with them the two Buddhist sects, Hinayana and Mahayana. However, it was a Chinese Buddhist saint named Fu Hsien who is said to have brought Buddhism to Java in 144AD when he was caught in a storm and landed on the island, staying for a period of five months. Over several centuries the influence of Buddhism spread to other parts of the archipelago.

Arabian traders first brought Islam to the area. Although the Indian merchants had monopolized trade up until the seventh century AD, trading restrictions imposed by their rulers created a vacuum that was soon filled by the Arabs. The Moslem merchants from Persia and from Gujarat in western India, first came to Indonesia in the thirteenth century, established trade links and brought Islam to areas of Java. Eventually they were to convert some of the Hindu kings, including the Sultan of Demak, in coastal Java. Under his influence Islam was to extend over the island, later spreading into Borneo, then west to Sumatra and eventually over much of the archipelago. At present many women wear the *rimpu*, or head and shoulder covering, and it is an accepted part of school uniform for the girls.

The Christian religion was introduced to the various islands where the Spanish and Portuguese had commercial interests. Christianity was often combined with the original animist or ancestor worship practised by the indigenous population, and although the percentage of Christians in the total population is not high, Roman Catholicism still has a strong following. Even today at Easter time the devout 'Brotherhood of the Queen of the Rosary' leads a procession of thousands of the faithful around the capital city of Larantuka in the island of East Flores. Four shrouded brothers carry a coffin containing relics of Christ's body, accompanied by a statue of the Virgin Mary.

The Slave Trade

The islands of the archipelago were the source not only of

precious spices, but also of sandalwood, horses and slaves. The white sandalwood, *Santalum album*, was one of several species of semi-parasitic tree that produced aromatic oil and scented wood. The island of Sumba was a prime producer of sandalwood, but also famous for a special breed of horses, and superb *ikat*-dyed woven cloth. Furthermore, for many years, even before the colonial period, Sumba was subordinate to several of the other islands and thus an important source of captives for the slave trade.

The slaves were sold to dealers in Ende in the island of Flores, and dispersed across the whole archipelago. They were particularly valued in Bali and Lombok, where they were bartered for rice, which was difficult to grow in the dryer islands to the east. The Dutch East India Company signed a trade agreement with Sumbanese rulers in 1756, and at first carried on with the slave trade. But by 1838 the moral climate had changed, and the Dutch sent a fleet to destroy the port of Ende when the dealers rejected their demand to put an end to the slave trade. Even so, trading continued in Ende, when the Dutch appointed a royal Arab leader named Abdul Rahman to a post in Kalimantan. He set up as a horse trader, but also turned a blind eye to slave trading in Ende, provided that none of the captives were Muslims; even as late as the 1870s, over 500 slaves were taken from Sumba every year.

The Philippines

This archipelago of over 7,000 islands, which forms the independent 'Republic of the Philippines', lies above the Celebes Sea in the Moluccas area to the south and has northern borders with the South China Sea. The Islands were conquered by the Spanish in 1571 and named after King Philip II of Spain. Manila, the capital city of the modern republic, is located on the largest island of Luzon. The Sulu archipelago to the south is formed of the second largest island, Mindano, and in the northern sector, the Batan islands.

The first aboriginal inhabitants were the Pygmies, or *Negritos*, though today, few exist. The ancestors of the Filipinos are of Malay stock, coming originally from Asia, and in later years, from Indonesia. In the tenth century there was an influx of Chinese immigrants, and ceramics and textiles were imported during the Chinese Sung period, from the tenth to the thirteenth century. However, there is evidence of earlier trading links with the Dong Son culture of northern Vietnam, with the discovery of bronze artefacts and drums.

The country was under Spanish rule for over 300 years, and they brought Roman Catholicism and the Spanish culture to many of the islands. Although Catholics are in the majority, Islam took hold in the southern areas and there

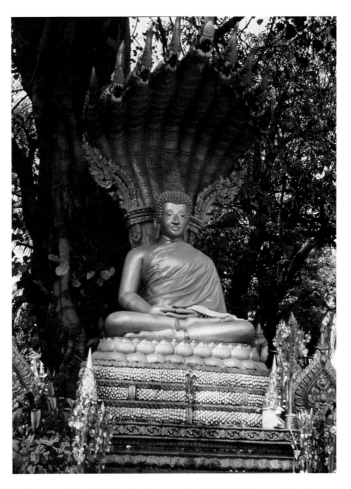

A statue of the Buddha in the grounds of Wat Si Muang, Vientiane, Laos, is shown protected by the hoods of the naga serpent that coiled itself around the Buddha.

are remaining groups of animist tribal societies. The diversity of ethnic origins and religious beliefs has led to conflicts that have not yet been resolved. Independence was declared in 1898, when the Philippines came under the rule of the United States. America was only too happy to have a trade and political interest in an area from which it had been excluded for so long.

Papua New Guinea and Irian Jaya

The island of New Guinea has a chequered history. At present it is divided into two: the western half, Irian Jaya, formerly Dutch Irian Barat, became part of Indonesia in 1969, after the Dutch lost control of Indonesia when it gained independence in 1949. The eastern half, once part of the British Commonwealth, was granted independence in 1975. New Guinea has been part of the Dutch East Indies,

divided between Germany and Britain, annexed by Australia, and temporarily occupied by the Japanese in World War II. This mountainous island is the source of rich minerals, gold and extensive deposits of copper. For hundreds of years Malay merchants traded in both goods and slaves, relying on the trade winds to time their journeys.

The island may have been occupied as long ago as 50,000 years, and evidence of an agricultural society is dated to 7000BC. The original settlers, who still live in the interior, are mainly speakers of the Papuan languages. It was in the remote highlands of the Australian mandate that a completely unknown tribal community was discovered in the 1930s. Over a million people, still practising an early

form of culture, lived in the area and had never come into contact with modern society. These people were, and still are, exploited as a source of labour for the coastal plantations. The island is rich in plant and animal life, with orchids and figs, and in the forests, the spectacular birds of paradise with their gorgeous plumage.

The Aftermath of War and Modern Trends

When the history of continuous conflict over the entire area of South-East Asia is taken into consideration, it is

A grain store in a war-torn village in northern Laos is raised high on spent shell cases to deter pests and vermin from damaging the crop.
Photo: Timothy Thompson

financial gain to countries with little else to support their economy. An effort is being made to encourage the crafts and culture of the various ethnic societies, but inevitably, fewer and fewer people are wearing their tribal costume. The younger generation has found an alternative lifestyle, and gives less time to concentrate on the labour-intensive production of hand-woven and ikat-patterned cloth. On the other hand, craftwork has found an outlet in tourist centres, and even if it is not as fine as the previous work, at least it is keeping the tradition alive.

The Role of Textiles in a Historical Context

Although the spice trade was of prime importance in the colonization of South-East Asia and, in particular, Indonesia and the islands, the role played by textiles has always been inextricably interlinked with sea trade. The fashion for chintz and the Indian-painted *palampores*, so popular in eighteenth-century England, required the importation of fabrics from India to Europe. The Indians had discovered the secret of mordanting cloth, a process that made fast the dye-stuff, so that fabrics could be washed and would not fade or lose their colour through abrasion or mishandling. The European desire for Indian fabrics was nothing new, for in the preceding centuries India had been the prime source of cotton textiles for the rest of South-East Asia. The superior type of cotton grown, their knowledge of the secrets of dyed cloth, and their mastery of intricate weaving techniques, made them leaders of the textile trade, at least until the fine cotton was grown in Cambodia and other areas.

The Indian expertise in cotton was matched by the Chinese monopoly of silk. At first a closely guarded secret, silk production gradually spread to other places, especially those under Chinese domination. The Chinese were fearless sailors, and ventured into areas unexplored by less determined traders. Both fine cotton fabrics and silks were exchanged by the merchants for trade goods, artefacts, rice, horses, slaves and local fibre products. The prestigious batiks, worked on to the imported Indian cotton, were re-exported to other areas. The royalty of mainland South-East Asia depended on imported silks and cottons for court costume and palace furnishings, gaining a level of prestige from the fact that they were foreign fabrics and, due to the expense, unavailable to ordinary people.

amazing that the majority of the people have managed to live fairly productive lives. Religious faith has played a great part in the way that people order their lives, giving solace when times are difficult, but also being the catalyst for much of the conflict that still rages across certain areas. Many of the tribal customs, ceremonies, symbols and way of dress, promote the individuality of the community and its position and relationship to other societies.

Today, many of the South-East Asian countries are battling with poverty, or are under the yoke of an oppressive governmental system. Although the advent of mass tourism has in essence destroyed some of the very elements it wishes to promote, at the same time the industry brings

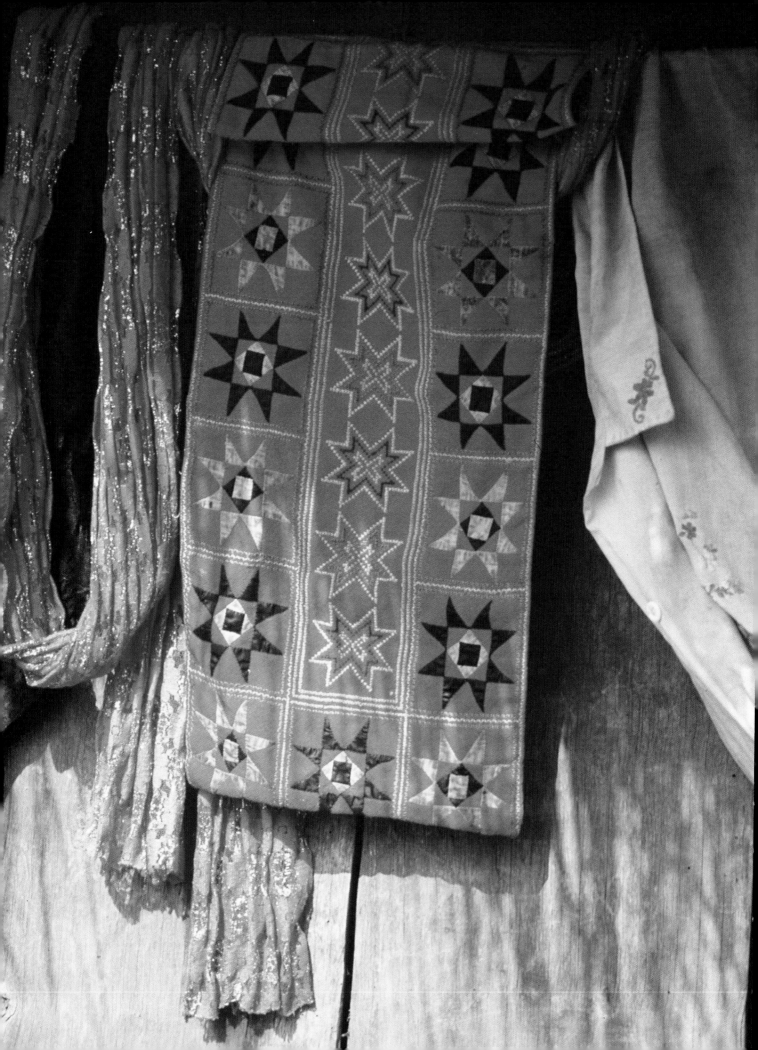

—— 2 ——

Symbolism, Pattern and Design

It is important that the meaning of a **symbol** is apparent to the viewer, otherwise it is completely ineffective. A symbol represents certain concepts or qualities that one group of people wishes to convey to another group, without the need of words, or of writing. This is particularly important in a mainly illiterate society. Symbols can express and give meaning to selected objects, or to concepts of spirituality, identity, nationality, dominance or allegiance. At times a symbol can also be the prerogative of certain sections of society, such as the aristocracy and religious or government institutions who wish to preclude the uneducated.

Normally a symbol does not contain lettering unless it is part of a logo, in which case it expresses something slightly different. A logo, short for 'logogram', is a badge of identity adopted by various groups such as a business, a specialist society, or even a political or military institution. A sign is usually composed of lettering, but may also contain a symbol, such as an arrow, which will indicate direction.

A **pattern** is a type or style of decoration which relies on the repetition of certain elements to produce the whole; it can include decorative figures, symbols or combinations of markings that occur naturally or by chance. Many patterns contain geometric elements, and can be reduced to mathematical formulae that correspond to the patterns that occur in the natural and scientific world. There are only seventeen ways in which a pattern can be repeated. The pattern symmetries are formed initially from a single motif, the smallest unit possible to make the pattern. This fundamental unit can be rotated, mirrored and glide-reflected, the end result producing a single unit cell, which is always in the form of a hexagon or a parallelogram. The fundamental

unit must have a shape that fits together with itself, and it is the repetition of this unit that forms the overall pattern or lattice.

A motif is not the same as a symbol, but a symbol can be used as a motif. The motif may be anything from a single flower to a geometric shape. It is possible to use a single motif as decoration, or several motifs can be combined to make a repeat or overall pattern.

A **design** is defined as a plan or pattern from which a picture or an object can be made. In this context the word 'pattern' means something that can be copied. There is always an initial idea behind a design, which corresponds to the end purpose for which the design is intended. To some extent, and especially in the world of textiles, the design will be affected by the limitations of the particular craft. In the context of weaving, geometric patterns are easier to work than pictorial designs, where a series of steps, however small the scale, are needed to form the curves. Wax-resist drawing, fabric painting and embroidery are all used to express fluid designs or pattern elements on to the surface of a fabric, with, to a certain extent, no limit on scale.

The Importance of Symbols

In a world where nothing is certain, where the future can hold unknown dangers, where individuals or even nations fear dominance or aggression by their neighbours or from superior powers, it is essential that the group stays together. It is their only hope of survival. Some tribal societies are known only by the difference in their dress or by the colours they adopt, and although these attributes are not symbols as such, they stand as a means of identifying the

OPPOSITE PAGE:
A repeat pattern of stars is embroidered on to an apron worn by the White Meo hill tribe, Doi Suthep, North-West Thailand.

31

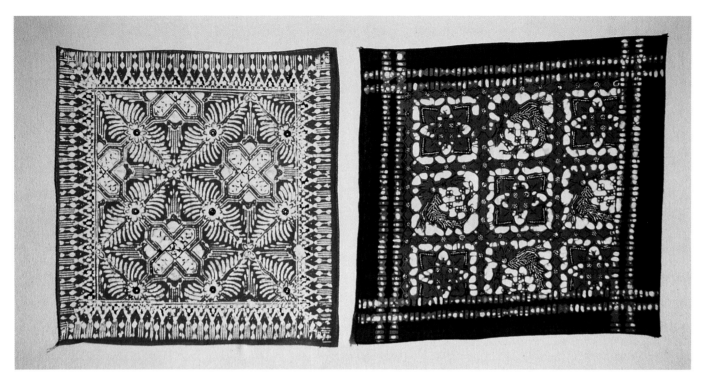

Mirror-image and repeat patterns form batik wax designs on little mats made for tourist sale, Singapore, 1989.

particular group, and often provide a name by which the tribe is known. The Muangs were particularly strict in demanding adherence to their dress codes, and expected all who came under their changing sphere of influence to adopt the Muang colours and symbolic costume. This is not quite the same as a military uniform, where certain symbols are used to identify friend from foe, or to give cohesion to a disparate group of soldiers, some of whom may be mercenaries, serfs who owe allegiance, or slaves taken from the enemy and forced to fight for the other side. Conquered nations often adopted the symbols of their oppressors in order to survive, or because over a period of time, these symbols became part of a new national identity.

Badges of Rank and Allegiance

Badges of allegiance could also take the form of silver ornaments, special headdresses, types of armour, standards or flags. Whatever their shape or type, they immediately identified the wearer as belonging to a certain tribal society, Muang, country or national group. As allegiances changed, so did the badges adopted by the wearers.

Certain symbols were used to define different levels in society, whether aristocratic, civil or military. The most famous are the Chinese rank badges, also known as man-darin squares, which to an extent were adopted in those countries conquered by China. The northern and central parts of Vietnam came under Chinese rule for many centuries, and although not everything Chinese was assimilated, the royal families adopted Chinese Court dress. These gold- and silk-embroidered rank badges were square shaped with a decorative outer border. They were separate items applied to the back and front of the outer garment, with the front one divided into two parts. Military badges depicted animal symbols, while civil badges showed birds and defined the position of the wearer in the Court hierarchy. As the wearer of the rank badge moved up in society, the symbol on the badge changed – which is why they were removable. Sometimes a symbolic bird of a lower rank was made to look rather like the one of the rank above, thus giving the wearer a false identity. The rank badge was a symbol of status, and their use gained an overweening importance.

Apart from the main animal or bird symbols, the rank badges would contain a selection of the eight Buddhist emblems, the emblems of the Eight Immortals or the Eight Treasures. These are not always easy to decipher, and are often hidden within the background embroidery. Common to many rank badges are the following: the Gourd, the Endless Knot, the Fan, the Lotus, the Conch Shell, the Canopy, the Flower Basket, and the Umbrella. All of these symbols, together with Taoist symbols and several other

sets of symbols, are illustrated by Young Y. Chung in her book, *The Art of Oriental Embroidery*. The rank badge illustrated shows the Fan, the Flower Basket, Gourd and Sacred Knot.

Pattern According to Status

The adoption of rank and other badges was not the only method of defining status, and certain prestigious fabrics – the highly valued Chinese silks, the use of gold and silver thread within the weave structure, and of foreign imports, especially from India – were reserved for royalty and the élite. In a slightly different category are the fabrics that are difficult to produce and which require a great deal of time and expertise in their construction. Any fabric or decoration that is in short supply or difficult to obtain, such as the bird of paradise feathers used in New Guinea, can be used as a status symbol. The royal court of a minor country would ape the status attributes of superior nations, even changing the styles of their dress to suit the new requirements.

The wives and concubines of the royal courts had their own dress code, and often there were problems when a bride was brought from another country or tribal area. Sometimes the bride would take on the costume and accessories of her new country, professing loyalty with a high-ranking husband; in other cases the bride would continue to wear her native dress, or adapt the costume so that at least she retained some of her original tribal identity. It must have been very difficult for these women, who were often exchanged as a form of tribute, or who were married to promote an alliance between two different countries.

Many of the tribal areas divide costume according to the age and status of the individual. Unmarried women would wear one type of dress, changing when they married to a more elaborate style of ornament to show their new status, then reverting to more soberly coloured clothing on reaching middle and old age. Young boys would adopt a different costume after the puberty ceremony, they would wear more trophy symbols when they reached warrior status, or in a few instances they would eventually show off the accoutrements of a shaman or village chief.

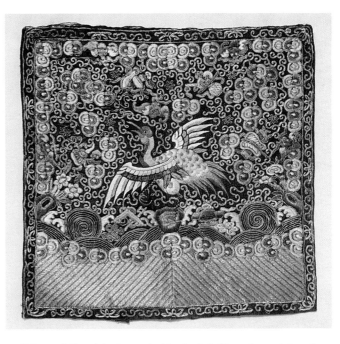

Chinese civil rank badge worked in shaded silks and metal threads. The bird is surrounded by a variety of symbols including the Bats, the Castanets, the Crutch and Gourd, the Vase, the Fan, the Endless Knot, the Sword and the Flower Basket.

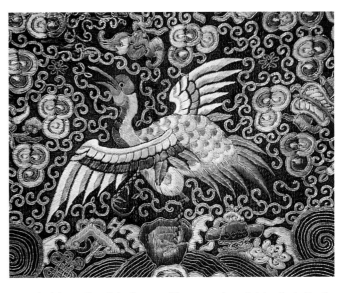

Detail of the civil rank badge, possibly a seventh-rank Mandarin Duck.

Prohibition of Royal Symbols and Pattern

Each royal court, principality or tribal chiefdom would reserve certain fabrics and pattern methods for their particular use, and this was particularly so in the context of the wax-resist patterned cloths of Indonesia. At times, severe punishments could be meted out to those who dared trans-gress the 'pattern' rules, and it was not until the demise of the royal families that these patterns came into common usage; now they are even found on trade cloths and on contemporary tourist fabrics. This pattern prohibition was no doubt because it was no more expensive to produce royal patterns as opposed to ordinary ones. It was

considered essential to use imported Indian cotton as a base fabric, while the batik waxing and dyeing process was equally time-consuming, whatever the pattern chosen. Other courts or principalities forbade the use of gold thread, jewels, pearls, silver sequins and gold or silver ornaments – in fact, the use of anything that threatened the royal position was frowned upon, and although their use was prohibited, those who wished to usurp the current rulers, took up the status symbols as a way of gaining authority.

The Importance of Certain Patterning Methods

Certain weaving patterns were also reserved for the aristocracy, especially those that required much manipulation, such as the 100 shuttle tapestry-weave patterns or the intricate weaving of thread inlay sequences. It is interesting that

several of these 'royal' weave patterns are copied today for ordinary use, using simplified fabric construction methods. Certain motifs and symbols depicted within the weave pattern were reserved for royal, priestly or shamanistic use.

The motifs also took on the role of talismans, and were incorporated within, or as an addition to, the textiles. Decorated or woven cloths were hung from important parts of the dwelling house, or from the gateway that framed the entrance to a village. This was to deter evil spirits, or conversely to welcome the spirits of ancestors, depending on the motif and purpose for which the item had been made. The ikats of Sumba show ancestor figures, tree-of-life motifs, and mythical beasts. These woven hangings are used in their ancestor ceremonies, which take place in a special village set aside for the purpose. All are worked in the time-consuming 'ikat' method, where bundles of warp threads are tied at intervals to resist the dye, then re-tied and re-dyed to obtain the various colours. It is only when the weaving is finished that the lovely patterns come

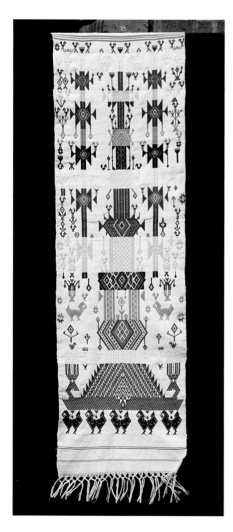

LEFT: A contemporary temple banner from North-West Thailand showing a series of bird motifs, plants, offering stands and a boat with naga heads.

BELOW: A young Kelabit woman from Bario in Sumatra, Borneo. She is wearing a prestigious beaded cap that fits closely to the head. This accentuates her long ear lobes that are extended with a series of heavy rings. Photo: Geoffrey Bradshaw

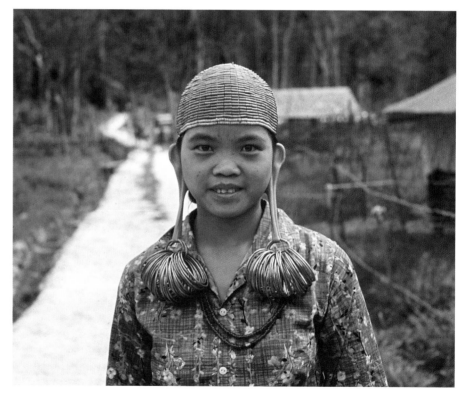

to life. Long, narrow banners hang inside the temples in rural Thailand, gifts made by benevolent women seeking religious merit for their labour. Some of these woven banners are decorated with stylized birds and tree-of-life motifs.

Rites of Passage

Each society has its own particular version of marking certain important stages in life. While birth and death are common to all of us, many of life's other significant phases are distinguished by particular ceremonies. Each occasion – whether it is the joining together in some form of matrimony, the celebration of a birth, the passage of puberty or coming of age – demands the wearing of special clothes and the display of appropriate symbols. These vary according to tribal custom and to the religious beliefs of a particular group. Puberty ceremonies are considered very important, for a young boy would be introduced into adulthood and become part of tribal society; some form of initiation ceremony, test of manhood, tattooing or scarification would take place.

After the onset of puberty the young girl would be considered ready for marriage, and the costly and arduous task of producing a dowry would begin. The girl and her female relatives would already have started work on this task, for she would have to provide woven, dye-patterned or embroidered garments and fabric not only for herself, but also for her intended husband and, even more importantly, for her future mother-in-law. The girl and her family would be judged on the standard of workmanship, and if it was not considered to be the best, a lower bride price would be offered. In parts of Indonesia, the girl's puberty ceremony was accompanied by ear-boring to accommodate various types of ear-ring, ear-plug or decoration. In other areas the teeth-filing ceremony was equally important, where the incisor teeth were filed to a point by the priest or shaman. Evidently this was to deter any demons who might harm the girl.

In Burma and other Buddhist countries, the majority of young boys take part in the Shin-Pyu ceremony, the initiation ceremony undertaken by a novice before he enters a monastery. Only a few of the boys go on to pass the rest of their lives as monks, but for a couple of years they are educated in Buddhist lore, and after the ceremony are regarded as 'human beings' rather than mere animals. By withdrawing from ordinary life, they are following the Buddha when he sought enlightenment. The boy is dressed for the ceremony in costly silken garments, he wears a golden crown, and is seated on a horse decorated with embroidered trappings: this signifies the worldly goods he must renounce before wearing the saffron robes of the order.

The different religions followed their own particular customs regarding funerals and the disposal of the body. In many instances the deceased was clothed in his or her best clothing, in some instances made by the bride-to-be when she produced the dowry garments. Whether this had anything to do with the possibility of death in childbirth is not known, but it may have had some bearing on the custom. Certain tribes wrapped the body in such a multiplicity of garments that it became a large bundle, sometimes stored in the roof space of a hut waiting for an auspicious date for the funeral, or until the family could afford to pay for the ceremonial feasting attended by the whole village community.

Religious Iconography

In societies where few could read or write, some visual method of depicting the symbols of faith was very important. In the same way that mediaeval European churches and cathedrals were decorated with scenes from the bible, so the various religions of South-East Asia made use of a rich repository of Holy Scriptures, spiritual stories and ancestor myths. These might be recorded as stone glyphs, as wall paintings, as embroidered wall hangings, or as decorative woven banners that were displayed in the temples. The *pidan* are sacred hangings consecrated for use in the pillared halls of the Buddhist Wats in Cambodia. The depiction of narrative scenes from the lives of the Buddha, produced by the labour-intensive ikat pattern technique, is superb evidence of the weaver's art. Auspicious symbols were included on canopies suspended above the Buddha image as well as on umbrellas or parasols that have a protective connotation in various religions. Symbols and religious motifs feature on altar cloths and banners used in both Chinese religions and the Christian faiths.

Types of Religion

Spirit Worship

Each form of religion had its own set of rules, and its own set of symbols and method of story-telling. The animists were essentially spirit worshippers, but this is an over-simplification: they believed that spirits inhabited the trees, rocks and other natural features, and although believers were at one with 'nature', at the same time their lives were

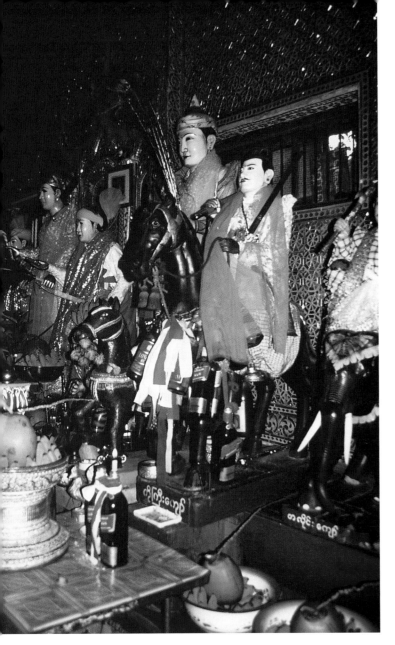

A Nat shrine in a temple at the foot of Mount Popa, Myanmar. The religion is a mixture of animism and Buddhism, where the images are presented with gifts of food, alcoholic drinks and decorated cloth.

when the full moon arrives, or in May to June when an important festival is celebrated at the foot of the sacred Mount Popa, an extinct volcano cone, north of Mandalay. Although the main religion is Buddhist, the two faiths exist in parallel, the one complementing the other.

Buddhism

There are two types of Buddhism: Mahayana Buddhism practised in China, and Theravada Buddhism which originated in northern India during the sixth to fourth centuries BC. The original sects divided in 235BC, with the followers of Theravada, or Hinayana Buddhism adhering more closely to the Buddhist's original teaching, while Mahayana Buddhism is considered to be the means of salvation to a larger number of people. Theravada Buddhism gradually spread eastwards, becoming dominant in Myanmar in the late eleventh century and in Cambodia and Laos by the thirteenth and fourteenth centuries.

The Buddhists do not believe in a 'soul', but rather that the sum of a person's karma, the balance of good and evil deeds, determines the level of rebirth. It is the concept of gaining merit by the offering of gifts to the monasteries that is important in a textiles context. In the same way that mediaeval Christians bought 'indulgences' to speed their way to heaven, so the Buddhist faithful seek to enhance their way to achieving Nirvana. Gifts are given in a number of ways: in many of the countries where Buddhism is practised, woven cloth is of great importance. Apart from the banners, temple shawls and monk's clothing, there are cloths to cover the Buddha statues and the tablet-woven bands that bind together the leaves of the Holy Scriptures. The embroidered cloths and woven bands were made by specialist craft workers and contained messages extolling the virtues of the individual donors. These donors were not shy about advertising their generosity in presenting expensive gifts, for merit can be shared by association.

It is an amazing experience to watch the 'monks' breakfast' at the Mahagandayon Monastery, a school for young monks in Mandalay. Here over a thousand monks, novices and several nuns line up with their alms bowls, ready to receive an offering of rice and bananas provided by the members of a family seeking merit. This is meant to be the only meal of the day, and the monks completely ignore the watching tourists, tolerating intrusion for the sake of donations. Their draped robes are in shades of maroon, the colours varying from rust brown through mauve-reds to a warm cinnamon. As the robes are gifts from the faithful, many of them hand-woven by the donor to gain merit, the exact degree of colour is of no importance. The nuns wear a delicate shade of pink, while some novice boys are in white.

governed by the need to placate mischievous or evil spirits, to obtain favour from good spirits, and to observe rituals that promoted their well-being. In some instances this went hand in hand with ancestor worship. All the spirits of past ancestors were available to help the living, provided they were treated with the correct ceremonial observances, and appeased with gifts of cloth and the essentials of everyday life.

In Burma, the *Nats* – spirits of nature – have special shrines erected in their honour. The Nat shrines are highly decorated with tinsel and embroidered pennants, while the figures of the 'Spirit Gods' are clothed in garments encrusted with golden thread. They are surrounded by offerings of food, cigarettes and bottles of wine, beer or spirits. Nat festivals are held in November and December

The 'monks' breakfast' at the Mahagandayon Monastery, a school for young monks in Mandalay. The family of donors handing out the food – in this case rice and bananas – will gain merit for their act.

THE BUDDHIST TEN JATAKA TALES

The Jataka Tales tell of the last ten lives of the Buddha, which are considered the most important in Theravada Buddhism. The Buddha perfected one virtue in each life until the last one, which culminated in his perfection as a mortal and the attaining of Buddha-hood when he was born as Prince Siddhartha. In her book, *Kalagas, the Wall Hangings of South-East Asia*, Mary Anne Stanislaw tells us:

Although these stories have religious roots, they are full of wonder, magic and miracles. Men and gods often leave their realms to visit the heavens or hells, and demons sometimes disguise themselves as men.

These stories, which vary from country to country, form the basis of many of the designs for the kalaga wall hangings found in Myanmar, Thailand, Laos and now many other South-East Asian countries. Raised and padded figures are surrounded by the glitter of gold thread and innumerable sequins, which catch the light in dim surroundings, giving the embroideries a mystical quality that is dispelled when they are viewed in a brighter light.

Hinduism

Hinduism is not easy to define. Although a Hindu may believe in many gods, this does not exclude the belief in a single god. According to *Britannica*:

Magic rites, animal worship, and belief in demons are often combined with the worship of more or less personal gods or with mysticism, asceticism, and abstract and profound theological systems or esoteric doctrines.

This has spawned a rich diversity of religious iconography, of exotic statues and rich textile decoration. Hinduism, a term introduced in about 1830, refers to a civilization that has lasted for over 2,000 years and originated from the Indo-European peoples who settled in India in the last centuries of the second millennium BC.

Indian influence spread gradually across South-East Asia during the first century AD. This was the result of increased trade, both overland through Thailand and Burma, and by sea around the coasts and into the Indonesian archipelago. Both Buddhist and Hindu religious beliefs were spread by the merchant traders, and their influences are still felt in these areas so that Hindu sculptures of the god Vishnu are found alongside Buddhist images.

The Hindu kingdom of Funan, established in Cambodia at the beginning of the first millennium, was taken over in the ninth century by the Khmer empire, famous for the relief sculptures at the temple complexes of Angkor. Many show the Hindu deities, including the god Vishnu and his incarnation Krishna and Siva. Hindu kingdoms first existed in western Java and Borneo during the fifth century AD, and their influence spread to artistic design on cult images and eventually on fabric decoration and patterns. These changed when the Arab traders introduced Islam, and figurative designs were no longer acceptable.

THE SANSKRIT EPIC POEMS: THE *MAHABHARATA* AND THE *RAMAYANA*

The Hindu epic poems existed alongside religious texts and were recited by the bards, with the tradition passed down from father to son. Originally these bards held positions as charioteers to the various noblemen, and, witnessing their military successes, chronicled the martial history of the families to which they were attached. From these beginnings the epic style of the poems developed.

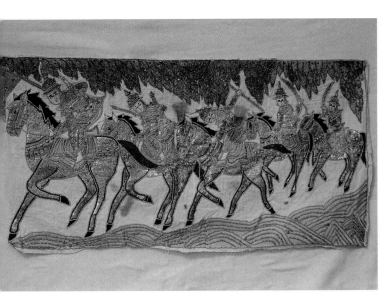

An embroidered 'kalaga' wall hanging showing a scene from the myths, depicting horsemen ready for battle.

A young Vietnamese girl lights a candle in the Chinese Thien Hau temple, Saigon (Ho Chi Minh city).

The *Mahabharata* is the longest known epic poem, composed between 400BC and AD200. It has been continually elaborated with additions and alterations, and tells the story of two sets of cousins, both of whom aspired to the same throne. The winners of a dice game secure the throne, with the losers, five brothers and their commonly held wife, sent into exile for thirteen years. On the losers' return, the winners refuse the brothers a share of the kingdom,

and the result is a war of all the tribes, with only seven warriors surviving the battle. Although military prowess is extolled, at the same time the wastefulness of war is pointed out. This story has been the source for many depictions in sculpture, including the bas-reliefs at Angkor. They also feature in narrative embroideries of different types. The Burmese 'kalagas', although originally made as Buddhist religious wall hangings, later took on a secular role and found limitless inspiration in these epic poems.

The *Ramayana* is the second of the great Hindu epic poems, and although shorter than the *Mahabharata*, is immensely popular not only in India, but also throughout South-East Asia. It is well known in Cambodia, Thailand and Indonesia where episodes from the poem can be found carved on to monuments. The heroes and their legends play an important part in the Burmese puppet theatre repertoire, as well as in Javanese and Balinese theatre, dance, and shadow puppet plays.

In Sanskrit, *Ramayana* means 'Romance of Rama'. Once again it is the story of a contested throne, with Rama banished into exile in the forest with his wife Sita and favourite brother, Lakshamana. Here Ravana, a demon king, carries off Sita while the brothers are pursuing a golden deer. While Sita rejects the amorous attentions of the demon, the brothers seek help from the king of the monkeys in order to rescue her. Rama kills the demon king, but the chastity of Sita is contended, even when she gives birth to Rama's two sons; eventually the family is reunited when they become of age. Still protesting her innocence, Sita asks to be received by the earth, and is duly swallowed up. In some versions Sita is cleared by undergoing an ordeal by fire. The recitation of this poem is considered an act of merit, while the iconography included in the epic provides endless subjects for design. It was popular during the Indian Mughal period of the sixteenth century, and in northern India, the events are still enacted in an annual pageant.

China: Confucianism and Taoism

Confucianism is more a way of life, learning and thinking than a religion. The followers of Confucius, the enlightened sage and teacher, pursued this way of life from the sixth to the fifth century BC and onwards to the present day. Confucianism is a Western term to try to explain this social ethic that was embraced by the Chinese for well over two thousand years. The influence of Chinese culture, governmental methods and education resulted in the theory and practice of Confucianism spreading to other countries, including Korea, Japan and Vietnam. Confucius had, in his enlightenment, recognized the mystery of the ultimate reality, but did not explain this concept in his teachings, realizing that it was impossible to express in words.

An embroidered Chinese temple hanging showing two of the Taoist patron saints, called 'Immortals', surrounded by flowering trees on little mounds and with the two bats known as 'Fu', the symbol for happiness.

Taoism is often linked to Confucianism, and although it has the same basic tenets, it represents a personal and metaphysical view where mysticism is to an extent related to the animistic practices of priests and shamans. The Taoist 'Eight Precious Things', also called the 'Attributes of the Eight Immortals', are a series of symbols relating to the various Taoist patron saints. The Fan is the symbol of the patron saint of the military, the Sword represents barbers, the Crutch and Gourd emblem depicts the sick, the Castanets the patron saint of actors, the Flower Basket portrays florists and gardeners, the Flute is the patron of musicians, the Lotus the female patron saint of housewives, and the Bamboo Tube and Rods the patron saint of artists and calligraphers. Apart from the Fan symbol, their use is fairly apparent, while the Bamboo Tube held the brushes used by the artists.

The secular 'Eight Precious Things' contain mainly literary and artistic symbols, implying a connection with Con-

fucianism. The Pearl symbolized the granting of wishes, the Cash was a copper coin decorated with ribbons and indicated wealth. The Open Lozenge symbolized victory, the Pair of Books meant scholarly learning, while the Painting represented by a solid lozenge, illustrated art. The Pair of Horns was a symbol of health as they resemble rhinoceros horns, valued in medicine, possibly with an aphrodisiac connotation. Lastly the Artemisia Leaf was considered the symbol of the good omen and the prevention of disease.

Cao Daism

This new religion took root in southern Vietnam during the 1920s. A civil servant named Ngo Van Chieu was visited in a dream by a supreme being called the Cao Dai, meaning 'High Tower', a Taoist epithet for the supreme god. This

being was symbolized by a giant eye, which is one of the foremost symbols of a religion not lacking in esoteric iconography. The sect was both religious and political, as the local disposed peasants were promised redress, and Cao Daism gained a large following. It accepted tenets from most of the other religions – Buddhism, Confucianism, Taoism, Christianity and Islam. An eclectic group of saints included, among others, Julius Caesar, Joan of Arc, Victor Hugo and Winston Churchill. In southern Vietnam, especially around the Mekong delta area, the temples proliferate. They are highly decorated in a gaudy manner, but obviously fulfil a need as they are well kept and highly regarded. Ornamental pillars entwined with dragon serpents hold up the porticos, while doorways are flanked by monkey guardians in exotic dress.

Islam: Types of Myth and Legend

Many secular stories and myths took on a religious meaning by transmuting into symbols for the soul longing for identification and reunion with God. Numbers and letters have taken on a mystical quality, with the threefold or sevenfold repetition of certain rites having a special significance. The number forty, as in the Christian Bible, is connected with periods of repentance and fasting undertaken by the novice preparing for the mystical brotherhood. Letters of the alphabet are important elements in Muslim pious thought, and feature boldly in many of the Islamic embellishments of mosques and religious colleges. The letters were given a numerical value, so that 'A' becomes number one, a symbol for the uniqueness of Allah. According to *Britannica*:

> M is the letter of human nature and hints at the 40 degrees between man and God. The sect of the *Hurufis* developed these cabalistic interpretations of letters, but they are quite common in the whole Islamic world and form almost a substitute for mythology.

Arabic calligraphic inscriptions in the form of birds and other motifs are found on Sumatran batik cloths.

As Islam spread further east through the Indonesian archipelago, the previously acceptable Hindu carvings and decorative elements were superseded by geometric or non-figurative designs. The western part of Mindano and the Sulu Islands in the southern Philippines are famous for a very finely woven tapestry technique cloth. While imported Chinese silk was preferred, the patterning was no doubt influenced by the Muslim traders who first controlled the area. Although the Philippines are mainly Roman Catholic, Mindano became a Muslim outpost where Islamic culture and crafts predominate. The autonomous region of Mus-

lim Mindano, which includes a number of the nearby islands as well as Mindano Western Territory, was established in 1990.

Christianity: Protestant and Roman Catholic

The missionaries were great travellers. Their aim was to spread the Christian gospel as far and as wide as possible, and over the centuries influence gradually spread eastwards across mainland South-East Asia. Protestant missionaries entered Indonesia from the west, and although the proportion of converts was not high, their influence left a lasting legacy. As well as establishing missions, they were instrumental in banning the ritualistic head-hunting practised in Kalimantan and Celebes, and the cannibalism that existed in northern Sumatra during the late nineteenth century.

Those areas of Indonesia controlled by the Spanish and the Portuguese were the first to be converted to Roman Catholicism. Wise priests allowed the faithful to keep many of their animist beliefs, transferring the observance of pagan rituals and titles of animist spirit gods to the veneration of the Catholic saints. When the Portuguese took control of the Lesser Sunda Islands and the Moluccas in the sixteenth century, they installed a fort and mission on the Solor Straits where Dominican priests converted and baptised many of the islanders. The 'Black Portuguese' were a community of mixed-blood Catholics, the result of intermarriage between native women and Portuguese sailors and traders.

Dutch Catholics set up missions in the Solor Islands. By the early twentieth century they were responsible for many changes, including the abolition of aristocratic control of slavery and internecine feuding between the villages. These changes had the effect of altering the existing society, which became more Westernized and lost much of the traditional ethos where textiles had played such an important part in the structure and spiritual life of the community.

The Spanish ruled the Philippines for more than three hundred years, and it became the predominantly Roman Catholic country in South-East Asia. Roman Catholic Spanish art came into the country from the east via Mexico, and the convent nuns taught religious embroidery. They introduced metal threadwork to embellish the church vestments, as well as Whitework embroidery, which even today is superbly stitched on to the local Piña, or pineapple fibre cloth. A Roman Catholic religious organization called the Society of the Divine Word was founded in 1875. The priests and lay brothers were sent all over the world, and set up missions in Indonesia, New Guinea and the Philippines where they published Catholic literature and promoted the Catholic faith.

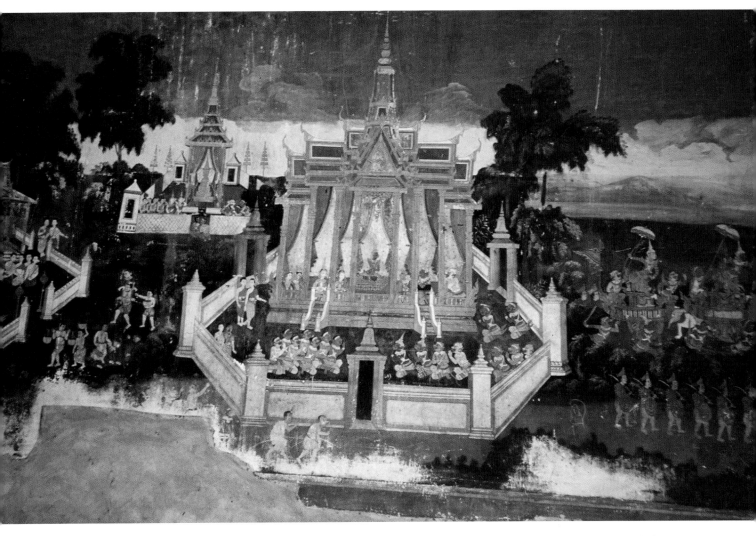

The mural that runs round the inner gallery of the Silver Pagoda courtyard, in the royal palace compound, Phnom Penh, Cambodia, depicts the story of the Indian epic, the Ramayana. It was painted around the end of the nineteenth century.

Creation Myths

There are countless Creation myths. Each religion has its own particular version of how the earth began, the origin of the Gods, and the coming of the people. In any society that knew only the immediate bounds of their country, territory or island, the Creation myths were tailored to meet their individual circumstances. These myths could be preserved by becoming part of traditional religious observances and ceremonies, or by being handed down as narrative poems related by the bards and shamans. Many Creation myths became the subject matter of the various religious scriptures, either in the form of carving, paintings or writings, and were included in different types of textile design.

THE ISLAND MYTHS

The Orang Asli, or 'original people' who inhabited the forests of Malaysia, imagined the jungles were the playground of good and bad spirits, and that in dreaming, the soul travelled abroad at night with the dreams forming a record of the soul's wanderings. Several of their myths are connected with features in the landscape, rather than the origin of life and the world. They believed that an island on the coast was raised from the ocean floor by a dragon princess, and that other beautiful princesses were connected with mountains and lakes. The dragon connotation may have been a reference to early volcanic eruptions, and the dragon symbol has always been a potent one in embroidery.

A talismanic 'shirt' from Myanmar inscribed with cabalistic symbols to both protect and enhance the reputation of the wearer.
Collection: Jennifer Hughes

A Creation myth of particular interest to weavers is connected with Sumba, one of the islands east of Bali. In a section of the book *Decorative Arts of Sumba*, Marie Jeanne Adams tells us how the island, famous for wonderful dye-patterned ikat cloths, has a legend connected with the warp threads – those that are stretched on to the length of the loom. As ancestor worshippers, the people of Sumba believed the island was tied down by a series of warp threads that connected the island to both the sky and the bottom of the sea; only the ancestors could see the threads that criss-crossed the centre of the island and prevented it from falling into the sea. As the act of inserting the weft threads by the weaver wears down the warp threads, so the threads of the cosmic loom would be worn away, thus imperilling the island. For this reason, weaving was banned in the highland centre of the island, thus preventing the

cosmic threads from breaking. This has resulted in the weaving of these textiles being restricted to certain parts of the island, mainly the western and eastern coastal areas.

FERTILITY MYTHS

The sun, as the giver of life, is of paramount importance in Creation and fertility myths around the world. In the pre-Angkorian era of Cambodia it was believed that the birth of the universe was the result of the union of the forces of the sun and the earth. This is a sensible concept, for without the sun, the crops would not grow and the earth would be sterile. The god Siva stood for the sun, and his wife Uma for the earth. Siva and Uma were never depicted in human form, but the god Siva was symbolized by the *linga*,

or male organ, and Uma by the *yoni*, or female genitalia. The people did not consider these portrayals in a sexual context, for the light of the sun, when in contact with the earth, was considered the source of fertility and the continuation of life. The stone-carved *linga* is situated in the important central part of a temple, while the female *yoni* is often translated as a geometric stone shape, rather than an actual representation.

A second legend from the island of Sumba is connected with the tying of the ikat pattern threads. The island is considered to be like a body that is covered with woven threads that let the rain seep through, while at the same time protecting the groundwater below from evaporating. According to Marie Jeanne Adams, the rain is seen as sperm sent by the male heaven to feed the female earth and promote plant growth. To prevent this heavenly juice from flowing away, it is deemed necessary to secure the outer edges of the island by tying the threads. Therefore the women who live in the coastal regions are duty bound to make tied ikat textiles.

CHURNING OF THE SEA OF MILK: CAMBODIA

The bas-reliefs at the twelfth-century temple of Angkor Wat

A decorative 'window' in the compound of the Imperial City, Hué, Vietnam, showing Chinese symbols and iconography depicting longevity and good fortune.

are considered to be an incomparable example of Khmer art. They form a frieze around the four sides of the temple's third enclosure, extending for a total of 600m. The relief carvings show scenes from the *Mahabharata* and the *Ramayana*, as well as the *Bhagavata* – a Hindu religious poem dating from about the first to the second century AD. The Creation myth from the *Bhagavata* shows the legend of the Churning of the Sea of Milk, in which the body of Vasuki, the giant *naga* snake, is coiled around Mount Mandara at the centre of the cosmos. The gods, together with the *asura* demons, rotate the mountain for 1,000 years by pulling alternately on the body of the naga snake, rather like a celestial tug-of-war. This churns the cosmic Sea of Milk, which produces *amrita*, the elixir of immortality which is to be shared between the demons and the gods. However, the gods renege on their promise to share the elixir, and the demons fight back and try to steal it. Naga snakes in sculptured stone line the entrance routes to many of the temples where the gods are shown pulling the snake on one side of the pathway, with the demons on the opposite side. Episodes from this story are depicted on many of the carved stone lintels above temple doorways, and it is always a popular design source for paintings and textiles.

AUSPICIOUS MOTIFS, MAGIC TALISMANS AND PROTECTIVE AMULETS

Any motif that gave the wearer hope for a better future in the form of 'good luck', that favoured success or was a good omen, could be called an auspicious motif. Many of the

symbols used in embroidery and textile decoration played a very important part on occasions such as weddings or the birth of a child. The swastika, an ancient Buddhist symbol of good luck and wellbeing, is found in many countries and societies around the world. The Chinese word for 'swastika' is synonymous with the character for 10,000, so together they mean 10,000 long lives. It features prominently in Chinese embroideries and iconography, and has none of the connotations of evil associated with the Nazis of 1930s Germany and World War II, when it was adopted as the official emblem. In the early twentieth century the swastika was used as a good luck symbol by the Cambodian women to decorate their skirt borders.

An auspicious motif could act as a magic talisman or a protective amulet, but the auspicious motif is more a symbol of hope than of defence against evil or protection against ill health or bad luck. Magic talismans took many forms, not necessarily as an embroidered or textile motif, but also as a magical object worn as an accessory to the costume. The talisman might be hidden, or displayed so that the evil spirits would be confused or held at a distance. Ancestor objects, or items converted to talismans by incantations from the shaman, might be sewn into the garments or put into a bag hung around the neck.

Protective amulets to a certain extent had magical properties. They were deemed an important necessity in societies where health care was virtually non-existent, and where small babies were lucky to survive their first difficult years. They could take many forms and shapes: some were made as items of jewellery, others as textile objects, or embroidered as motifs on to clothing. Amulets were also worn in battle to protect the warrior, both as magical objects, mystical symbols, written spells or religious inscriptions – all thought to be equally effective. In Cambodia the three-pronged *yantra* symbol is considered to give personal protection from both physical and spiritual harm; it was depicted on manuscripts, painted on garments, or took the form of a tattoo.

Additional protection was gained from amulet symbols painted on to house doors, or as items hung from the roofs and rafters, while auspicious motifs were incorporated as part of the building construction. A palace window in the compound of the imperial city of Hué, central Vietnam, contains several symbolic motifs. In theory the emperor was responsible for creating a happy nation, so the central symbol is surrounded with four bats: the word 'fu', which means happiness, is tonally the same as the word for bat, so they share the same symbol. The circular band shows alternating symbols of a scholarly nature, the chessboard and the lute, together with two of the longevity symbols, the pine and the bamboo. Thus a single window proclaims the benevolent and scholarly character of the emperor, who wishes to live a long life, and be seen in a favourable light by his Chinese overlords.

Horoscopes and Signs of the Zodiac

It is understandable that people should want to know what the future holds. In the Chinese temple in Saigon, the worshippers selected random numbers that related to written texts that foretold their future. It was their personal choice of number that determined their fortune. The early Chinese astronomers soon added astrological divination to their list of skills. Many rulers relied on astrological sources to make important decisions regarding battles and the running of their country. This was an easy way out, for if the outcome turns out to be wrong, only the poor astrologer is to blame. Even today in Myanmar and Thailand, the reading of horoscopes by an astrologer is of prime importance when planning any special event or business operation. The astrologer will assign an auspicious day for the event to take place, and Buddhist monks are requested to make the appropriate blessings so that any business enterprise will succeed.

The twelve Zodiac signs have always been a popular source of inspiration for the embroiderer. Whether they are used singly to signify the birth month and sign of a fortunate recipient, or as a circular design to surround a central motif, they are all regarded as auspicious. The months of the year are named differently in Buddhist countries, with both real and mythical animals standing for our more familiar Western set of Zodiac signs. In Thailand, the Thai 'lunar New Year' was altered to coincide with the beginning of the Roman year. Astrologers still prefer to use the former system, which can cause some confusion when comparing dates.

Divining the Future

In a shamanistic society there was a variety of ways to divine the future. Most required that the shaman or priest should go into a trance-like state, either self-induced or produced by inhalations, plant drugs or other narcotic substances. The favourite methods included the scrutiny of animal entrails, the way that sacrificial blood flowed, and the reading and interpretation of the pattern formed by scattered animal bones. The way that a sacrificed animal behaved also had implications for the good or bad fortune of the tribe. The shaman was an elder member of the society, either elected to the position or inheriting the priesthood. His duty was not only to divine the future, but with a knowledge of plant lore, to administer medicines and provide protective amulets. When conducting ceremonies, he would adopt special clothing and ornamentation, together with a mask or some form of ritualistic covering for the face. This distanced him from the ordinary people, adding to the mystery and effectiveness of the performance.

The Skull Tree

Until first the European missionaries and finally the Indonesian authorities succeeded in banning the custom, headhunting was practised in a number of the islands. The Skull Tree, known as the *andung*, was one of the most important motifs in the lives of the people of Sumba. Headhunting trophies were proof that the tribal warriors had conquered their enemies and thus ensured the security of their territory. The severed heads were an intrinsic part of religious ritual and shamanistic rites connected with rainfall, hunting and fertility. The scalps, which were considered sacred, were purified with complex rites and incantations before they could be stored in the open roof-space areas of the huts. Meanwhile, the skulls were cleansed and purified and placed on the bare branches of the Skull Tree, which stood in the centre of the village. It is this emotive symbol that forms the distinctive motif associated with the ikat textiles of Sumba. Sometimes the motif resembles tiered candelabra, with skulls instead of lamps; at others it is a less recognizable geometric outline. Occasionally, the skulls are replaced by human faces showing eyes, nose and mouth.

Motifs

The Cosmos, the Sun, Moon and the Earth

While these motifs are common to nearly all societies, some were considered more important than others. The *yin-yang* symbol, a circle bisected by a curving S-shaped line, with one half white and one half black, symbolizes the cosmos. It represents light and dark, the sun and the moon, cold and heat. The dark *yin* stands for the female principle of procreation, the light yang side for the male principle, so it is also seen as a fertility symbol. The sun and the moon both feature in Chinese embroideries, with the sun one of the symbols of longevity. Water, waves and mountains are also longevity symbols, connected with the earth and, in a wider sense, with the spiritual world. The sun disc also represented the emperor, appearing on the Mandarin insignia badges.

A series of worlds and star galaxies exists in some versions of Buddhist cosmology, where a complex system of individual suns, moons and stars makes up these separate worlds. Even more important are the gods and demons, guardians and naga serpents that control the lives of mere mortals on earth. The inhabitants of this heavenly cosmos

are depicted on the temple murals, and Susan Conway has devoted many years of research to these paintings, recording the results in her book *Thai Textiles*. Certain Buddhist festivals coincide with the full moon, including the end of Lent, which takes place at the beginning of the dry season when boat races are held in northern Laos. During the November full moon, just before the rice harvest, new robes are presented to the monks as an act of merit.

In Hindu astrology nine planets were identified, which included the sun, moon, Mars, Mercury, Jupiter, Venus and Saturn. In Burmese temples, each day was assigned a planet, with each planet represented by an animal, but as there were more planets than days, Wednesdays were split into two. The eighth planet is ruled by the king of the planets, a mythical beast called *Pensarupa*: this is a composite creature with a deer's antlers, an elephant's tusks and trunk, a lion's mane, the body of a naga, and the tail of a fish.

In the Chinese symbols of authority the sun symbolizes heaven and intellectual enlightenment, while the moon is shown as a circle containing a hare, preparing the elixir of life in a pestle and mortar. In the Sumba Islands the sun is regarded as 'hot' and the moon is 'cold', standing for the male and female elements. Female crafts and tasks are regarded as cold and pure, while the warlike and strong male attributes are hot. As the two must not mix and definitions are fluid, this can lead to complications between the sexes.

Birds

Birds have always been popular motifs, and their ability to fly made them superior to earthbound animals and mortals. Pairs of opposing birds appear in designs all over the world, and this symbol may have been derived from the ancient Assyrian winged deities that guarded the tomb entrances. Generally, the opposing birds have a tree-of-life motif or a fountain of life, or a pedestal placed in between them. Birds played an important part in the Chinese civil rank badges, introduced following a royal edict in 1391. Starting with the first and highest rank, the birds were as follows: Manchurian crane, golden pheasant, peacock, wild goose, silver pheasant, egret, mandarin duck, quail and lastly, paradise flycatcher. When an official's rank extended to his wife and children, identical badges were worn, but during the eighteenth century the wife's badge was turned the opposite way, so that the birds would face one another when the couple sat together on state occasions.

Birds combined with foliage, another Chinese derivation, are found on Javanese batiks. Long-tailed birds perch on blossom branches, adding a decorative element to the tree-of-life design. The peacock and peahen are considered attributes of beauty. As a symbol of the sun, the peacock

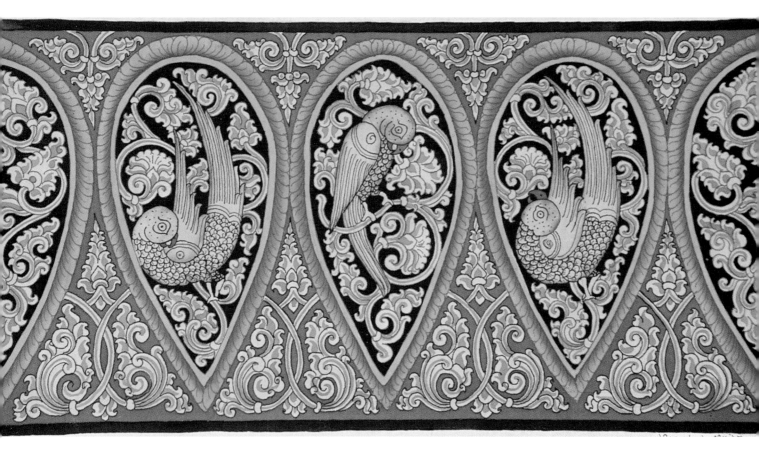

Hamsa birds decorate a hand-painted cloth from Myanmar. Purchased from the artist, outside a monastery near Bagan, in 2006.

became a royal emblem in Burma, and is the central motif on many kalaga wall hangings. Peacock pairs form a repeat border on a royal sarong from Bali, worked in gold thread as a supplementary weft technique. The double-headed eagle motif, taken from the colonial Dutch, is occasionally found in Indonesian textiles. The cockerel and the chicken are depicted on the ikats of Sumba, while in Java, the clucking chicken with open beak and expressive feet is a fertility symbol on batik cloth. The chickens were an important source of divination, for their entrails were 'read' by the shamans. In China, a red cock, standing for warmth, was a protection against fire, while a white cock deterred demons at funeral ceremonies.

HAMSA OR HINTHA BIRD

This bird, possibly originating in India, appears as an important motif in several countries and goes by a series of names. In Hindu mythology the Lord Brahma was transported from heaven seated on the *hintha* bird, which resembles a goose. In former Burma it became the heraldic symbol of the Hamsavarti kingdom, and today, in modern Myanmar, it is the emblem of the country, appearing on hotel menus and on the tails of aircraft. The duck-like *hamsa*, as the symbol of purity and gentleness, is featured on many of the kalaga designs. The bird is depicted as a swan in Thailand, and goes under the name of *Hong*, abbreviated from *Suwannahong*. Bronze statues depicting these birds were placed around the temples, while the king's royal barge was formed in the shape of this heavenly bird. Opposing birds in the form of swans, or hongs, form patterns in a variety of colours on the woven borders of Thai women's skirts.

Animals

The twelve-year cycle of the Buddhist years is defined with a series of animals. In his wisdom the Buddha invited the animals of the forest to pay homage to him, but only twelve of them bothered to appear, so each of these loyal ones had a year named after them. The cycle starts with the

Rat, followed by the Ox, Tiger, Rabbit, Naga-Dragon, Snake, Horse, Goat, Monkey, Cock, Dog and finally the Boar. The cycle birthday has great importance, coming only once in every twelve years, and is the cause for a special celebration. Animals also symbolized martial courage and were used on the Chinese military rank badges. The first rank was the *qi lin*, a mythical animal similar to a unicorn; this was fol-lowed by the lion, leopard, tiger, bear, panther, rhinoceros, rhinoceros again and lastly the sea-horse. Several types of animal are depicted on the batik cloths of Java, inter-spersed with mythical beasts and floral designs, with little notice taken of size and scale.

ELEPHANTS

Trained elephants were an important means of transport, both for goods and people, as well as providing power in the teak logging industry. The elephant, a symbol of strength, prudence and power, appears on both painted

The white elephant is still a favourite subject for the bead- and sequin-embroidered kalaga pictures and wall hangings made in the Mandalay workshops, Myanmar.

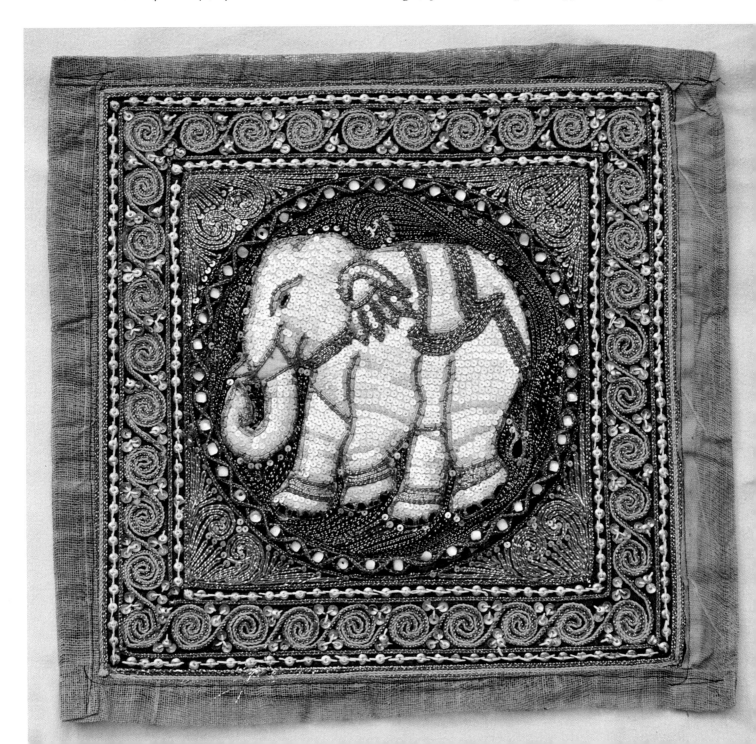

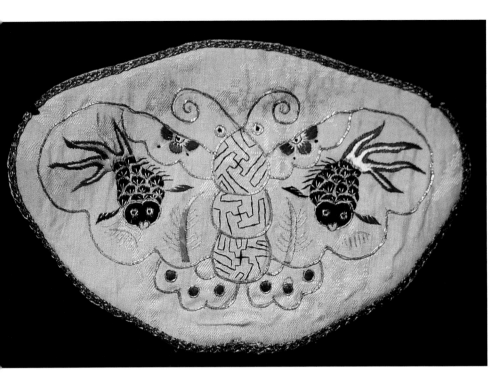

A Chinese purse combines a butterfly symbol with two fish, expressing fidelity and conjugal happiness. Couched outlines in metal threads contrast with coloured silk embroidery.

and woven textiles, as well as in paintings and on temple murals. When the kings of Thailand wished to show their allegiance with the Cambodian royalty, they adopted many of their symbols, including that of the Hindu deity Indra riding on Erawan, his seven-headed elephant. This motif is the subject of Angkorian relief carvings and became a familiar element of the dye-painted cloths imported from the Coromandel coast of India. In the Flores Islands, a strange elephant motif is used in supplementary weft techniques. A simplified outline resembles a horse with perky ears, but with a long spike protruding upwards in a forty-five-degree angle from below the head. In some areas this is recognized as an elephant, in others it is thought to represent some extraordinary animal. Elephants with long trunks form decorative borders on Thai textiles, sometimes with little men apparently standing on their backs.

WHITE ELEPHANTS

When a rare albino elephant was born in Thailand, it was always presented to the king. In Hindu mythology the white elephant appeared during the Churning of the Sea of Milk and, having control over the rain clouds, was regarded as a symbol of prosperity. The Buddha was born as a white elephant in one of his many reincarnations, giving the animal a special status. There are several stories relating to these special animals: one concerns King Ava Thihathu, a handsome young man who delighted in chasing beautiful women when he rode around the countryside on his special white elephant. This caused much distress to his

queen, so she persuaded one of the Shan chiefs to shoot the king with an arrow when he visited a lake to watch the women bathe. He fell, mortally wounded, into the lake. He is normally depicted on the Burmese kalaga roundels seated on his white elephant, sometimes with a sword, at other times pierced by the arrow.

The other tale is of the Indian king who rewarded a courtier who had displeased him with a present of a white elephant. As a holy animal it could not be put to work, killed or given away, thus burdening the recipient with expense and trouble for an indefinite period of time. The white elephant appears in Indian textiles and paintings, and this favourite design soon travelled into other parts of South-East Asia.

HORSES AND DEER

The original ancestors of the horse first came out of the steppe lands of Central Asia. According to *Britannica*:

Asian breeds were strongly influenced by Arabian or Persian breeds, which together with the horses of the steppes produced small, plain-looking horses of great intelligence and endurance.

Horses were greatly prized, not only as cavalry in warfare, but also as pack animals and as a means of personal transport. A rider looks down on foot travellers, and his rank and status are increased by the use of elaborate horse trappings, whether woven or embroidered. A sequin-covered

white horse is featured in many of the kalaga designs, and life-like horses are woven into the borders of the Thai temple banners.

In Sumba, the horse is of paramount importance, forming part of the bride price exchange. A man may even be known by the name of his horse in addition to his own name, as the horse denoted wealth and nobility, as well as male machismo. Evidently the Sumbanese became wealthy in the early twentieth century by breeding horses for the Dutch cavalry. The horse, sometimes with a rider who appears to be integral with the design, appears on many of the ikat textiles.

The deer features in the mythology of the *Ramayana* and stood as a symbol for the Buddha's teachings long before actual Buddha images were allowed. It was a favourite motif in the inlay woven patterns of East Sumba, where the antlers present a decorative element for the weavers, who obviously take a delight in interpreting this feature. Deer with large candelabra antlers symbolized royalty, being the property of the king who organized the deer hunt in the dry season. A deer shown with the tail up, represents the prestige of virility.

FISH, REPTILES AND AQUATIC CREATURES

People who lived on any of the myriad of Indonesian islands were bound to take inspiration from the sea creatures that surrounded their coastal areas. In a Malayan proverb the prawn with its humped back symbolized our lack of graces, as the prawn is unaware of the hump. The crab, which can only walk sideways, symbolized the desire to be without sin and go straight. The lobster and the squid, together with fish of every description, are also depicted on the wax-resist painted fabrics that form the sarong skirts. They float within a pattern of fronds and aquatic plant life, part of the microcosm of the tropical seas. In the island of Sumba, aquatic creatures, including crayfish and turtles, symbolize longevity and relate to the nobility. The turtle also symbolized endurance, and was the subject of many legends featured on Javanese batiks, as the Hindu god Vishnu took the form of a turtle in the Churning of the Sea of Milk.

In China the word 'fish' is synonymous with abundance, and a pair of fish entwined symbolizes conjugal felicity. The carp is regarded with special esteem, while long-tailed goldfish feature on Vietnamese embroideries and lacquer work. Geometrically shaped fish form an alternating pattern on the border of a warp ikat mantle in East Sumba, while exotic fish with flowing tails and fins are incorporated into Javanese batik design. The fish is a favourite motif around Lake Erhai in Yunnan Province, embroidered on to bags, aprons and baby carriers.

The crocodile, being an amphibious animal capable of living both in the water and on land, is regarded as a mediator between two worlds. Lizards of different kinds, including the Komodo dragon giant monitor lizard, are shown on the Sumbanise warp ikats. Lizards worked by the Dyaks of Sarawak take on a more geometric aspect, worked in supplementary warp technique. Serpents often resemble nagas, but are shown without the seven hoods. Sometimes they have two heads, one at each end of the body, and they twist and turn to fit the design. A speckled design found on ikat cloths of Sumba resembles the skin of the python, and the multicoloured pattern is a sign of abundance.

FLOWERS AND PLANTS

Flowers of all descriptions were used as single- or repeat-pattern motifs, incorporated in designs as trailing plants or tendrils, or as a group of flowers in a vase or pot. If a single plant was shown in a pot, it was more likely to be a tree-of-life motif. Some motifs are so stylized it is difficult to recognize the individual plants; others are completely naturalistic, such as the floral designs worked by the Chinese in Yunnan Province and the Vietnamese in their silk embroidery workshops. The lotus flower symbolizes purity and summer, the chrysanthemum friendship and autumn, the plum beauty and winter, the peony prosperity in spring. Ears of rice and other edible plants were a popular motif on Javanese batiks, symbolizing plenty.

The tree of life can take many forms, varying from a simplified geometric rendering in woven textiles, to elaborate designs on the batik cloths and painted Palampore hangings from India. Through branch and root, the symbol links the upper and lower worlds, thus representing fertility. The tree motif is used as a repeat pattern, both in weaving and batik, or as an individual design on silk embroideries, at times showing the Chinese influence of bonsai tree culture. Butterflies, a symbol of joy and longevity, and various insects are portrayed among the flowers.

FIGURES OF GODS AND PEOPLE

The Mahabharata and the Ramayana epic poems provide a vast store of subject matter, which includes the exploits and lives of the gods. These are shown in detail on the kalaga wall hangings of Burma, as well as on painted cloths from India. The deva is a minor deity, one of thirty-three in the Vedic system, while the devata is a celestial goddess of great beauty who enjoys eternal youth. In Hindu mythology it is the Apsaras who are the celestial dancers, performing with celestial musicians to entertain the gods. Kings and heroes who die performing brave deeds are rewarded in heaven by the Apsaras, who were so highly regarded that they are

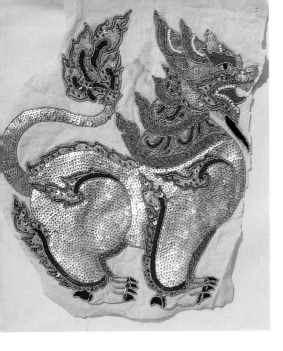

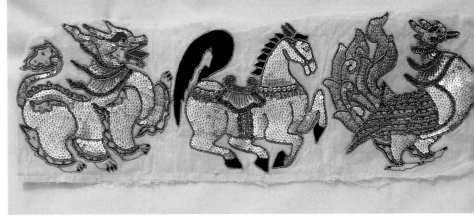

ABOVE: The chinthe, horse, *and* hamsa *bird form a set embroidered as kalaga cut-outs.*

ABOVE LEFT: The chinthe, *or* singha, *is a mythical lion, guardian of temples. A sequin-embroidered 'cut-out', ready to be applied to a kalaga picture, Myanmar.*

BELOW LEFT: A lion dog, symbol of valour, is shown on a Chinese skirt panel. The 'Waves' are the home of the dragon, the Rock means permanence, the Pine-tree longevity and the Bat stands for happiness.

BELOW: A fierce Naga-snake with an expressive tail. Kalaga cut-out, Myanmar.

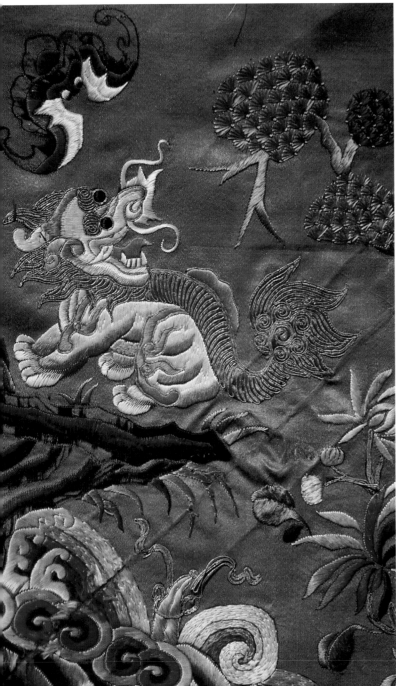

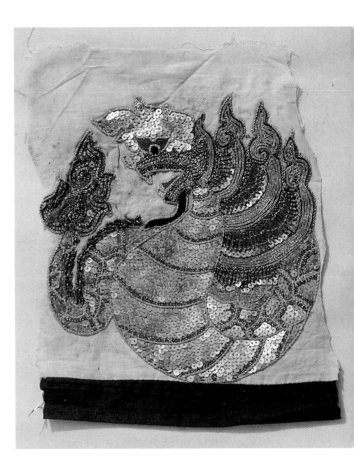

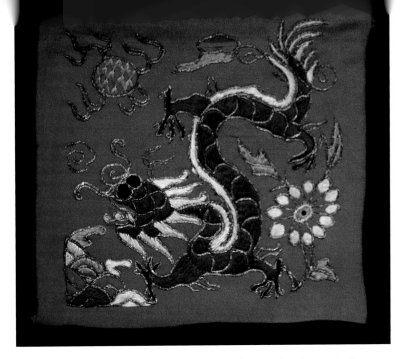

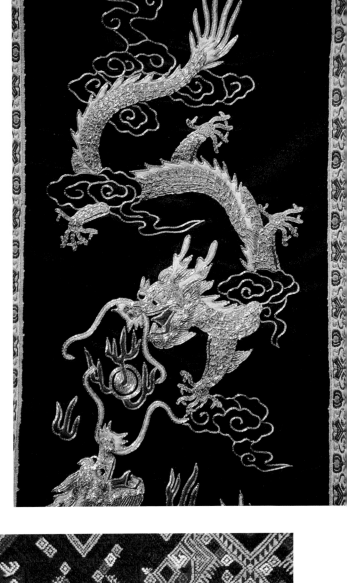

ABOVE: *A Chinese four-toed dragon embroidered on to a bag front. The flaming pearl represents the power of the dragon.*

RIGHT: *A five-toed 'royal' dragon, worked in gold threads on to a panel made in modern China, chases the Flaming Pearl of Wisdom.*

BELOW RIGHT: *Mirror-image naks or naga snakes, shown as a repeat pattern on a long temple shawl from the Lao-Vietnam border. These dragon snakes are connected with fertility, rainbows and water. A border with kosa-sing elephant birds lies beneath. Cotton weave with silk inlaid threads, mid-twentieth century.*

BELOW LEFT: *This dragon serpent, seen fighting an exotic bird, is worked in traditional batik wax technique on an antique sarong skirt, Indonesia.*

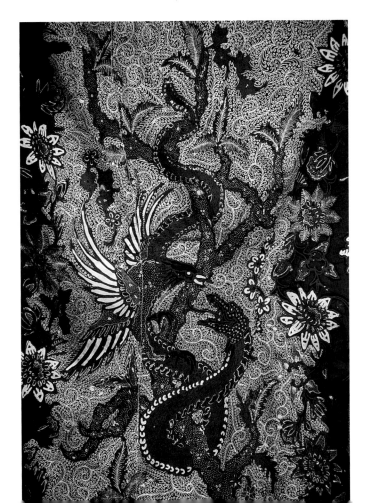

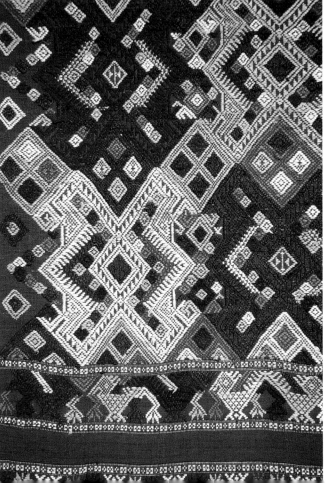

included in many of the Angkor temple carvings, part of a Khmer tradition.

Ancestor figures are of prime importance on the ikat cloths of Sumba, and the forward-facing human figure is considered one of the oldest to appear in Sumbanese textiles. Many of these figures are depicted with upright hands and outward-pointing feet. Similar representations throughout Indonesia are thought to have originated from Dong Son cultural migrations in the past, coming from Vietnam. Little stick figures are shown alongside the elephants on the Flores textiles, as well as more realistic figures on the ikat fabrics where stylized men are shown fishing with a spear or holding a parasol. Narrative embroideries from Vietnam and Laos show scenes from the everyday life of the displaced hill-tribe people. These embroidered wall hangings and cushion covers are now sold in tourist outlets.

Mythical Creatures

Chinthe or *Singha*

A guardian of temples in both Myanmar and Thailand, this mythical creature in the form of a lion is found, often in pairs, guarding the temple entrances, as it was considered impossible to defeat. A ferocious-looking animal, it is depicted with an open mouth, sharp teeth and staring eyes. In a Burmese pagoda, a giant *chinthe* even has a tiny Buddhist statue sitting in its mouth. During World War II, General Orde Charles Wingate took the name of Chindits for his brigade of British, Gurkha and Burmese guerrillas who harassed much stronger Japanese forces in the jungles of northern Burma.

The *manusiha* is a composite creature with the upper body of a man sandwiched between the lower bodies of two lions. Once again, it is the guardian of temples in Burma and Thailand. In China the mythical lion-dragon with fierce teeth, flowing mane and flame-like tail is the symbol of valour. The Chinese lion-dog known as *fo* – another name for the Buddha – is a cross between a lion and a spaniel, often depicted with a ball. Characteristics are a long-haired back with wing-like protuberances, a decorative tail, drooping ears and a curly beard beneath the chin.

The qi lin was a mythical beast with a dragon's head, the body of an ox, hooves of a deer and a lion's tail, with flames springing from the body. In the grounds of the Imperial Palace at Hué, Vietnam, there is a sculpture of a Chinese unicorn, a symbol of benevolence. The truncated cone-shaped horn is barely visible, and the animal resembles a qi lin with a fierce aspect, a scaly body, hooves and a flourishing tail.

Naga

These mythical serpents are part dragon, part snake, with five or seven cobra-like hoods. They live under the earth or in lakes, rivers and oceans, and are credited with magical powers and have connections with fertility, rainbows and water. One legend tells of the Buddha being rescued by a naga when caught by a storm near a lake: the naga coiled itself around the Buddha seven times, lifting him above the surface of the water and protecting his head with the seven hoods. This image of the Buddha and naga snake is often seen in temple sculptures. Hooded nagas carved in stone line the important pathways to palaces at Angkor, and even temples in rural Thailand have their naga-flanked staircase leading to the entrance doors. It was Vasuki, the giant naga snake, that formed the tug-of-war rope in the Churning of the Sea of Milk.

Dragons

Dragons of one kind or another are part of every culture. They take many forms and shapes, some are malicious, others are benevolent, and they have existed in myth and legend from time immemorial. The dragon had the power to make itself visible or invisible, thus symbolizing transformation. The Chinese dragon represented *yang*, the principle of heaven, activity and maleness in the *yin-yang* of Chinese cosmology. On the imperial dragon robes, the type of dragon and its placement were important – thus the emperor and his family down to third rank adopted the five-toed dragon, while lower rank family members used the four-toed dragon. The dragon was adapted to fit the shape of roundels with legs akimbo, surrounding the flaming pearl of wisdom which contained the thunder symbol representing the power of the dragon.

The dragon takes on an even more decorative quality when portrayed on the batik textiles. At times it appears to be more like a serpent, with truncated legs and a writhing body tapering at the tail. On the ikats of Sumba, the Chinese dragon looks like a cross between a bird and a fish, and there would appear to be no end to its diversity. The Christian religion associated dragons with the serpent in the Garden of Eden, and regarded it as a malevolent symbol of paganism. Saints are pictured with a prostrate dragon at their feet, while the story of St George killing the

dragon has always been popular. However, this aspect of the dragon was not accepted in South-East Asia, as the benevolent dragon had long been part of their traditional beliefs.

Garuda *or Galon*

The *garuda* is part man and part bird, having the body and lower limbs of a man. The eagle-type head and talons are complemented by a set of eagle's wings, one of the creature's important attributes. Traditionally the enemy of the nagas, the garuda is also a symbol of loyalty and is sometimes depicted as one of the transformations of Vishnu, a member of the Hindu Trinity. The garuda wings alone are

An antique temple shawl showing the boat symbols made from conjoined naga snakes. A triangular canopy, surmounted by a border of upright snakes, contains ancestor figures, or depictions of the Buddha. Sam Nuea, Houa Phan Province, North-East Laos. Provenance: Mrs Chanthone Thattanakham, Vientiane

used as a decorative element in many of the Javanese batik textiles, and once recognized, become a familiar motif often found as a repeat pattern in the borders of the sarongs. At times a tail is added to the wings, when it becomes a *lar* design. Fierce-looking garudas guard the entrance to the Elephant Terrace at Angkor, and the creature is depicted on many of the kalaga embroideries.

Phoenix

The phoenix is associated with sun worship. In the Egyptian legend the phoenix bird lived for up to 500 years, at which time it made a nest of aromatic boughs, set it alight and was consumed in the fire. Miraculously a new phoenix emerged from the flames, giving rise to a legend of immortality. Gold-embroidered phoenix badges, the symbol of female nobility, were worn in China by the Ming empresses. This privilege extended to the emperor's concubines, while lesser princesses wore flower-embroidered phoenix badges. The double phoenix symbol, the *feng huang*, represents both male and female attributes. The phoenix is found on Indonesian textiles, the result of a continuing Chinese influence.

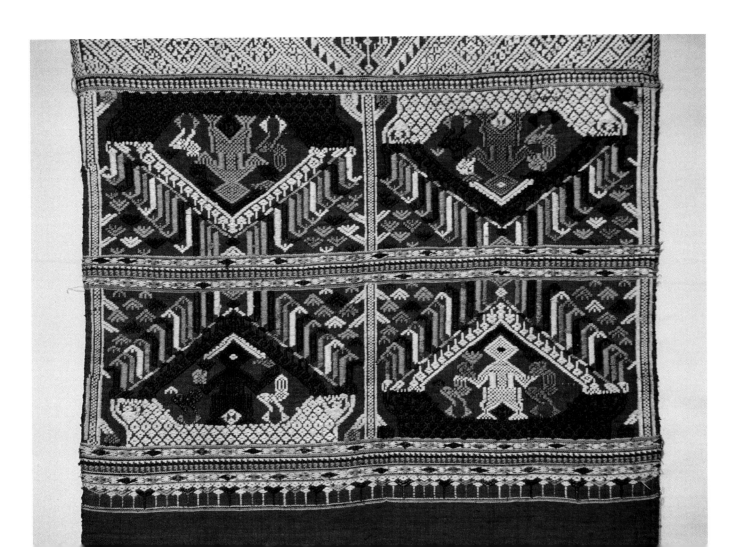

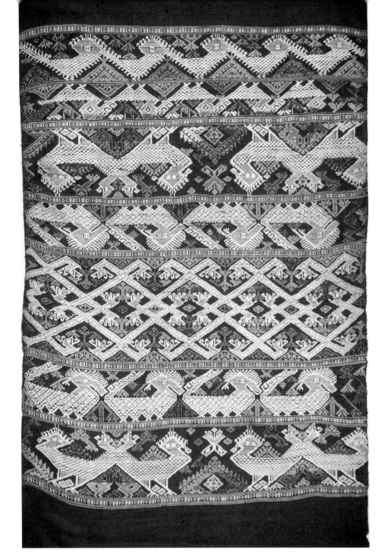

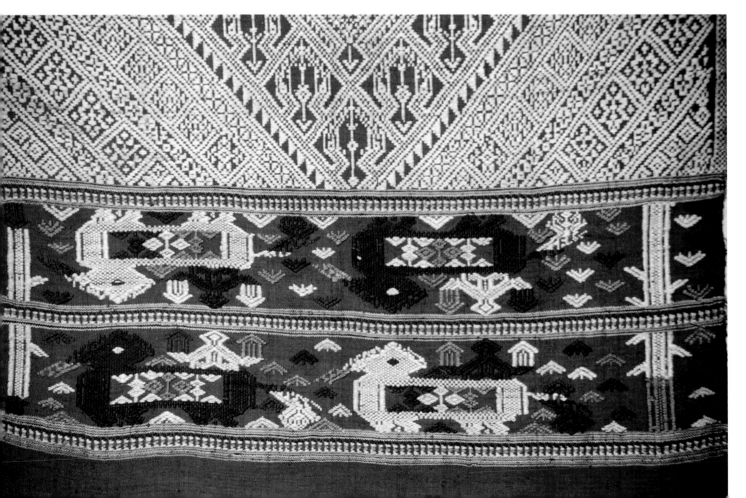

Mythical Creatures in Thai and Laotian Textiles

The woven textiles of northern Laos and Thailand have distinctive design elements incorporated into their supplementary weft fabrics, including the *nak* mythological snake, or the naga dragon serpent. At times two naga, with tails joined in the centre of the motif and their heads raised to form a candlestick pattern, resemble a boat and may contain an image of the Buddha. The nak designs can be intricate, with the snakes forming interlocking diamond patterns, accompanied by monkeys and other small animals. Even more distinctive are the so-called X-ray patterns. Figures of people or mythical creatures are shown with a hollow centre which may contain another figure or a different motif. A pair of joined birds with an X-ray centre are said to indicate a wish for children. The long-nosed mythical *kosa-sing*, resembling a squat elephant with short legs, has ancestor spirit figures with upraised arms shown riding on its back, a symbol of transition used on rites of passage textiles.

Other Weaving Patterns

Boats and the Important Ship Symbol

River and sea craft are depicted in many of the textiles, reflecting the life of river-going and maritime populations. Of special importance are the Cambodian ship cloths of the late nineteenth to early twentieth centuries: these oblong cloths are woven in an uneven twill, which is a technique indicative of a Cambodian textile. The designs show 'archaic' ships with nak prows, sailing ships and symbolic ships, all used in the festivals at the end of the rainy season. Gillian Green, author of *Traditional Textiles of Cambodia*, has made an extensive study of these cloths, which are constructed in the time-consuming ikat technique. Not a great deal was known about these textiles, as the patterns have long been abandoned. The ship motifs are accompanied by a variety of animals, birds, naks, dragons and tree-of-life motifs. Pavilions on stepped mounds are often included, with additional human and spirit figures.

In Sumatra, ceremonial ship cloths of varying sizes were woven in supplementary weft technique. The ships had distinctive curved prows and sterns, with tall masts branching out into tree-of-life motifs. A group of many people packed into the boat symbolized a ship of the dead carrying the souls away to the after-life, once a common motif in Indonesia.

Geometric Patterns

The interlacing process of warp and weft threads lends itself to weaving patterns based on a geometric grid structure. Even when representational symbols are included in the design, they are reduced to simple geometric shapes. Diamonds can stand for stars, squares for the earth, and zigzag lines for lightning or wave symbols. The supplementary weft technique is used to produce single design elements, or a wonderful variety of mirrored repeats. The tapestry woven patterns of the southern Philippines are purely geometric in concept, the result of a strong Muslim influence where figurative designs are not used. The Patola patterns imported from India, based on a grid of tiny squares, were copied in other weaving techniques, as the double ikat method was seldom used in Indonesia. The beaded textiles of Borneo show geometric spirals and hooked designs reminiscent of the Dong Son culture.

Stripes are an important element in some of the Indonesian island textiles. The placement and width of the stripes can vary with the tribe, or with the age and status of the wearer. Many years ago on the island of Savu, two sisters had a bitter quarrel as to who was the better weaver. They split into two groups, and ever since that time, the weaving of the Greater Blossom Group has fourteen black stripes on a red ground, while the Lesser Blossom Group has eight black stripes on an indigo blue ground.

Influences of Imported Designs from China and India

Although the influences of countries and cultures outside South-East Asia have changed over the centuries, those of the neighbouring empires of India and China have had the greatest impact. These influences were spread partly by conquest, partly by religion, and to a greater extent by merchants and traders. Whichever culture was in ascendancy became the role model for vassal or subordinate states, influencing design and, to a certain extent, court costume. Imported textiles had an added importance as they were both costly and difficult to obtain, and their 'foreign' origin gave them an additional aura of glamour.

The design influences travelled eastwards across South-East Asia from India, bringing a mixture of Hindu and Buddhist iconography, a desire for Indian painted and printed cloths, Indian cotton, metal thread and bead embroidery, puppetry, weaving and dyeing techniques. From the north came the design concepts of China, the religious motifs of the Buddhists and the learned symbols of Confucianism, silk fabrics and threads, damask weaving, and finally a superb embroidery tradition in both metal and silken threads.

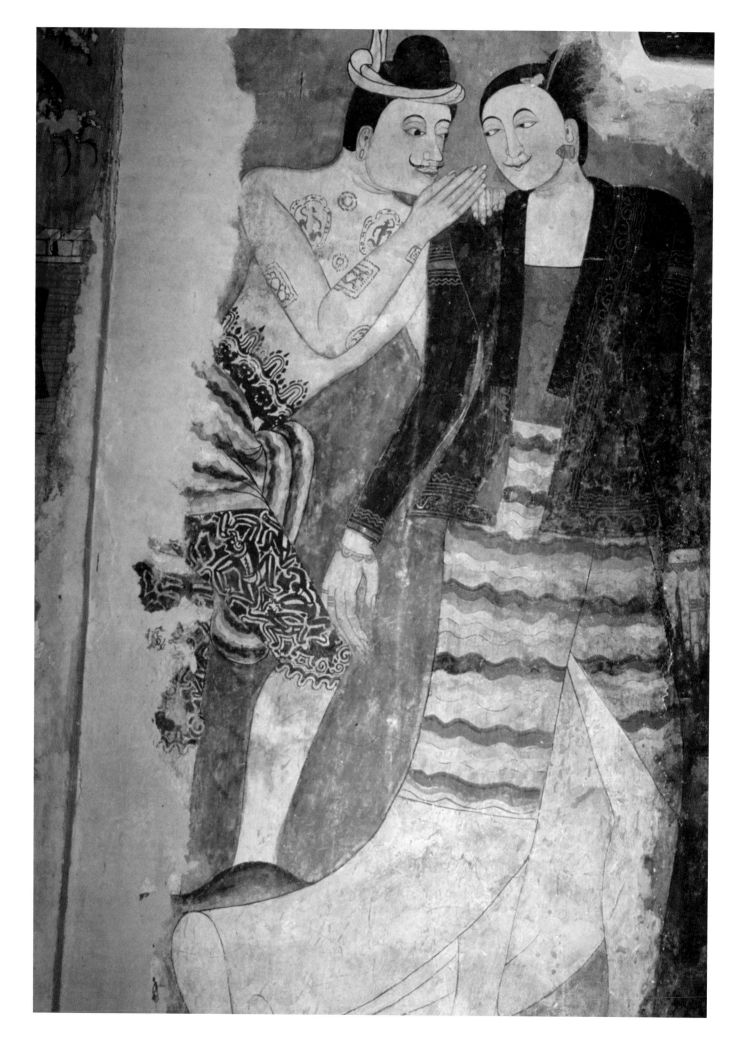

Costume: Uncut Cloth

Open Dress Based on Uncut Cloth

Fifty years ago, in Western culture, home dressmaking was a common craft born out of the thrift ethos of World War II and the lack of well made garments in the lower end of the clothing industry. Fabric departments in the large stores were a treasure trove of cloth bolts, piled high in a profusion of pattern and colour. Today, with the mass production of clothing, we are even further removed from the actual fabric that forms our garments, and the finished item is of greater importance than its substance.

This was not always so. In the early societies the amount of work and skill required to produce a piece of cloth gave it a value far above the uses to which it was put. In fact, the woven cloth could take the form of currency, and was in great demand as tribute or, more importantly, as a gift item. A young girl's weaving skill was judged when her dowry cloths were displayed – the better the weaving, the higher her standing in society.

The completed fabric, whether patterned within the weave structure, with resist dye processes, or with additional ornamentation, was an entity that contained a magical element. The fact that two separate lengths of thread – whether of twine, silk or cotton – can be combined to make a two-dimensional fabric, is magic indeed. Even the making of the initial thread was extremely time-consuming. The setting-up of the loom, the pattern threading and working all added to the sum total of the intrinsic value. Cloths that were blessed by the priests or shamans took on an increased worth with the added religious and talismanic

properties. There are many legends connected with woven fabric. Some believe that the secret of the universe is hidden within the weave structure and that if the cloth is cut, the magical power will drain away. In some religions the uncut cloth has the connotation of purity and is thus worn for religious ceremonies, or specially made as gifts to the temple.

It was not until the development of looms with a cloth width wider than the arm reach of the weaver that the fabric for draped garments could be made in one piece. Until that time, narrower strips were joined along the length or width to form a whole, often incorporating purposely woven pattern borders and matching ends. Sometimes these joins are hidden within the garment folds, at others contrasting horizontal bands are a feature of the costume and can denote age groups, status or tribal identity. The completed fabric piece was worn in a variety of ways, in some cases draped around the wearer with the ends knotted or tucked in, at others joined at the short ends to make a tube, which is also knotted, pleated or tucked. Whether the fabric is a single piece, or temporarily sewn into a tube, it still forms a piece of uncut cloth.

Loose garments have long been the favoured form of dress in the hot climates of the world. The togas of Ancient Rome, the saris worn by the women of India, the indigo blue shawls draped around the Tuareg warriors of northern Africa, all have one thing in common – they trap a layer of air around the body, which helps to keep the wearer cool. These draped forms of dress may have the same basic shape, but they are called by a variety of names, according to the country of origin, while the mode of wearing can change with different allegiances and the demands of fashion. Although the names used in the different countries will be alluded to in context, it is easier to refer to an uncut fabric in wear as a wrapped skirt, or if joined at one side, as a tube skirt. The word sarong is used in parts of Malaysia and Indonesia for the tube skirt, or in some instances, for a wrapped cloth. Some authorities refer to the wrapped skirt as a hip wrapper, but this is more common when referring to a male garment or the shorter loincloth.

OPPOSITE PAGE:
A nineteenth-century temple mural painting from Wat Phumin, Nan Province, Thailand. A couple, possibly visitors to the Nan La court, are shown wearing Burmese-style dress. The woman has an open longyi skirt and wears a jacket over a breast cover. The man has a twisted head-cloth and his heavily tattooed legs show beneath his loincloth.

Village men from the Khon Kaen area of North-East Thailand wear wrapped skirts with woven plaid patterns during the Buddhist End of Lent festival.

Variations due to Climate and Geographical Terrain

It is interesting to travel through a country such as Thailand, which has a variety of topographical features, and observe the loose-fitting costume of those who live in the low rice-growing areas, and the fitted clothing of the hill tribe people in the mountains. These differences are partly the result of the influx of tribes from a northern area who brought their own dress codes with them, and partly because the indigenous population adopted a mode of

dress suitable for a valley climate. Thus a diagram showing the distribution of the costume of the hill tribe people would correspond loosely to a contour map of the entire area, with a similar distribution for those who inhabited the lower regions. There are, of course, exceptions to every rule, and there are intriguing examples where the two cultures mix.

A loose dress style is found in most areas of Indonesia, Malaysia and Cambodia, the lowlands of Thailand and Myanmar, parts of Yunnan Province and some parts of Vietnam where the tube skirt is still worn in the central and

southern areas, especially around the Mekong delta. The centuries of Chinese influence in Vietnam have resulted in a variation of Chinese closed dress, but with extra width in the trousers, more suitable for a tropical climate. It is part of a governmental policy that the men of modern Myanmar still wear the male longyi wrapped tube skirt, although with a Western-style shirt and jacket on formal or business occasions. The only exceptions are certain military and other officials, or manual and construction workers.

Influences from India

It is not known whether the draped garment arose from the desire to keep the cloth whole, or whether influences first came from outside South-East Asia. The spread of trade with India brought a wealth of Indian textiles and cloths to many areas, together with different modes of dress. It was the type of fabric, the dye-print patterning method and weave structure that was of greatest importance. These prestigious cloths were valued for their beauty and rarity; it was left to the individuals in the different areas as to how they were best draped and worn. The sub-continent itself had been invaded by tribes from Central Asia long before the first millennium, and they brought a closed form of dress to northern India that was more suitable for horse riding and a colder climate. These influences were only felt in the north-western parts of South-East Asia.

The Various Methods of Draping the Cloth

In Western society we are so used to keeping our garments together with buttons and zip fasteners that the idea of a costume needing constant rearranging is completely foreign to us. In South-East Asia this rearrangement is part of life, and socially, is perfectly acceptable; thus a man will retie the knot of his longyi skirt while walking in the street, and a woman at a market stall will unfold her tube skirt, repleat it, and carry on trading.

Although a similar basic wrapper shape may be adopted by both sexes, a woman may fold a pleat in the tube skirt one way, a man the other way. In Myanmar, the woman can make a pleat by holding the seam out to one side, folding the excess across and tucking it into the waist. The man will centre the seam at the front, hold the excess out at the sides, bring each side section forward in turn, and tie the folds at the front in a single knot with one end tucked in and the other left out. This last method forms an inverted pleat section at the front, covering the seam join. In some countries a belt is worn over the wrapped or tube skirt, but not always.

The free-wrapped skirt is also fastened in a variety of ways. In Indonesian Bali, a man will centre the rectangle of cloth at the back, holding the two free ends out to the front. The left-hand part is taken across to the right and fastened into the waistline; the right-hand part is wrapped over the left section and tucked into the waistline, with the surplus rolled and taken back over to the right. Sometimes a sash is worn over, wrapped twice and tied in a knot at the front.

In the Flores Islands the woman's tubular sarong is worn and wrapped in a variety of ways, with the ends knotted or tucked into the waistline or at arm-pit level. The high-level sarong may reach above the breasts, worn with or without a blouse. For formal wear the sarong is made from a decorative supplementary weft fabric, worn together with a matching shoulder cloth. Today, the women wear modern cotton blouses in various colours above the traditional skirts. The man's sarong can be plain, plaid or striped and reaches up to waist level. It is often tied at the front with a large knot, the ends of which may hang down in a heavy bunch.

If the skirt is pleated, then the pleats may be held in place by a belt or cord. Sometimes these pleats are arranged in a fan shape at the front, as shown on the carvings at Angkor, in Cambodia. The fashion of arranging the pleats or knots altered with time, and it is interesting to compare the different methods used on the sculptured figures displayed in the National Museum at Phnom Penh, showing the various styles that existed from the ninth to the twelfth centuries AD. Of particular importance is the fan-shaped pleat, or naga style: so called because the finished effect resembles the winged head of the cobra or naga snake, it is depicted on many of the Angkor relief figures.

A clue as to how it may have looked in actuality was given by the dancers who performed for the Cambodian National Ballet Company. The girls were in classical court costume, and their wrapped skirts were made from richly brocaded silk fabric. The pleated section was at the front, with the pleats creased into firm lines within the fabric and held in place with a decorative belt. The excess of pleats that protruded above the belt was opened out into a fan shape at the front, and because of the stiffness of the fabric, they held their shape. Later, at the Cambodian National Silk Institute, a kind assistant demonstrated how the pleats were folded: she placed a length of uncut fabric around her lower body, with the middle of the cloth at centre back. She held the two free short sides of the cloth stretched out in front of her, placing the two edges together. Starting from the top outside, she flicked the two fabric layers backwards and forwards between the first two fingers of her right hand until she came back to her waist, thus forming an evenly pleated section. This pleated section was either tucked down into the waistline, or held with the belt.

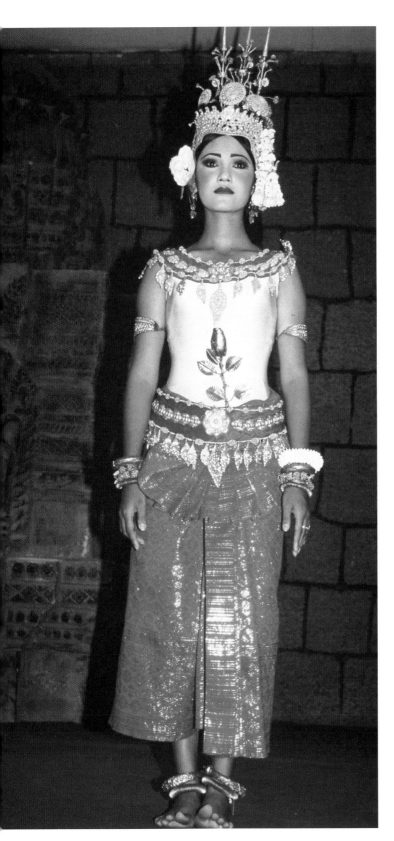

A dancer from the National Cambodian Ballet Company wears a wrapped skirt with the front folds pleated into a naga fan-shape at the front. Her head-dress echoes the crowns worn by the devata at Angkor.

The Khmer and Angkor Period in Cambodia

Costume Shown on the Historic Sculptures

In an age when it is possible to record everything that we wish, there is no problem in researching contemporary changes in fashion; in a historical context, the portraits of royalty and other important people give us a continuous visual record. In South-East Asia the climate has not been conducive to the preservation of actual costumes or fabrics, and we rely to a great extent on temple murals, paintings and sculptures to give us representations of clothing in the past centuries. In more recent times, actual embroideries and dye-painted fabrics have helped fill in the picture, as fashions in the wearing of uncut cloth have not altered much over the years.

We are lucky in that the half-relief and sandstone sculptures of the temple complexes at Angkor on the vast plain of Siem Reap in Cambodia still exist to give us a record of fashion changes in court dress over a period of nearly five hundred years. Similar carvings in the Cham area of Vietnam provide an equally valuable source. The National Museum Collection of Cambodia in Phnom Penh has recently been restored, together with a display of sculptures accompanied by an excellent catalogue that details the different styles and how they have evolved through the years. This does not include the half-relief carvings of the female deities that are such an emotive feature of the Angkor temples, but the information is invaluable and relates to all the sculptures. The exhibits include pieces that have never been displayed before, including some that were hidden under the throne room of the royal palace during the difficult times of Pol Pot, when the museum fell into disrepair.

The authors of the catalogue point out that the sculptures should be considered as still belonging to a temple context, for these divinities were regarded as living gods, part of a complex belief in Brahmanism and Buddhism, where the worshippers came to the temples for help and support. The devi are female goddesses whose role can transmute, and they are regarded as benefactresses, protectors and symbols of fidelity. They can equally be the consorts of the various gods, and are venerated as such. The female sculptures are known as Preah Neang Devi, meaning 'superior wife of the king or god'. Also referred to as devatas, they are in a different category from the Apsaras, or celestial dancers who date to the Angkor period and feature in the palace of Angkor Wat, where the kings considered themselves to be elevated to the status of a god. Once, the

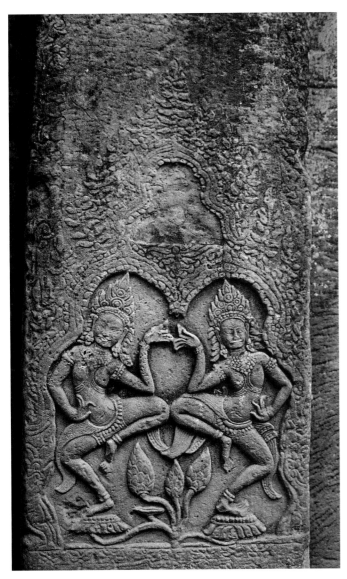

A bas-relief panel at the twelfth-century Bayon Temple, Angkor, portraying a pair of dancing Apsaras.

indicate the use of a light and filmy material. When caught in a certain side light, these celestial dancers appear with their lower limbs softly swathed in a transparent fabric, sometimes decorated with small flower motifs in a repeat pattern. The fine cloth may have been imported from India, as there is no indication of any horizontal fabric joins on the carvings. The costume is so detailed in every other aspect, that it is inconceivable that the artist would not give a true depiction. There is little recorded detail of the loom types used at that period, but it is thought that they were by no means as sophisticated as the Indian looms, and would only produce a narrow width of fabric.

The Dacca area of East Bengal, now Bangladesh, was famous for the production of a fine cotton muslin fabric. In fact, it is said that even eleven layers of Dacca muslin were still transparent, and it was much in demand in Indian court circles. Although it reached its apogee of fame during the seventeenth century, Dacca had been a power

This reproduction of a sampot skirt from one of the sculptures at Angkor shows the floral patterns worn by the Apsara dancers, together with details of the decorative belt. National Centre for Sericulture, Siem Reap, Cambodia.

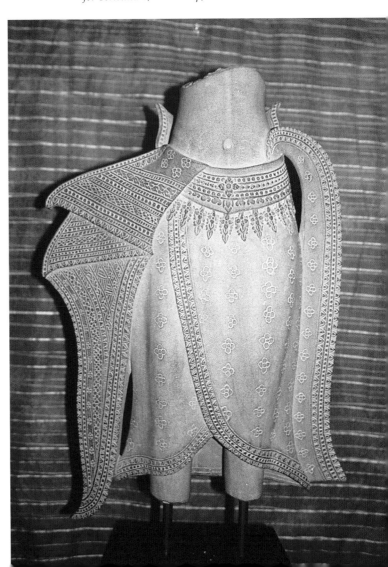

dancers entertained the gods as part of Hindu mythology, and consequently were regarded as the sensuous reward of those kings and heroes who died bravely. It was only in Khmer mythology that they were important enough to form an essential part of temple decoration.

It is not easy to equate the portrayal of dress on a statue with reality, even when it is shown in the round. Some of the fabrics may have been white, but most would be coloured. There is evidence that at least a few of the Angkor carved figures were painted, as traces of colouring have been found. Neither is it possible to visualize the exact quality of the fabric, although there are some clues given within the carving. The stone half-reliefs of the Apsaras at Angkor Wat, which are beautifully executed, definitely

since the tenth century, and it is more than probable that this fine muslin was exported to the Cambodian royal courts, having the prestige of both transparency and the desired width of cloth to reach from waist to hemline.

There has also been much speculation as to the method used for the floral patterns shown on the carvings. If we take the possibility of a muslin fabric imported from India, then it would make sense to include the Jamdani inlay weaving often described as 'woven air', where thicker thread motifs are inserted into the fine muslin cloth during the weaving process. The motifs, which could easily be flower shaped, in reality stand slightly proud of the ground material and appear to float over the fabric.

The Wrapped Skirts of the Women

The skirts of the devata goddesses are referred to as sampots, a Sanskrit word meaning 'cloth'. The pre-Angkorian style of the seventh to ninth centuries is more naturalistic, with simple folding methods. The sampot skirt covered the lower portion of the body; the breasts were always bare and did not have any connotation with nudity. As the devi were married to the gods or kings and thus more mature, a fuller figure was admired. Lines encircling the lower neck and lines etched below the firm bosom, together with a well rounded stomach, were all considered signs of good health – and these beauty lines continue right through the centuries. The sampot skirts are low slung on the hips, held with a belt, and they normally show the navel. At this period the rectangular piece of cloth was folded in the front, and was called *sampot chuok*, sometimes with a spare end draped over the front, from above the belt, with the selvedges forming the top and bottom of the skirt. Only one museum statue is shown with horizontal joining lines on the skirt, and these curve around the body giving a fluid, draping effect. A twelfth-century relief carving in Preah Khan temple shows a series of joined horizontal pattern bands, but this is an exception.

The Angkorian style, from the ninth century onwards, shows a more elaborate approach, with finely pleated skirts where the sampot is folded across the body, called *sampot bat*, or folded centrally with a middle, lengthways fold. Individual styles are named after the temples where the statues are found: thus the Preah Ko temple style, 875–893AD, shows fine pleating in the central area, with one pleated end protruding over the belt like a naga head, and the other pleated end draped sideways, coming from the overlap. The Bakheng temple style, 893–925AD, features a sampot with fine pleats all round. The naga-head fan is spread right across the front, over the belt, and in a side view of the sculpture, stands out several inches (centimetres). The underlap shows as a fine pleated line above the

fan pleat. This is best understood if one imagines a finely pleated length of fabric, wrapped one and a half times round the body, and held on the hips with a belt. The front naga-head pleated fan will overlap the belt, leaving the inner pleated layer to protrude above.

From this style onwards, all the deities wear pleated sampots. Some of the carvings on the temples have weathered due to time, so that over the centuries the pleating on the devata sampots has eroded in places. Nevertheless, it is well worth the steep climb up to the higher level temple terraces to see these lovely statues in context. They stare out over the surrounding tree-covered plain below, with the late afternoon sunlight catching the remains of the pleated creases, bringing them once again to life.

The following Pre-Rup and Banteay Srei pleated styles are very similar, but show the gradual development of the ornamental belts. They are followed by the style named after the Baphoun temple, from 1010–1080AD, where the finely pleated sampot skirt joins at the centre front, with a slight overlap of the pleated fabric making a fish-tail or anchor formation in the front. The top of this centre pleat is tucked into the waistband and overlaps, while the belt is tied with a cord, forming a central reef knot. Finally, the Angkor Wat styles are shown on the devata statues, from 1100–1175AD. Here the fish-tail overlap central pleat takes on more importance, draped in a variety of ways, until the skirt appears to be made of some brocaded fabric and the fish-tail cascades in alternating layers, with all held in place by a very ornamental belt. Reproductions of some of these statues are found in the display of the Cambodian National Silk Institute.

It is not difficult to distinguish between sculptures of the devata goddesses and the Apsara heavenly dancers. The devata stand serene within their ornamental niches, crowned with a round *makuta* headdress from which the hair protrudes as a bun at the top, or as a bun alone, while the hands may indicate the gestures of devotion, or contain a religious symbol. The 'adorned' Preah Neang Devi are more decorative: they have neck ornaments, long ear-rings, wrist bangles and anklet rings, and wear a more intricate crown headdress.

The Apsaras are delightful creatures. They also stand in elaborate niches, singly, in pairs or in threes, with tantalizing expressions that seem to say they know they are beautiful and will stay beautiful for ever. Their costume is more fluid, their gestures far more expansive, their headdresses an elaboration of crowns, plumes and bejewelled discs. The edges of the diaphanous skirts are folded out at one side in a series of alternating layers, each transparent layer showing the pattern of the ones beneath. These folds may be part of a separate skirt or undergarment, with the ends pulled out, and it is possible that the fine fabric may have been stiffened with some kind of starch, as material folds are held out on the opposite side like a long tail. Their jewelled

belts are elaborate concoctions, low slung on the hips, matched by the circular neck ornaments, armbands, wrist bangles, anklets and long dangling ear-rings. No wonder they are called 'celestial dancers'.

The Wrapped Loincloths of the Men

The wrapping methods of the men's loincloths changed in a similar way over a period of time. In the earliest Phnom Da style, 540–600AD, the short sampot chang kbin loin-cloth was usually worn with the gathered ends of the material pulled from the front between the legs and tucked into the waistline at the back, giving the effect of short trousers. A statue of the god Vishnu shows this centrally draped cloth with the folds gathered up in the middle and tucked into the centre front, while the surplus is taken to the back. It is helpful to be able to walk round a statue and see the fold methods back and front, faithfully delineated by the artist.

The Prasat Andet style, 690–700AD, was more complex, with variations reflecting a period of political unrest. The front of the sampot was gathered towards the left side and held in place, but with the long surplus fabric end turned back on itself and tucked into the central front waistline. This fold formed a 'pocket' and is generally referred to as the 'pocket-fold'. A narrow hip belt covers the front drape and pocket-fold, holding all in place. The loincloths of these carved sandstone statues do not make sense unless this fold is taken into consideration. Drawing up the fabric and tucking it into the back waistline gives a closely fitting line, and the following Kulen style shows this close fit, but with the front surplus as a naga-head fan over the belt and with the pocket-fold coming from centre to the left, in a series of drapes. The naga-head fan was even more pronounced in the following Preah Ko style, being part of an anchor-shaped drape at the centre, together with a pocket-fold on the left and a wide belt.

By the time of the Bakeng style, 893–927AD, there is even greater elaboration. In keeping with the women's pleated sampot skirt, the men's loincloth was also made from finely pleated fabric. A belt holds the front naga pleats in place, while below, elaborate anchor or fish-tail shapes cascade down the front, with the foremost drape being the longer. This effect is achieved by using separate pleated additions, called *pamn muk*, tucked under the belt and hanging down over the front. The pleated pocket-fold is turned to the left, beneath the front drapes. Ko Ker-style statues of wrestlers (921–945AD) show how the pleated fabric that was taken between the legs and to the back, was either tucked beneath the belt, forming a minor naga-fan at the rear, or was knotted within itself, with the end resulting in a fan.

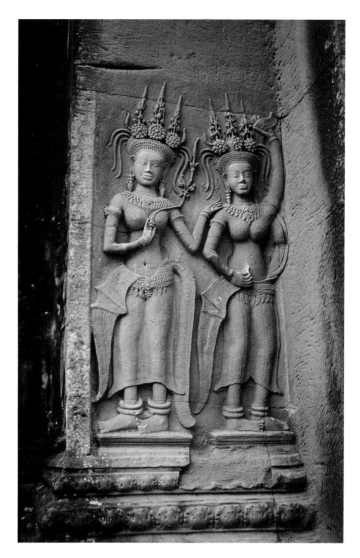

A pair of Apsaras, or heavenly dancers, share a niche on the upper platform of the temple of Angkor Wat. Their elaborate crowns and jewellery contrast with the diaphanous texture of their skirts, patterned with delicate floral motifs. Date about twelfth century AD.

Later, the Angkor Wat style of 1100–1175AD shows a sampot chang kbin evidently made from heavier fabric, with rigid pleats. The anchor pleat motifs on the front are more constrained and have the back drape the longest, while the pocket-folds at the left are opened out to contrast with the finer pleats, in some examples partially covering the right leg as well as the left. Many of these costumes are featured in *Khmer Art in Stone*, an educational booklet produced by the National Museum of Cambodia during the 1990s, and which includes photographs and excellent line drawings of the various sampot styles.

In the Champa culture of Vietnam, stone sculptures show very similar garments, with more elaborate draping

Reproduction sculpture of a man's sampot showing the pocket folds and the anchor-shaped drapery at the front, slotted under the belt. Bakheng style, c.893–c.927AD. National Centre for Sericulture, Siem Reap, Cambodia.

the costumes of princes and gods, but also the clothing of slaves and warriors. The slaves are wearing simple loin-cloths, barely more than a cache-sexe, while the Khmer foot soldiers have fuller loincloths and wear two layers of jackets, the bottom one longer than the upper one. These jackets, which are obviously meant to form a type of protective armour, appear to be decorated. They may have been made of ornamented leather or of a thick animal skin showing natural patterning. It is interesting that Siamese mercenaries at the head of the procession are shown wearing helmets and fitted jackets, with even more definite patterns of circles, flowers or possibly solar disc motifs. It is possible that these might have formed some type of quilted armour, padded to deflect spears and arrows.

We do have a record of civilian clothing in that the Chinese ambassador to the Khmer Courts wrote down his observations in the so-called Chinese Chronicle. Zhou Dagan visited the Angkor Court in 1296, and during his year's ambassadorship, travelled widely. He recorded facts on the customs and dress of the people, saying that both men and women went barefoot, they were breast-naked and wore a piece of cloth wrapped around their waists. Ordinary women did not wear hair ornaments, but might wear arm bracelets and golden finger rings. He also records that the most beautiful of the common women were selected and sent to the court to serve the king and his family.

Court Cultures and Influence on Dress

KHMER TEXTILES AT BANGKOK COURT

The boundaries of mainland South-East Asia changed according to which country was in the ascendancy, and the conquered areas showed their allegiance by adopting the court dress of the reigning power. The Khmer empire extended into Burma and Vietnam, Siam and Laos, and even as far down as the Malay peninsula. The Siamese Court at Ayuthaya adopted Khmer costume and customs, while at other times the Burmese Court adopted Thai clothing edicts, and vice versa when allegiances changed.

The early court costumes of northern Thailand are depicted on the walls of the temples, giving us a unique

methods evolving through the centuries. Both the men's sampot loincloths and the female sampot skirts dating from the seventh to fifteenth centuries AD display an increased use of patterned fabric in the women's pleated sampots, and additional decoration on the loincloths worn by the dancing figures.

The Dress of the Ordinary People

These descriptive sculptures show the dress of gods and kings, but the costume of the ordinary people would be far simpler. The bas-reliefs at Angkor, depicting scenes of the battles of the Hindu Mahabharata legends, show not only

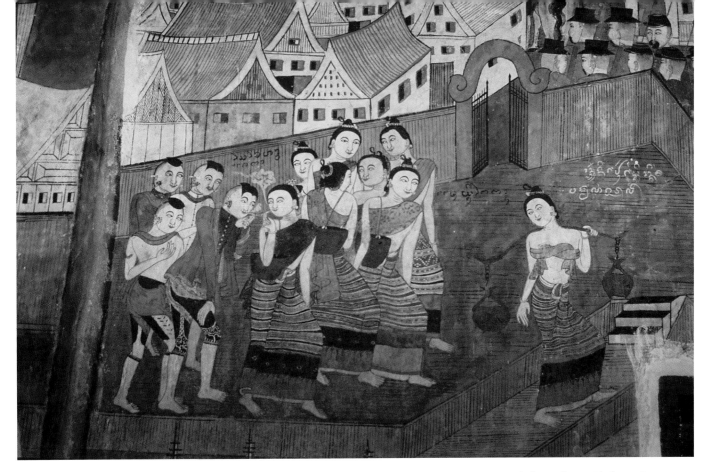

A temple mural painting from Wat Phumin showing Nan La court dress. The women, wearing striped phasin skirts with decorative hem bands, drape narrow shawls across their bare chests. Tattoo-legged men wear short loincloths and high-collared shirts. Their heads are shaved except for a topknot of short hair.

glimpse into the past fashions of the era. The Lan Na women's striped skirts from northern Thailand are shown in a variety of patterns and styles. As in neighbouring Cambodia, the women of the early period were bare-breasted above the wrapped skirt, but with an additional shawl or sash draped across the shoulders in a variety of styles. These sashes are still worn today, but over long-sleeved blouses, or a gathered camisole top. The men are wearing the *chong kraben* loincloth breeches, or an even shorter loincloth that reveals the heavily tattooed patterns on their waists and thighs: the denser the pattern, the greater the man's status – a visual proof that he could endure the pain of the needle. There are still a few elderly men who have these patterns, and one village elder in northern Laos was only too pleased to show us his tattooed legs and back.

In former Burma the formal court dress demanded that the women wear an extra long wrapped skirt. Made from a rectangular cloth, the short fabric ends were decorated with brocade weaving, or metal thread embroidery, jewels and sequins. The cloth was worn with the selvedge at top and bottom, and the fabric ends at the centre front so that it opened out at the ankles, with the excess fabric parted to flow behind like a train. It was interesting to see a modern Myanmar dance troupe wearing the court longyi and expertly 'kicking' the train out of the way as they turned within the stately phases of the classical dance.

The Nineteenth and Twentieth Centuries

The Wrapped Loincloth: Cambodia and Thailand

In Cambodia, the *sampot chang kbin*, also called the *sampot chawng kbun*, continued to be worn in one form or another right up to the early twentieth century. It was an essential part of court costume worn by both men and women, and still forms part of the traditional costume in religious festivals and dance displays. The young players of the Cambodian National Dance Company, who performed court dances, wore very formal sampot chang kbin, made from stiff gold brocaded cloth; the fabric formed sharp pleats

that stood out at the sides when gathered up to pass between the legs. The ends that were finally tucked into the belt at the back were pleated to lie flat, and a tail end hung down behind; but there are other ways of treating this fabric end. In one demonstration, the spare corner of the fabric was twisted round and round, and since it was on the diagonal 'cross' of the fabric, the twist became smaller until the top end was reached, which fitted neatly beneath the belt at the back.

In nineteenth-century Cambodia, wall paintings of the various classical legends show shorter versions of the sampot chang kbin worn by the soldiers, while the gods and demons have fuller, multi-layered variations. Even longer loincloths, resembling three-quarter-length trousers, are shown as civilian wear on sculptures and in photographs, and formed the costume of fishermen in the National Dance Display. Sometimes this style has the spare end of fabric as a definite pleat at the front, holding the side folds in place. Made of cotton fabric, the wrapped loincloth formed a practical garment; it was worn by the ordinary people, slaves, agricultural and other workmen. It was fashionable well into the early twentieth century, but in 1920 a decree was passed by the royal Siamese Court ordering their women to wear the wrapped tube skirt in preference to the sampot chang kbin. This fashion soon spread to Cambodia, although here the wearing of the tube skirt was not compulsory, for the sampot chang kbin is still worn on ceremonial occasions, for dance displays and festivals.

In Bangkok, Thailand, the wrapped loincloth, called a *chong kraben*, is worn by dancers who perform a religious dance around a sacred shrine, once part of a temple complex but now swallowed up within the city. The dancers are paid by the faithful for every single time they encircle the shrine, and the faithful have to pay more money for each additional dance rotation, thus gaining increased religious merit. Once again, the stiffened brocaded fabric is used and the decorative loincloths are topped with the heavily embroidered costume, once worn at the Siamese courts. These stiff loincloths were fashionable costume in central Thailand from the beginning of the nineteenth century, but earlier ones were gathered at the front and tied in a knot. A softer form of chong kraben is shown in a 1920s photograph, worn by a Lan Na prince from northern Thailand. The draped fabric reaches below the knees with a low-slung crotch, and is worn with a European-style shirt.

The Hip-wrapper and Wrapped Tube Skirt

The wrapped skirt-cloth was at one time common to many of the South-East Asian areas. The free-style wrapped skirt was worn up to and during the 1960s, but the seamed tube skirt found greater favour as the twentieth century progressed. The seaming may not have been permanent and could be undone easily for washing or repleating. The type

of fabric used for the *longyi* depends on when and where it is to be worn and the status of the wearer. Cotton material breathes naturally in a hot climate and is always preferred in a working situation. If affordable, silk is the choice for festivals and special occasions. The women favoured a fabric made from plied threads of different colours, giving the fabric a 'shot-silk' appearance. A pattern of small dots produced by a supplementary warp technique is used for the men's longyi, and in some areas, stripes are worn.

The Union of Myanmar refers to the amalgamation of the seven states that once went under the former name of Burma. Throughout the centuries there have been border changes and assimilations of the different neighbouring ethnic groups. Although the upper garments of the tribal costumes change in the different locations, in most instances the common denominator is the wearing of the tube skirt. The main exceptions are the Karen tribes on the eastern Thai border, and the Taungyo girls, once part of the central Tibeto-Burman group, who wear a tunic-type blouse.

The Chin women of north-western Myanmar wear different versions of the wrapped skirt, and the tube skirt. These come in various lengths, formed of two to three narrow loom widths. A different type of skirt, worn by the Taung Mro women, is made from a single loom-width, with one end decorated in supplementary weft patterning. A typical skirt measures about 36cm (14in) in depth, joined at the ends to form an elongated tube, rather like a roller towel. This short skirt is worn double, draped around the hips as a single cloth with the patterned end forming a slight overlap, but open at the left thigh. A decorative belt holds all in place, with the top of the skirt reaching just below the navel.

On the north-western border with India, the Naga women wear a short, wrapped, sarong-type skirt in plain or striped fabric, worn above the breasts, or at the waist with a short blouse. The men wear very little at all, a cowrie-shell decorated scarf, a small loincloth or a decorated cache-sexe. It is interesting to see the various types of tube skirt worn in Taung To market on the shores of Inle lake. The classic decorative longyi is worn by the local men and women, together with conical straw hats, while the visiting Pa O women from neighbouring Shan state wear a plain indigo tube skirt.

The wrapped tube skirt goes by many names: in Thailand it is called the *phasin* if worn by a woman, and the *pha sarong* if worn by a man (the word *pha* means 'cloth' and the word *sin* refers to the central part of the woman's skirt). This garment was developed from the earlier fashion when the rectangular draped and pleated cloth was worn. The backstrap loom produces only a narrow width of cloth, so the phasin is made up of a series of fabric strips, joined lengthways, which in wear form horizontal bands. These vary in width and type, but for daily wear the bottom band

Temple dancers outside a shrine in Bangkok, 1991. The male dancer wears a chong kraben wrapped loincloth over tight-fitting knee trousers, while the two girls wear wrapped skirts of stiffly pleated brocade-patterned silk.

is a strip of black, dark red, brown or indigo-blue woven cotton. This plain hem-band, referred to as a *teen*, can be replaced when worn. For festive wear a decorative hemband is included, woven in a supplementary weft technique called *teen jok* to produce brocaded patterns in silk or in metallic thread. Separate bands can be purchased and added as required. The top band, or waistband, is also of plain fabric, but a different colour to distinguish it from the hem, which being near the ground and next to the feet, has 'unclean' connotations in a Buddhist religious context. The waistband itself is considered a private part of the wearer and is often removed if the tube skirt is sold, given away or abandoned.

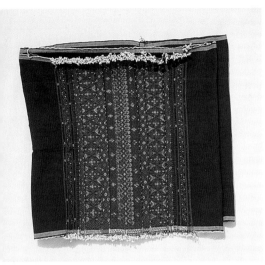
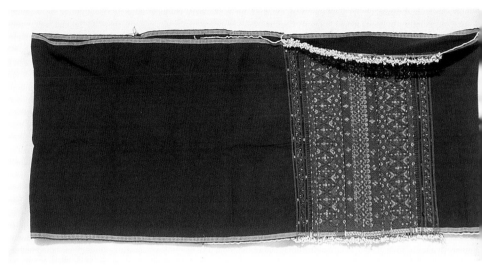

ABOVE RIGHT: The opened-out tube showing the decorated section with a border of tiny white beads added in clusters at top and bottom.

ABOVE LEFT: The Taung Mro women of north-western Myanmar wear a very short tube skirt which is wrapped to overlap around the hips. The lapped end section is decorated with supplementary weft patterning. Shown folded as worn.

LEFT: Three generations of village women from Ban Tai Dam in the Luang Prabang area of northern Laos. Mother wears an indigo tube skirt with an inlay-weave decorated hem. The child has an ikat-patterned, wrapped skirt and a modern red T-shirt. Grandmother wears an indigo skirt and a woven shawl with inlaid weft patterning.

In Laos the tube skirt is similar to the Thai phasin in construction, but differs in the decoration of the central panel, with colours altering according to age and status. Ikat or mut mi designs are popular in the central area around Vientiane, while intricate inlay patterns are a feature of the northern regions. The method of folding the phasin altered according to the occasion on which it was worn: thus a side fold for casual wear, and central folds or pleats for formal wear, when the phasin would be made of heavily brocaded fabric in gold or silver. The men's pha sarong may be striped, or woven in the favourite check plaid pattern in cotton or for special wear in silk, with the plied weft threads giving an added glint to the fabric.

Patricia Cheesman has spent many years researching the tube skirts, waistbands and hem-bands of the Lao-Thai people who, over the centuries, migrated from central China into northern Vietnam, northern Thailand and Laos. Originally the descendants of the lowland people from the

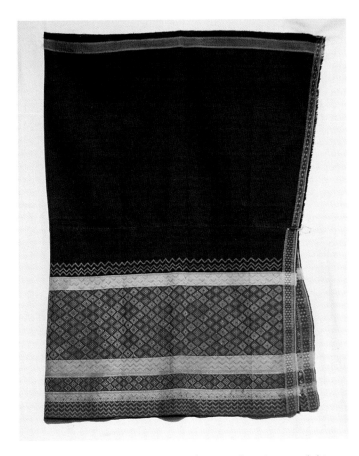

ABOVE: *A mid-twentieth-century, Chin State lungyi wrapped skirt from former Burma. The skirt is formed of two horizontal indigo-dyed sections, the lower part decorated with very fine supplementary weft inlay patterning.*

RIGHT: *Women weavers from Ban Doing Chi in northern Thailand are wearing batik-patterned sarong-type skirts, together with modern blouses and jacket.*

skirts belong to matrilineal societies, where ancestors are traced through the female line. When a couple marries, the young man is brought to live in the girl's household. This may be permanent, or the girl may transfer to his home when the first child is born. Zhong Xiu, a reporter for the monthly *Women of China*, made a journey through Yunnan Province in 1980, recording the costumes and customs of the people. She was continually surprised by the differences she found in closely related areas; when she asked why, the answer was that they had 'always done things like this'.

The Sarongs of Malaysia, Indonesia and the Islands

The important trading post of Malacca, which is situated on the southern tip of the Malaysian peninsula, brought together many foreign influences. These came from India,

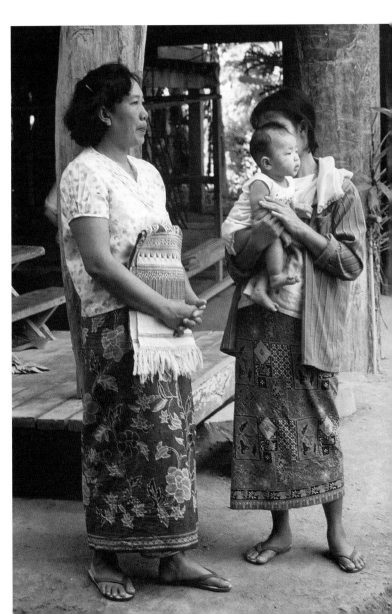

Yangtze river basin, they were absorbed gradually into the southern hilly areas that were regarded by their persecutors as not worth occupying. In adapting to a colder climate they wore more layers of clothing, and in addition leggings, or strip-wrapped gaiters. Variations in the tube skirts include the extension of the waistband to reach above the breasts, so that the blouse worn beneath is very short. In many areas a simple indigo-dyed blouse top was worn, the importance being given to the decoration of the tube skirt and of any accompanying shawl or waist sash.

Both the tube skirt and various types of trouser are worn in the northern areas of Vietnam and both Yunnan and Guizhou provinces in South-West China. Adjoining village tribes may adopt either kind of dress, though whether this is a preference, or a dress code based on ancestral migrations, is not clear. However, many of the women wearing

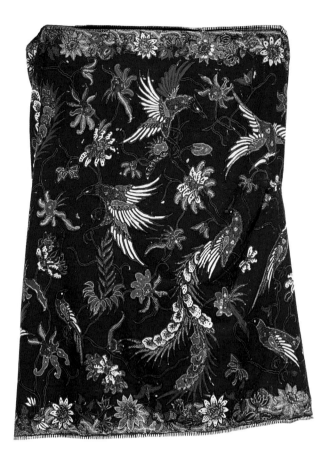

An early twentieth-century batik sarong from Indonesia has an intricate design of floral patterns and exotic birds, surrounded with a tracery of filigree fronds. Gift, Janice Williams, 1995.

Java and Bali, as well as the Malay-controlled parts of western Borneo. Cotton fabric, printed with naturalistic Indian dyes, came from the Coromandel coast, while the batik designs from Java and Bali became an important ingredient of Malaysian culture. During the nineteenth century, British and Dutch control of the Malay peninsula brought imports of smooth woven cotton from the European factories, suitable for printed batik.

The batik-decorated sarong had long been the favourite garment for both men and women, and the oblong of cloth, joined at one side to form a tube, measured twice the width that the cloth was woven. Nowadays the cloth measures about 1m by 2m (just over 1yd by 2yd). The open-ended *kain pankjang* or 'long cloth', worn on formal occasions, measures up to 2.5m (2.5yd) long. The kain pankjang was draped in a variety of ways, common to Indonesian areas as well as in Malaysia. Illustrations in the form of early twentieth-century photographs show different draping methods. A woman may wear the kain, meaning cloth, folded around the body just below the armpits, or the long end of the fabric is pleated together and held in place at the front with a decorative sash. The pleated fabric

ends protrude out to one side, hanging down in a similar way to the skirts of the Apsaras in Angkor Wat. This free end was held out by court dancers, or an additional wide fabric was used as a sash with both ends held out.

The Javanese tube skirts and long cloths are worn in a similar way. Sir Thomas Stanford Raffles was the British governor of Java for a brief period during the early nineteenth century, and he made a study of the local dress and batik production of the region called *The History of Java*. This book contains some delightful illustrations of the people wearing the kain pankjang, including one of a Javanese dancing girl whose front-lapped kain is held by a long sash. Later in the nineteenth century, photographs of royalty show both the men and women wearing the kain pankjang, the male version sometimes over matching batik trousers. The fabric is pleated in front or draped freely in order to expose as much of their exclusive royal parang batik patterns as possible. Javanese women arrange the kain into a series of pleats at the front, occasionally starched to hold their shape.

The warp-ikat decorated fabrics of the Island of Sumba are unique, showing plants, animals and ancestor figures with the vertically woven designs. The designs are in mirror image at either end of the fabric, so that when worn as a narrow *hinggi* cloth around the waist, the knotted ends hang down in the correct orientation. When horse-riding, the men tuck these long ends between the legs, rather like a loincloth. Two similar hinggi cloths are worn at the same time, the second one draped across the shoulders. All is topped by a large turban. The women's ankle-length sarongs are wrapped at armpit level, occasionally with one end going over the shoulder. They are accompanied by a shoulder cloth or mantle, and both may be decorated with warp-ikat or supplementary weft patterns. In some areas, the women wear plain indigo-dyed cloth, in former times with bare shoulders, but since the 1960s with a blouse underneath.

Banded sarongs, or sarungs, are a feature of parts of Flores and the Solor Islands. These tube skirts are constructed from sections of fabric bands, woven as vertical warp strips. The long, double-length cloth is cut in half and reassembled the opposite way, so that the patterns join in mirror image down the centre, and vertical stripes become horizontal. This means that in wear the stripes are upright. The number of bands included in the sarongs varied in the different areas of the islands, and the central and any subsequent seam joins are visible, showing the construction

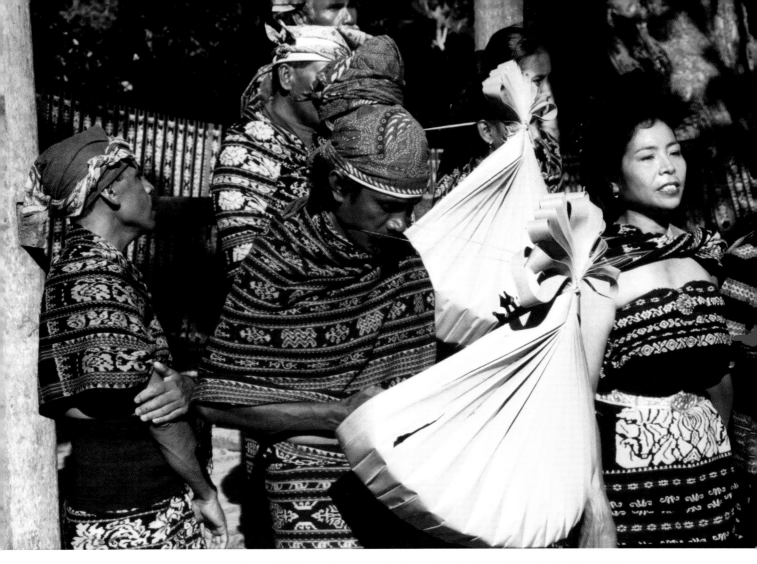

Men and women in Savu wearing traditional clothing. The men are playing the ketadu, the traditional stringed musical instrument made of a lontar palm leaf. Horniman Museum photo archive. Photo: Geneviève Duggan

method. The diverse methods of decorating these woven bands featured stripes, the Indian 'patola' pattern, and different arrangements of patterning within the bands.

During the late 1920s, Ernst Vatter, a German ethnologist and curator of the Völkerkunde Museum in Frankfurt, travelled through the Flores and Solor Islands on a textile-collecting mission. He recorded the daily events of tribal life on early movie film, an invaluable record. He describes the tubular sarong, made of two fabric bands seamed together and joined to form a circle; in some instances there are three bands, including an ikat band near the border. As in other areas of the islands, a double-length warp was woven, then cut into two panels and reassembled. Vatter records that, in the past, a married woman used wooden pins (or thorns) to fasten the long cloth over her shoulders, and that the fullness was probably belted in at the waist.

Several islands used the warp ikat weaving method, using a variety of fibres. Among others these include north-ern Sumatra, Sarawak, Kalimantan, Sumba, Savu, Sulawesi, the Moluccas and the southern Philippines. The weavers produced designs based on ancestor figures, plants and animals, all said to be influenced by the ancient Dong Son culture brought over the seas from northern Vietnam. Originally these countries followed animistic beliefs, but after the introduction of both Islam and Christianity, geometric patterning was preferred. What they have in common is the joining of the narrow woven sections in different ways and orientations to produce individual patterns by combining anything from two to four fabric bands. In the Philippines, an elaborate section called the 'mother piece' is centred between two separate panels, each called a 'child piece'. In Sarawak, the important panel is called the 'head' and is always centred on the woman's pleated sarong, which is overlapped in front and tucked to one side. The men wear the kilted sarong over their shirt and loose trousers, with the brocaded cloth folded in half lengthways, and the panel worn at the back.

The Use of Fabric Lengths

Shawls

The fact that it was only possible to produce a limited fabric width on the simple backstrap loom meant that joins were inevitable in the making of a wider fabric. As most shawls and shoulder-cloths were narrow, this obviated the need for joins. The weavers seem to appreciate this lack of constraint, and the result is a wealth of beautiful designs and weaving patterns. Sometimes the narrow width matches one of the sections of the long-cloth or tube sarong. These shawls and shoulder-cloths go by a variety of names in the different countries. In Laos the ceremonial shoulder-cloth is used in religious and rites-of-passage ceremonies, when geometric designs in woven inlay show motifs of ancestor figures riding on mythical beasts.

The shawl can be an extension of the wrapped garment. In *Thai Textiles*, Susan Conway illustrates a temple mural showing Burmese dignitaries wearing a type of lungyi called a paso. This shows the extended cloth wrapped round the waist, taken between the legs and then draped round and across the shoulders. This is not unlike the original Scottish plaid, a length of cloth loosely pleated around the waist and held with a belt, with the remaining fabric draped up and over the shoulders. This cloth is now a separate item, and the Asian fashion may have developed in a similar way.

The Minangkabau men and women of West Sumatra are famous for their distinctive shawls and shoulder cloths. Inlaid metal threads form intricate patterns on the cloth, many influenced by Indian designs. Anne and John Summerfield have researched into the various ways of wearing the *salendang* folded rectangular cloths, and the *salempang*,

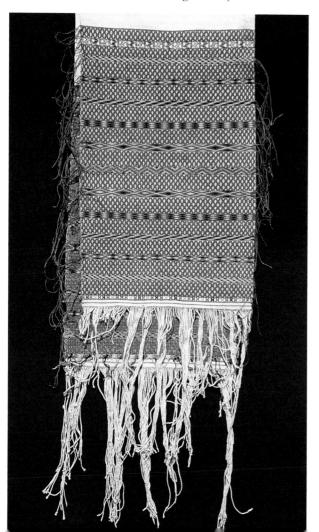

The Karen women, who live on the northern Thai-Burma borders, have superb weaving skills. This long turban cloth, dating to the mid-twentieth century, is woven from cotton thread. (Provenance: Madame Thaire, Yangon 2005)

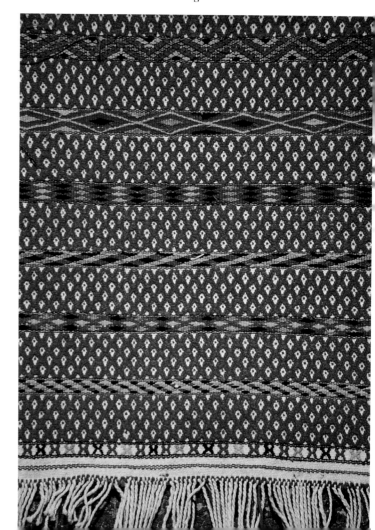

Detail of the turban end, showing the distinctive 'honeycomb' pattern in red and white, interspersed with bands of yellow, black and green. The inlay pattern threads form a fringe at the selvedge sides.

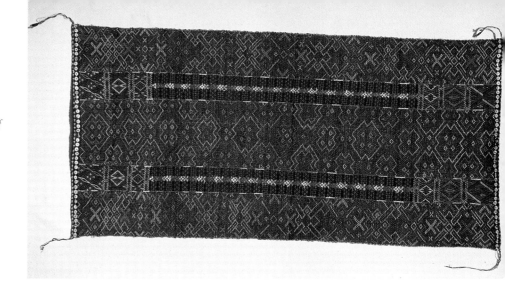

The Khami women of the South Chin state in former Burma wear a breast cover in the form of an oblong cloth with ties at the ends. This cover, woven on a narrow backstrap loom, has supplementary weft patterning worked into the upper shed only, which does not show on the reverse. Date said to be about 1970.

which is a continuous length of woven cloth joined to form a circle. The wearer steps into this, wearing the cloth draped diagonally around the body, or when folded flat lengthwise, as a shoulder shawl.

Chin Ceremonial 'Blankets'

The Chin tribes, who originally migrated from central China, spread into the highlands of north-western Burma; as land became scarce, some eventually migrated back north into eastern India and Bangladesh. The mountain range that spreads from north to south reaches heights of over 3,000m, and the geographical variations produce a climate of alternating monsoon and dry season, with sharp differences in temperature during the year and on individual days. It was probably to cope with these difficulties that the early Chin people adopted the woven 'blanket', a length of hemp or cotton fabric, made from two or three backstrap loom widths joined together.

As time passed, these blankets assumed a great importance: the positioning of the warp stripes, their number and colour, the way the weft stripes intersected, the manner in which the cloth was joined, all held significance. They could display rank, status and age, and were prized as items of dowry cloth. A woman would weave a shroud blanket for her future husband. If the husband died before the wife, the blanket would be divided in half, but if she died first, her half would be returned as bride price.

A woman's blanket could be used to wrap a baby, or it could serve a multitude of purposes. Originally the men wore nothing beneath the blanket, which was wrapped around the body and fastened on the left shoulder. Later, very long loincloths were used, knotted with the decorative

ends hanging down in front and behind. Women wore a breast cover: this could be long and narrow, like a shawl, with the ends hanging down over each breast, or as a shorter oblong, worn wrapped around the chest with the ends held over one shoulder.

Turbans and Head-cloths

Cloths woven as head-cloths may have plain sections where the cloth is wound around the head, with patterned

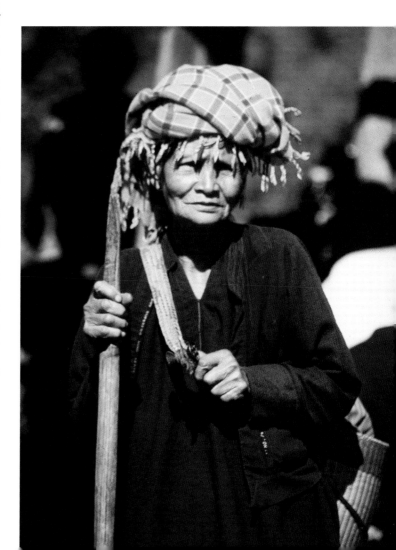

This Pa O woman wears a plaid turban cloth, an oblong folded in half and draped around the head. Similar turbans were for sale at the Taung-To market on the shores of Inle lake, Myanmar, 2005.

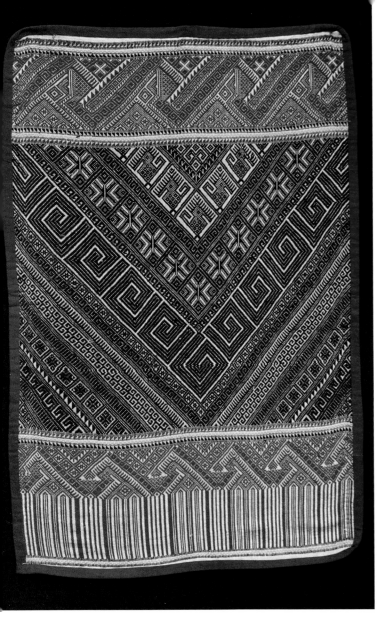

A pha tuum, *sometimes called an 'elephant head-cloth', shows the distinctive supplementary weft patterning in indigo and red dyed threads, featuring a central diamond, symbol of fertility. The edges are bound with red cloth. Used as a baby wrapper, blanket or sitting cloth. Xieng Khouang Province, Laos, c.1970s. Provenance: Mrs Chanthone Thattanakham, Vientiane*

sections that show at the front or side, or form the decorative ends. These head-cloths may match the tube skirt or loincloth, or they can form a contrast. The turban is made from a length of cloth, folded and draped around the head. The one worn by the Pa O people in the Shan state of Myanmar is made from a woven oblong in bright check colours; this is folded in half before being wound loosely around the head. An oblong length of woven cloth forms the turban of the Karen tribes of south-eastern Myanmar; the women weave the intricate diamond patterning at both ends, finishing off with a long fringe. An oblong checked cotton scarf called a *kramer* is worn by many of the countryside people of Cambodia; it is worn wound round the

head, but when unfolded can become a carrying cloth, a sarong, or even a baby sling.

In Indonesia and the islands, various styles of head wrapper and turban are worn by both men and women. In West Sumatra, the Minkangkabau women fold their stiffened head-cloths and wrap them in a figure of eight formation to form a pair of horn shapes at the sides of the head. The exact shape depends on the particular tribal area. Rice paste starch is used or a paper former is added to the cloth to obtain the required shape. The fabric ends are draped over towards the back and may have the addition of tassels or fringes. In some Muslim areas, a white fabric is wound round the man's head, with one end forming an upright cockade, while many Muslim women have adopted the head veil.

Bedcovers, Baby-wrappers, Carry-cloths

Cotton bedcovers and sheets, woven from two lengths joined down the middle, are made to the width of the bed with no surplus. Smaller cloths are used to sit on, or to make a cover for the kapok padded mattress which is rolled up during the day. The blanket cloth, or *pha tuum*, is a distinctive textile woven in northern Laos, edged with a red cotton binding and having a central diamond pattern in the middle, symbol of fertility. The inlay weave is in dark indigo blue and red on a white background, sometimes with one end over-dyed in red. The name alters according to the use to which it is put: thus as a bedcover it is lined and lightly padded; unlined it is used as a baby wrapper – the carry-cloth that wraps around both mother and baby to hold the child firmly. It is used as a sitting cloth in a temple, and is esteemed as a coffin cover. In Thailand, a version of this cloth, sometimes called an 'elephant cloth', was used to cover the elephant's head during a procession to celebrate a young boy becoming a monk. Experts disagree as to the exact meaning of this cloth and why it is used in this context, but the association of the cloth throughout life from baby-hood to death, may have some connection. The boy, dressed in his finery, sat near to the elephant's head, next to the cloth.

It is a Laotian tradition that a baby should not be wrapped in new clothes woven by its mother, so the child is wrapped in one of the mother's old skirts in order to deter the evil spirits. For several months, the baby is carried in a specially woven shawl, or an all-purpose cloth that can double up as a cradle cover. Each tribal society has its own version of baby-carrier.

Cloths of all types are used to carry goods of all kinds; it is the easiest way when no other form of transport is available, or a simple alternative to the woven basket slung from a forehead strap is needed. Zhou Dagan, the Chinese

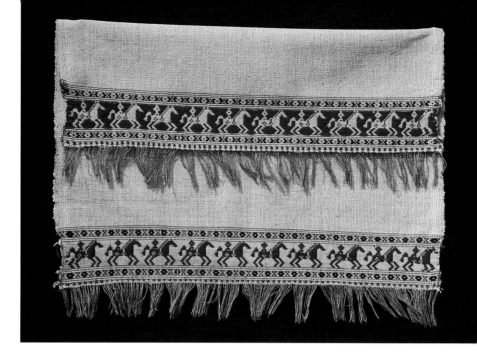

ambassador to the Cambodian Court during the thirteenth century AD, tells us in his *Chronicles*: 'The common women were in control of trade in the markets, setting out their goods on cloths spread on the ground.'

Even today, the cloth that is used to carry produce or goods can change its use and become a sitting cloth for the vendor, adding to the kaleidoscope of colour and pattern that make up the rural market scene.

Gift Covers, Temple Hangings and Banners

Gift covers and cloths are used to 'dress' the Buddha images on special occasions. In Mandalay, a cloth embroidered with the name of the donor in order to gain merit, is laid across the lap of the Buddha in a temple ceremony. Other embroidered cloths are laid over sacred relics, or are used as covers when taking gifts to the temple. Even greater merit was gained by the village women who wove banners for the temples. In Thailand these banners are long and hang freely from the roof timbers. The designs, on a cotton or silk ground, feature elephants and little horses with riders, stupas, ceremonial offerings, all in supplementary weft patterns. Some banners are still woven for the temples, but many find their way into the tourist market as decorative wall hangings. For special ceremonies, even longer banners are suspended from poles in the temple grounds. Banners form an important role in the textiles of all the religions, encouraging the faithful, rather like the military banners that proclaim the identity of the tribal group or country.

In a courtship context, small white cloths with horses and riders worked in supplementary weft technique at either end are given by young girls to their sweethearts. These tokens are collected by the young men, who if serious wear them tucked into a belt. They also play an impor-

tant part at wedding ceremonies, being given by the bride to her in-laws.

Religious Dress: Monks and Nuns

The saffron yellow robes of the Buddhist monks are an iconic element recognized throughout South-East Asia. Although their religious edict states that the robes should be a dull yellow-brown, the colours vary through the range, according to the country of origin and the dyes available to the weavers who make the robes to gain merit. Saffron dyes are still used in some rural areas, but much of the cloth is now purchased, factory made and synthetic dyed. The plain tube skirt, shoulder sash and enveloping outer robe are normally made of cotton, but in some silk-producing villages, the women wove silken robes as ceremonial gifts. White robes are worn during Lent and for ritual bathing, as well as by nuns and novices. In Myanmar the nuns were in a delicate shade of pink, somewhat at variance with their bare, shaven heads.

It is the custom for most young Buddhist boys to spend at least a short time in the monastery. Here they will get some schooling and gain merit for their families. Men who have served in the armed forces may choose to spend a year as a monk, as a form of atonement when they are released from military service. These monks are not confined, but move about the country to visit other monasteries, reliant on alms-giving to survive. In some areas they may carry a shoulder bag, but the weavers disagree as to the suitability of bright colours. Other monks under a stricter regime are not even allowed the bamboo parasol covered with purple-dyed mulberry paper, but keep the fierce sun from their shaven heads by shading with a simple fan.

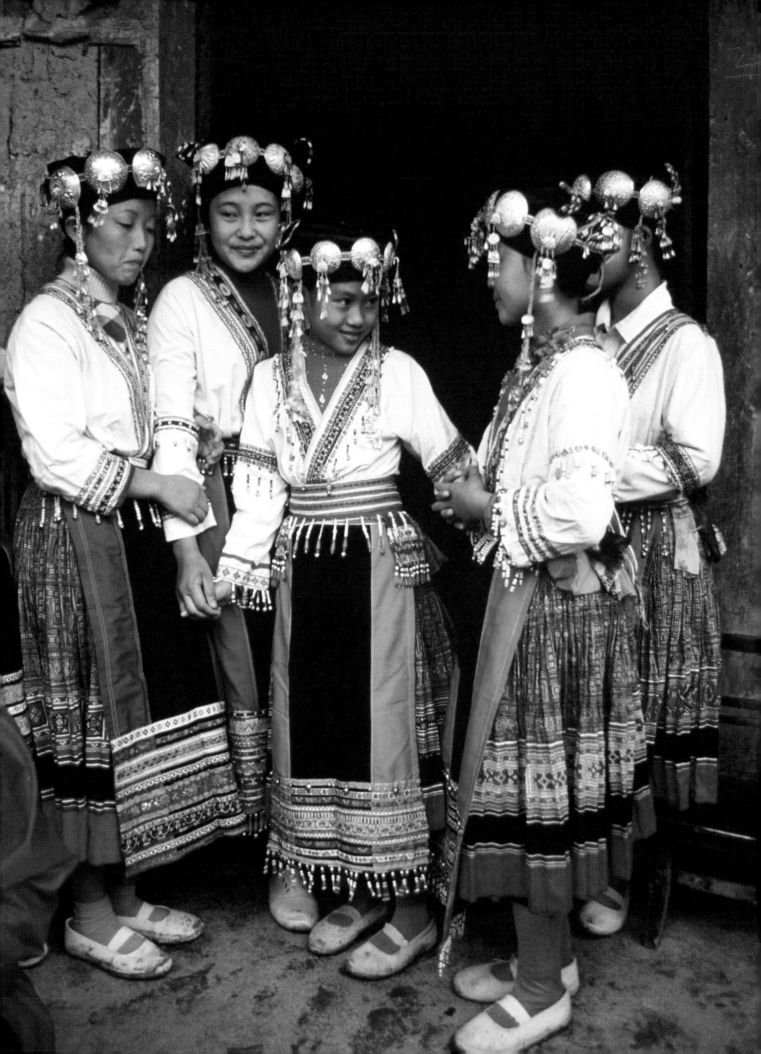

Costume: Closed Dress

Seamed Costume Based on the Woven Width

Many of the migrating tribes from central and southern China were accustomed to variations in climate and had adapted their dress accordingly. There was a reluctance to cut into any already woven cloth as it was labour intensive to produce and as a result, expensive. The woven cloth was still imbued with talismanic connotations, and patterned motifs were seldom cut for fear of reducing their magic potency. As most of the woven cloth was produced on a backstrap loom, the cloth width was limited to the arm length of the weaver – the distance that allowed the shuttle to be passed through the open weft at one go. The backstrap loom is one that relies on the longitudinal warp threads being held in position by tensioning on to a post or secured bar at one end, and a cord or belt passed round the weaver's waist at the other end.

The narrow-width lengths of cloth produced on these looms could be seamed together to make a greater width. This method was used to make the large rectangles for the wrapped and tube skirts worn by many of the tribes, together with seamed upper garments. The basic shape for a sleeveless upper garment was the tunic. The simplest form was made from two narrow lengths of cloth joined together down the middle, with a central portion left open for the head to pass through. The cloth was folded in half at shoulder level, and the sides would be seamed up, apart from a space for the arm openings. This very simple type of tunic varied in length from tribe to tribe. At times it formed a very short blouse, reaching to above waist level. This short blouse was normally accompanied

by a tube skirt or by trousers. Longer tunics can reach to ankle level, in which case there may be no visible under-garment; or if the tunic reaches to just below knee length, the wearer binds the lower legs with braids or with cloth leggings.

The tunic can take the form of an over-garment – that is, joined across the shoulders, but open at the sides like a tabard, displaying the under-tunic worn beneath. Several of the Miao tribes of Guizhou Province wear a split over-garment with a long panel hanging down the back and a shorter front which shows the pleated skirt. The 'Red' Miao, who live in a remote mountain area, wear an indigo-dyed jacket with a long back flap that is heavily embroidered in red stitchery – thus their name – with the short front held above the knife-pleated skirt. The different types of tunic are worn hanging loose, or held in at the waist with an ornamental belt or woven sash. Occasionally the tunic blouse is joined at the shoulder seams, or it may include sections of woven cloth, joined to form designs of horizontal or vertical stripes.

The simplest kind of trouser is formed by sewing together two rectangles of woven cloth. These are first folded in half longitudinally to make tubes for the legs, before the upper parts are opened out and joined with seams at back and front to encase the body. The fullness is controlled and held by a sash or belt around the waist. In more complicated versions, a rectangle of plain cloth is folded on the diagonal and inserted to make a crotch-gusset to give ease between the legs. A pair of Yao-Mien trousers purchased in north-western Thailand has a large square gusset that has been joined together across the diagonal. The tops of the diagonally folded square end at waist level where an extra band is added, while the points of the diagonal reach nearly to the ankles. The oblong panels that form the trouser legs are beautifully embroidered in counted stitchery, a complete contrast to the plain gusset which is held with coarse over-sewing. Some of the trousers have a modicum of shaping, with inner joins tapering at the ankles. Any cutting of the cloth would not destroy the pattern, as the embroidery can be added afterwards.

OPPOSITE PAGE:
The girls of Bai Jia Po village, Guizhou Province, south-western China, wait for the rain to stop before starting to dance. Braid-decorated aprons cover their pleated and embroidered skirts.

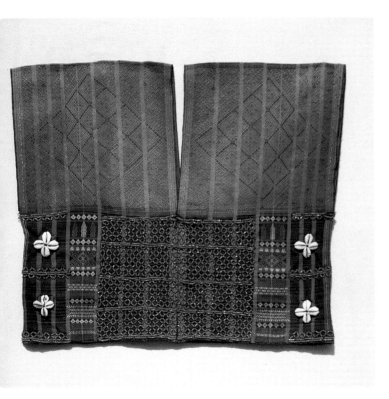

TOP: *A tunic blouse top from the Chin States of former Burma, dating to the 1970s. A grid of red beads is stitched on to the supplementary weft patterns worked into the top shed only. Provenance: Madame Thaire, Yangon*

MIDDLE: *Short jackets are worn by the men of both the Blue and White Hmong tribes of North-West Thailand. This jacket fastens at the left-hand side with fabric ties.*

BOTTOM: *Detail of the embroidery and appliqué work on the jacket flap.*

Shaped Dress Defined by Cutting and Seaming

The introduction of the floor or frame loom allowed fabric of a wider width to be produced in greater quantities, more cheaply. Sleeves that are added to the tunic shape can take the form of folded oblongs of cloth, or of tapered oblongs; both shapes are joined on the straight to the arm-opening section of the tunic. A tunic left open at the front will form a jacket, in which case a shallow curve is cut out for the neckline. Those tribes influenced by Chinese dress had a lapped front to the jacket, with a curve coming from the shoulder down across the front to the waistline, normally passing from the wearer's left to right. It is said that this curved shape was originally derived from the Mongol horsemen who wore whole animal skins draped across their bodies, leaving the bow or sword-arm free.

Front-opening jackets with a centre-back seam have sleeves cut in one with the front and back halves. A curved under-arm seam gives a dolman-shaped garment. These jackets are normally quite short, above or just reaching to waist level. Square back-collars are added to Hmong jackets, and the fronts are decorated with additional lapel bands or intricately cut facings and bibs. Fastenings are buttons and loops or cloth ties.

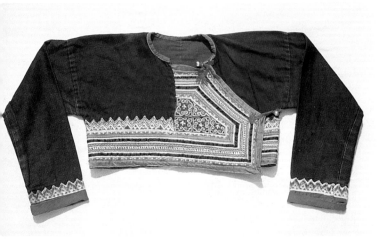

Pleated Skirts

Pleated skirts have always been popular, and the development of viable methods for holding the pleats in place resulted in the elaborately decorated skirts worn in both south-western China and in areas of the Golden Triangle. The basic fabric shape was oblong, up to 6m in length, with the pleats sewn permanently into a waistband at the top after the accordion pleating process was completed. Normally one side of the skirt is open, and lapped around

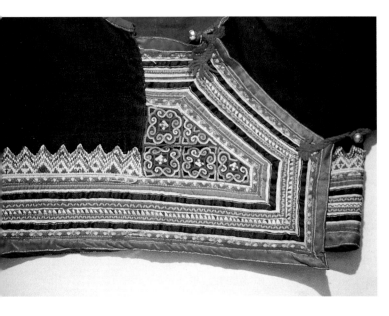

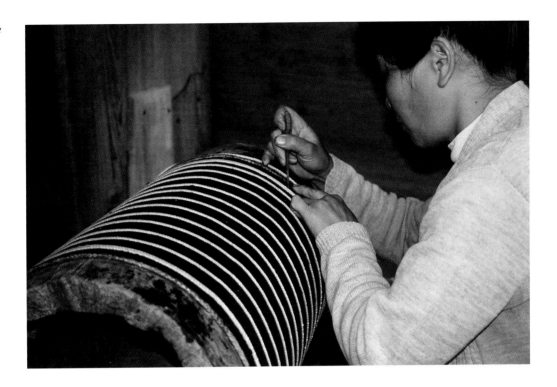

Skirt pleating by a woman of the Small Horned Miao, Guizhou Province, South-West China. The fabric is stretched on to the drum, and each pleat is tucked into place beneath the cords.

the waist and secured with fabric or braid ties, but some skirts are seamed up for tourist sale, with an elastic casing at the waistline. The various methods of making the creases were aided by brushing on a stiffening or starch mixture. The Blue Hmong in northern Thailand pleat their skirts by running a series of threads through as the pleats are formed. The pleats are held down temporarily with herring-bone stitches, and this is how the skirt is stored.

In mountain villages in Guizhou Province, South-West China, the girls pleat the skirts over a wooden cylinder. The cloth is held with bands around the cylinder, and each pleat is tucked under the preceding one by prodding with a metal tool or pointed bamboo stick. Gradually the pleats build up around the cylinder until completed, when a layer of stiffening is pasted over and left to dry. In other villages the skirts are pleated around a bale of rice straw.

In the book *Clothing and Ornaments of China's Miao People*, the pleating method used by the women of the Rongshui area of Guangxi, on the borders of Guizhou, is described. The usual length for the skirt is 50cm (20in) and the width over 6m (20ft). It is pieced together from eighteen pieces of narrow-width cloth. The method is labour intensive, taking three women three whole days to complete the skirt by the continuous process. A piece of shiny cloth is placed on a wooden board, starched and then beaten. Next, vertical lines are drawn evenly on both sides. The cloth is then folded along the lines, and both ends are sewn up tightly. The folded piece is tied up on a semicircular piece of bamboo, put into a bamboo tube and

steamed for an hour, after which the cloth is taken out and air-dried.

Gina Corrigan has studied several of the skirt-pleating methods of South-West China. Writing in an article for *Embroidery Magazine*, she explains how the Dong and the Miao women of Guizhou Province make very fine pleats by holding the cloth over a flat board and marking the cloth with a finger-nail, before pinching each pleat between finger and thumb and drawing up at either end. The finished cloth is bound round a piece of wood and held in place by a woven and knotted fibre. It is not known if any starch or steaming was used. Other villagers boil up water-buffalo hide, and the solution is applied to the pleated fabric before folding as before, and steaming in a wooden container. Some tribes wear pleated skirts divided into two parts, worn over trousers.

After pleating, the folded skirt ends are secured by ropes and held between two poles. Next, the ropes are doused with water, which tightens and stretches the fabric. The pleats on the back section are secured with narrow lines of stitching, and then brushed over with egg-white, which gives a shine to the pleats. The shorter front pleats are not stiffened, which makes them looser. We are told that the value of the skirt increases with the number of pleats, as all of these skirts take time and effort to produce.

Whatever method is used to make the pleats, they are not completely permanent. The dancers in a mountain village, in Guizhou Province, would not start their display until it had stopped raining. The skirts are decorated with

indigo-dyed batik patterns as well as with embroidered sections, so there is always the danger that the dye could run. Gina Corrigan tells us that while they once wore bamboo strips to protect the skirts on wet days, they now use sheets of plastic for the same purpose. New skirts are worn for festivals or for trips to market; older, dirty ones are washed and dried around a basket, but the pleats then lose their definition, so these skirts are worn for everyday work.

The Influence of Migrating Tribes from China

The closed dress of trousers, tunic top and some type of jacket – which was a feature of ethnic groups whose ancestors came from the Yangtze river basin – gradually filtered southwards. The various interpretations of this basic costume were legion, each tribe emphasizing or exaggerating different aspects in order to state their individuality. Certain groups were forced to adapt to lower altitudes. They did not necessarily alter their style of clothing, but purchased lighter fabric from local weavers. Others adopted the wrapped or tube skirt, which they wore together with their traditional upper garments.

Decorative aprons were worn by the women of many of the migrating tribes. The apron varied in shape, from a small rectangle of embroidered cloth tied around the waist by braided cords, to an oblong that could reach down to ankle level. The apron is normally worn with trousers or with the pleated skirt, and in some instances, with the wrapped or tube skirt. A fringe or an edging of decorative beadwork can be added to the hem, and the apron itself provides a field to display the embroidery expertise of the wearer.

The late nineteenth century saw the start of elaboration in the costume, which continued throughout the twentieth century, culminating with highly impractical garments and headdresses, generally worn for festivals and dance displays. At first this elaboration was purely a statement of identity. The Chinese minority tribes were neglected by the governing authorities for many years during the Cultural Revolution, but the current desire to promote tourism has brought about a change in official policy. Competitions in which the costume as well as the participant's dance expertise are judged, are officially encouraged, and villagers are persuaded to dress up for tourist demonstrations.

This phenomenon has spread throughout many of the indigenous tribes in the northern areas of Vietnam, Thailand and Laos. In Myanmar and Cambodia, costume displays were limited to official dance presentations. However,

A set of greetings cards, purchased in Hoi An, Vietnam, illustrates the typical costumes of the area.

the villagers cannot be blamed for adding much-needed cash to their limited earnings, and while some may say that tourism is destroying the indigenous culture, nothing is ever static, and this can possibly be seen as one method of preserving these traditions.

Vietnam: National Long Dress

Although the tube skirt is a common garment in the warmer climate of southern Vietnam, the approved national costume worn by many Vietnamese women has a definite Chinese origin. The *Ao Dai*, which literally means 'long dress', is a two-part costume formed of a long, flowing tunic, open at the sides from the waist down, worn over a pair of loose-fitting trousers. The tunic itself has a fitted

top, sometimes with an upright Mandarin-style collar and a diagonal front fastening. The sleeves are always long and close-fitting. The trousers are often in white, and the tunic may be of a diaphanous fabric that floats outwards with the movements of the wearer. On one level this costume has become the traditional wear for female hotel staff and for assistants in high-class shops, while on a more normal level, it is everyday dress interpreted in firmer fabric. It is now a fashion statement, but less popular in the cooler north.

The Ao Dai is a modern adaptation of court dress and of the traditional Chinese *chong san* tunic dress, and was created in 1932 by a literary group called Tu Luc Van Doan. It has become an eponymous school uniform, worn by girls in central and southern Vietnam. These young girls present a delightful picture riding to school on their bicycles. Their black trousers contrast with the long white dress, the free-flowing flaps controlled by sitting on the back panel of the dress and by holding the front panel in place on the

handlebars. A mane of their long dark hair flows behind at the back, sometimes free, at others protruding from beneath the conical straw hat, known as the *Non Lá*, which is worn throughout the land.

Costume Definitions of the Hill Tribes

Although migrations had taken place throughout the centuries, large groups of Miao people emigrated from southwestern China towards the end of the nineteenth century, and gradually moved into the hilly areas of Vietnam, Laos, Thailand and eventually into Myanmar. The Hmong tribes were originally of Miao origin and are named after the colour of their costumes, so that we can have, among others, the Blue Hmong, the White Hmong and the Black Hmong. In a similar way, certain tribes of northern Thailand are still known as the Blue Miao, the White Miao or

Vietnamese girls visit a local market in Saigon (Ho Chi Min City), wearing the Ao Dai long dress of wide trousers and long tunic with front and back flaps. Photo: Timothy Thompson

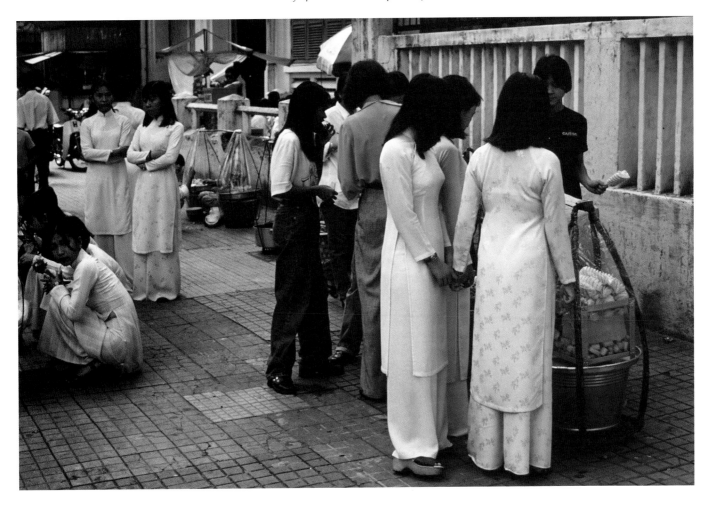

the Small Flower Miao. Some groups are named after their special headdresses, or the length or width of their trousers. It is obvious that the naming of the group, by the type or colour of costume that they wear, is of prime importance. In a society where the swidden agricultural technique of slash and burn was the only viable lifestyle, constant moves to new territory meant that a sense of group identity was needed for the tribe to survive. Fashions did change, but this was not a display of individuality, and any new ideas were adopted by all. If we take the analogy of a shoal of fish, no one wished to stand out from the others, as there was safety in being part of the group.

South-West China

Pleated skirts of one kind or another and in various lengths are a feature of costume from many areas of Guizhou Province. Some are left plain, many are embroidered, and the majority have bands of batik decoration. Whatever the skirt type, a narrow, decorative apron is worn at the front,

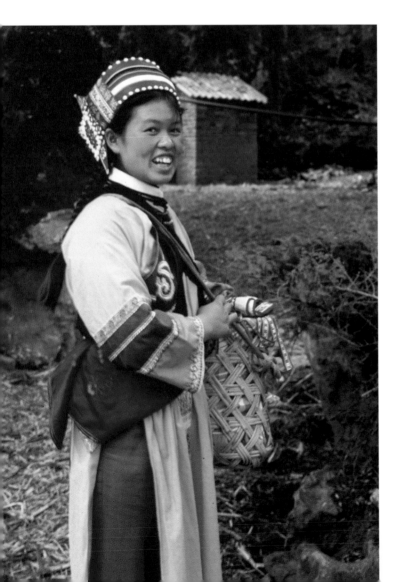

tied round the waist with cords or bands. The length varies, from very short to almost ankle length. In eastern Guizhou, the Dong apron is made from a large rectangle, worn on the diagonal with the turned top corner at the neckline and the side corners tied around the waist to form a breast-cloth top.

The costume in Yunnan Province shows even more variation, as the Dai women wore sarong skirts. It is not clear whether this custom was derived from a returning migration of tribes back from northern Vietnam, or whether there were other influences. Zhong Xiu, in her book *Yunnan Travelogue*, published in 1983, tells us that women's skirts had a connotation with witches and demons, and the men avoided touching them: if they did so, they believed they would become poor hunters and fishermen. However, in other branches of the Dai people, the unmarried women wore trousers and short aprons, while the married women wore long black skirts and a short top. Zhong Xiu records that the Sani women of Stone Forest in the Kunming area also wore black trousers, but with knee-length pale blue or white linen tunics split at the sides. Over this a black corduroy apron was worn, and their heads were covered with black, red and white lace.

In the Stone Forest area in 1989 the women still wore the tunic, together with a decorative apron, but over modern jeans and with trainers instead of Chinese slippers. The open-crown headdress, which is such a distinctive feature of their costume, was worn by several of the Sani women. The Bai women around Lake Erhai had also reverted to jeans worn beneath their festival finery, with elaborate tunic tops, decorative bibs and aprons. Their headdress was formed from many layers of embroidered squares, held in place with a padded band. The tops, jackets or blouses show Chinese-style decoration, with the curved diagonal band a recurring feature. Today, the men in all these areas wear the usual indigo-dyed blue jacket and trousers, or in a modern context, blue jeans, denim jackets and European-style shirts.

Northern Vietnam: the Hmong and Dzao

The Hmong tribes migrated from central China in the mid-nineteenth century, seeking freedom from oppression. In fact the word Hmong, which is pronounced 'mung', actually means 'free'. They settled first in northern Vietnam and later in the mountain regions of northern Laos and

A Sani girl from the Stone Forest area near Kunming, Yunnan Province, South-West China, wears a long over-tunic with front and back flaps. In 1987 her open-crown head-dress was still worn on an everyday basis.

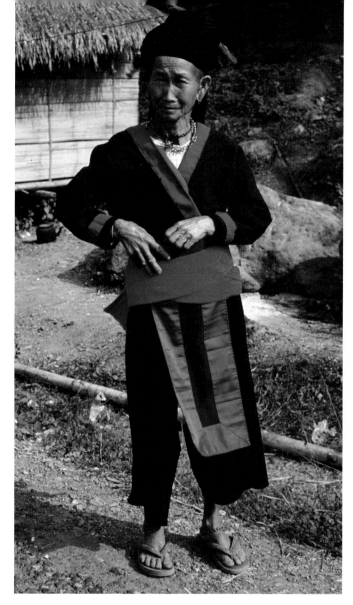

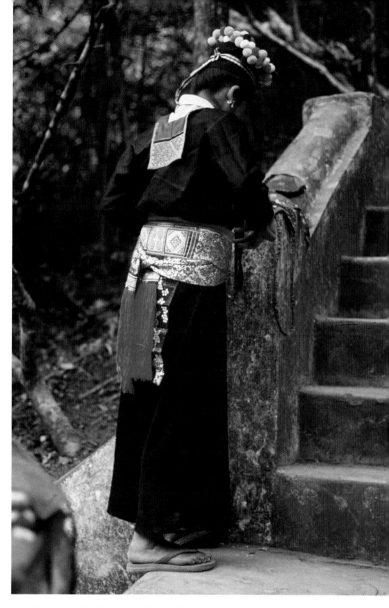

In northern Laos, a Hmong woman from the Nam Ou river area wears her traditional costume of long apron over indigo trousers and jacket with contrasting revers.

A Hmong girl sells embroidery at the entrance to the Pak Ou Caves near Luang Prabang, Laos. She has an embroidered sash with long thread tassels over her indigo trousers and a small back-collar on the jacket. A pom-pom-decorated hat completes the costume.

Thailand, reaching even as far down as northern Cambodia. In the twentieth century, during the period of the Vietnam War, many who were driven from Laos and Cambodia sought shelter in refugee camps in Thailand. Some of the Hmong who had helped the American troops during the Vietnam War emigrated to the United States, and although they have been absorbed into the general community, they still cling to their distinctive embroidery styles and wear traditional costume at festival times.

The Hmong, as one of the minority Miao groups, continue to follow their Chinese background by excelling in embroidery and decorative techniques. The women are masters of the art of batik wax-resist painting, indigo dyeing, narrative embroidery, cross and counted stitchery and reverse appliqué spiral designs. Many of these techniques are applied to their costume. Embroidery and appliqué bands decorate entire sleeve lengths and outline the borders of collars and lapels. The pleated skirt is still a favourite, topped by a long apron which can be of plain indigo cloth with applied borders, or shorter with batik and embroidered panels. The White Hmong women wear a heavy, pleated white skirt made from undyed hemp. This is accompanied by a long dark apron, a decorative waistband and a long-sleeved jacket worn over a white tunic top. An embroidered back-collar is attached to the jacket back, and all is topped by a woven turban or head-cloth worn in a variety of styles.

As well as the usual decoration on collars, cuffs and facings, festival and wedding outfits have large embroidered panels applied to the back shoulders and sleeve areas. The shorter pleated skirts are accompanied by cloth bindings for the lower legs, sometimes many metres (yards) long;

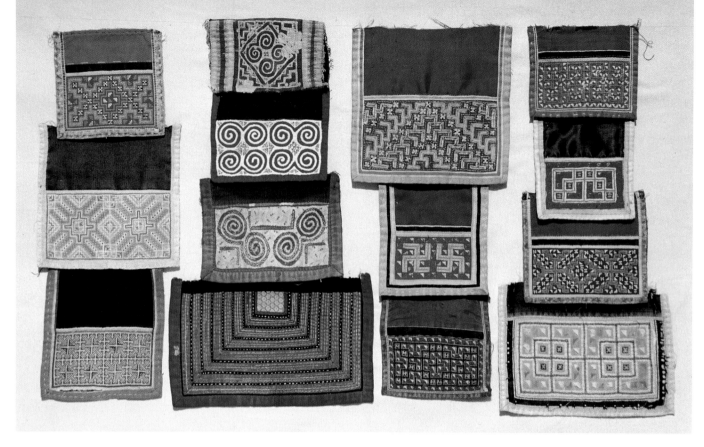

A collection of back-collars from the White Hmong tribes of north-western Thailand, showing a variety of needlework techniques including cross-stitch, appliqué and reverse appliqué.

these give warmth in the higher regions as well as providing protection from thorns and bushes when working out in the mountain fields. They vary from plain indigo dyed cloth to elaborate woven braids.

Northern Vietnam: Sapa

The Sapa area of north-western Vietnam is now a popular tourist destination, but originally it was home to many of the migrating tribes from the north. Today, several of these tribes, including the Hmong and the Dzao, still wear their traditional costumes and work embroidery and craft items to sell in the markets. The Red River valley, bordered to the west by the high mountain range of the Tonkinese Alps, slants at a diagonal across the country before ending in the delta area of Halong Bay by the South China Sea. The Sapa people were adaptable, and as seasoned farmers, cultivated the mountain slopes into wet-rice terraces and used the Red River as a transport system. The area was opened up to Europeans by a Jesuit missionary in 1918, and members of the French administration built French-style houses in the Alps as a retreat from the summer heat of the plains.

The Hmong tribes are divided into several sub-groups, including the Black Hmong, whose name is derived from the dark indigo cloth that forms their costumes. The

women wear an open-sided tunic over a short pleated skirt and a long-sleeved top. All fabric is as black as possible, the colour only obtainable by repeated dipping into the indigo dye. The outer tunic is polished to give a shiny effect, produced by beating the fabric over a stone or piece of wood, together with the application of egg white, bullock's blood or other substances. They wear a turban made from a narrow length of indigo cloth, wound round the head to produce an open crown. The lower legs are bound with indigo cloth. Embroidered sashes, collars and bindings add colour to an otherwise sombre outfit.

Hmong women from the Lao Cai area wear long skirts that are only lightly pleated and with the fullness gathered into the waistband. The upper part has a deep section of patterned indigo fabric, while on the lower area, bands of embroidery alternate with appliqué borders. Separate flaps of decorated fabric are worn at the back and front, like short aprons attached to a waistband. The jackets are very decorative, either in black or in shiny blue or green fabric. The Chinese-style diagonal lapel is bordered with a wide band of appliqué which forms a collar at the back, while embroidered or appliqué cuffs can extend to cover the whole sleeve. Bright check-patterned turbans complete the outfit.

The Red Dzao women wear large, red cloth turbans wound about the head, with one long end coming from beneath at the front. This fabric is then draped over

backwards, allowing a vast array of red pom-poms to hang down behind. These turbans are definite status symbols: the larger the headdress, the wealthier the wearer. Their indigo-dyed costumes have embroidered and appliqué panels down the front, across the lower back and on sleeve cuffs and collars. The Red Dzao women pluck their eyebrows and shave the frontal hair to produce a large expanse of forehead, a custom similar to the Bouyei women of neighbouring Yunnan Province. The young people still come to Sapa to sing courtship songs on market days or at festive gatherings. Nowadays they perform for the tourists, but in the past the girls sang their songs under the cover of darkness, waiting for the boys to find them. If a couple favoured each other, they would vanish into the forest for three days, generally as a prelude to marriage.

Northern Laos and Thailand: Mien and Mun Yao

The Yao are an ethno-linguistic group who, during the last millennium, migrated from central China, ending up in areas of northern Vietnam, Laos and Thailand and in the Shan States of Myanmar. Jess G. Pourret has made an intensive study of the different tribes that make up the Yao group, and records her research in a book on the subject. Several minor tribes sought refuge amongst the Yao people, but the main Yao groups are the Mien, who speak a Miao-Yao language, and the Mun who are close to the Mien, but also have several language variants. This variation is hardly surprising, considering the migrations, the breaking-up of the various groups through war and famine, intermarriage and changing political allegiances. The Mun are thought to have originated in Fujian Province, South-East China; from there they are believed to have migrated across Guangxi to Yunnan Province, where some still live today.

What these tribes do have in common, is the general wearing of trousers by the women as well as by the men. The over-garments may vary, and the width and length of the trousers can change from tribe to tribe, but the overall impression is of a very similar dress code, with dense embroidery patterns decorating the indigo-dyed fabric.

There are several Red Yao tribes living in Chinese Yunnan and Guangxi and in the Vietnamese Lao Cai provinces. The women all wear elaborate red-coloured turbans and head-dresses in different shapes and sizes, some with cascades of red tassels similar to the Red Dzao from the Sapa area. The split over-jacket varies in length, sometimes reaching to the ankles, or shorter to show off the embroidered trousers. The back panel of the jacket is always heavily embroidered, with a predominance of red thread. Trousers may be very wide, or so narrow they are similar to drain-pipe trousers, and several tribes take their names from the type of trousers they wear. Others take their names from

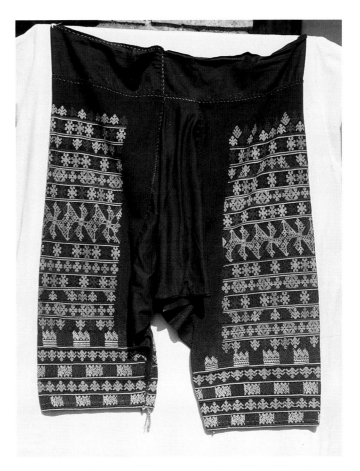

Both men and women of the Yao Mien tribes of the Golden Triangle wear embroidered trousers. This pair, possibly dating back to the mid-twentieth century, was purchased in the Chiang Mai area of North-West Thailand.

the amazing headdresses that are draped over a removable pronged framework attached to a skull cap or circular wooden disc. A hole in the middle allows the hair to be pulled through, and it is then held semi-permanently in place with beeswax. These tribes are called the 'Small Plank Miao', or the 'Large Plank Miao' according to the size and shape of the long attachments. The hair is washed about twice a year, when the contraption is once again waxed into shape. Various tribes in North-West Vietnam wore some type of wax-moulded headdress for daily wear until the 1970s.

The Iu Mien women in northern Laos and Thailand embroider the entire fronts of their trousers, with the chosen patterns and colours defining their place of origin. Bright red 'boas', made nowadays from synthetic yarns, are draped around the neck. The two ends hang down straight in front, or are crossed and tucked into the belt. Their large indigo-dyed turbans, made from several metres of cloth, are wound round the head to show one decorated end, or are held in place with crossed silver bands.

Skirts are worn by only one Mien sub-group. The Tien Yao women who live in the Cao Bang Province of northern Vietnam are known for the distinctive zigzag patterns worked on the lower skirt borders in wax-resist batik. The skirt is gathered, not pleated, reaching to just below the knees, worn beneath a long-sleeved tunic, open at the front and slit at the sides. Today these people are lowland farmers who grow wet rice, but they may have originated from the rugged mountains of Guizhou Province, as the batik skirt patterns have links with the designs worked by the Bouyei women from that area.

Men's Costume

In the past, the men wore a tunic similar to the women's over plain indigo trousers. Traditional jackets in indigo fabric had decorated cuffs and a patch bearing various symbols, including the 'Pan Hung' or Dragon Dog, sewn on to the back. Sleeved jackets normally open down the front, fastened with buttons. In Thailand, the Iu Mien jackets have the diagonal front flap which fastens under the left arm with silver bead buttons and loops. Turbans and waist sashes varied according to the tribal affinity, while a cloth or net bag was normally carried over the shoulder.

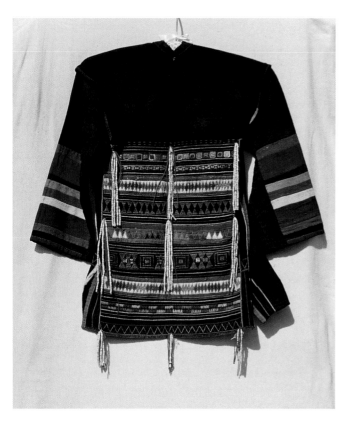

Although most men wear Western styles today, traditional garments are still saved for market days or festivals.

The Golden Triangle

The area known as the 'Golden Triangle' covers north and north-western Thailand, parts of northern Laos and south-eastern Myanmar. Six tribes entered this mountainous region, coming from different directions. Originally these people came from South-West and South-East China, and many of their descendants still live in the Triangle area today. The Mien and the Hmong worked their way through northern Vietnam and Laos, entering from the east. The Akha, Lahu and Lisu tribes came from China, eventually migrating through the southern Shan states of Myanmar to Thailand. The true origin of the Karen people is not known, but it is thought they may have come from South-West China or South-East Tibet. They inhabit the long range of mountains that create a border between modern Myanmar and Thailand, and in recent years many have passed over into Thailand to escape a government that seeks to control their lives in a manner unacceptable to the majority. This has caused friction and many still cross the borders, although their inherent desire is to live in harmony and avoid conflict whenever possible.

The Hmong and Mien people wear costumes very similar to those worn in northern Laos and Vietnam. The pleated skirt, decorated with embroidery and batik, is worn with the lower legs wrapped in cloth leggings rather than woven tapes or braids. The jacket decoration varies according to the tribe, the White Hmong having straight embroidered bands on the front opening, rather than the zigzag-shaped lapel of the Blue Hmong. An embroidered back-collar completes the outfit. Men's jackets are shorter, but equally decorative, worn with plain blue trousers, an embroidered sash and a black satin skull cap with a red pom-pom on top. The Mien women wear embroidered trousers and a plain indigo jacket together with the fluffy red boa. The turban and indigo sash have embroidered ends, and for special occasions, an apron with appliqué designs is added.

The Lahu women wear sarong-style skirts decorated with appliqué strips and stitchery, short jackets and cloth leggings. Tunic edges and borders are sewn with contrasting fabric bands, and the cuffs and sleeves of the women's jackets are decorated with embroidery. Silver buttons and dangles add sparkle to curved jacket fronts and circular collars,

The backs of the Loimi-Akha jackets worn by the women are even more decorative than the fronts. Bands of appliqué, featuring diamonds and triangles, alternate with cross-stitch embroidery. Long strings of Job's tear seeds form tassels that hang in layers down the back.

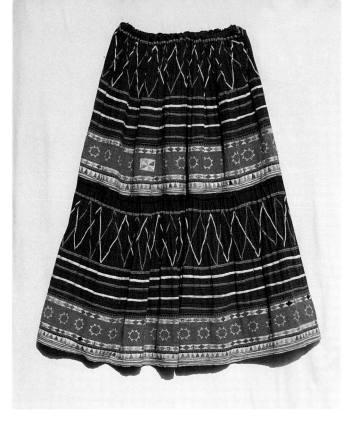

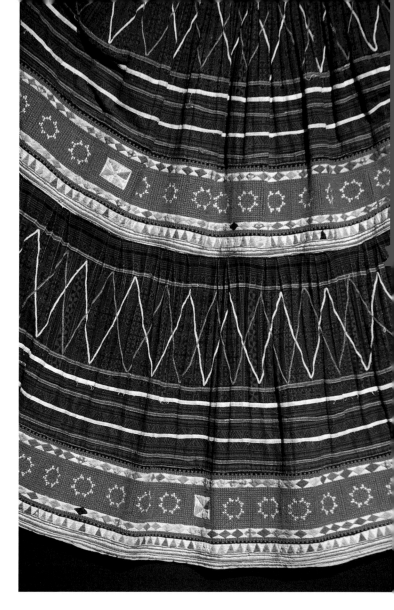

ABOVE: *A Blue Hmong pleated skirt with a waistband adapted for tourist sale.*

RIGHT: *Detail of the Hmong skirt showing bands of cross-stitch embroidery alternating with applied triangles of cloth and a lattice of machine-stitched braids.*

while contrasting bands of applied fabric are a feature of many of the garments. The men normally wear plain indigo-dyed jackets and trousers, but these are embroidered for festive occasions.

The Lisu women's costume is influenced by the Chinese. They wear wide, knee-length black trousers under a full tunic split at the sides. The front is slightly shorter than the back and the sleeves contrast in colour. Narrow bands of appliqué border the diagonal front fastening, frequently hidden by the heavy silver neck ornaments of beads and pendant dangles. The turban is festooned with long tassels of multi-coloured wool and the lower legs are bound with red cloth.

The Akha women are very decorative. They make use of seeds and beads on both their jackets and their hats; and feathers, gibbon fur, silver ornaments and cowrie shells are added to appliqué and embroidery, giving a rich effect. Thai Akha women wear a pointed headdress, while those who came from Burma wear a flatter, fitted headdress. Both are covered with a profusion of silver coins and discs. The straight-fronted, knee-length skirt is pleated at the back,

and a halter top is worn under the jacket. The halter, or breast cover, has a diagonal strap going over one shoulder and is fastened at the side. A heavily decorated sash hangs in front, and tube-shaped leggings are worn below the knee. The man's jacket is also decorated, worn over plain trousers.

The Karen women are superb weavers who embellish their simple white fabric tunics with bands of red patterning. There are two main sub-groups: the Sgaw and the Pwo. The Pwo girls decorate their tunics with diamond-weave patterns from the waist down, while the Sgaw girls have a simple band at waist level and emphasis on the seams. This changes when they marry and abandon the shift for a sarong skirt and over-blouse. These blouses, made from two narrow loom widths, are elaborately decorated with seeds and embroidered stitchery. The Pwo married women rely on striped and counter-change woven patterns for both blouses and sarong skirts. The men wear long shirts made in a similar manner, together with sarong skirts. Occasionally a sleeved jacket is worn over loose trousers. In the past, tattooing was the main decoration for the men,

covering the back, arms and sometimes the upper legs down to the knees.

Ethnic Groups of Myanmar

Most of the tribes in Myanmar wear some form of tube skirt combined with a fitted or tunic-style top. The Pa O women who live in the mountain area above Inle Lake wear a dark indigo costume consisting of a wrapped skirt, under-tunic and over-jacket. The tunic is made from two lengths of cloth, seamed at the sides with orange and blue overhand stitches. An orange line is machine top-stitched down the centre front and back, and the faced

neck opening is bordered in blue. The shorter over-jacket has sleeves cut in one with curved under-arm seams. A Mandarin-style collar and two pockets are machine stitched in blue thread. The women's crowning glory is a large bright red or orange check turban, which is draped loosely around the head with fringe ends hanging down. In a village on the shores of Inle Lake during 2005, a market stall was selling the actual costumes, proof that they no longer make the clothes themselves.

As many of the eastern tribes who still wear traditional costume have links with their neighbours in Thailand and Laos, it is not possible to define them by official borders. The Karen and the Hmong have only minor differences in basic costume and are easily identifiable. Tribes in the southern states have more in common with the wrapped-skirt wearing people of Cambodia and Thailand, and the main difference is one of decoration and headgear.

Ring-necked Women

The long-necked women of the Padaung tribe belong to the Kayin group who live in the Kayah State that shares a border with north-western Thailand. In fact, several groups have crossed over into Thailand and settled in the area. In one of the river-side villages the Padaung women, who had integrated with a Karen tribe of backstrap weavers, wear a three-quarter-length white tunic over a short black skirt. The seams and hems of the tunic and skirt are decorated in red, and a red or multi-coloured cloth turban is draped over the head. Silver arm bracelets are worn, and brass rings on the legs are partly covered with blue cloth leggings.

From the neck base, the brass rings decrease in circumference towards the middle of the neck, then increase in diameter, allowing a padded cloth to be worn under the chin. A new ring is added every year, and the long necks are considered a sign of beauty. Of course, the number of vertebrae cannot increase, they can only stretch in length, and this has an effect on the larynx and alters speech. According to an X-ray photograph, the weight of the rings depresses the clavicles, forming a hollow that makes the neck appear even longer. At one time, little girls had their first ring in place as a five-year old. The custom was declared unlawful in Thailand, but there was no way of verifying if this was so in the surrounding areas. According to the chief, the women are treated as princesses, as they bring much-needed money to the village.

A Pa O woman visiting Taung-To market on the shores of Inle Lake, Myanmar, wears a layered costume of wrapped tube skirt, over-tunic and a long-sleeved short jacket, all in indigo-dyed fabric.

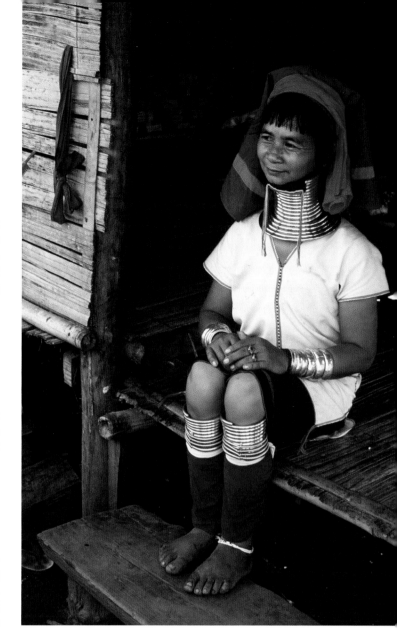

This Padaung woman belonging to the Kayin group lives on the border of Myanmar and North-West Thailand. Her extended neck is bound with brass rings, and she wears a simple tunic over a short indigo-dyed skirt. Karen weaving village, 1991.

Over the border in Myanmar, the Padaung women wear a similar short tunic over a skirt or knee-length trousers together with a long-sleeved black jacket. They have red turbans wound closely round the head. In a booklet on *National Ethnic Groups of Myanmar*, researcher U Min Naing tells us:

> They wear brass rings on their calves and neck. Small diameter rings are put around the neck and underneath the bigger rings to give strength to the elongated neck... They wear big earrings in their ears and silver or bead necklaces.

The rings referred to are separate, but an alternative was a continuous ring that was wound around the neck. This was more flexible, held in position at the back with a stiffener which could be unhooked and the coils removed.

Religious Dress Priests and Shamans

The Shamans occupied more than one level of consciousness. They were human beings, but were regarded as having magical powers that elevated them above ordinary people, and so it was necessary to show this difference in dress and regalia. As they were in constant communication with the ancestors, they needed to be easily recognizable, or their 'ancestor contact' rituals would not be effective. Rich fabrics such as silk, or those that required elaborate and time-consuming weaving techniques, or contained special designs and symbols not normally worn, were given by grateful worshippers for the favourable outcome of a healing ceremony. In northern Thailand and Laos, healing cloths were woven with elaborate supplementary weft techniques. Red silk was considered the most effective for these long scarves, which would provide protection as well as healing. In dancing or healing ceremonies similar to those used by the Buddhist priests, the shamans wore them draped around the shoulders, and female shamans sometimes wore them crossed in front.

Chinese dress was worn not only by the past ruling classes in Vietnam, but frequently formed the regalia of the priests. Many of the Yao people of northern Vietnam, Laos and Thailand practised the Taoist religion. The priests wore a decorative Chinese skirt and a plain silk tunic over their normal trousers. A sleeveless Dragon robe, lavishly embroidered in silver and gold thread and an equally ornamental hat formed the costume, together with a sash and various symbolic accessories. These outfits varied according to the customs of the different areas, but the basic design of a sleeveless chasuble embroidered with Taoist and auspicious symbols, was common to all. These were made especially for the priests, or in some instances a Dragon robe may have been passed on by a ruler when worn out, or given as a gift in supplication for some religious favour.

Royal Costume in Burma, Cambodia and Siam during the Nineteenth Century

When the Siamese sacked Angkor in the early fifteenth century, they were surprised to see the lack of upper body covering. Royal dancers transferred to the court at Ayutthaya had to comply with Siamese traditions, and wear some

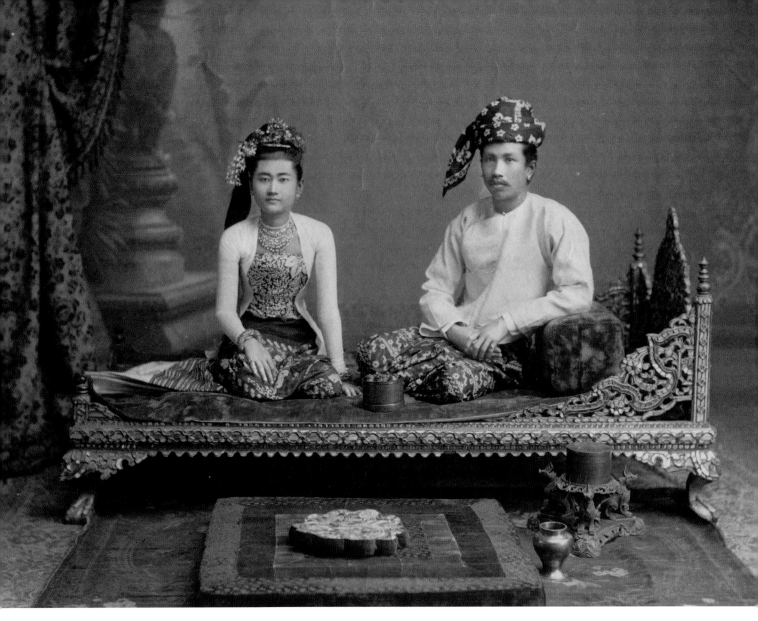

A Burmese aristocratic couple, wearing prestigious court costume. Above their longyi skirts, which appear to be worked in the luntaya acheik tapestry technique, they wear fitted upper garments. The lady's open jacket reveals a patterned breast cover, while the man has a shirt woven in three-in-one twill pattern. This mixture of seamed and uncut cloth is typical of late nineteenth-century costume. Print: from an old plate photograph purchased from an antique shop, 1987

form of top garment. Eventually this had an influence on Cambodian fashions, and during the nineteenth century covered tops were made obligatory as part of a royal reform in dress. This was instigated to bring the country up to date and in line with the European powers that controlled the area.

In Burma and Siam, the traditional royal regalia of stiffly layered and embroidered costume continued throughout the nineteenth century, but gradually became supplanted with a hybrid mixture of European and national dress. The male royal personages were especially fond of European-style uniforms, wearing the jacket tops together with the sampot chang kbin wrapped trousers. The more gold braid, fringed epaulettes, decorations and medals on the tailored

jacket, the greater the desired effect. At the end of the nine-teenth century, their wives adopted European-style frilly blouses, copying the current fashion for high necks and long sleeves. They were worn with the traditional tube skirt made from richly woven silk fabric. Once again, this fash-ion was carried to excess, and the blouses became frillier and lacier as time went on.

Religious Constraints and Influences

It is possible that the missionaries had a prime influence on changes in dress in South-East Asia. To a greater extent

Two women of Bandan, an indigo dye and weaving village in North-East Thailand, wear versions of camisole-top blouses above their phasin tube skirts in 1991. Their companion is in European-style dress.

this affected the tribal women, who were persuaded to adopt Western-style blouses or tops to cover their 'modesty'. Previously, many had worn the sarong or wrapped skirt without an upper covering, apart from the 'breast cover' worn by Burmese and Siamese tribes. Sometimes the sarong covered the breasts, while at other times they were exposed without the slightest connotation of nudity. The Thai women, more accustomed to upper coverings in the form of a draped shawl or scarf, adopted a chemise-style blouse with front and back sections gathered on to a yoke, combined with wide shoulder straps. This is still worn today.

In Indonesia the women wear satin, waist-length blouses called *kebayas* with their sarong skirts. They are semi-fitted with set-in sleeves reaching to just below the elbow, have front neck openings and are often tied with a sash around the waist. The Muslim concept of modesty in dress has influenced many island women to 'cover up' and adopt Muslim veils and head coverings. Today the *rimpu*, or head and shoulder covering, is now an accepted form of dress, and is part of school uniform for the girls.

Islamic Minangkabau women from West Sumatra have devised a compromise that combines traditional values with Muslim dress. At prayer time, they wear the *Mukena*, or Islamic women's head-veil. This cloak-like garment, which covers the head, reaches to knee-length and is made of white cotton or polyester with a front fastening to outline the face. White embroidery or lace borders the hem-line and face opening. After prayers, the woman folds up the *Mukena* and incorporates it with her traditional folded head-cloth, so that the lacy edges form decorative borders on the horns and a lacy cockade to one side.

Colonial and Foreign Influences

Colonial dress fashions were copied above the waist, in that European-style blouses were – and still are – worn together with the wrapped and tube skirt. The men adapted to Western dress more quickly, wishing to emulate

whichever colonial power had control, thus increasing their chances of employment or promotion.

Chinese influence in dress was more obvious in the countries they had conquered or traded with. Vietnam still has more in common with the Chinese than the French, who strove to overlay their culture on to one already long established. The many Chinese immigrants in Cambodia, Laos, Myanmar and Vietnam have set up their own communities with markets, commerce, religion and education following Chinese customs. Some women of the Shan states of Myanmar wear Chinese-style blouses with the upstanding Mandarin collar and front fastening.

The Indian merchants brought dyed and printed fabrics that had a lasting influence on the costumes of Malaysia and Indonesia. The superior quality of these cloths was probably one reason for the long-standing adoption of the long-cloth and tube skirt throughout the islands. These fabrics were expensive, and a definite status symbol.

Costume Accessories

Hats

Hats have several roles. The first is one of utility – to keep the head warm, or shaded from the sun, or protected from the rain. Eventually these hats developed into status symbols, either through decoration or through size. In ethnic societies, hats are made from materials that are easily available. The cone-shaped hat is commonly seen in the countryside throughout the whole of Vietnam. This hat, called *Non Lá*, is made from latania leaves and is worn mostly by the women. Villagers in certain areas specialize in the making of these hats.

Hats made of rice straw have a woven appearance. The flat, circular straw hats once worn by the Tonkinese women of the farming class in northern Vietnam are at least 75cm (30in) in diameter, giving these women the name of 'Big Hats'. They are slightly domed in the top, which gives room for the decorative thread interlacing stitches on the inner surface. Ribbon or cloth ties are linked into the interlacing stitches so the hat can be secured under the chin. This cartwheel of a hat is only 8cm (3in) deep, and would form an excellent umbrella, or a winnowing pan for the rice seeds. Old photographs show this hat being worn, together with a Chinese-style black tunic dress.

Although many of the people who live in South-East Asia use a head covering of cloth wound as a turban, several tribes in the northern area wear hats of one kind or another. Little boys in Yunnan Province wear embroidered caps depicting a lion head, decorated with fur trimming; this is to confuse the evil spirits, who otherwise might harm the child. The Sani women's caps take the form of an

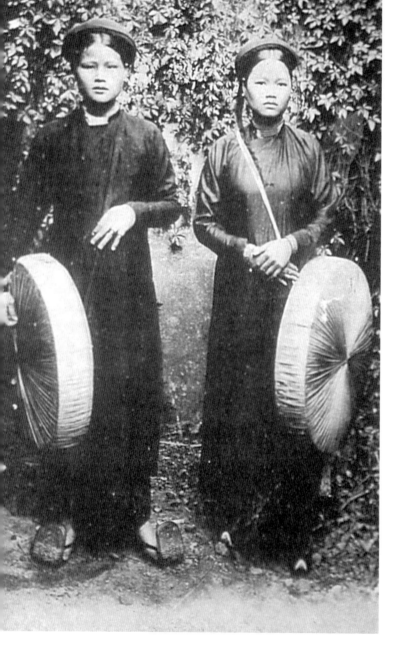

Large, cartwheel-shaped straw hats were worn by the Tonkin women from the farming regions of northern Vietnam. Late nineteenth century. From an old photograph, origin unknown

open stiffened crown, or a shaped cap with protruding wings from which little silver bells dangle. Hats in Guizhou Province can take the form of a crown with a deep fringe of beads, or the helmet shape of the Gejia tribe girls, with fringed sides and a silver pin in the top.

The Mien women of north-western Thailand make delightful little hats for their children. The basic shape is circular, a cap made from indigo-dyed fabric, gathered or seamed into the centre to make a domed top. These caps are heavily embroidered in coloured threads using cross and double running stitches. The girls' and some women's caps are decorated with red thread pom-poms that encircle the top, leaving an indentation in the middle from which protrudes a long thread tassel. The boys' caps have a single plump pom-pom in the middle of the top, surrounded by several smaller ones on the rim, or single ones placed on the cap sides. Hmong men and boys wear the black satin Chinese-style skullcap, also with a red pom-pom on top.

The Akha caps are heavily decorated with beads, seeds, silver discs and coins, thread and feather tassels. They vary greatly in shape from tribe to tribe: some have a flat section at the back that stands upright, which may be level with the cap top, or stand proud above it. Those from Myanmar tend to be taller at the back. The whole cap, including the back section, is covered with silver domed beads, giving the reticulated appearance of a terrapin or scaled lizard. Coins, beads and tassels are always added. This cap may form a woman's wealth; she is literally carrying her 'bank' on her head. Other caps are completely covered with small silver buttons that contrast with lapped layers of larger silver coins. At times a plain straw hat is worn perched on top, possibly to give shade when working on the rice terraces, for the fancy hat is worn at all times of the day.

Bags

Shoulder bags are an important accessory, as pockets are few and far between. The universal pattern has a square-section back and front, and the handle is formed from an extension of the side gussets. These bags are decorated in many ways, including with fringes, beading and embroidery or, in the case of a hunter, the small fur pelts of the latest kills, which make a talismanic addition. Lisu men's 'courting' bags are highly decorated with a network of beads, silver dangles, embroidered side strips and tassels. Hmong money bags have cord or braid handles, and most are exquisitely decorated with fine embroidery stitches, appliqué and beads or red pom-poms. Netted bags are made from jungle vine fibre. These have the advantage of expanding to fit the contents, while back-held baskets are common to all areas, often shaped to fit the back.

A Malay coachman wears a European-style uniform with his 'local' straw hat over a cloth turban, c.1880. Antique print, origin unknown

Baby Carriers

Small children are carried until they can walk, particularly as some tribes consider a crawling baby to be unlucky. Most carriers are of cloth, sometimes padded and stiffened like those from Yunnan Province, with ties that encircle both the mother and the child to hold all in position on the back. The child is laid on the baby carrier first, then picked up with the carrier and tied in place beneath its buttocks, with the feet and lower legs protruding from below. These carriers act as both status symbol and protection for the child, for they are embroidered or decorated with auspicious motifs and designs.

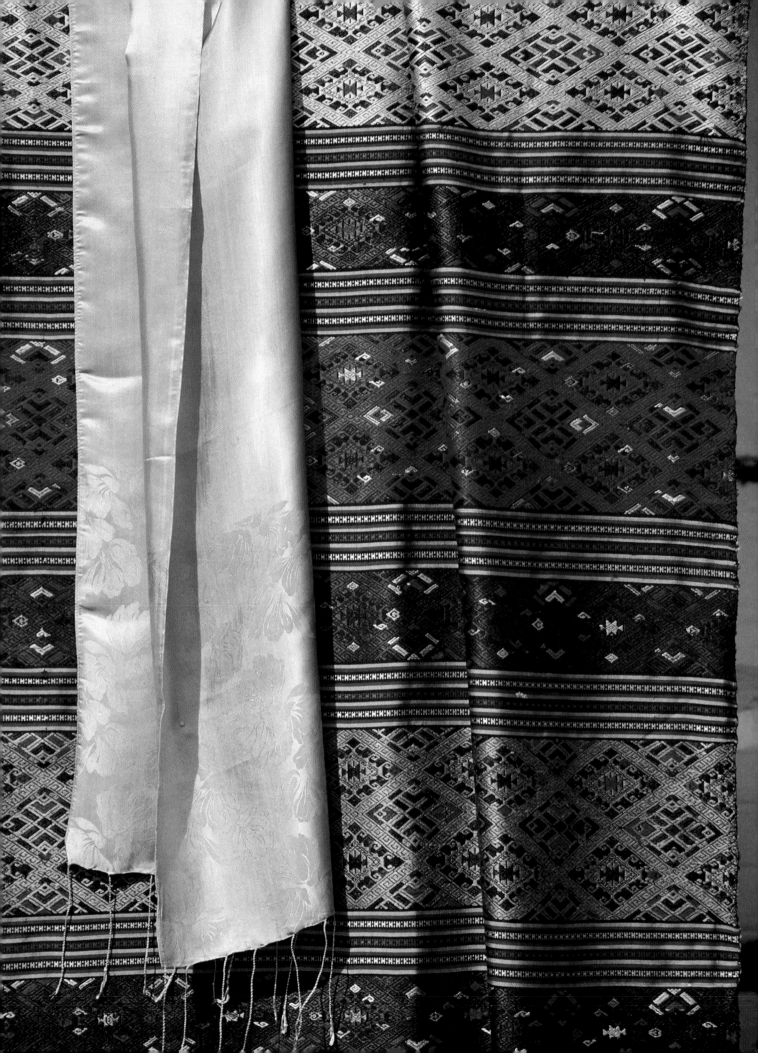

Threads and Fibres, Spinning and Dyeing

Cotton

Cotton still forms an important element in modern clothing and furnishings, in spite of the introduction and frequent use of synthetic fabrics. Cotton absorbs moisture, but at the same time allows the fabric to 'breathe' and get rid of excess moisture. It is soft to the touch, takes dyes readily, and seldom shrinks when washed. We take it so much for granted that it is difficult to believe that it is only about 350 years since cotton was introduced from India to Britain and Europe via the East India Company.

Agricultural historians tell us that the original cotton plants grew in Africa some fifty million years ago. It is thought that some seeds were carried on ocean currents to India from the eastern side of the continent, while others drifted across to Central and South America from the western side. The two types of cotton are different, having mutated genetically in their newly colonized areas. The Indian plant, *Gossypium arboreum*, is referred to as 'Old World cotton', while the American plant, *Gossypium hirsutum* is called 'New World cotton'. Both belong to the mallow (*Malvaceae*) family, but the two species are botanically distinct.

There is evidence that Old World cotton, as opposed to wild cotton, has been cultivated in India and woven into cloth for a period of up to 5,000 years. A small fragment of fabric was discovered in 1921 at Mohenjo Daro when archaeologists were excavating the Indus Valley site in the Sind area of India (now Pakistan). The fact that the fabric was dyed red with the madder plant, which requires a mordant to fix the dye, was evidence of an already sophisticated society, substantiated by the unearthing on the site of several dye vats. Indian cotton, *Gossypium arboreum*, is a tree-like shrub with yellow flowers that turn pink and then to red before they wither and dye. The cotton boll containing the seeds bursts open when ripe, exposing the fluffy cotton fibre. Early European travellers and writers confused this fibre with wool, and even in Roman times, Pliny the Elder described the plant as 'Trees that bear wool'.

Indian weavers produced superbly woven cloth from the earliest times – it is thought that even in 3,000BC, during the Mohenjo Daro period, pit looms, with treadles and heddles to control the lifting of the warp threads, were already in use. The Indian sailors navigated their ships around the Indian Ocean, crossing to the ports of East Africa and the Arabian Sea from one side of the sub-continent, and to areas of Malaysia and Indonesia from the other. The main cotton-growing area was the Deccan, which stretches across the central area of India. The Gujarati and Malabar coasts on the west, and the Coromandel coast on the eastern side, provided access to trading posts for the export of the cotton. As it was not possible to grow high-quality cotton in some eastern areas, superior cotton, which was much in demand in Indonesia, was taken long journeys by bullock cart from the central Deccan area to the eastern ports.

The Introduction of Cotton to South-East Asia

It is not known when Egyptian cotton was first introduced to India, supplanting much of the wild cotton that had

OPPOSITE PAGE:
Silk fabrics from the Van Phuc workshop in Hué, Vietnam in 2006. A damask-weave yellow scarf draped over a supplementary weft-patterned shawl.

Cotton bolls on display at a weave village near Bagan, Myanmar.

flourished there for thousands of years. The Indian merchants became great traders, setting up posts throughout the Indian Ocean and finally into Indonesia and beyond. As well as trading in a variety of goods, they were instrumental in bringing Hinduism to Indonesia. The cloth was traded for spices, nutmegs, cinnamon and cloves, and these in turn were exchanged along the silk routes of both China and Central Asia. The trade flourished for several centuries until the newly powerful Brahmans prohibited Hindus from trading across the water, for fear they would become contaminated by other religions. The Arabs, who were the first to call the plant *qutan* or *kotn*, soon took the place of the Indian merchant seamen, and by the seventh century AD had established themselves as the premier distributors of trade goods. The Arabs in their turn brought Islam to Indonesia and the islands, to an extent supplanting both Hinduism and the indigenous animistic beliefs. It was not until the Portuguese, who were followed by the Dutch, entered the area in the sixteenth century, that the Arab traders lost their dominance.

The Importance of Cambodia as a Cotton Exporter

Although India was the premier producer of first quality cotton, the plant was soon established in surrounding geographical areas which provided the right conditions for growth. The Cambodian climate includes an essential dry season from November to April, while at the same time plenty of water was available from the irrigation systems of the Mekong and Bassac rivers, flowing from Laos. The cotton was exported as woven cloth, an industry already well established by the Khmer backstrap weavers, as noted and recorded by Zhou Dagan in the late thirteenth century.

By the seventeenth century, the plant was cultivated alongside rice paddies, and both rice and cotton formed the basis of a profitable export trade to neighbouring countries unable to produce their own. The people of the island of Sumatra found the Cambodian cotton cloth far cheaper than that imported from India, so the trade thrived. By the end of the seventeenth century, Chinese communities were well established in southern Cambodia, where the Chinese merchants traded in spices and sugar, as well as in cotton. The port of Kampot, situated at the mouth of the River Mekong, became an important outlet, giving access both to the interior of the country and the adjoining Malay peninsula. Ultimately, under French rule in the nineteenth and early twentieth century, the production of Cambodian cotton increased and the industry was able to supply not only Vietnam, but also much of Indonesia. By this time,

Gossypium hirsutum, the 'New World cotton', had been introduced as a viable commercial alternative.

The Importance of Cotton to Indonesia and the Islands

Indian cotton fabric was valued more for its prestige than for its utilitarian properties. It was necessary to use high quality imported cotton, as the local wild cotton produced a rather coarse material, unsuitable for the fine batik wax and painting processes. Certain designs worked on to the fabric had both magical and royal associations, and as such were limited to specific priestly or aristocratic classes. The so-called 'painted' cloths of India, which were a mixture of Ikat-dyeing and painting, were highly prized textiles

The stages in cotton spinning:
FAR RIGHT: Ginned cotton.
FAR LEFT: Cotton rolags ready for spinning, with the spindle shown at centre.
BACKGROUND LEFT: A natural dyed cotton cloth from the workshop of Mrs Saeng-da Bansiddhi, North-West Thailand.
BACKGROUND RIGHT: A striped cloth in open weave, from the cotton village, Bagan.

reserved for rights of passage, ancestor and other ceremonial purposes. These heirloom trade-cloths gained in importance the longer they were preserved. Ancestor cloths were stored in rattan baskets in the rafters of the highland village houses, often surviving through several generations. The cloths were not only a sign of wealth, they took the place of money and became a form of stored wealth, as well as providing valuable dowry goods in marriage settlements.

How Cotton is Prepared and Spun

The cotton boll forms a fluffy expanse for the hairy seeds, which if not harvested, would eventually float away on the wind. The main problem in cotton preparation is the removal of the hairy seeds from the cotton boll. It is a tedious process to pick them out by hand, and each society has invented some form of contraption, or 'gin', for removing the seeds. In Thailand, Laos and many areas of South-East Asia, a device looking rather like a miniature clothes-wringer or mangle, is used in cotton spinning villages. The raw cotton is teased out and fed between the wooden rollers, which rotate in different directions, worked by a simple gearing mechanism. If only one woman at a time is ginning the cotton, she will have to

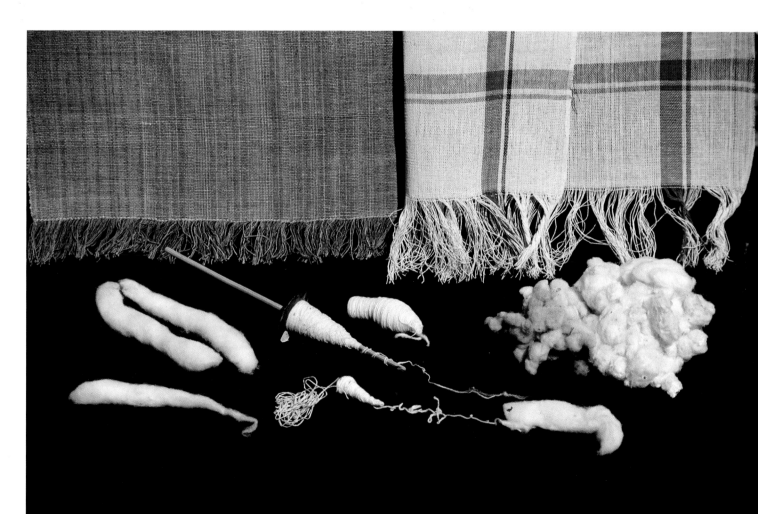

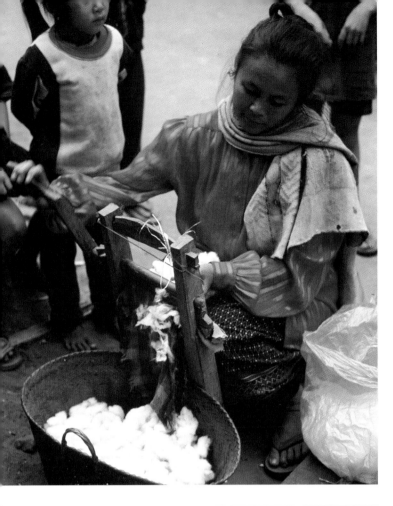

guide the cotton mass through the rollers with one hand, while turning the handle with the other. Most of the seeds will pop out, and if necessary, the cotton can be passed through again, or the remaining seeds removed by hand.

Next, this ginned cotton has to be fluffed up before spinning on a spindle or a spinning wheel. In some areas the cotton is fluffed by beating with a pair of thin sticks, which raises the fluff into the air. In the Flores Islands a rattan mat is used as a surface on which to beat the cotton; in other areas any resilient heavy-duty fabric is suitable. In a cotton village in Laos, a waxed bow-string was plucked over the cotton mass, to produce a similar fluffy substance. The fluff is contained by working into an open, woven basket shape, thus preventing the cotton from blowing away. In Indonesia, a fine strip of rattan vine is used for the bow-string, and the Flores Island women sit together in a row, working the bows in unison while the fluffed cotton builds up around their feet.

The fluffed cotton is straightened by drawing between two carders, generally in the form of a pair of wooden bats studded with tiny wire hooks, or in rural areas, covered with teasels or similar spiked plants. Next, a film of carded cotton is placed on to a wooden board or plate, then firmly rolled and pressed round a small stick. The stick is removed to reveal a cylindrical *rolag* of cotton, which forms the basic material from which the thread is spun. These rolags are then stored in a basket, ready for use.

Types of Cotton Spindles, Spindle Whorls and Spinning Wheels

Although European-style spinning wheels were introduced by the various colonists when they took over cotton production to put it on an industrialized basis, the simple drop spindle is still used in many of the villages. In order to make a viable thread from any type of fibre, be it cotton or wool, it is necessary to draw out the fibres and at the same time impart a twist to the thread, thus locking in the shorter lengths of fibre. Wool has the advantage that the animal hair is formed of tiny overlapping scales that intermesh when the twisting process takes place. Cotton is not so easy to spin, and some moisture, whether from the air or as added water, helps in the formation of a firm thread.

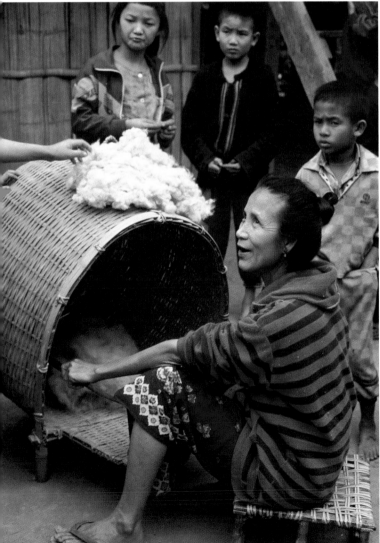

TOP LEFT: *A woman 'gins' cotton to remove the seeds and prepare for spinning. A cotton village, Luang Prabang area, Laos.*

BOTTOM LEFT: *Fluffing the cotton with a strung bow. The confines of the basket prevent the fluffed cotton from blowing away. Cotton village, Luang Prabang area.*

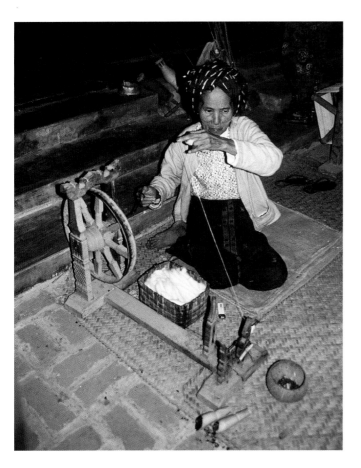

ABOVE:
Cotton spinning in the weave village near
Bagan, Myanmar. The woman has a basket
of cotton rolags ready for use and a
bowl of water for dampening the thread.

The spindle will vary from one area to another, but the basic shape will stay the same. A cylindrical stick or rod, measuring anything from 15 to 30cm (6 to 12in) in length, is passed through a circular weighted object or spindle 'whorl'. Whorls can be made of wood, pottery, stone, or even metal. They can be round like a ball, or a flat circular disc, or dome-shaped. Normally located near the base of the stick, the whorl stabilizes the spindle and allows the spun thread to be wound on to the stick without slipping off. In use, the stick top is twisted between finger and thumb, or the shank is rolled across the thigh, to impart a twist to the fibre which is teased out from the rolag. As the weighted spindle drops, so the twisted thread is extenuated. At the end of the drop, or 'reach', the spun thread is wound back on to the spindle shank. The Akha tribes in northern Thailand use the thigh spindle; here, the twist is given to the thread by the spinner first rolling the spindle shank along the thigh, then holding the spindle out at arm's length to attenuate the thread.

The delicate cotton fibres are frequently spun on a support spindle, one that revolves on to a hard surface, like a pottery dish, a gourd or even the compacted ground. This prevents the thread from breaking. Spun threads are 'plied' by combining two already spun threads, with the twist going the opposite way, to form a stable thread. A twist going clockwise to the right is called a 'Z-twist', and a twist going to the left is called an 'S-twist'. Various combinations

RIGHT:
A ring-necked Padaung woman belonging to
the Kayin group winds cotton thread from a
hank on a rotating 'swift' frame. Border area,
North-West Thailand and Myanmar, 1991.

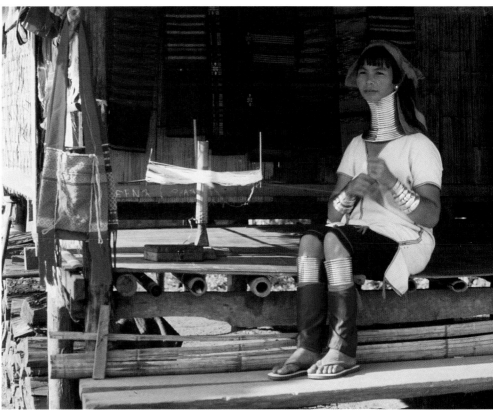

of twist can produce a variety of threads with different properties, used to advantage in textured weaving.

A spinning wheel called a *charka* has been in use in India since about the tenth century, and versions are found throughout South-East Asia. The charka wheel was the basis of the portable spinning wheel favoured in 1920 by Mahatma Gandhi, who wished to bring the art of spinning back to the people. The spinner sits on the floor, turning the wheel with a handle, which allows the thread to be drafted from a horizontal revolving spike which takes the place of the drop or support spindle. This method is similar to the European spindle wheel, which was in use long before the 'Saxony' or flyer wheel evolved during the sixteenth century. The foot-treadle flyer wheel has a double drive-band round the wheel, which, through a differential, allows the thread to be wound on to the bobbin while spinning takes place.

Silk

Lustrous silken fabrics have always been regarded as one of the world's most prestigious luxury materials. They have been bartered on the Silk Road, woven into wondrous garments for emperors and for the priests; used for temple and palace hangings; given as offerings to the Gods, paid as tribute and as bride price. For centuries silk was the sole prerogative of the Chinese rulers, with the secrets of its production fiercely guarded and its use strictly limited. Bales of silk were traded across Asia, finding their way into the Middle East and then to Italy and the rest of Europe. Silk is an insect filament, not a vegetable fibre or an animal hair, and this affects its qualities, the way it is harvested, and how it is turned into a thread suitable for weaving into cloth.

The Introduction of Silkworms from China

There are many legends relating to the discovery of silk threads from the cocoon of the silk moth. One tells of a Chinese princess, the Lady Hsi-Ling, who observed the silken strands that extended from a silk-moth cocoon when it was removed after falling from a mulberry tree into her cup of hot tea. She became known as the 'Lady of the Silkworms'. However, sericulture had already been established long before she became chief wife of the Yellow Emperor Huang-Ti, who reigned during the second millennium BC. It is more likely that silk cocoons were heated in water to cook the grubs, which still form a necessary source of protein in many areas of South-East Asia. In China, stir-fried silkworm pupae are considered not only a delicacy, but also a cure for high blood pressure. It is thought that the Chinese discovered silk some 5,000 years ago, and there is evidence through carbon dating that it was woven into fabrics during the period around 3,000BC.

By the first millennium BC the Chinese were trading with other countries, and within a few centuries, caravans were taking silk to India, Persia and Turkestan. Few merchants ever travelled the entire length of the Silk Road: rather, the goods were passed from trader to trader, each one based at a convenient caravanserai where lodging was provided both for the dealers and for their camels. The explorer Marco Polo, in the late thirteenth century, was one of the few Europeans adventurous enough to complete the entire journey.

The stages in silk production:
CENTRE: *White and yellow silk-moth cocoons from Thailand.*
LEFT AND RIGHT: *Hanks of reeled silk before de-gumming, Thailand.*
BACKGROUND: *Ikat-patterned silk cloth from Chonnabot workshop, Chiang Mai area, Thailand.*

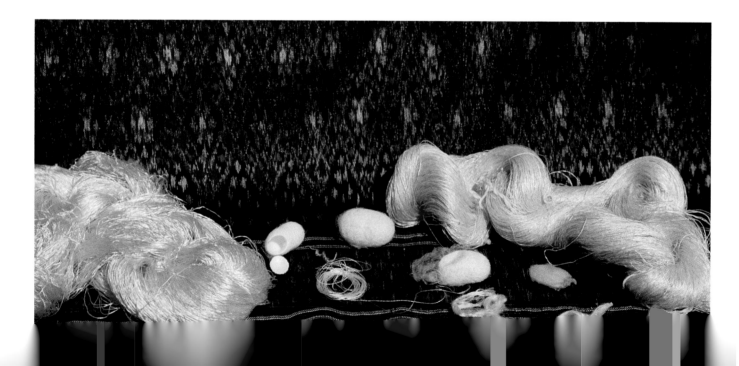

The Chinese still kept their secrets, and silk-importing countries became increasingly desirous to learn the methods of sericulture themselves. In desperation, Persian craftsmen were driven to unravel silk fabrics to obtain the threads for pile-woven carpets and rugs. It is said that the Byzantine emperor Justinian I, who reigned during the sixth century, was instrumental in first bringing sericulture to Constantinople. In about the year 550AD he managed to prevail on two Persian monks to smuggle silk-moth eggs in their hollow bamboo canes when they returned from a visit to China. The eggs survived, and the hatched worms adapted to feeding on the leaves of the black mulberry tree. They were to become the progenitors of the silkworm varieties that supplied Europe with silk for many centuries. This is a much-quoted story, and is probably only one of many instances of the secret importation of silkworm eggs from China, for it is said that eggs from the *Bombyx mori* had reached India by about 140BC. The Indians were no strangers to sericulture, having for centuries obtained silk from the wild silk moths that lived on oak and other leaves in the northern forests.

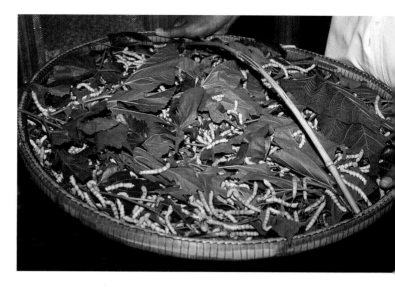

ABOVE: *Silkworms in a tray of mulberry leaves, educational display, National Centre for Sericulture, Siem Reap, Cambodia, 2006.*

BELOW: *The silkworm cocoons placed in the circular compartments of a woven wheel container. National Centre for Sericulture, Siem Reap, Cambodia, 2006.*

Silk Moths

In the wild there are many types of silk-producing moth. Most are very decorative with large wings, unlike the domesticated *Bombyx mori*, which is blind and flightless. It is said that the ancestor of this cultivated moth is the *Bombyx mandarina Moore*, which lives on the leaves of the white mulberry tree and produces a round filament that makes a finer quality of silk thread. The wild silk moths produce a flatter filament that is liable to tangle and break during the reeling process. This rough silk is not easy to bleach and dye, but is often used to make a slubbed silk called 'Tussore' or 'Tussah' from the Sanskrit word tasara, meaning 'shuttle'. The wild silk is sometimes combined with cotton, and the natural ecru-colour and slight stiffness of the thread makes it more suitable for heavier-type fabrics.

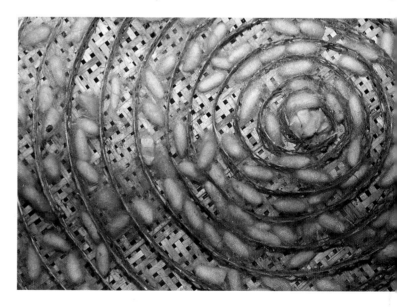

The Cycle of the Silkworm and Production of Silk Threads

In the wild, the silk moth lays its eggs on the branches and twigs of the mulberry tree, where they wait till the warmth of springtime to hatch out into tiny black grubs. For thousands of years this yearly hatching cycle was followed in domesticated silk-moth rearing, but this was superseded by continuous breeding throughout the year when it was discovered that temperature and light would affect the cycle. Some moths are allowed to break out of the silk cocoons for breeding purposes. The females are recognizable by their distorted stomachs, and mate with the smaller males before laying their eggs.

The tiny worms spend the next twenty-five to twenty-eight days eating a diet of fresh mulberry leaves. During this period their bodyweight increases about 10,000 times, and they moult out of their skin a total of four times, each time resting for a day. The moment the skin is sloughed, they begin eating again. After the final moult they anchor

themselves to a suitable surface, ready to form the cocoon, which they spin in a figure-of eight formation around themselves. The 'silk' is a liquid protein called *fibroin* coated with *sericin*, a sticky substance that is extruded from spinnerets on the lower lip. These are connected to two silk glands held within the body of the grub. The cocoon hardens in the air and forms a casing, inside which the grub will pupate into a moth, a process which takes about three to four weeks. When ready, the silk moth dissolves the cocoon casing and bites a hole, through which it emerges, fully grown. The adult moth lives only long enough to mate, and if female, to lay several hundred eggs. The moths die within a few days of mating, and the cycle starts again when the warm weather heats the eggs.

Rearing the Silkworms

Domestic silk-moth rearing is a time-consuming and arduous process. First there must be an adequate supply of mulberry leaves: orchards are planted round the silk villages, and are tended for several years before they reach maturity. The leaves are picked fresh daily and laid out on flat baskets or trays, first covered with paper. The paper is changed when the leaves are replenished, as cleanliness is imperative if the tiny grubs are to thrive. The trays are covered with a gauze fabric in order to prevent the mosquitoes from biting, or flies from laying eggs on to the worms. In silk villages in north-eastern Thailand, the baskets were

placed on to shelves and the entire hatchery draped with net curtains. The workers took great care when going in or out.

When the grubs are ready to spin their cocoons, they are placed in suitable resting places, which differ from country to country. In Thailand, flat, circular wheels of straw divided into segmented compartments form little divisions into which selected cocoons are placed, while in Vietnam and Cambodia, rectangular bamboo frames fulfil the same purpose. These are also kept covered until it is time for the moth grubs to pupate. Only a few are left for breeding purposes, as the hole made by the emerging moth breaks the continuous filament of the cocoon. The pupae are stifled by steaming, or dispatched quickly in boiling water before the filament can be unwound.

Reeling the Silken Thread

Silk is not spun, it is reeled. Cocoons are placed into a pot of hot water to soften the sericin gum that coats the filaments. Experienced workers are able to locate the filament from each cocoon, and pick up about ten of them with a brush or a stick. The group of filaments is then taken up

Hanks of silk decorate a village tree for the Buddhist End-of-Lent Festival, Khon Kaen area, North-East Thailand.

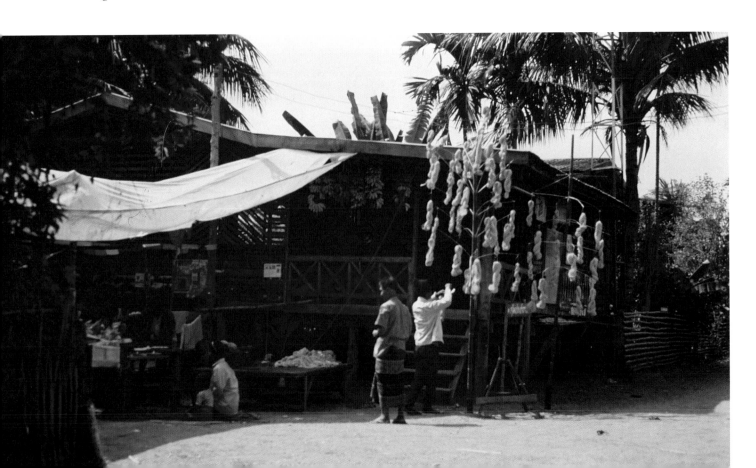

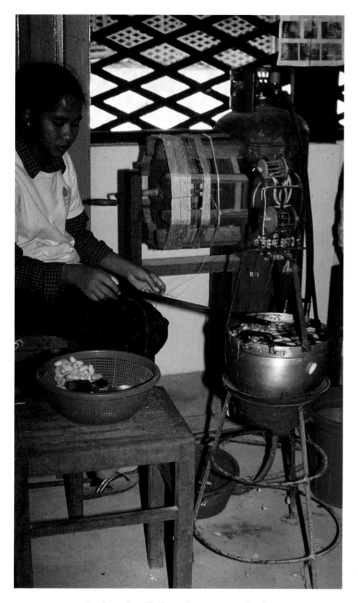

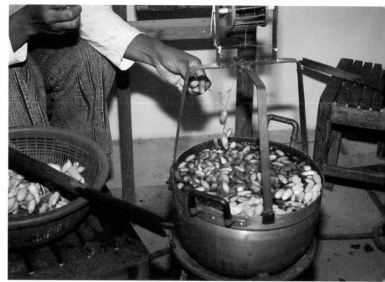

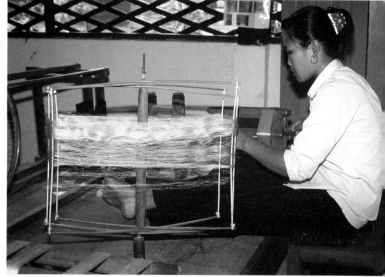

ABOVE: *Reeling the silk from the cocoons. The filaments are drawn through a hole in the frame before winding on to the reel. National Centre for Sericulture, Siem Reap, Cambodia, 2006.*

TOP RIGHT: *The cocoons in the heated water-pot. National Centre for Sericulture, Siem Reap, Cambodia, 2006.*

MIDDLE RIGHT: *Winding the reeled silk on to a swift, ready to make into hanks. National Centre for Sericulture, Siem Reap, Cambodia, 2006.*

BOTTOM RIGHT: *De-gumming the silk by removing the sericin with an alkali solution. Weave workshop on Inle Lake, Myanmar.*

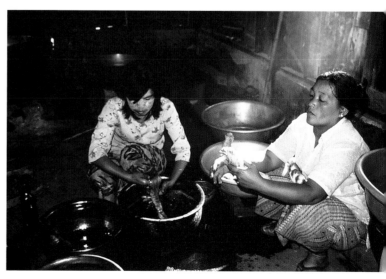

and passed through a hole or metal ring in a framework above the pot, then wound on to a reel while the cocoons bob in the hot water and gradually unwind. The silk is allowed to lap into a bowl of sand that stops it from sticking together before being wound into skeins. In some areas the silk is reeled over a hand-turned wheel which imparts a slight twist, referred to as 'throwing', before being wound on to a swift to form skeins. The outer filament layer of the cocoon is coarser than the inside layers, and the two qualities are reeled separately, or later joined together to make a stronger thread for weaving warps. Alternatively, the coarser thread is cut into short lengths, carded, and spun in the normal manner for cotton spinning.

The *Bombyx mori* cocoons are yellow in colour, and the sticky sericin makes the threads harsh and stiff. The sericin is removed by first immersing the skeins in an alkaline solution of strong lye, then rinsing and heating in boiling water. They are rinsed again and hung out to dry. In the past, vegetable dyes were used which give a certain gleam to the silk that cannot be achieved with synthetic dyes. If a pure colour is required, the silk is bleached first, as over-dyeing of the pale yellow silk will give altered colours. These skeins of yellow silk were used to decorate the branches of a tree in a thanksgiving ceremony in North-East Thailand, while at the same time, offerings were taken to the temple in gratitude for a good season.

Vegetable and Bast Fibres

Plant and Leaf Fibres

The lush vegetation of a tropical climate is put to practical use in most of the countries of South-East Asia. Leaves can form the covering for roofs, can substitute for cooking pots, or be fashioned into plates and bowls; they can be layered and formed into a cape to provide protection from the rain. They are used as bedding, are divided and woven into mats and panels for house walls, or can become sails for canoes or small boats. Leaves are twisted as ropes and cords, woven into sandals, plaited into baskets. In Malaysian Sarawak, lemba palm leaves are cut into strips to make the binding threads for tying the thread bundles in ikat resist dyeing. The sago leaf is also used in Sarawak for mat making, but has to be folded in half to give it more strength. The fibres of the lontar palm are combined with cotton by the Tanimbar weavers.

There are many uses for these large leaves, and the calabash-shaped palm spathe, removed in its entirety, makes an excellent food dish or container for dye-stuff. One important use of leaf fibre is in the making of hats. Latania leaves from a type of fan palm are used to cover the cone-shaped hat known in Vietnam as the *Non Lá*. Other hats are woven from rice straw and grasses, or whichever plant is in abundance in any particular area.

Pineapple Cloth

Fibres from the leaves of *Agave pinnata* were used in the Philippines and Malaysia, as well as by the Iban tribes of Borneo, to make sewing thread before commercial cotton thread became available. The fibres are 'retted' by soaking the leaves in water to enable the outer skin and pulp to be removed. Both Filipinos and the Kayan of Borneo wove these fibres into fabric, and a mixture of pineapple threads and cotton was used to make raincapes for the aristocracy in Sulawesi. A very fine white fabric known as *Piña* cloth is woven from pineapple fibre in the Philippines, forming a material used for decorative work by the Catholic nuns, as well as for Chinese-style embroidery worked in white threads.

Agave and Bamboo

The spear-shaped leaves of *Agave sisilana* and many types of bamboo plants are treated by retting and soaking in a similar way. Bamboo fibre is soft and slightly lustrous, but has a short staple length. The pulped fibres of several bamboo species, particularly *Bambusa arundinacea* and *Dendrocalamus strictus*, are used to make fine quality paper.

Abaca

Fibres from the leaf stalks of *Musa textilis*, native to the Philippines, are normally used for cordage, and although known as manila or cebu hemp, abaca is closely related to the banana plant and is not a true hemp. In 1925 the Dutch set up plantations in Sumatra, and later abaca was introduced to North Borneo. The pulpy material is scraped from the stalks by hand or machine in order to free the long fibre strands, which are sun dried. The lustrous inner fibres can be used without spinning to manufacture lightweight, strong fabrics, used locally for garments, hats and shoes. Colours depend on plant variety and stalk position, ranging from white through brown, red, purple or black.

Ramie

Ramie (*Boehmeria nivea*) is a stalked perennial belonging to the nettle family, growing up to 2.4m (8ft) tall. It is native to China, and has been cultivated in eastern Asia since pre-historic times. Another source found in Malaysia is the variety *tenacissima*, generally known as 'rhea'. The stems of the shrub are cut by hand, and the outer layers peeled off to form strips; these have to be soaked in water in order to separate the bark and allow the adhering fibres, which are covered with a resinous gum, to be scraped away. Before the plant dries out, the fibres are beaten or put through rollers to make them more pliable. This is a labour-intensive process and today, caustic soda is used to soften the fibres.

These white bast fibres, which are stronger than flax or cotton, can be spun and woven to form a lustrous fabric that does not deform or shrink, and improves with washing. It has the advantage in a tropical climate of being resistant to micro-organisms and mildew, but it is difficult to spin, the fibres being both brittle and slightly hairy. A strong and durable fabric, known as 'China grass', was woven and exported to the West from the early eighteenth century onwards. Ramie is cultivated in the Philippines as well as in Japan and Taiwan, and the fibre is used for sewing thread, fishing nets, household fabrics and filter cloths.

Lotus Flower Thread from Inle Lake

This lake is the second largest in central Myanmar, and famous for the villages that are built on wooden piles in the middle of the lake. It is said that the original lake dwellers came to find new land, but none was free, so they were forced to set up communities actually on the lake itself. The lake is only about 3m (10ft) deep, and floating gardens of reeds and water weeds are anchored to the lake bed to support vegetables and produce of all kinds. They are tended by boat people who propel slender boats while standing up, using a single leg-oar.

The lake supports large beds of water hyacinths, the flowers bobbing in unison on the water surface in the wake of passing boats. Even more important are the lotus flowers, for these provide a special type of thread, made from the sap found in the long stems that reach down to the bottom of the lake bed. It is not known how anyone discovered that a viable thread could be made out of sap. The stalks of the Badonmar lotus (*nelumbium speciosum*) are gathered from the water during the months of May, June and July, when they are at their best. Several species of lotus grow within the lake, but only the Badonmar lotus is suitable for lotus cloth.

A week before cutting, nine offerings of food are made to the spirits of the lake to ensure a good harvest the following season. The tender stalks must be used within the next twenty-four hours, before they become dried out. They are first cut into two lengths, and 10cm (4in) sections are marked with a knife. The thread maker sits on the floor with a table or piece of board in front of her, and breaks off the marked stalk section, deftly drawing the two pieces apart to produce a length of sap which she lays on the board. This is then rolled backwards and forwards with wet fingers, rather like a child rolling play-dough into a thin length. Several of these lengths are formed and then joined together by wetting and rolling, until a viable length of thread is made. The ultimate colour is a pale ivory and the thread is somewhat uneven, varying in thickness with slubs.

The stages in lotus thread cloth production:

FRONT LEFT: *The broken stems of the Badonmar lotus that grows in Inle Lake.*

RIGHT AND CENTRE: *The extruded sap rolled into thread.*

BACKGROUND: *Woven lotus thread fabric with plied fringe ends.*

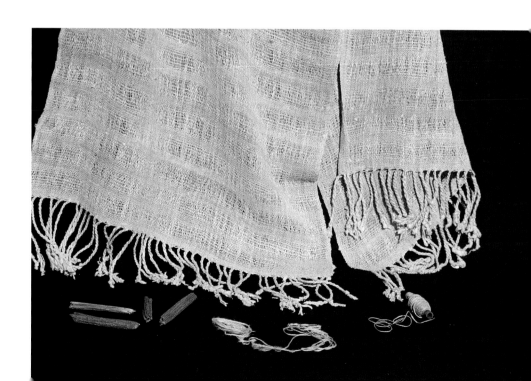

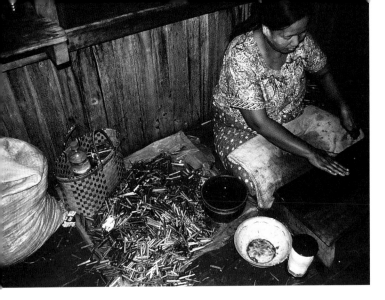

ABOVE: *A woman in the Inle Lake workshop rolls the sap into thread. Used stem pieces are abandoned in a pile on the left. A pot of water helps keep the thread damp.*

BELOW: *The stem pieces being drawn apart to extrude the sap before rolling into thread. Inle Lake, Myanmar.*

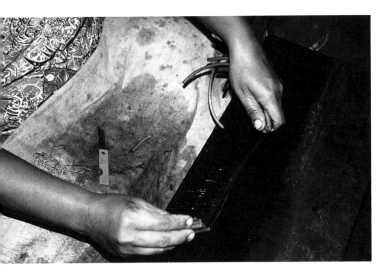

The thread is wound into skeins and dried in the sunshine. Next it is wound on to spools, and then five full spools are combined on a spinning wheel. The thread is stiffened with a 'glue' or a rice paste to make a stronger thread ready to be woven on a floor loom. When taken off the loom, the material is washed to reveal a soft fabric with a strange luminance that is difficult to define. It is left in its natural state, or dyed with vegetable dyes.

The cloths are made in Kyaint Khant village, and their production is so labour intensive that the fabric is always expensive. In the past it was reserved for royal and priestly robes and regalia. It took a month to make a single robe, using about 220 thousand lotus stalks, as the weavers needed to produce about 10m (10yd) to complete the outfit. These robes have a special connection with Buddhist beliefs, and are linked to the five buds of the lotus brought by the Brahmas to the place where holy persons lived. The

weavers must be virgins or women of virtue, and to protect the loom, it is surrounded with a split-bamboo fence containing royal diamond shapes, with banana and sugar-cane tied on at intervals. The resulting sweet-scented lotus robes are offered to images of the Buddha or to eminent monks for religious services rendered.

Kapok

The tropical kapok tree is not native to Asia, but was brought originally from the New World via Africa; it was cultivated commercially for the flossy fibre that comes from the large seed pods that hang down from this gigantic tree, which can reach a height of up to 50m (164ft). The Javanese kapok tree (*Ceiba pentandra*) takes its name from the Carib word for a dugout canoe which resembles the shape of the seed pod. The kapok flowers do not bloom every year, but when they do, they are extremely prolific. They are pollinated by bats, which feed on the pink-white blooms at night. Known also as Java cotton, the ripe pods are cut down or gathered where they fall, and are then broken open with mallets.

The fibres vary in length from 2 to 2.5cm ($^3/_4$–1in) and are resistant to moisture, being quick-drying and buoyant in water. These lustrous fibres, which contain both wood lignin and cellulose, are too brittle to spin, but weigh far less than cotton. Anything up to 200 seeds are dispersed within the fibre of each pod. These are separated from the fluff by hand-stirring the pod contents in a basket, which allows the seeds to fall to the bottom, thus freeing the yellowish-brown fibres. Although kapok is cultivated throughout South-East Asia, it is an important commercial product in Indonesia, especially in Java. Its main use is for stuffing mattresses and pillows and for padding. It is used in surgery in place of cotton wool, and being buoyant, in life jackets and water-safety equipment. Oil from the seeds is used to make soap, and the dross makes excellent cattle feed – nothing is wasted.

Rattan

Rattan or *rotan*, belonging to the palm family, is also known as 'malacca cane'. It is one of a variety of woody climbing plants with tough, pliant stems that can easily be bent and formed when supple, but hold their shape when dried out. The rattan vine grows in lush jungle forests and was exported from many parts of Indonesia and the islands. It is cut into lengths and stripped of the outer thorny skin to reveal the smooth cane inside. This is split into several divisions, depending on the thickness of the

A kapok tree in the bead-weave village on the Boleven Plateau, central Laos, showing the long fruit pods.

family (*Arecaceae*). The nuts are impervious to sea water and survive long journeys on ocean currents, thus spreading throughout the tropical islands. They flourish with plenty of rainfall, and have been propagated for many centuries. The kernel produces oil, the edible flesh is mixed with water to make coconut milk, and a refreshing drink is found inside green nuts. Commercially, the fibre of the husk, called coir, is of prime importance. The Philippines and Indonesia are the leaders in copra production, and it is used to make ropes, mats, brushes and brooms. Simple hats were made from the coconut fibre, secured with bands of split bamboo, and although coir fibre still forms a substantial export business, its uses in Indonesian culture are countless.

Bark Cloth

Bark cloth is felted, not woven. It is made from strips of bark from several tree varieties, and only the fibrous inner layer of the bark is used. The paper mulberry tree (*Brousonnetia papyifera*) was originally found in eastern Asia. Its use spread to Myanmar and Thailand and eventually southwards into Malaysia and Indonesia. Bark from the breadfruit tree (*Artocarpus elasticus*) is used by the forest people of the Malay peninsula, while in Borneo another breadfruit variety (*Artocarpus tamaran*) is found. Bark from several types of native *Fiscus* tree, used in Polynesia, was highly valued and believed to be a gift from the Gods.

The whole bark, comprising inner and outer layers, is stripped from the tree and then softened by soaking in water for several days. This enables the outer bark to be scraped away from the inner bark, which is then wrapped in plantain leaves to allow fermentation to take place. The fermented fibre is placed on to a hardwood plank which provides a surface for beating. A four-sided wooden mallet is used by the women to beat the fibres until they spread out and cohere together. A grid of grooves is incised into the mallet sides, increasing in number and fineness on each side. The grooved sides are used in sequence, the large-scale side first and the finest side to finish off the cloth. There are different qualities of bark cloth, depending on the type of tree bark available and the amount of beating used. Well beaten cloths can be as fine as cotton muslin, used for prestigious clothing. In Java a thicker cloth is produced to make sleeping mats and wall hangings, in some instances by pasting layers of the bark cloth together.

The cloth can be bleached and then painted or dyed, using vegetable dyes obtained from jungle plants or juices from the Fiscus tree, to give variations of red, black, yellow and brown. In central Borneo, the women decorated their bark-cloth skirts with elaborate stencilled patterns, sometimes combined with printed commercial cotton borders.

vine. The smooth cane skin is used shiny side outwards for fine work, and strips are cut to an even width by drawing through two equidistant knife blades. The strips are used for making mats, which are woven diagonally corner-wise, and they are essential for baskets of all kinds, including ones for transporting the unhusked rice. Bemban reeds provide an alternative material, softer than rattan, so more suitable for sleeping mats.

The women of tribes in the northern Shan state of Myanmar wear a series of rattan rings around the hips placed over the tube skirt, rather like a set of hula hoops; while the Palay women of the Silver Palaung tribe decorate their rings by binding threads around in alternating colours. This custom is not confined to mainland South-East Asia, for girls of the Sarawak tribes wore rings around the upper body, rather like a corset formed of different diameter circles. These are not constricting, but stand away from the body at the top, unlike the Iban Dyak women who wear tight rings both above and below the waist, exposing the breasts. Rattan was also used to make the framework for many of the elaborate headdresses worn throughout the region of South-East Asia.

Coconut Fibre

The coconut tree (*Cocos nucifera*) belongs to the palm

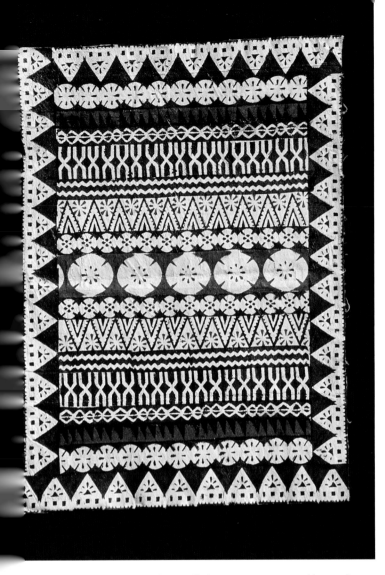

ABOVE: *Bark cloth with stencilled patterns using vegetable root dyes, Polynesia, 1989.*

BELOW: *Dyed silk hanks displayed on woven silk fabrics, Van Phuc workshop, Hué, Vietnam, 2006.*

In the past, the inhabitants of Sarawak relied on bark cloth for clothing rather than weaving, and although less used today, revived the craft when fabric was unobtainable during the Japanese occupation in World War II.

Dyes and Dyeing

Natural Dye Substances

The use of colour forms an important part of the desire for expression in many societies, whether in art, the colouring of cloth or even in body painting. Certain colours, which are difficult to obtain, have always been reserved for royalty or the aristocracy, for instance the Tyrian purple from the mollusc shells of the Mediterranean, or deep reds and intense saffron yellows. In Cambodia certain colours, with origins in the Hindu religion, were worn on different days of the week in respect of the deity of the day. In the museum of the Royal Palace, Phnom Penh, a display of court costume features *chwang kbun*-style silk hip wrappers in the following various colours: Sunday – red, Monday – orange, Tuesday – violet, Wednesday – green with a red sheen, Thursday – light green, Friday – blue, Saturday – plum red. It is essential to wear the correct colour when celebrating the Buddhist New Year, as well as at weddings and other ceremonies. The Chinese dynasties were associated with different colours, and cloth dyed with red madder has been found in tombs in ancient China as well as blue from indigo and yellow from gardenia flowers.

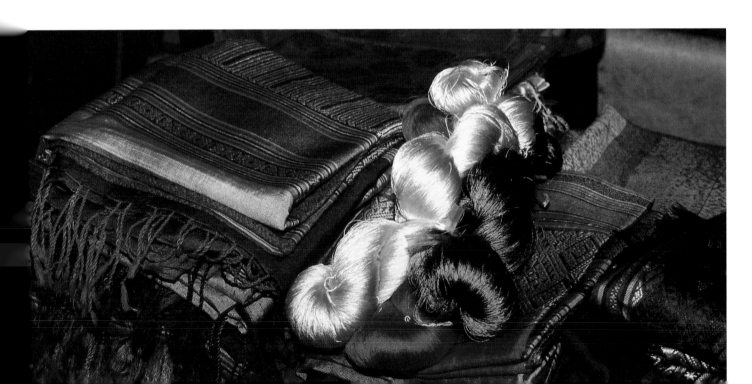

Saffron-robed monks framed in the second inner gateway of the ruins of Angkor Wat, Cambodia.

Plant Dyes

Over many thousands of years skilled fabric dyers experimented with the plants that grew in their surrounding areas. Some produced better results than others, and the knowledge was handed down through the generations. Successful dye stuffs were traded throughout the whole of South-East Asia, and even imported from as far away as India and beyond.

Safflower (*Carthamus tinctorius*) flowers annually with red, orange, yellow, or white petals. It was known to the ancient civilizations of Asia and North Africa, and spread from India into Indonesia, to become an important dye plant. Safflower was cultivated in Bali, Sulawesi and Sumbawa, from where it was exported to Java. The petals are crushed into cold water, and after kneading, the coloured water is drained off and the process repeated until a small residue of red dye remains. Lime, derived from limestone or coral, is used to reverse the acidity of the dye-stuff. The red dye, known as 'carthamin', has been replaced by synthetic aniline dyes, but is still used in parts of South-West Asia.

The purple-flowered saffron crocus (*Crocus sativus*) is a perennial of the iris (*Iridaceae*) family. It is native to Asia Minor and spread into Europe, but was also cultivated in Kashmir and introduced to China during the sixteenth century. Both dye-stuff and food colouring is produced from the three golden-coloured stigmas found on a single flower. These are hand picked and then spread on to trays, and dried over charcoal fires; it takes the stigmas from 75,000 flowers to make 0.45kg (1lb) of saffron. The stamens, which at times were worth more than their weight in gold, were distilled to make a golden-coloured, water-soluble fabric dye; this was reserved for royal robes, and became the official colour for priestly garments soon after the Buddha died.

Root Dyes

One of the most important vegetable dyes is obtained from the roots of the madder plant, also called dyer's madder, which belongs to the madder family *Rubiaceae*. There are over forty species, with *R. cordifolia* native to Java and to the uplands of India. According to *Britannica*:

> The common madder (*R. tinctorum* and *R. cordifolia*) was formerly cultivated for a red dye, alizarin, that was obtained from the ground-up roots of these plants. This dye was used for cloth and could be prepared and applied in such a way as to yield pink and purple shades as well as red.

In southern India, a red dye was extracted from the roots of the chay plant (*Oldenlandia umbellata*), which thrived on lime soils. The resulting alizarin product (*Morinda citrifolia*) known as *ail*, was considered superior to madder.

Dye colour takes easily to animal fibres such as wool, but it is more complicated to dye cotton and vegetable fibres. Wool dyeing requires a simple mordant such as alum, which helps the dye to 'bite' into the fabric, to become part of it; without the mordant, the dye would not be fast to washing or to light. Cotton was subjected to various stages including immersion in rancid olive oil, or castor oil, which together with a mordant, eventually produced the dyed fabric known as 'turkey red'. This method is thought to have originated in eastern India, several thousand years ago.

The fugitive yellow dyes are difficult to fix on to fabric, even with the use of mordants. The turmeric plant (*Curcuma domestica*), a member of the ginger family, has tuberous rhizomes, or underground stems used both as a spice and a yellow textile dye. It is native to southern India and Indonesia. The roots are sliced up and boiled in water together with slaked lime, and the yarns or fabric are immersed into the cooled water, or the dye-stuff can be painted on to silk.

Tree and Bark Dyes

In Indonesia and the islands, chips of wood from a prickly shrub (*Cudranta javenesis*) are combined with a mordant to produce a yellow dye used in Javanese batik. 'Soga' brown, a dye obtained from the bark of the soga tree (*Peltophorum ferrugineum*) is the other colour associated with Javanese batik textiles. Processed teak tree leaves, grown in the eastern islands of the archipelago, develop a reddish-brown colour. Sappanwood (*Caesalpinia sappan*), normally used as a source of tannin, provides a russet red, or vermilion with added alum mordant. When combined with tin, bright pink and purple colours are available, while an iron mordant applied after dyeing produces lilac. Bark from the forest mango tree (*Mangifera caloneura*) is used to make a pale cream colour, and the heartwood from the jackfruit tree (*Artocarpus heterophyllus*) a brighter, golden yellow.

In eastern Sumba, the inner root bark of the kombu tree (*Morinda citrifolia*) is pounded in a wooden mortar; the women then squeeze handfuls of the pounded chips in a bowl of water to release the red dye. This process is repeated six times until a dark liquid is produced. Ground-up bark from the loba, or candlenut tree (*Aleuritas molucana*), is added to the dyebath as a mordant, and the red tones are dependent on the amount used. These colours are used to dye the warp-ikat hangings for which the villagers are renowned. Women from the island of Savu treat the yarn with oil before dyeing it with morinda roots. Ashes from various plants and luba tree leaves and twigs are added to the dyebath to assist the cotton to 'take' the dye.

Insect Dyes

Cochineal

Although the dye-stuff named 'cochineal' is indigenous to areas of Central and South America, it was exported as a high-earning product by the Spanish to Europe from the early 1500s. Eventually their monopoly was broken, and the actual host cactus plants (*Napalea*) were cultivated by the British in India, by the Spanish in the Philippines and the Dutch in Java, where the main areas of production were the south-western coast and Bantam Province. Much of the dye-stuff was exported to Holland and to China.

It is the female of the scale insect family *coccidae* that produces the dye-stuff. After fertilization by the males, the females swell to contain the eggs. But before these are laid, the insects are harvested from the cactus leaves, a

time-consuming process. After drying in the sun, or exposure to controlled heating, the insects die and are then ground up to produce the so-called 'scarlet grain', which is the basis of the dyestuff. In industry the strong carmine colour was heightened by the use of a tin solution combined with various acids.

Stick-Lac

Another red dye is produced from the gum secreted by the Indian scale insect – *Tarchardia* (*Lacifer*) *lacca*. The name 'lac' is said to be Cambodian in origin, while in Sanskrit it means many thousands, referring to the number of insects needed to produce the dye. Most of the host trees belong to the *Fiscus* family. The female lac insects feed on the young shoots, ingesting a form of resin that they secrete around themselves after fertilization by the males, covering the fig-tree branches with a thick coating of red shellac-type resin which hardens around them to make a nest for their eggs. The resin-covered branches are harvested before the larvae hatch, and are broken into smaller pieces, which are sun-dried to kill off the insects. The stalks are pounded and the woody bits removed, and the resin flakes are then crushed to a powder and soaked overnight in water. The liquid is sieved through a cloth to leave the dye-stuff, which can be used at once, or dried to form dye cakes. The dye liquor takes readily to silk, but cotton requires both the addition of acid and tannin, provided from leaf extracts added in careful proportions.

Indigo Vat Dyes

Indigo dyes have been used throughout South-East Asia for several thousand years. Indigo is a substance derived from various plants and shrubs of the genus *Indigofera* and *Isatis* within the pea family (*Fabaceae*). The shrubs have somewhat hairy leaves, divided into smaller leaflets. Some species, including *I. sumatrana*, were common to Indonesia and used for batik and ikat dyeing. Indigo works in a different way from other dye substances, in that it does not penetrate the surface of the fabric, but builds up as a series of layers which if treated roughly, can be subject to abrasion. Indigo has to be combined with alkaline salts in a vat where the oxygen is extracted by bacteria.

Preparation methods vary, but the fresh leaves are gathered and soaked in water for up to two days. When they are removed, slaked lime is added and the water is beaten into a froth, producing oxygen in the vat. After a period of beating, the solution changes colour and starts to form a precipitate, referred to as *indoxyl* or 'white indigo'. The blue dye

A woman dye expert of the indigo village of Ban Dan in North-East Thailand, pouring indigo solution into a pot.

pigment is insoluble in water, at which stage it is called *indican* and settles to the bottom of the vat. The water is poured off, and the precipitate can be used for the dyeing stage, or dried into cakes for future use. The white indigo is combined with lye in the form of ash from various sources, including kapok tree wood or coconut husks, to remove the oxygen, after which the dyebath can be used. The colour does not 'take' until the fabric is exposed to the air, and repeated dippings are needed to obtain deeper shades of blue.

Some tribes simplify the process by placing water and pounded leaves into an earthenware pot and leaving the mixture to ferment for a week. The liquid is stirred several times, releasing a pungent smell. When it is considered ready, impurities are removed and thread hanks inserted into the dyebath. These are kneaded to absorb the dye, removed to oxidize in sunlight during the day, then returned to the pot at night. The process is repeated until the desired depth of colour is obtained. Roti bark, containing tannic acid, gives a darker colour. Sometimes lime in the form of ground-up coral or sea shells is added, but if no mordant is used, the colour is not stable. In the islands of Flores, the fresh sea coral is stacked into layers with firewood and burned in ceremonial bonfires on the beach. Incantations by the shamans, to protect from evil spirits, ensured a good result. Indigo dyeing is always regarded as having magical properties, and only certain people are allowed to be in charge of the process.

Synthetic Dyes

Chemical dyes – basically natural dyes with the addition of tin to produce bright pinks and purples – were traded by the Chinese early in the nineteenth century. The accidental discovery by William Perkin in 1856 of 'mauvine' led to the introduction of the first petroleum-based aniline dyes. Originally, William Perkin was trying to find a substitute for quinine, which came from the bark of the Peruvian cinchona tree – very expensive and always in short supply. Quinine was used as a treatment for malaria, the mosquito-borne disease that was one of the greatest hindrances to colonization in tropical areas.

Although a few synthetic dyes had been discovered in Europe before the 1850s, none had been developed commercially, being regarded as interesting, but of little practical use. Nevertheless, William Perkin was so impressed by the deep 'Tyrian purple', which was dye-fast and impervious to sunlight, that he left his secure job in research for one in commercial industry. When the Empress Eugenie of France took to wearing the new colour, the fashion for 'mauve' was established.

The red dye alizarin, originally obtained from the madder plant root, was synthesized from *anthraquinone* in 1868 and produced commercially in 1871. The result was that alizarin took over from the vegetable dyes used previously, and the price of madder, imported from central and western Asia, fell dramatically. At the same time, these synthetic dyes were introduced to countries ruled over by the European colonists and in many instances, superseded the natural dyes that had been used for countless generations. They were a status symbol in that they were traded from afar, and thus highly prized by the weavers in rural areas.

A resist-patterned, indigo-dyed cloth is hung out to dry in a Hmong village in North-West Thailand.

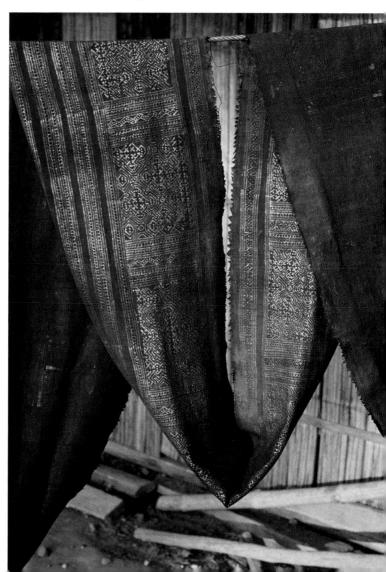

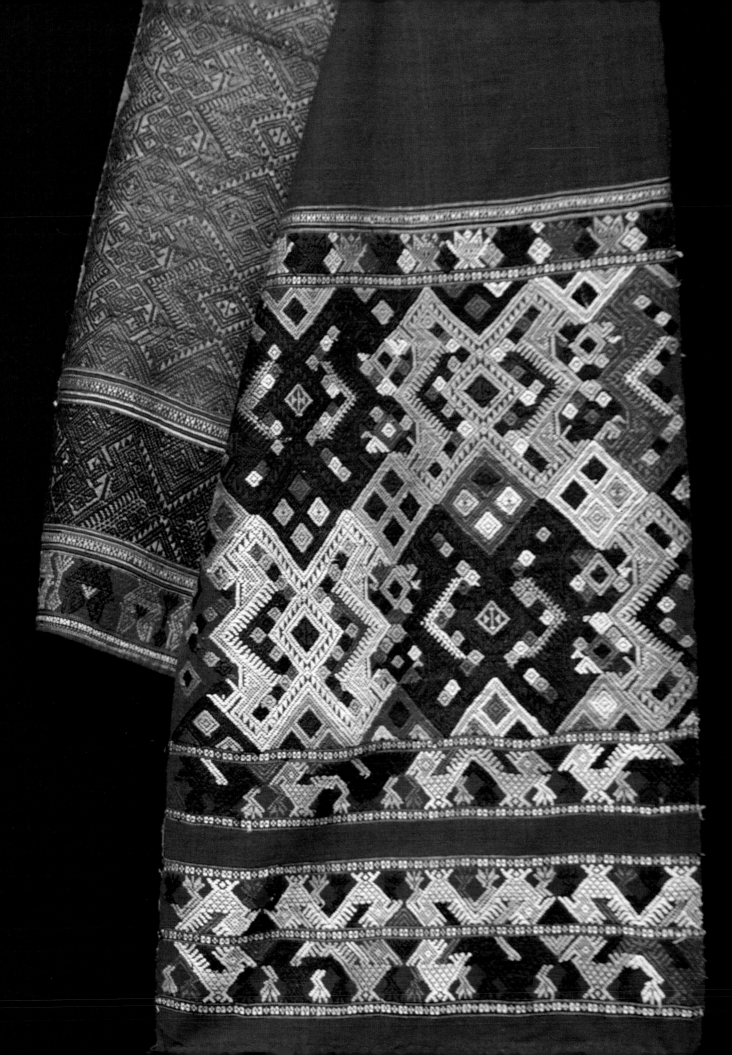

Weaving and Loom Types

Weaving

The art of weaving has always been revered throughout the area, for the woven cloth was both a status symbol and a form of currency. Many of the weaving processes are so labour intensive and require such a high level of expertise, that it is no wonder that superior fabrics are reserved for high-ranking and royal personages, for priestly robes and offerings to the Buddha. Many woven pieces are used in temple or religious ceremonies, and the intrinsic symbolism which forms part of the weaving structure, gives the cloths a value that cannot be quantified in the normal manner.

Young girls started to weave at about the age of seven, but they would have imbibed the weaving processes by watching their mothers, even from babyhood, for often the cradle was set up to hang beside the loom where the weaver could pull a cord to rock the baby at intervals. Others shared the rhythms of the loom and the spinning wheel through the body of the mother, when tied to her back in a baby-carrier. By the time the girl started to weave cloths for her wedding dowry, she would already be expert in the chosen techniques, knowing full well that her future status as a bride would depend on the quality of the finished fabrics.

On the Indonesian island of Savu, weaving was an essential part of traditional life, and a special ceremony marked a woman's first introduction to weaving. The woven textiles were used for the special rituals marking the passage of

OPPOSITE PAGE:
An antique Tai Kao ceremonial temple shawl or shoulder cloth from northern Laos is worked with supplementary weft patterning.

life, starting when a three-year old child received a first loincloth or tube skirt, then carrying on through to puberty, marriage, and eventually, the funeral. The Savu weavers are renowned for their ikat-dyed and woven striped textiles, worked on simple backstrap looms. Anthropologist Geneviève Duggan, who first discovered Savu islanders on a cruise tour, has since made a number of visits to the island to study and record their rituals, customs and textile techniques. Weaving and dyeing could only be carried out at certain times of the year, with work restricted to designated areas or the confines of the family meeting house. There are two groups of weavers on Savu, the Greater and the Lesser Blossom Groups, distinguished by the number of stripes on their tube skirts. Legend tells us that two sisters quarrelled as to who was the better weaver, and the different group members were not allowed to intermarry or wear the same patterned garments.

Although the former royal courts throughout South-East Asia set up their own weaving workshops in order to supply their needs, weaving was regarded as a suitable occupation for the Siamese princesses and concubines who excelled in the art. However, at a middle-class level during the twentieth century it was considered demeaning for the wife of a professional to weave commercially. In Chiang Mai, North-West Thailand, Mrs Saeng-da Bansiddhi was married to a doctor. Born in 1919, she had been taught weaving and dyeing by her grandmother and wove only for the family, including the uniform for her husband during World War II. But after the war she set up a cotton-weave factory – Bai Pai Ngarm – as a charitable enterprise, gathering the local village women to form a housewife union. Her idea was to conserve traditional methods and increase employment. Native cotton plants were grown, and all vegetable dyes, including indigo, were used. Mrs Bansiddhi gained a reputation for her artistry in the mixing of dyed

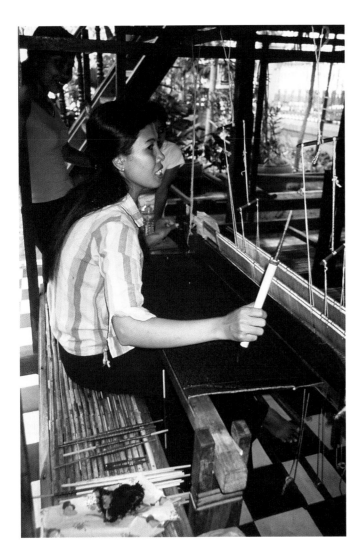

A young girl weaves ikat-patterned cloth in the grounds of the Royal Palace, Phnom Penh, Cambodia. The pirns of coloured thread lie in order on the bench, and one is inserted into the cylindrical shuttle, ready for use.

thread colours within the cloth, and she was declared a 'National Folk Artist'.

Today, weaving still flourishes in the countries of South-East Asia, with many villages keeping up their tribal traditions; but at the same time, an increasing emphasis is being placed on weaving as a way of earning a living. The weavers not only make cloth to sell locally, or in the markets, but have commissions from agents for re-sale in the local towns and tourist shops. Commercial workshops, as distinct from village communities, are set up by private enterprise and by government departments. Charitable institutions – often based in Europe – organize village weavers and provide fair-trade outlets for the work, both locally and abroad.

The Basic Methods of Weaving

A woven cloth is formed by the interlacing of threads set at

right angles to one another. The longitudinal threads are always referred to as the 'warp' and the lateral crossways threads are the 'weft'. When a length of thread is wound backwards and forwards around a wooden frame and kept at tension, then a second thread can be darned in and out of these fixed threads at right angles to form a fabric. The darning on each row must go over and under the alternate threads not secured in the previous row. If the darning thread is continuous, then a viable fabric can be produced which, when taken off the frame, will not fall apart.

Different societies throughout the world have devised methods to facilitate the simple weaving techniques, especially when constructing pattern weaves. The darning method is only suitable for very small pieces of cloth, or those decorated with single strips of leather, fibre or bark. It was discovered that if the warp threads were wound on to the frame in a figure-of-eight formation, a 'cross' would be formed that divided the alternate threads into two separate sets. One set of threads could be secured by inserting lifting strings, or heddles to form the upper shed opening for the thread-wound shuttle to pass through. The lower thread set was kept open by inserting a wooden 'sword' into the alternative shed opening. The sword, which is longer than the warp width, can be anything from 5 to 10cm (2 to 4in) wide. It is turned on to its side when the shed is to be opened, and laid flat when the heddle threads are lifted. Extra shed sticks are inserted into the cross of the warp, either to add or release tension on a fixed warp, or to facilitate patterning.

A simple frame limits the cloth size, so the next problem to be solved was that of warp length. It was found that if the wound warp threads were slotted on to bars at either end, then the length could be extended, provided this simple 'loom' was kept at tension. Another solution was to make the warp circular, thus doubling the working length.

Throughout the ages, weavers have devised a variety of loom types, suited to their personal needs and using the natural materials available in their immediate environment. The basic requirements in loom construction are similar, whatever the country of origin, and it is interesting to compare the different ways in which practical problems have been solved.

Shuttles

To enable the weft thread to be passed through the open

This loom in southern Laos has long string heddles that are used to form the complicated supplementary weft patterns. A pair of boat shuttles, each with two pirns of coloured thread inside, lie on the already woven fabric. Mekong river area just north of the Thai border. Photo: Timothy Thompson

shed at one go, the thread is wound on to a notched length of wood, or bamboo, then unwound as the thread is used up. A more sophisticated wooden shuttle that can be thrown to glide easily through the warp shed opening is shaped like a boat. The thread is first wound on to a small bobbin or pirn that is slotted on to a little wooden or metal bar fitted inside the central hollow of the shuttle. The thread end is passed through a hole and unwinds as the shuttle is thrown across. The pirn is replaced when empty

or a change of colour is required. Some shuttles from Laos hold two pirns, giving a choice of a double thread, or threads of two different colours. In Cambodia a cylindrical metal shuttle, developed from a bamboo cane, holds a longer thread-wound bobbin which unwinds from the hollow end. A polished bamboo shuttle has a pointed metal cap at the front to give weight and so ease its passage across the warp threads.

Loom Types

The simplest loom has a woven band as the backstrap, or one with a fibre-plaited section that fits into the small of the back. In parts of Indonesia, a carved wooden shape fits the woman's back, held by cords that are slotted round a protrusion at either side, or are threaded through holes. These wooden shapes are often decorated with carving by the men and can form a present to a sweetheart. Whatever the type of strap, it is held by separate cords to the end bar of the loom, allowing it to be removed easily when the woman takes off the pressure.

Iban woman from Sarawak, Malaysia, weaving on a backstrap loom. She is wearing a corset, skirt and ornaments, 1895–1900. Photo: Charles Hose. By kind permission of Pitt Rivers Museum of Oxford. Accession No. 1998.170.21.3

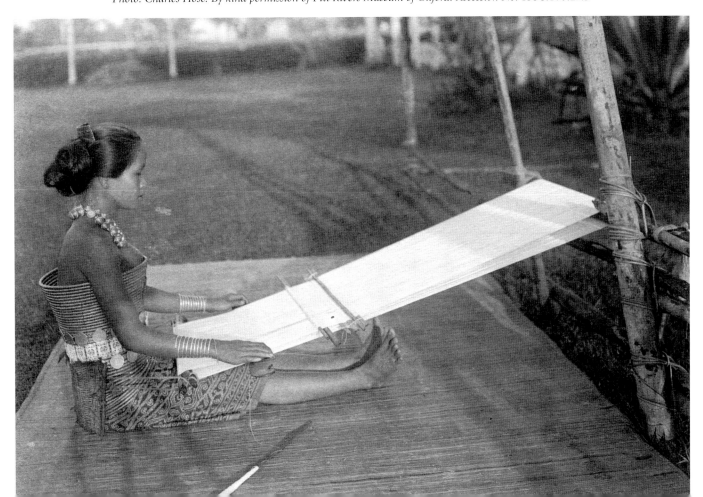

The woman sits at the loom in different ways: in several areas of South-East Asia, she sits on a floor-mat with both legs extended in front of her, and exerts pressure by pushing on a fixed bar with her feet. In areas as far apart as the highlands of the Boloven Plateau, Central Laos, the villages in Borneo or the islands of Sumba, the women sit this way and do not appear to tire of the position. The other position is for the weaver to squat kneeling on the floor with legs tucked underneath her. This allows more movement of the upper back.

In Myanmar and parts of South-West China, the backstrap loom is combined with a framework that holds two foot pedals, while the woman sits on a bench, not the floor. It is a hybrid between a simple and a more complicated loom, with the foot pedals allowing the warp threads to be raised and lowered, unlike the simple backstrap loom where it is necessary for the weaver to raise and lower them by hand. Whatever the type of backstrap loom, the weaver is limited to a cloth width that corresponds to her 'arm reach'. The length of cloth depends on how easily a circular warp can be managed, as it has to be moved around the two bars as work progresses. In the case of the foot-braced loom, the warp length is double that of the weaver's legs.

The Simple Backstrap Loom

In the weaving process, the warp threads have to be kept at tension, evenly spaced across the two bars around which the threads are looped. The 'backstrap', or 'hipstrap' loom is held at tension by the weaver's body at one end, and is tied to a fixed bar, log, post or tree at the other end, or is

A foot-braced backstrap loom from a village on the Boloven Plateau, central Laos. The weaver is lifting the string heddle bar in order to raise the warp threads and make a 'shed' opening through which to pass the weft thread. Photo: Timothy Thompson

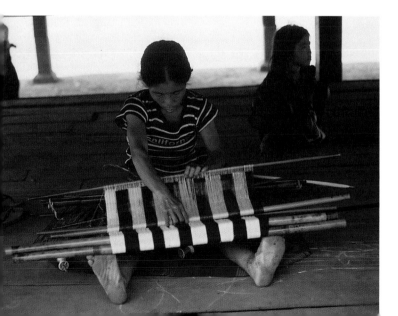

braced by the feet. These looms, although the same in principle, do vary in the different countries as to the methods used to secure the backstrap and the end bar. They all have in common the ability to be easily dismantled, rolled up and stored, or taken and set up in a different location. The foot-braced looms are believed to have originated in Yunnan Province, China, at the beginning of the first millennium, as examples are depicted on bronzes of the Western Han period.

Frame Looms

Experts disagree as to the exact dates that 'frame' looms were introduced into South-East Asia. Writers from periods before the nineteenth century may describe exotic woven cloths, but seldom mention the looms. In the National Silk Institute of Cambodia at Siem Reap, a simple frame loom made from lengths of bamboo is illustrated. The horizontal frame that holds the warp threads is much longer than any possible on a backstrap loom. An upright framework above the weaver supports the ground-weave shafts that hold the string heddles through which the individual warp threads are threaded. These shafts are lifted alternately, or in sequence, to give the 'shed' opening to enable the weft, or lateral weaving threads, to be passed through. In village looms, the heddle strings are slotted over rods at top and bottom with the upper rod tied to a pulley cord fixed to the loom framework above. Commercial heddles are made of wire, each having an integral eyelet through which the warp threads pass, and they are set into shaft-frames that are supported by the loom's harness.

Further developments in this simple Cambodian loom show how the bamboo gradually gave way to elaborately carved wooden side-pieces, together with the addition of a warp-board around which the surplus length of discontinuous warp threads was wound. This allowed the warp to be unwound at the far end when the weaver had completed part of the cloth and needed access to more warp. The woven part was then wound around the square-section 'breast-beam' slotted into the front framework. The horizontal warp-board was held on to the far 'end beam' with ties that could be undone, or was slotted at either side into openings cut into wooden guides. These guides were fixed with ties to the end beam and were often carved with decorative symbols of dragons. The pair of pulleys that allowed the heddle shafts to be raised and lowered by the use of foot peddles, were also carved, sometimes in the shape of confronting birds.

A Cambodian loom in the National Silk Institute measures about 5m (18ft) long, by about 1.25m (5ft) wide. The framework above the weaver is confined to one end, with the horizontal warp frame extending beyond. This type of

loom, known as the 'Western Loom' meaning 'Western South-East Asia', was also used in Malaysia and parts of central Sumatra and the Indonesian archipelago. The 'Malay' loom differs from the Cambodian in that the upper framework extends the length of the loom, which is slightly shorter than the Cambodian, and the warp-board is suspended above the loom in a vertical position. The Cambodian-style looms are still used in areas of North-East Thailand near to the former Cambodian border, a reminder of a mutual Khmer inheritance.

Frame looms in parts of Thailand, Laos, Myanmar and other northern countries of South-East Asia are of the more conventional, squat shape. Sometimes called a 'standing loom', the framework resembles the construction of a four-poster bed. We are lucky in that examples of these looms are depicted on the mural paintings of the Thai temples, where ladies of the court are shown at work. Once again, there are various methods of securing the ends of the discontinuous warp that allow it to be unwound when necessary. The warp length is either taken up and over the back framework of the loom and tied with a cord above the weaver's head with a slipknot, or the entire length is taken over the top, then down to the floor and looped over a bar. An alternative method is to wind the warp on to a cylindrical end beam that is held in a slot in the rear framework that allows it to be rotated and temporarily held by ratchets on wheel cogs set at either side.

All of these looms have foot pedals connected by cords to pulleys, which raise and lower the heddle shafts. Some looms have a 'comb' made from slivers of palm frond or cane, set into a narrow oblong frame the width of the loom, through which pairs of warp threads are threaded with a bamboo hook. This is held in front of the heddle shafts and helps separate the threads. At times it is combined with a wooden beater, the weight helping to batten down the woven threads. In Myanmar this heavy wooden

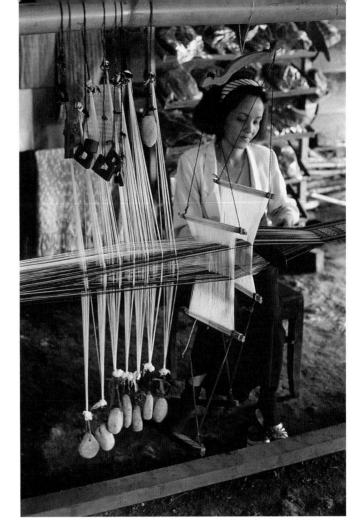

A girl from southern Vietnam weaves a patterned band on a sideways loom with seven string pattern heddles controlled by suspended stone weights. A foothill village in the Dali area, north of Saigon. Photo: Timothy Thompson

beater – which is often carved with incised decorative patterns – is suspended from the upper framework of the loom to give a swinging motion. Commercial reed combs are made with narrow metal teeth set into a frame and are now in general use.

The Side-Operated Loom

These small-scale looms are used in Cambodia, Vietnam and parts of Indonesia to weave narrow bands or belts and sashes, using warp-faced patterns. A miniature loom is chosen to add a decorative sideways band to an already woven skirt in the island of Sumba. The size varies from a small loom that can be set up on a table, to one where two posts support a bamboo pole placed above the weaver's head, parallel to the warp. The weaver sits to one side of the loom, with two foot pedals placed below at a 90-degree angle to the warp threads. Several pattern heddles can be included, as well as the usual pair of string heddle shafts

This nineteenth-century mural painting from Wat Phumin in northern Thailand, shows a traditional frame loom with the warp taken over the back of the loom and secured at the loom top front. A lady from the royal court is weaving with four shafts attached to foot pedals.

that are used to lift the alternating ground fabric sheds, all secured to the pole above.

A side-operated loom used in the Dali area several hundred miles north of Saigon, southern Vietnam, has seven sets of string heddles to control the warp-faced pattern. Each heddle group is about one metre (yard) deep, with the weft threads passing through loops in the middle. The string groups are gathered together at top and bottom and tied into knots at either end. These knots are threaded through large stone weights to hang free at the bottom, and through smaller metal weights at the top, looped by cords over the horizontal bamboo pole. Two foot treadles are connected to the main shafts which are tied to the top pole. The pattern heddles are raised by the weaver pulling on the top weights which act as a counter-balance, thus drawing up the groups of selected threads from the striped warp.

Horizontal Looms

In its simplest form, the horizontal loom has the breast beam at the front end and the warp beam at the other end, held apart with stakes hammered in the ground, or strung on to heavy stones. A string heddle is normally used to lift the warp threads. As weaving progresses, the finished cloth is wound around the front beam by repositioning the stakes that hold the back beam. The horizontal floor loom is a version of the upright rug loom, but laid out flat. There is a separate 'rigid heddle' frame which is lifted by the weaver who sits on the actual completed portion of weaving. This is the way that tribal pile and flat-weave rugs are woven in Turkey, Iran and neighbouring countries. The loom is easy to disassemble and therefore popular with nomadic weavers.

A rigid heddle is formed from a narrow oblong wooden framework that has bamboo or wooden segments inserted equally across the length. Each of these segments has a hole bored into the middle, through which one set of warp ends are threaded. The alternate ends are passed through the slots between the segments. This means that when the heddle is lifted, the threaded holes rise, raising the upper warp threads. When the heddle is depressed, the threaded holes are lowered, passing below the slotted threads, thus forming the alternate shed.

Flying Shuttle Looms

In normal weaving, the worker passes the weft thread, which is wound on to a variety of shuttle shapes, through the shed opening in one go. The frame looms allowed a broader width of cloth to be woven, but very wide fabrics

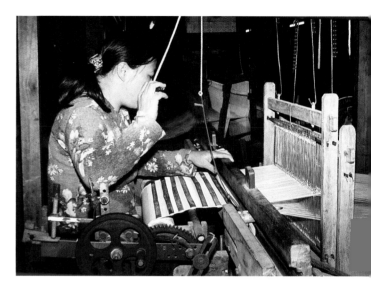

The flying-shuttle loom is used in commercial workshops. The weaver is pulling the cord to flick the shuttle through the warp threads, saving time and effort for plain or striped fabrics. Van Phuc workshop, Hué, Vietnam.

needed two weavers to pass and exchange the shuttle in the middle. This requires considerable skill, and eventually a hand-operated 'flying shuttle' was invented by an Englishman, John Kay, and patented in 1733.

The thread-loaded shuttle sits in a box at the side of the open warp, ready to be propelled across by a lever activated by a central hand pulley. The shuttle reaches the box at the other side and is returned by jerking the hand pulley, allowing the weft thread to be passed across the opposite way. This speedy type of weaving is not suitable for hand-inserted thread inlay patterns.

These looms are used today in commercial weave workshops in areas of Vietnam and Cambodia where they were first introduced by the Chinese. They are used to produce cotton fabrics, including the check fabric used for the Cambodian *kramer* scarves worn as turbans and shawls.

Draw Looms

The draw loom, which has a set of cords fixed above the loom to lift groups of pattern threads, was probably introduced by the Chinese who were past masters of the art of damask silk weaving, where the light and shade formed by differently facing threads creates a subtle pattern. Silk brocades with inlaid coloured threads were also woven on similar looms, some of which required up to 100 pattern changes. The loom had the conventional foot pedals for lifting alternate sheds to form the ground fabric. Cords

attached to the selected pattern warp threads had to be activated by hand, and the weaver employed a little boy assistant to sit on top of the loom and lift the correct group of cords in turn. These cords were grouped on to an upright framework, and the accuracy of the patterning depended on the ability – and wakefulness – of the drawboy. Several attempts were made to mechanize the process, and in 1725, Basile Bouchon invented a mechanical 'drawboy' to select the pattern cords. This took the form of a perforated roll of paper passed around a cylinder, which activated needles that were pushed in or out to control the warp pattern cords. This was the foundation of the successful Jacquard mechanism.

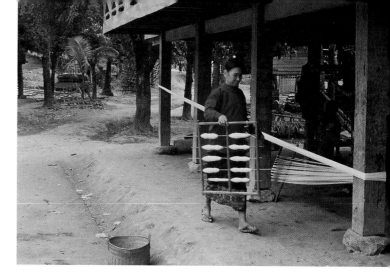

A silk weaver in Ban Tai Dam, a village on route 13, Laos, uses the house posts as supports to wind her warp ready to set on to the loom.

Commercial Jacquard and Dobby Looms

The Jacquard loom was invented in France by Joseph-Marie Jacquard in 1804–05, and improved during the early years of the century. The 'Jacquard mechanism' is a device incorporated in special looms to control individual warp threads by the use of interchangeable punched cards, so that any pre-planned pattern can be achieved automatically. The card mechanism is connected to a series of horizontal needles that control the set of weighted lifting cords attached to the warp threads of the loom. Each row of punched holes corresponds to one woven pattern row. A warp thread is lifted if a horizontal needle passes through the vertically placed hole, or not lifted if the needle is pushed back in the blank area. Complicated patterns are produced by combining a set of punched cards that are strung together and held above the loom. In a commercial weave workshop in the Hanoi area, the Jacquard looms were being used to produce beautiful silk damask fabrics. Hundreds of cords formed a deep network connecting the warp to the punched cards above, a labour-intensive threading exercise that pays off once the loom is set up.

Dobby looms use a simplified form of the Jacquard mechanism, having a dobby attachment, with narrow strips of wood taking the place of the Jacquard cards. Dobby weaves produce all-over patterned fabrics limited to simple, small geometric motifs, with the design repeated frequently. They are easier to set up than the Jacquard loom, and the fabrics are fairly inexpensive to produce.

It is interesting to note that the Jacquard system was adopted during the 1830s by the English mathematician Charles Babbage to make designs for his proposed 'analytical machine'. The same punched card system was used by the American statistician Herman Hollerith to feed data into his census-tabulating machine. This in turn led to the use of a binary 'positive-negative' system for early digital computers, eventually to be replaced by modern electronics.

We have now come full circle, and computerized patterns are produced in modern industrial workshops, both for woven and for knitted textiles.

Weaving Preparation

Anyone who is unfamiliar with the weaving procedures has little idea of the complicated stages necessary to prepare the threads ready to be set up on the loom before any weaving can begin. Although these processes are now highly mechanized, in many countries the traditional time-consuming methods are still practised. The weavers never appear to resent the amount of work needed for thread preparation: it is undertaken in a ritualistic way, with skills passed down from generation to generation, often rewarded by the renown gained by belonging to a respected specialist group.

Once the cotton thread has been spun and the silk threads reeled, they are wound into hanks on a 'swift', a rotating holder that can be adjusted to make circular thread hanks of different diameters. The hanks are tied at intervals to keep the threads in order, and several hanks are gathered and tied together ready for the various dyeing processes. After dyeing, the thread hanks are then wound on to spools ready for the warping process. These spools can be set on to a series of horizontal pegs in a board, where they will rotate as they unwind.

Winding the Warp

The whole art of making a warp is to keep the threads in the correct order and form one, or sometimes two crosses to separate the upper and lower layers of the warp. The

simplest form of winding is on a warping or peg-board, using a figure-of-eight sequence. The pegs are set at the correct distance apart, depending on the warp length required, with an extra peg sometimes included to form the cross. The warping threads are drawn up from the rotating reels, or in rural areas, from balls of thread placed in a basket. In a village in northern Laos, a long warp was being wound between pegs set into the ground, the woman paying out the threads from a reel of silk as she walked backwards and forwards. A rotating warping mill, which is an upright circular wooden framework around which the warp is wound, is a more sophisticated method used in commercial workshops, and suitable for long warps.

When the warp is taken off the frame or lifted from the pegs, it is 'chained' by pulling a series of loops through themselves, thus reducing the length of the warp and allowing it to be undone when needed. In areas of North-East Thailand, where the flat warp-board is used, the front end of the wound warp is secured before the entire length is laid out, supported on sticks. At the far end, two women

End view of a 'long loom' placed under the weaver's house, Koh Dah Island in the River Mekong near Phnom Penh, Cambodia. The flat warp board, wound with blue silk thread, is held on to the end beam with rope ties.

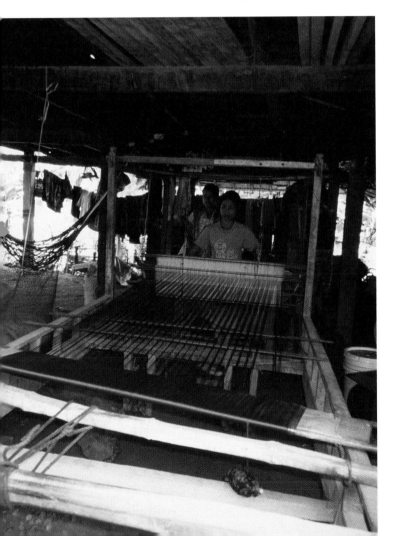

slot the warp-board through the loops, arranging the threads evenly. The board is then rotated by hand and the warp rolled up by the women, who walk back, keeping the tension firm. When completed, the full warp-board is tied in position to the end bar of the loom frame, and the threaded heddles and comb put in place at the front. In certain weaving villages in Cambodia where the workers produce fabric for commercial outlets, warping has been simplified by the delivery to the village of factory-wound warp beams full of machine-spun cotton.

Threading the Loom

Loom threading is a time-consuming process. On a simple backstrap loom, the circular warp is held at tension, threaded on to a back bar at one end, and to a front bar at the other. Two sticks are inserted into the 'thread cross' and tied together to keep them in position. A continuous string heddle can be inserted while the warp threads are being wound on to the warping frame. Two women will work together, the one winding the warp around the pegs in a figure-of-eight, while the other passes a continuous heddle string up and down between every other warp thread. When in position, this allows the alternate warps to be lifted. The heddle strings are threaded on to a rod in correct order, and tied securely at either end. If the warp is already in place, a continuous heddle string can be inserted on the loom by picking up the continuous string from below the warp, and drawing up a loop between every other warp thread. Once again, a rod is put through the loops and secured.

On the frame loom, the discontinuous warp is looped on to the back beam and rolled up before the individual ends are threaded through the loom from back to front. If heddle shafts are already in position on the loom, the warp threads are passed through the heddle eyes with a hook, before they are threaded through the reed comb and finally tied on to the front beam. It is a tedious process to thread the warp through the heddles each time a new warp is needed. The solution is to cut off the finished weaving to leave the remaining warp threads in position through the string heddles. In North-East Thailand, the old warp thread ends are tied to the new warp ends, covered with a rice paste and left to dry. These stiffened threads are then pulled back through the heddles and comb, which are secured into position once again. In other areas the new threads are tied on to the old threads, either singly or in groups, without the addition of the paste.

In many South-East Asian countries a rice or alternative starch paste is used to strengthen the warp threads. Weavers at Lake Inle, Myanmar, place yarn hanks in bowls and knead rice paste in with their feet. The yarn is dried and

then dipped again, excess starch is shaken off, and the yarn finally dried ready for the warp. Another method is to brush starch on to the warp when it is on the loom. Sometimes a plain, dry brush is used, which helps to smooth the threads.

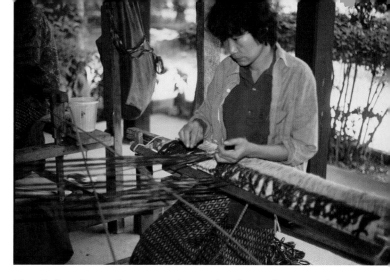

Threads from the new ikat-patterned warp, slotted over a bar, are tied to those of the old warp. Weft threads will be a plain colour. Workshop of Mrs Saeng-da Bansiddhi near Chiang Mai, Thailand, 1991.

Pattern Weaves

Pattern Types

A fabric that has the intersecting warp and weft threads of the same thickness and at even tension is called a 'balanced cloth' or plain 'tabby' weave. On a frame loom, two shafts are needed to make this weave, whether they are lifted by hand or by depressing the foot pedals that are connected to the shafts by cords and pulleys. On a backstrap loom, a rigid heddle or a string heddle and use of the sword will give the alternate shed openings. If the warp threads are set closely together, then the lateral weft threads will be less prominent and the weave called 'warp-faced'. If the warp threads are spaced further apart and the weft threads beaten down to cover them, then the fabric is called 'weft-faced' – this is a feature of tapestry weaving.

If the warp threads are striped, achieved by tying in different colours at spaced intervals, then a longitudinally striped fabric is made. Check patterns result from combining the striped warp with a striped weft. These are popular in all the areas of South-East Asia, especially for male tube skirts, sashes and turbans. When two contrasting threads are plied together and used as a weft thread, the resulting 'shot silk' effect is sometimes referred to as 'squirrel tail'.

Twill Patterns

A minimum of three shafts is necessary to weave 'twill' patterns. The weft thread will 'float' over more than one warp thread, according to which shafts are lifted. This float stitch can be staggered across the row, so that the float patterns will form a diagonal pattern up the cloth. If the pattern order is reversed, then the diagonals will slant the other way. In an 'uneven twill', the weft float will go over two warp threads and under one warp thread in sequence across the row; this uneven 2/1 twill is used with the ikat-dyed weft pattern threads where the colour of the fabric changes from one side to the other. Thus, on the right side, the weft colour is predominant when two weft floats pass over the warp, and one weft thread under it; while on the fabric reverse, the warp colour will predominate when the two weft threads pass under the warp and only one above. This results in one side of the cloth being brighter than the other. If the weft is in a contrasting colour, another element is introduced, adding subtlety to the weave.

If the shaft threading sequence is altered, this can produce zigzag and diamond patterns, but pedal order will also determine the patterning. In an even twill, the floats will go over two, and under two warp threads across the row. This is called a 'two and two', or a 2/2 twill, and a minimum of four shafts is needed to work the pattern.

Even on a simple loom it is possible to produce the most intricate designs, and it is not surprising that woven fabrics were considered magical and the weavers held in such high esteem.

Supplementary Weft and Brocade Patterns

Any thread that is inserted into the weft as an extra element and is not part of the ground fabric is termed a 'supplementary weft'. These extra threads are used to create decorative patterns which can, in some instances, resemble embroidery. If the extra thread is laid in right across the warp shed opening, then it is called a 'continuous supplementary weft'. This method is used for brocaded patterns, whatever the type of thread. The term 'brocade' is often reserved for gold- and silver-thread weaving, but it also applies to any continuous supplementary patterning. In Indonesia, the use of supplementary metal threads is called songet weaving. The city of Palembang in Sumatra is famous for backstrap weaving with gold weft-thread patterns on a silk warp. In Thailand, metallic threads form the brocade patterns on the hem bands of the tube skirts, and the technique has long been used for regalia and upper-class garments.

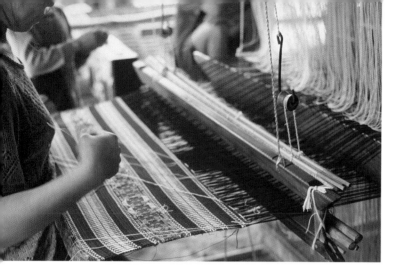

ABOVE: *Both continuous and discontinuous supplementary weft threads are used to form the pattern on this long-heddle loom at Ban Tai Lu, near Luang Prabang, Laos. To the right, the sword is upturned to open the pattern shed.*

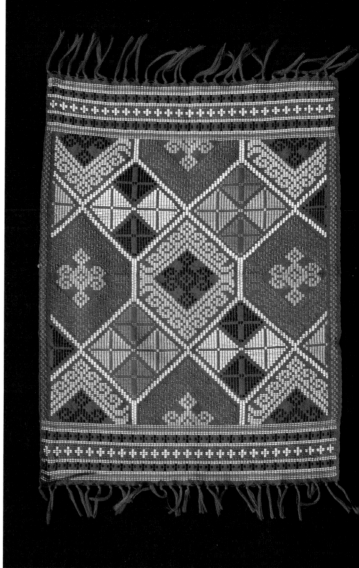

ABOVE: *Geometric patterns decorate a cloth made by the Yakon tribes from the Island of Basilon in the Philippines.*

LEFT: *Detail. A discontinuous supplementary weft technique is used to insert the pattern threads.*

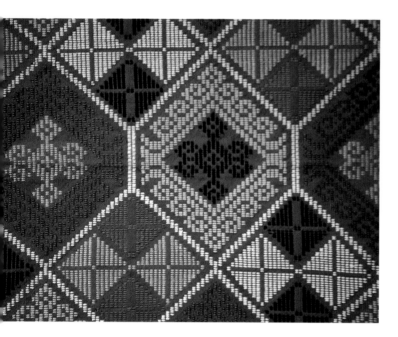

If the inserted threads only pass backwards and forwards in a limited area, the method is termed 'discontinuous supplementary weft'. A separate supplementary thread is needed for each pattern section, which may be repeated at intervals, or used as an isolated motif. These pattern threads hang down on the working side, available to be woven in on each pattern row and then left to hang down, ready to be picked up on the return row. Threads can be finger-manipulated or, as in Chiang Mai, Thailand, a long metal needle with a curved tip is threaded for each colour in turn. One or two weft picks of plain tabby are worked between each pattern row to secure the inserted threads. Supplementary weft insertion with free-hanging threads is woven in South-West China, Thailand, Laos and Myanmar. This method is often combined with multiple-heddle brocade weaving.

In Indonesia the technique is called *sungit*, from a Malaysian word meaning 'needle'. Here the patterning threads are wound on to small bobbins, or threaded into small needles made from bone or porcupine quills. The supplementary threads are twisted round the chosen warp threads a number of times, so that the design appears the same on both sides. According to John Gillow, this technique is used by the Iban of Sarawak to decorate ritual cloths and clothing, and by the people of Timor for sarongs, *selendangs* and bags. Additional embroidery may be added to the sungit patterns, making it difficult to distinguish between the two techniques.

Supplementary weft patterning is worked throughout South-East Asia, decorating the tube skirts of Myanmar and Thailand, depicting the symbolic motifs on the healing cloths in Laos, and patterning the geometric designs on the

sashes and headscarves of the Yakan tribes who inhabit the island of Basilan in the southern Philippines. The artistry of some of these pieces of weaving elevates them way beyond the concept of a mere craft, a fact understood by these societies, but not always appreciated by the world at large.

Pattern Selection Methods

When pattern heddles are used to raise the warp to form the shed, the extra threads are inserted into the open shed of the weaving, so that they are sandwiched in between. In some simple looms, the pattern warp threads are picked up by hand using a pick-up stick, or with the fingers alone. The decorative threads may lie between the two warps, or completely wrap around both upper and lower warp threads to give a counter-change pattern.

If they are inserted into the top layer of warp threads only, then the pattern will show on the front, and will be almost invisible on the back. Several methods may be combined in the same textile. In the Chin states of northwestern Myanmar, a tunic blouse can have a brocaded pattern worked into the top shed only, over a striped warp, with sections of inlay in between. A similar technique on the short wrap-around skirt worn by the Taung Mro women of the Buthidaung area is enhanced with embroidery stitches in very fine threads.

Even on a simple backstrap loom, the most intricate supplementary patterns can be accomplished. Pattern sticks can be inserted into the warp behind the main shafts by picking up the pattern threads one row at a time. The wooden sword is used to keep the pattern shed open, and is depressed when ordinary tabby weave follows. The sticks are removed as the design is worked. But this is time-consuming, and several methods of storing and repeating the patterns evolved.

Vertical String-Heddle Harness

In areas of northern Thailand and Laos the vertical heddle technique is used to make the beautiful geometric supplementary weft patterns for which they are renowned. The string-heddle harness is suspended from the top of the loom behind the two main shafts, reaching nearly to the floor. In Thailand these long heddles pass between the warp threads, and each one is tied at the intersection with a controlling loop. Sets of pattern sticks are interlaced into the upper section of the harness, each bamboo stick corresponding to one row of the pattern. Pattern cords, which take up less room, may be inserted instead of sticks,

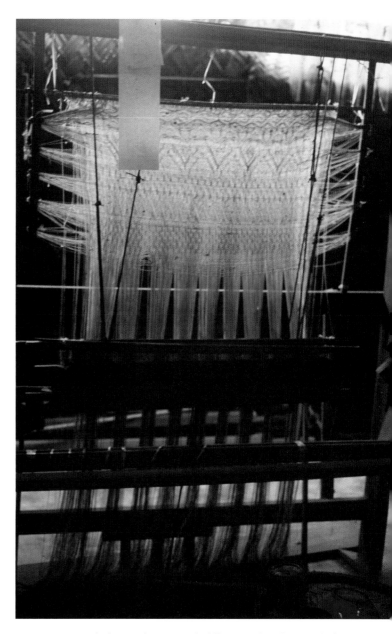

A pattern is worked into a long-string heddle using threads instead of rods, thus increasing the scope of the design. Carol Cassidy weave workshop, Vientiane, 2001.

enabling a longer pattern repeat to be woven. They look particularly beautiful, especially when held up to the light.

The weaver moves the sticks down, one at a time, for each pattern row. The selected stick is used to open up the pattern shed by teasing the heddle strings sideways towards the weaver. Next, this pattern shed is transferred to the wooden sword behind the main shafts and the sword is turned on its side, thus providing the correct opening for the supplementary weft thread. When the pick is woven, the pattern stick is transferred into the corresponding

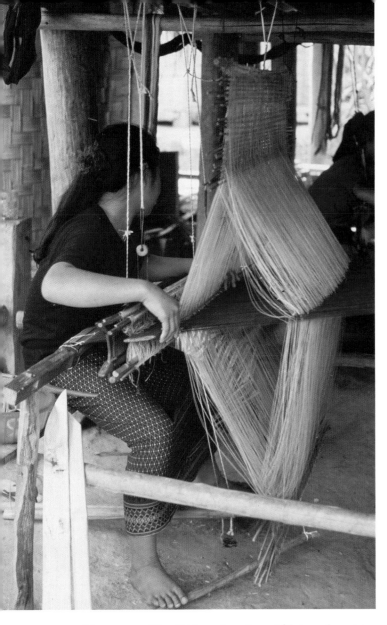

heddle opening below the warp, in correct order. The sword is depressed, and a row of tabby weave secures the threads. The next pattern stick is lowered to continue the rotation, which results in a 'brocade' pattern of continuous supplementary wefts. When all the sticks have been passed to the bottom layer, the patterning is reversed, and the sticks are brought up to the top layer, one at a time, where they are held in position with a hook. Sometimes extra threads are put in by hand across the row, using the string heddles to form the shed, thus combining continuous and discontinuous insertion.

On small looms it is easy for the weaver to reach the heddles, but large looms with long warps are worked by a weaver and two assistants, one to move the pattern sticks, while the other lifts and depresses the sword. This speeds up the weaving.

This method is illustrated, with the other patterning methods, in a video produced by 'Ends of Earth', on location in northern Thailand.

Separate Pattern Heddles

Apart from the main shafts that are used on the frame loom to form the ground weave, separate pattern heddles can be inserted. These have short lengths of warp threads already in position, which can be tied on to the new warp threads and pulled through into position. This saves a lot of time in pattern threading. In Mrs Bansiddhi's workshop in Chiang Mai, a whole collection of pattern heddles hung from the roof rafters, ready to be used when a change of pattern was needed.

In Cambodia, separate heddles for supplementary weft patterns are inserted into the loom warp in front of the two main heddle frames used for the ground weave. There can be as many as thirty of these pattern heddles, each one with a different threading. Unlike other loom patterning systems, where the heddles are tied to separate pedal cords, either singly or in groups, the Cambodian heddles are left unconnected until required for use. The selected pattern heddles are linked on to a suspended hook connected to one single pedal that is fixed laterally at floor level across the back of the loom. The weaver depresses this with his foot to activate the cord that raises the selected heddles. When the pattern section is woven, the heddles are unhooked, a new set is selected and the process repeated. In a village on Koh Dach Island in the Mekong River near Phnom Penh, both men and women used this method to weave gold thread inlay patterns for commercial supply. When only one pattern heddle was needed, a woman lifted it with her finger, possibly to save time.

A man weaver in a silk workshop in Myanmar was selecting warp threads on the frame loom by picking up the

ABOVE: The weavers of Ban Tai Lu make patterned fabrics on long-string heddle looms. The girl has opened the heddles to make the correct pattern shed, and is about to up-end the 'sword'. The connecting ties, linking heddles to warp threads, are plainly visible beneath the blue warp.

BELOW: The up-ended sword is used to keep the pattern shed open. When the pattern 'pick' is woven, the weaver will flatten the sword and select another pattern row from the heddles. Luang Prabang area, Northern Laos. Photo: Timothy Thompson, 1998

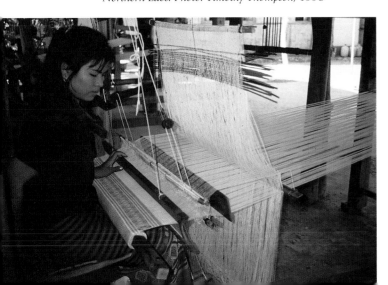

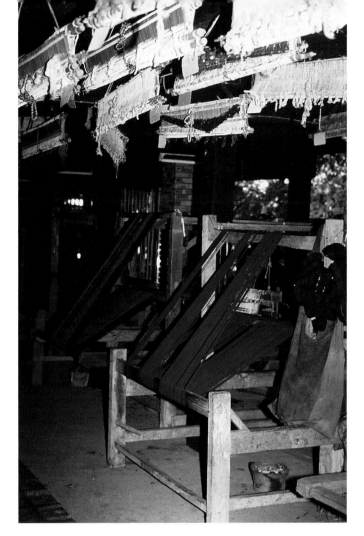

ABOVE: *The workshop of Mrs Saeng-da Bansiddhi near Chiang Mai, showing pattern heddles stored in the rafters. The method of taking the extra warp threads from the back of the loom and over the top of the frame is common to this area of northern Thailand.*

Supplementary Warp Patterns

Supplementary threads can be added to the upper warp layer. These threads are quite separate from the ground-weave warp threads, and on a frame loom are threaded through individual heddles to be lifted when required. In Minnanthu weaving village near Bagan, Myanmar, a loom had been set up to produce a striped fabric that combined supplementary 'dashes' within the warp stripes. A pair of foot treadles, made from inverted half-coconut shells, controlled the two ground-weave shafts. The extra pattern heddles were lifted by hand and attached to a hook to control the supplementary warp threads. These supplementary threads were taken through the main shafts to the back of

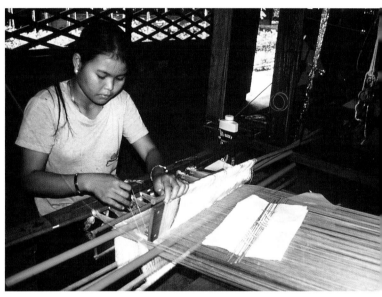

ABOVE: *A weaver from the National Centre for Sericulture, Siem Reap, is inserting a continuous string heddle into the warp threads, following a pattern of threaded sticks laid in front of her.*

BELOW: *When completed, the heddle strings are threaded on to rods fastened to the lifting pulleys, placed above. This loom has a large number of pattern heddles placed in front of the normal four weaving shafts, seen with white heddle threads.*

threads on to a rod according to a graph-paper pattern. The pick-up selection was then passed to the far end of the loom, beyond the main shafts, by the use of shed sticks. Long heddle threads were connected to the pattern warp, and the process was repeated until all was strung, making a veritable forest of heddle strings at the far end of the loom. The heddle threads were looped on to rods connected to the top of the loom in groups. Each group is activated by a pulley cord attached to a foot treadle, but on some looms the heddle groups are controlled by hand.

In the National Silk Institute, Cambodia, a young girl was threading a continuous string heddle across a frame loom. She followed a pattern model – formed of thin sticks set into a separate warp section – to select the individual threads that she looped on to a rod the width of the warp. When secured at the ends, this formed a lifting device for a single pattern row, but additional heddle sets were needed to complete the entire pattern. Although these methods appear labour intensive, they are time-saving once the pattern heddles are set up.

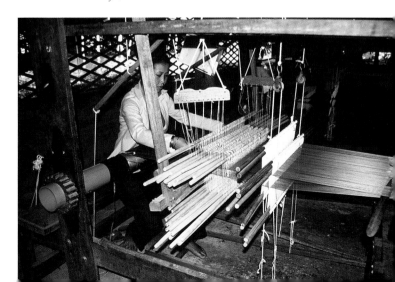

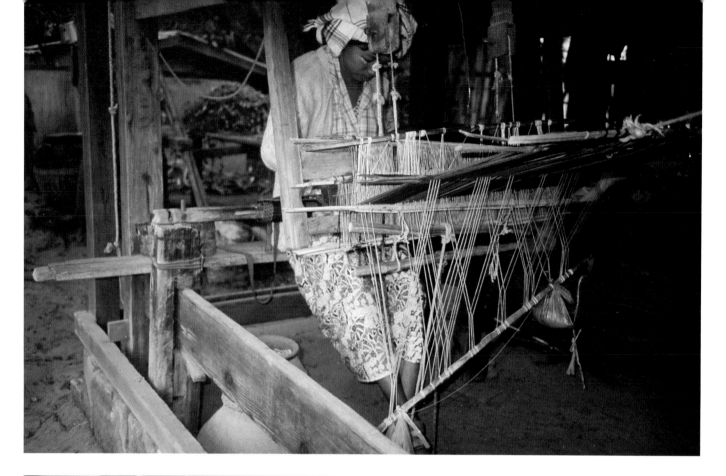

ABOVE: *This loom, at the cotton village near Bagan, Myanmar, is set up for a supplementary warp pattern. The extra threads, in yellow, are strung on to a weighted bar below the warp.*

LEFT: *The yellow threads, attached to individual pattern heddles, are lifted separately by hand, according to the pattern.*

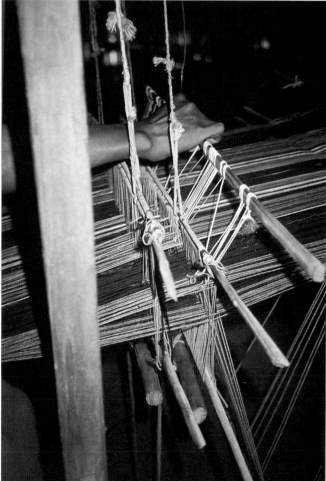

the loom, but diverted to loop down beneath a weighted floor-level rod and back up again before being tied on to the end beam. This gave a tensioned extra length to the supplementary warp in order to cater for the 'take-up' used by the pattern weave.

Rare examples of antique textiles woven in Laos show the combination of supplementary warp and supplementary weft techniques worked at the same time. This requires a considerable weaving skill to achieve, and in the past, these special pieces were reserved for ceremonial and religious use. A girl in a workshop in modern Vientiane, central Laos, was weaving an exotic silk fabric for export to the USA. The usual string heddles controlled the main supplementary weft patterns, but extra heddle strings lifted the supplementary warp threads. These were lifted by hand and a series of little weighted bags hung down to control and tension the supplementary pattern threads.

In the Indonesian island of Sumba, the supplementary warp pattern for the noble-woman's tube skirt, *lau pahudu*, is stored on a string model. Marie-Hélène Guelton has made a study of these string models, not many of which survive as they were burned at funeral times. Zoomorphic

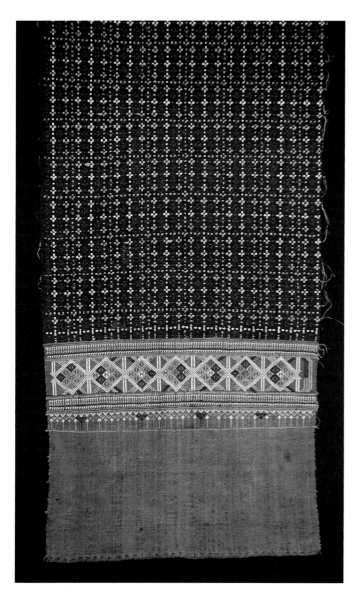

A rare antique ceremonial shawl, showing both supplementary weft and supplementary warp patterning, combined. Sam Nuea, Houa Phan Province, Northeast Laos. Provenance: Mrs Chanthone Thattanakham, Vientiane

loom and used the rods as a guide to insert thin pattern sticks into the actual supplementary warp. The thin sticks were pushed up to the top of the warp and when the set was complete, each one was replaced by a thicker stick. These were taken out one at a time as the pattern was woven. The process would be repeated for the next section, containing a different part of the pattern. In Sumba, this supplementary warp technique is called *pakhikung* weaving.

Tapestry Weave Methods

Tapestry is a discontinuous weaving technique. The weft threads do not go right across the warp, but are confined to the pattern areas, with different colours, each one on a separate shuttle, inserted when necessary. These pattern sections can be joined to each other at the sides by linking the shuttle threads together, or left free to form a slit. Fine-scale tapestry weaving in silk and cotton threads is a feature of Eastern textiles, quite unlike European tapestry wall hangings, worked in wool and linen threads.

100 Shuttle Silk Weave – Myanmar

At one time this prestigious tapestry-weaving technique was reserved for court costume. *Luntaya acheik* is the name given to the 100 shuttle tapestry patterns still woven today in the silk workshops of Myanmar. The tiny shuttles, into which little 'pirns' of coloured thread are inserted, have a slight lip at one end to facilitate insertion between the weft threads. As only a single row, or 'pick', can be worked at a time, each one of these shuttles has to be inserted through the open shed in sequence and linked in turn to its

The luntaya acheik *100-shuttle tapestry weave technique is still practised in Mandalay weave workshops. The girls twist the shuttle threads together to link the pattern motifs.*

designs have an iconography connected to the Vietnamese Dong Son culture, and others are reminiscent of the Indian Patola patterns. Cotton threads on the model representing the supplementary warp are strung backwards and forwards on to an upper and lower rod, to form the string base. Thin bamboo rods, which can total up to 200, are interlaced into the 'warp' threads delineating the pattern. The actual weaving is worked in a 2/1 twill, or sometimes a 3/1 twill.

In a modern context, a similar string model is shown in use in an 'Ends of Earth' video of weaving in Sumba. A village girl placed the string model in front of her backstrap

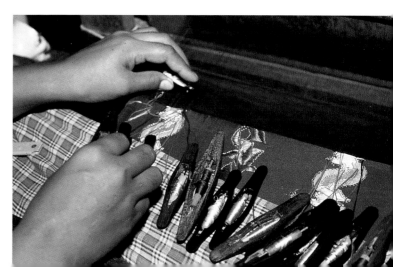

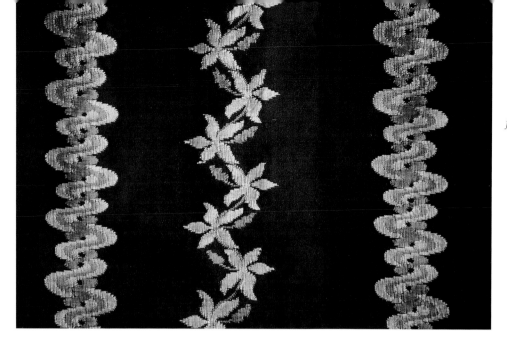

A modern design on a longyi skirt uses fewer shuttles, but the work is still labour intensive.

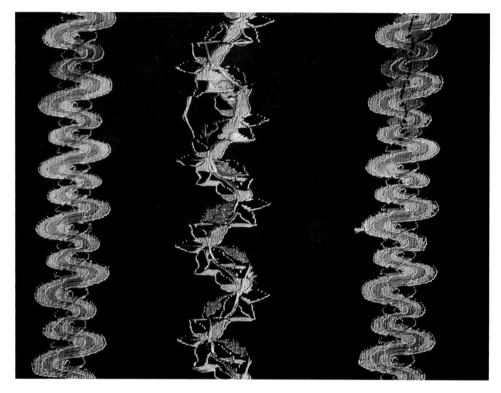

The pattern is worked from the reverse side, with the vertical linking threads on the fabric surface.

neighbour. When completed, a row of plain tabby weave gives stability to the tapestry areas, using a larger shuttle loaded with the ground thread colour.

Nineteenth- and early twentieth-century silk weaving for court dress was very complicated, and could entail the use of up to 200 shuttles. The tapestry designs are worked up the fabric, often in a wavy pattern of undulating curves and zigzags, or flower motifs joined by sinuous stems. In the Shwe Sin Taing silk workshop in Mandalay, two girls sat at each frame loom, deftly twisting the linking threads of the shuttles. They followed a coloured graph-paper pattern, and as the right side was on the underside of the fabric, were proud to show their work with the aid of a mirror.

Fabrics with limited pattern areas were woven for sale in the tourist shops, but complicated designs are still produced for ceremonial use. The *luntaya* tapestry method was imported to areas of Thailand, but a simpler version of the zigzag patterns is woven in workshops near to Chiang Mai with a limited number of colour shuttles for the *phasin* tube skirts, in cotton rather than in silk.

Pis *Cloths: the Philippines*

The Tausug tribes are a dominant group living in the Sulu

archipelago of the Southern Philippines. Their women are famous for tapestry woven fabrics, generally known as pis cloths, although in actuality this refers only to the men's shoulder or head-cloths. Both the pis cloths and the men's waist sashes (*kambut*) are woven in the tapestry technique, in the past always out of silk thread imported from China. These silk threads were unobtainable during World War II, and stricter government control of sea trade has resulted in the use of cotton and synthetic threads during recent times. Complicated tapestry designs, worked using a silk weft and cotton warp during the latter part of the twentieth century, decorated the tube skirts worn by both men and women. It is suggested that the rainbow-hued, geometric patterns may have an origin in Indian Mandala patterns, as there is a definite spiritual element to the rectangular designs.

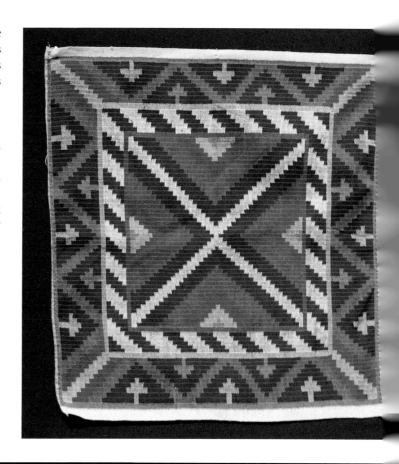

RIGHT: *A tapestry weave technique is used for the pis cloths worn by the Tausug tribes of the Sulu archipelago, southern Philippines.*

BELOW: *These geometric patterns are worked to an extremely fine scale, and at first glance the cloths may be mistaken for machine-woven fabric.*

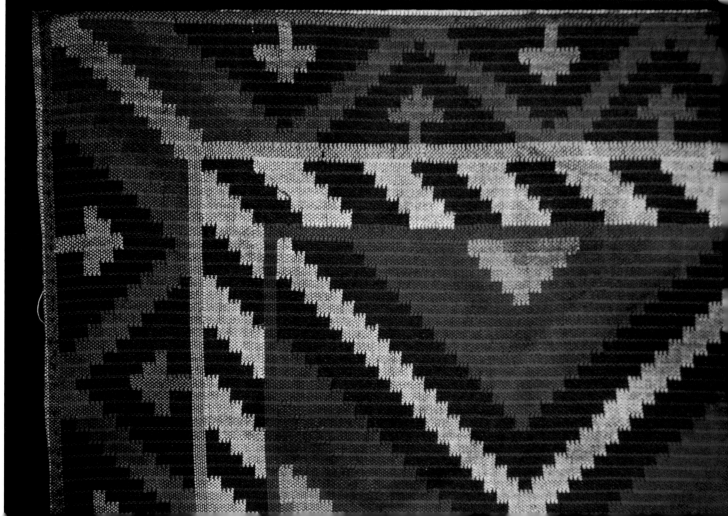

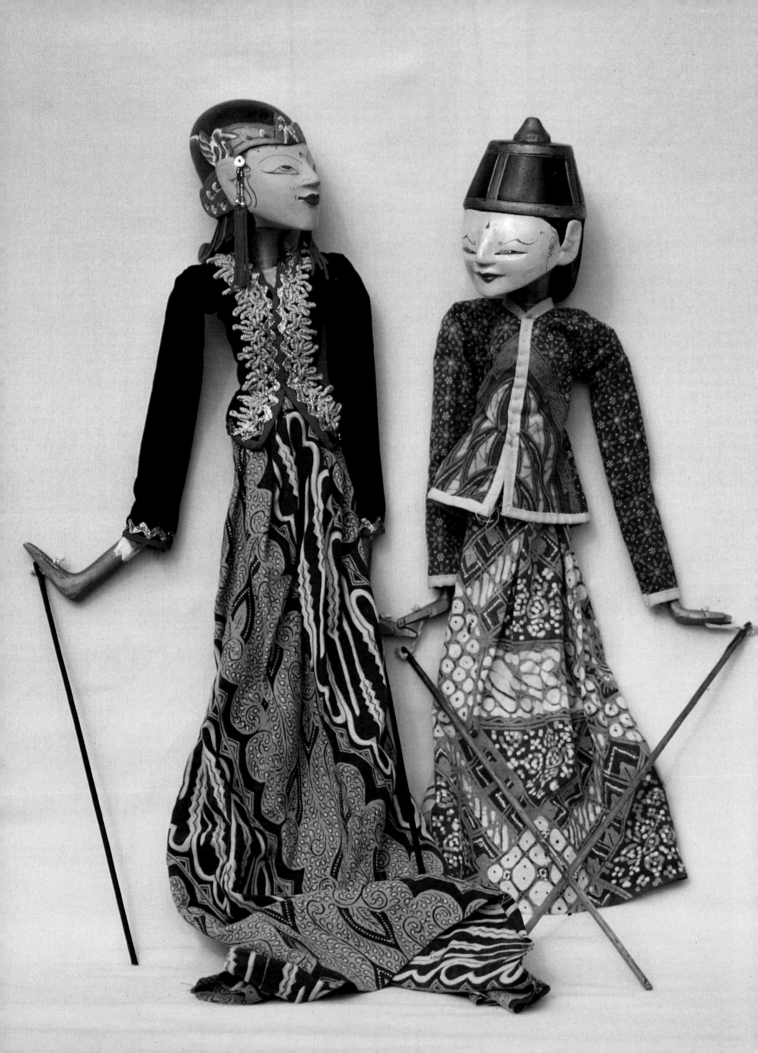

Dye Pattern Methods

Ikat

The word 'ikat', pronounced 'eekat', comes from the Malaysian word *mengikat* meaning 'to tie'. Although the process of tying and dyeing the weft or warp threads before the actual weaving begins is generally called 'ikat', it is also known by other names. '*Hol*' weaving is the term used to define the beautiful Cambodian ikat cloths, woven in the 3/1 uneven twill in complicated diamond and trellis patterns.

The Ikat Method of Tie-dye Threads for Weave Structure

It is possible that a batch of unevenly dyed thread hanks, with certain parts left free of the dye colour, was the inspiration for the tie-dye method of thread decoration. Then it was only one step further in the dyeing process to deliberately prevent the dye from reaching certain areas. This was achieved by binding tightly around the threads before immersing them in the dye; the original thread colour was revealed in the form of stripes when the bindings were undone. The next stage was to re-tie the thread hanks in another position, and dye again in a second colour. A subtle mixture of shades is created by over-dyeing on both the plain and already patterned areas.

The random colours that unwound from the hank were the forerunner of the complicated tie-dye process in which pre-determined patterns were tied into the weft threads for 'weft-ikat', or alternatively into the warp threads for 'warp-ikat'. This was achieved by winding the pattern threads on to a separate frame which measured the exact weft width,

OPPOSITE PAGE:
Rod puppets, called wayang golek, are often dressed in scraps of antique batik fabric. (Lent by Jane Davies)

or the warp length. In some countries the frame is laid out flat, in others it is set up vertically, either propped up or on a stand.

Tying the Bindings

The weft threads are wound round the frame in groups, varying in the number of threads according to the fineness of the pattern. The bindings are wound round these thread groups, forming a series of resist 'blocks' that make up the pattern. Today, the bindings are made from synthetic threads, but in the past they were always of vegetable substance and included anything that resisted the dye-stuff well, such as strips of palm leaf, banana twine or jungle vine.

It is fascinating to watch an experienced worker tying the bindings with speed and accuracy to produce a design that many hold in their heads without recourse to a pattern model. The binding strips are cut into lengths, or taken from a ball or spool as required. In Sumba, narrow strips of Lontar pine leaf are flattened by the worker with dampened fingers, using water from a small bowl. The binding is wrapped round several times to cover a certain 'block' or pattern area. A knife is held in the worker's hand throughout the process. The binding is cut off and the end is taken through a slip-knot loop, and the process repeated until the tying is completed. When the frame is held against the light, it is easy to see the basic pattern shapes represented by the tied bundles, although with wispy ends poking out in all directions.

When any one set of tying is completed, the threads are taken off the frame with the looped ends tied together so that the pattern order is maintained when they are inserted into the dyebath. When dry, the threads are replaced on to the frame, and some of the existing bindings are removed by cutting with the knife. Additional bindings are added in different places, and this binding and dyeing process can be repeated a number of times, depending on the complexity of the pattern. The dyer works from light to dark,

131

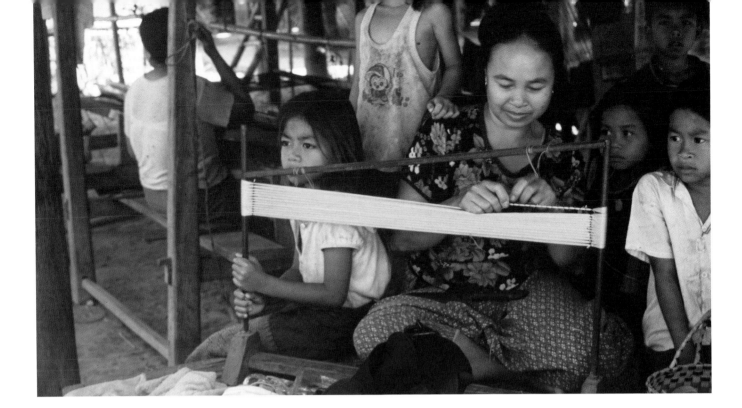

ABOVE: *A woman from Ban Saman, a weaving village on an island in the Mekong River, ties a resist pattern on to threads wound on an upright stand frame. Pakse area, Laos.*

LEFT: *A young girl uses a knife to cut the thread ends of a resist pattern for ikat dyeing, tied into silk threads and wound on to a horizontal frame, called a* snoeng. *National Centre for Sericulture, Cambodia.*

BOTTOM LEFT: *Hanks of ikat-tied and dyed threads, ready to be re-tied and dyed in other colours. Chonnabot Silk Workshop, Chiang Mai, Thailand.*

starting with pale yellows, adding indigo to make green, dyeing in reds and browns and finally over-dyeing in a sequence of indigo vats until the exact density of colour is reached. In many areas, indigo dyeing alone is frequently used for the ikat patterning. When the dyeing is complete, the entire weft threads are removed from the frame and all the bindings are cut off, sometimes with the help of a second person to hold while the cutting takes place.

It is essential that these tie-dyed weft threads are kept in strict pattern order. In Thailand the circle of weft threads is wrapped around a winder frame so that one complete pattern length can be wound off at a time. The operator winds the weft on to small bobbins on a hand-operated bobbin winder, keeping them in pattern sequence. Starting at the right-hand side of the winder frame, the threads are wound on to the bobbin until the left-hand side of the winder frame is reached. This equates to one entire pattern length of a thread group. The thread is broken off, and the bobbin is strung on to a cord. The next bobbin is wound from left to right of the winder frame, so that all the threads will still be in pattern sequence. The full bobbin is threaded on to the cord in pattern order, and the process will be repeated

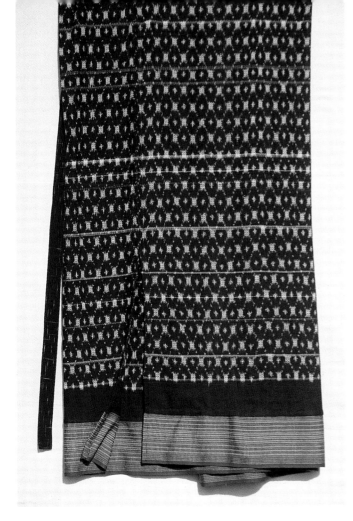

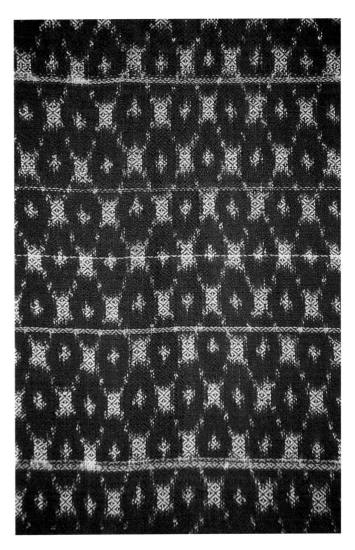

ABOVE: *This phasin tube skirt from North-West Thailand has a teen bok band woven in horizontal stripes attached to the hem. The weft-ikat indigo-dyed cloth is woven using an uneven twill hol pattern.*

RIGHT: *A detail of the skirt shows the ikat patterning separated by narrow bands of warp stripes in yellow, white and red; it is worn horizontally.*

until all the thread groups are wound on to the bobbins. The weaver hangs the cord – which looks like a large beaded necklace – on to the loom so that the bobbins are ready to take off one at a time when needed.

Weft-Ikat: Thailand, Myanmar, Cambodia, Laos

There are several different ways of storing the wound bobbins in correct order, ready for the weaving to begin. In Myanmar silk workshops, the bobbins were slotted on to upright spikes set in rows into a rectangular tray. On Inle Lake, shuttles were wound with the dyed threads and placed in a box. In Cambodia the bobbins are laid in sequence on the weaver's bench, ready to be inserted into the cylindrical shuttle. A small boy was chided for attempting to pick up a bobbin, since any disruption in order would destroy the pattern.

In Thailand the ikat patterning, which decorates the *phasin* tube skirts of the women, is referred to as *mudmi* or *matmi*. The wooden tying frame, called a *lakmee*, has four short legs which support two adjustable ends held apart by a board. These ends hold the two rods on to which the weft threads are slotted, and allow different skirt widths to be tied. Many tube skirts are in plain indigo dye, but other colours are popular, including a green formed of indigo blue dye over yellow. The hem bands that border the Thai skirts are in simple indigo ikat, with more decorative bands held within the skirt. Cotton skirts are mainly of one colour, in contrast to the more complicated series of ikat colours used in silk weaving. A silk tube skirt from the Luang Prabang area of northern Laos combines a striped warp with weft-ikat patterns showing river dragons alternated with bands of brocade inlay. The original ground colour is transformed into a mosaic of subtle colours: cream, yellow, warm reds and the deep purples of indigo over-dye.

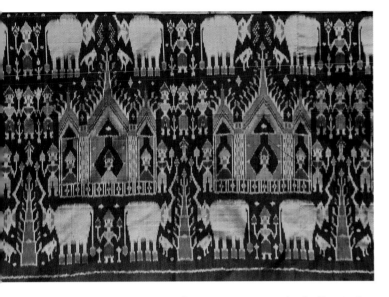

ABOVE: *A silk wrapped skirt from Ban Saman, an island village in the Mekong river, Pakse area, Laos. This design, worked in the ikat technique, is similar to the* pidan *religious picture cloths. Symbols include temples with ancestor figures, elephants, offering stands or 'tree-of-life' motifs.*

BELOW: *Similar large-scale motifs are shown on a coarsely woven cloth from Koh Dach Island in the Mekong river, Phnom Penh area, Cambodia. Symbols include temples, ancestor figures, dancing goddesses, elephants and horses.*

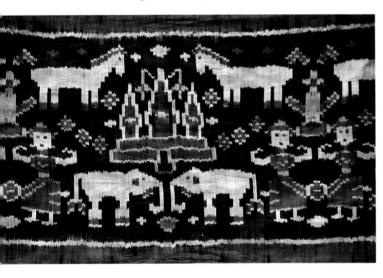

Pictorial ikat hangings are made in several Mekong river areas. In the weaving and fishing islands in southern Laos, pictures similar to the Cambodian pidan cloths or temple hangings are still woven in silk today. These island cloths are made in a plain weave, their decorative quality formed by the design which shows ancestor figures with upright hands in temples on mounds, together with trees and elephants. Some are kept for tourist sale or hotel wall hangings, but others are made to be worn as a tube skirt, reserved for ceremonial wear.

Several hundred miles to the south, in a Cambodian weaving island in the Mekong river, similar pictorial hangings were for sale. It was not clear whether they were made in Koh Dach Island, or in one of the many other islands scattered within the expanse of the river. These hangings are coarsely woven, but still have a vibrancy about them.

Hol Patterned Cloth

The 3/1 uneven twill hol patterning is used in both north-eastern Thailand and in Cambodia. This technique,

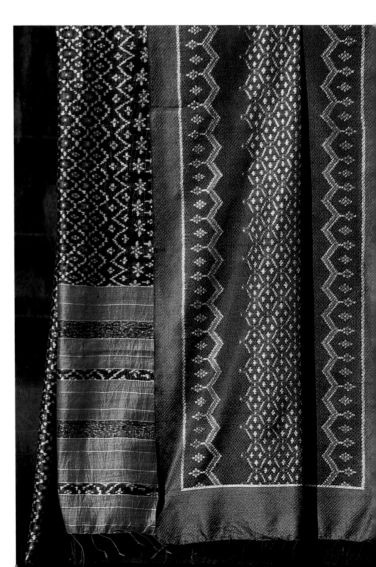

RIGHT: *Ikat-tied, naturally dyed silk cloths from the National Centre for Sericulture, Siem Reap, Cambodia. The left-hand shawl is in plain weave, the right-hand shawl is woven in the 3/1 uneven twill hol pattern method.*

Detail of the 3/1 uneven twill hol pattern, showing the lozenge structure of the grid weave.

is also used to produce indigo-dyed ikat-pattern cotton phasin skirts in areas of northern Laos and Thailand. Plain-coloured stripes in the warp are combined with the weft-ikat, and the hol-pattern weave produces a slightly textured fabric.

Warp-Ikat: Thailand

A warp-ikat patterning method was used in the workshop of Mrs Saeng-da Bansiddhi near Chiang Mai, Thailand in 1991. The warp threads are tied on a frame, then dyed in indigo vats before untying and threading on to the four-shaft loom. The ikat warp is taken from the front of the loom, through the main heddles to the back beam, then up over the loom to be tied in a knot over the upper top front of the loom. A tabby weave of plain weft threads is hidden within the final ikat pattern. The finished cloth lengths are made up into the women's phasin tube skirts.

A shoulder scarf from Indonesia shows the silk weft-ikat patterning combined with the cotton striped warp.

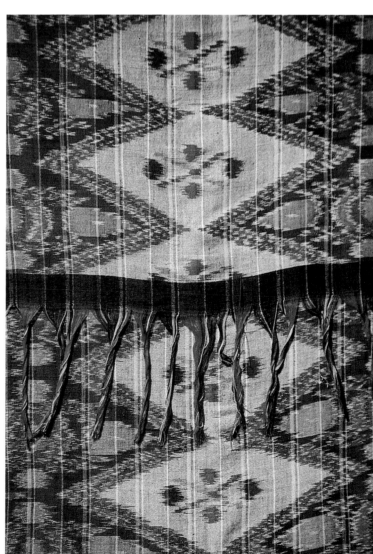

inherited from the court weavers, is evidence of a combined past culture. The pidan cloths or sacred canopies showed descriptive scenes from the lives of the Buddha, woven in the hol dye-pattern method. This ikat dye method is still used in the workshops of the National Centre for Sericulture, Siem Reap, Cambodia. It was interesting to see the tied pattern completed on a hol tying frame, called a snoeng, next to a finished woven cloth. These prestigious textiles are not cheap, reflecting the amount of time and effort needed to produce them. The grid-like twill weave gives an added dimension to the ikat patterning so that the heavy silk fabric has a crunchy feel, while the light and darker sides of the cloth both reflect and absorb the light in turns.

In North-East Thailand today, this method is used to produce silk scarves, sashes and wall hangings. Colours are mainly golden yellow, green and warm reds, together with a rich purple-brown for the background achieved with indigo over-dyes. Designs that feature the elephant, the emblematic symbol of Surin in Isaan, are shown on woven scarves and wall hangings. Although many of these items are produced solely for tourist and export sale, they maintain a valuable link with the dyeing and weaving expertise handed down from the past. The hol uneven twill method

Weft-Ikat: Malaysia, Indonesia and the Islands

It is thought that Arab traders first introduced the craft of weft-ikat via the sea routes during the fifteenth century. Most of the weavers in these coastal areas are Muslims, except for parts of Bali and Lombok Island. The combination of a striped warp with the weft-ikat would appear to be a popular design element in areas of Indonesia: it is like looking at two different patterns at the same time, with the ground stripes showing through the dyed weft in varying densities. Weft-ikat is used to make small mats in the Kuala Lumpur area of Malaya. Striped warp borders encase anthropomorphic designs of river dragons and water serpents. These motifs are especially popular in countries where water transport is so important.

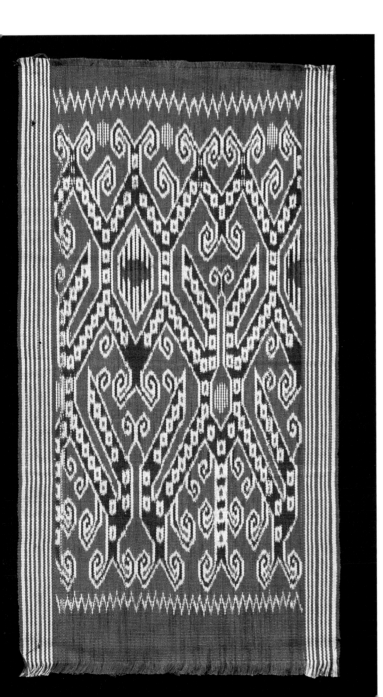

The long tradition of indigo dyeing and ikat weaving continues today, and workshops with modern looms have been set up in many places, including the town of Jepara in Java where fabrics are made for clothing. The slight 'bleeding' of one pattern colour into another, the result of imprecision in the tying process, is a valued part of the design in some areas, and has even been copied by machine-printed versions of ikat-dyed cloth. However sophisticated the loom, the hand-worked ikat process is still time-consuming, and the indigo-dyed cotton fabrics have a simplistic beauty, reminiscent of moiré patterns on silk.

Warp-Ikat: Indonesia and the Islands, Sumba

When the warp is tie-dyed to form the pattern, the weft threads are plain, generally in a finer thread. One way to distinguish warp-ikat from weft-ikat is to examine the threads on an area that has been cut, and then to unravel a fraction. The selvedges of a cloth are always at the sides and easy to identify. If the unravelled pattern threads go across, then it is weft-ikat; if they are longitudinal, then it is warp-ikat.

Several of the islands of the archipelago are famous for their warp-ikat. The women of Flores weave cloth with indigo-dyed warp threads enlivened by the addition of yellow to the original white. The Batak people of northern Sumatra are also celebrated for their ritual warp-ikat cloths, called *ulos ragidup* meaning 'pattern of life cloth'; these are presented as gifts at weddings. In the island of Sumba, the men's *hinggi* cloths and the women's sarongs are woven in this technique, together with the ancestor cloths for which they are renowned. The production of warp-ikat cloths is time-consuming, but this adds to their value. In Sumba the workers tie two separate warps at the same time, one set for the hinggi loincloth and the other for the shoulder mantle, enabling the designs to match in mirror image when woven.

A similar labour-saving method is used in the islands of Savu and Timor, where several hanks are tied and then dyed at the same time. The warp threads are wound on to a tying frame, and the first stage of the design is tied in. The hanks are removed, ready for the dyebath of brown-red colour – in Sumba extracted from Kombu roots. This is labour-intensive, taking up to a day to prepare, as the roots require hours of pounding in a wooden mortar. Subsequent re-tying and other dye stages are followed by a number of indigo dips to produce the varied colours used in these

A weft-ikat mat woven in strong cotton, from the Kuala Lumpur area of Malaya, shows a mirror-image and repeat pattern formed of river serpents.

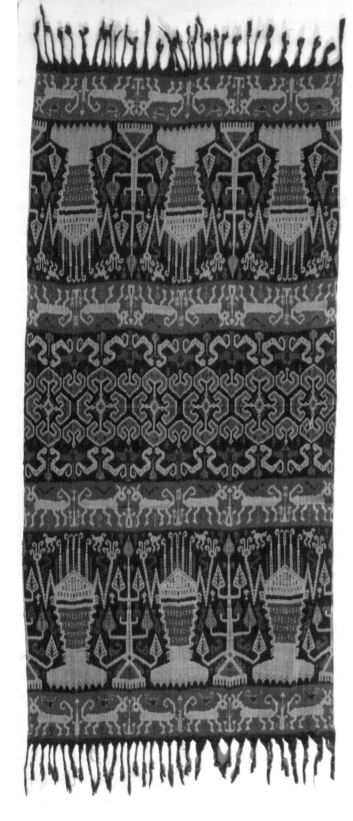

important textiles. The pattern-dyed warp is put on to a backstrap loom, and when the weaving is completed, the piece will be displayed at the next ceremony in honour of the tribal ancestors.

Double-Ikat

The weavers of Malaysia and Indonesia were influenced by merchandise imported from India, including the double-ikat silk *patola cloths*. These are said to have been traded from well before the sixteenth century and were held in such high esteem that the Indonesian weavers did their best to copy them. However, they were not familiar with the difficult technique of combining both warp and weft-ikat in one fabric, a craft perfected in the Bhuj area of Gujarat in North-West India and also in Japan. Not only

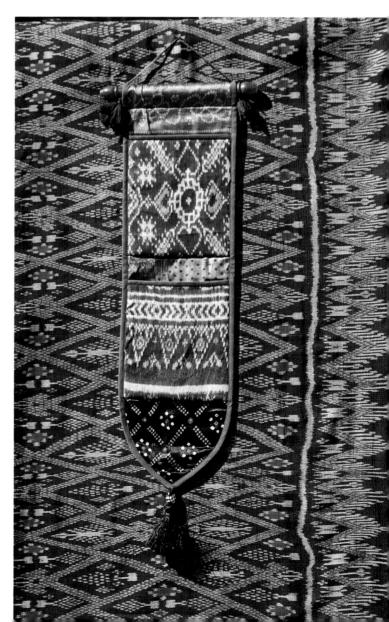

ABOVE: A warp-ikat patterned hinggi cloth from the island of Sumba. Horniman Museum number 2002.538. Photo: Heini Schneebeli

RIGHT: A weft-ikat sarong from Indonesia reflects the patterns of the double-ikat patola samples on a tourist wall hanging purchased in Patan, Gujarat, North-West India in 1991.

was it essential to tie the design with a high degree of accuracy, sometimes it was necessary for a second weaver to adjust the warp threads so that they crossed the weft design in perfect alignment. Many of the South-East Asian weavers copied the grid-like patterns, but in a single-ikat method, which resulted in a less precisely defined formation. These prestigious patterns, called *patola ratu*, were reserved for the aristocracy of eastern Sumba, while commoners wore less complicated ikat designs.

Only in Tenganan Pegeringsingan village in north-east Bali was the true double-ikat patterning achieved. It is suggested that the ancestors of this remote village may have come from the eastern coast of India and brought the methods with them. Simple backstrap looms were used to weave the narrow widths of *geringsing cloth*, the local name given to fabric worked in this double-ikat process. There are many taboos and customs connected with both the weaving and wearing of the precious cloth, as it is considered to have magical properties. Cloths were used in rites-of-passage ceremonies and offered to the Hindu gods.

Tie-Dye on Fabric

Tie-dye, known in South-East Asia as *plangi* or *pelangi* meaning 'rainbow', is a resist technique found in most areas of the world where textile workers both produce and dye cloth. There are many different ways of tying and folding the cloth to make resist patterns, the simplest one forming a white pattern on a coloured background.

The easiest method is to bind a thread round a pinched-up section of cloth and repeat the process. A pattern of circular spots will be formed when the bindings are removed after dyeing. A metal hook placed on a stand is used to hold the cloth in position, while a fine thread is bound round the point, a technique used in Japan today. The tied 'pimple' is removed from the hook, and the tying repeated without cutting off the thread. When the fine threads are unwound, the grid pattern of raised points will keep formation until washed or ironed. Objects such as coins, stones or buttons tied into the cloth make different types of circles, while twisting, knotting or binding the cloth round other objects will all make a pattern, providing the binding thread is firm enough. Folding the cloth and tying will produce other types of pattern, depending on how it is tied.

No one knows where the craft originated, but both Japanese and Chinese workers are expert at producing these tie-dye cloths, and the technique spread to India and into South-East Asia. Superior cloths included tied dots of different scale and spacing so that designs of animals and other motifs could be worked. Dyers in the Lake Erhai area of Yunnan Province use these methods to decorate their

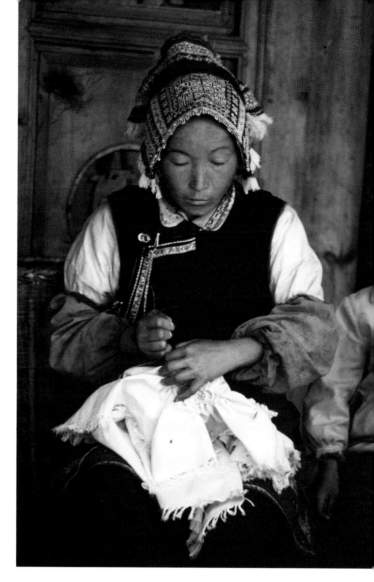

Lake Erhai, in the western area of Yunnan Province, South-West China, is famous for both batik and tied-resist dyeing. A Bai woman, wearing a series of indigo-dyed head-cloths, is working a sewn tritik *pattern into the white cloth.*

square head-cloths that are first fringed all round by withdrawing the edge threads. These small cloths are dyed in indigo to leave a pattern of white 'butterfly' spots. Several folded cloths are layered on to the head, the fold of each one protruding slightly at the front.

Cambodia and Malaysia

This same technique of little raised spots is used to make the silk head-cloths known as *kiet*, worn by the Cham women of Cambodia who were of Malay descent. Gillian Green tells us that these head-cloths are also called by a Khmer word meaning 'scales of the *nak*'. This is a very apt description of the fabric covered with the tiny raised points, looking very much like the serrated skin attributed to this mythical river dragon. Before tying, the kiet head-cloths

were first folded in half horizontally, then again in half vertically. The pattern of circular spots was tied through all four layers, so that when opened out, the pattern is symmetrical; this results in half of the spots being indented on alternate quarters of the fabric. *Plangi*-decorated cloths are also worked in areas of the Mekong river. Fishermen followed fish supplies and made temporary homes on islands and sandbanks exposed in the drier season. It is possible that the technique travelled upriver as the boat people traded with the local population.

Indonesia

Plangi (meaning 'rainbow', to express tie-dye) was an important technique used in Sulawesi, where sacred cloths decorated with circular patterns were hung on poles to mark the house of a tribal member who had died. Plangi-dyed cloths were also used in areas of Bali, Java, Kalimantan, Lombok and Sumbawa. Palembang, in southern Sumatra, produced cloths in patterns of a definite Indian origin, using the zinging colour combination of crimson, green, pink, violet and yellow.

Sewn tie-dye, known as *tritik* or *teritik*, gave the worker more control over the finished design. In Java, the technique was used to make the patterns on the women's breast-cloths, and in Sumatra, tritik was combined with plangi on the silk cloths worn as shawls by the women. Pattern areas are sewn with parallel rows of running stitches using a strong pineapple thread; these gathered threads are pulled together and then tied. Additional colour can be

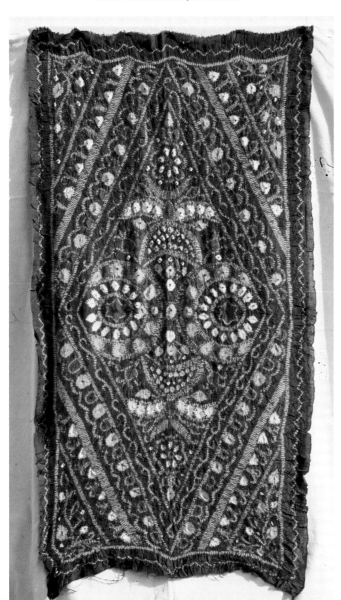

A silk kiet, *worn by the Cham women of Cambodia. This head-cloth, which comes from the Mekong river area, has an old tie-label which states 'Phnom Penh, French Indo-China, 1937'. Provenance: Joss Graham*

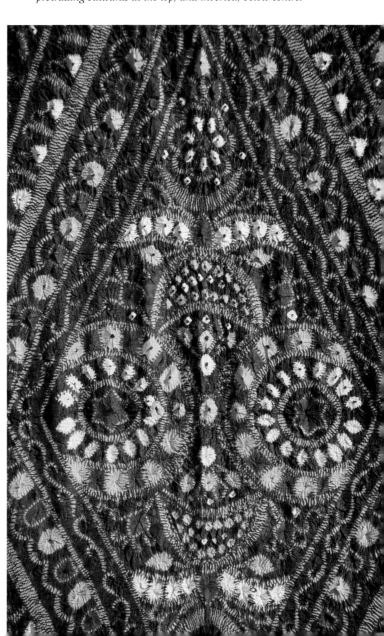

Detail of the kiet, *showing the cloth folded with the untied 'points' protruding outwards at the top, and inverted, below centre.*

introduced by removing or adding the bindings and immersing in a second dyebath. Colour is built up from light to dark, the last dyebath determining the final ground colour. Both cotton and silk are used for tie-dye, but heavy grades of fabric are not suitable.

Batik

Batik is a patterning method that relies on various substances to form a resist before dyeing. Patterns on Sudanese ceremonial blankets are drawn with rice paste, while in Sulawesi rice paste is used as a resist for wooden printing blocks. In other areas, starch pastes such as sago are used. Wax is more common, heated to a liquid and applied to the fabric with a metal tool that varies in shape from country to country. The viscosity of the wax is important: too hot and it will flow too freely from the drawing tool, too cool and it will not flow at all. In the past, beeswax was

A square cloth, made for tourist sale in Kuala Lumpur, Malaya, is an example of a large-scale batik wax design based on flower and leaf motifs.

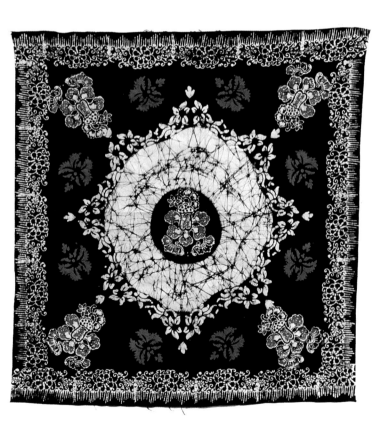

readily available, but nowadays a mixture of beeswax and paraffin wax, or of paraffin wax alone, is used. The various types of wax react differently to heat, and judging the correct temperature is an important aspect of the waxing process.

Fabrics and Dyes

Although silk fabric is used frequently for batik work, the usual material is a cotton cloth with as smooth a surface as possible, or a hempen fabric for less detailed work. In many of the South-East Asian countries the native cotton was too coarse to allow the fine design lines that were part of the artist's traditional repertoire, so fine Indian cotton cambric was preferred for the backgrounds. By the early nineteenth century Dutch machine-woven cotton material was imported from Europe. Later, cotton fabric came from Japan, but today Indonesia produces much of its own machine-woven fabric.

In Java the cotton was prepared by washing, soaking in vegetable oil, beating with wooden bats to make pliable, then starching to prevent the wax flowing too readily. Similar methods were used in other areas. When a design is completed and the wax has cooled and hardened, the fabric can be dyed in a cold water solution. Alternatively, the dye can be painted on to the fabric, giving an entirely different look. Once again, pale colours of the initial dyebath can be waxed over when dry, to preserve the colour underneath. The worker starts with the palest colour and gradually builds up the wax layers in stages until finally, the deepest dye colour is used.

The wax is removed by scraping off the surplus, followed by boiling the cloth in a pan of water. The melted wax will float up to the surface of the water and when cold, can be removed and re-used. In some areas a 'crackled' surface is much admired, so the finished cloth is entirely covered with a layer of wax, which is crunched up when dry. The cracks in the wax surface allow the dye to seep through, and this effect is so admired that these cracks are copied as part of the design in imitation 'printed batik'. After waxing, the cotton was first dyed in indigo blue, re-waxed and then dyed in soga brown. This resulted in the traditional Javanese colours of cream, golden yellow, brown and indigo blue. If red is required, the cloth is soaked in an alum mordant solution of djirak leaves to fix the madder dye.

The Chinese were established manufacturers of batik, both for local and export sale, featuring designs adapted from classical Chinese embroidery such as the meandering 'storm cloud' pattern found on imperial robes. Chinese entrepreneurs introduced the use of chemical dyes to northern Java in about 1890, including synthetic indigo

A selection of triangular batik pen tools is displayed on a wax design before it is immersed into the indigo dye. Tools to left and centre are old, the ones on the right are new.

and alizarin. These dyes gradually took over from the natural dyestuffs, being much easier to use and fast to washing and sunlight. This tended to destroy the subtle colour schemes afforded by the native dyes, but natural dyes are still used for special textiles in many of the areas.

Differences in Tools

The wax is heated in a pan or any metal receptacle that will withstand the heat of a charcoal fire or small oil-burner. In modern batik studios, electric temperature-controlled heating pots make life easy for the batik artist. The village batik worker does not have this advantage, and the wax pots are continually moved to a different part of the charcoal fire which is set within an iron pot, placed beside the worker.

The greatest difference is in the metal tools, or pens. In South-West China, a small triangle of folded brass is fitted into a wooden handle by binding the upper point in place with cord or copper wire. The wide triangle base is left open to form a narrow crack through which the hot wax

flows. These triangular tools, which come in different sizes depending on the thickness of the line required, probably developed from the bird quills with shaped and cut ends, used for waxing in the past. In the hands of an expert, the finest of expressive lines, curves, spots and subtle shapes flow from the tool, which is held like a pen, but facing backwards. In Anshun, in Guizhou Province, members of a study group were instructed by a local artist, only to find that her fluid lines were difficult to copy, with resulting blobs and thickened lines, impossible to remove. There is no room for mistakes in the waxing process.

In Indonesia the tool is called a *'canting'* or a *'tjanting'* (pronounced 'chanting'). The shape is completely different and easier to control than the triangular tool, being like an oval, miniature brass saucepan attached to a bamboo or wooden handle. A curved spout at the front, through which the wax pours out, is used to draw the lines. Refinements are the addition of one, or a number of little spouts so that a series of parallel lines can be drawn at one go. This type of canting tool was not known in India, where cloth was painted with brushes, but is thought to have originated in central Java, where it was once used as an art tool by the court ladies.

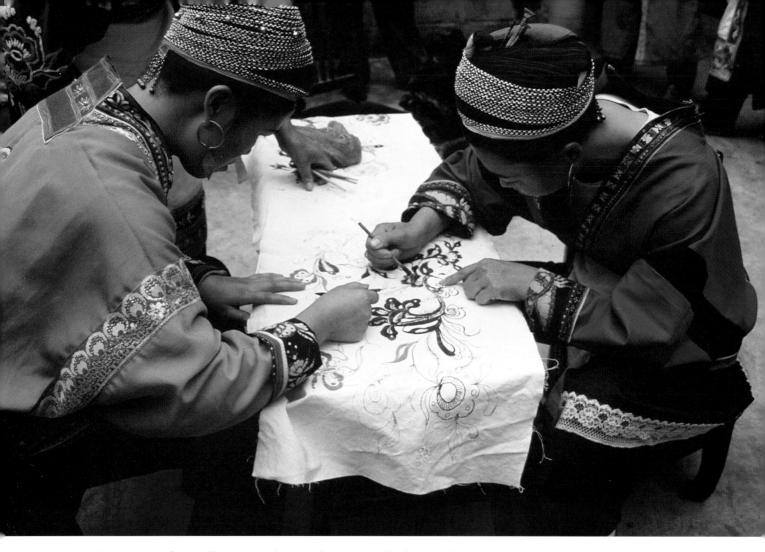

Two Miao girls from a village near Anshun, Guizhou Province, South-West China, working together to produce a batik wax design, the one shown with the tools.

Indigo Batik in South-West China and Areas of the Golden Triangle

The pleated skirts worn by the women of these northern areas are decorated with blue and white indigo patterns. Within the geometric framework the women work as individuals, using the structure adopted by their particular area or village, but with personal modifications. The indigo-patterned cloth is inserted into the width of the skirt, together with similar bands of cross-stitch and decorative braids. Strips of applied fabric may later be added to the indigo cloth, creating a further decorative element. The indigo patterns lose some of their definition when pleated, but take on new formations as the pleats overlap.

The pleated skirts found in north-western Thailand have patterns that are very similar to those of South-West China, evidence of a shared culture. Bands of batik fabric decorate jackets and aprons in the majority of the tribes who use this wax-resist technique. Both cotton and hemp fabrics are used as a base for the waxing, normally of beeswax, though paraffin wax is now introduced into commercial workshops.

In Guizhou Province the women work on a flat board. The fabric is held at slight tension by applying wax to the edges to hold it firmly in place. The main grid of the geometric pattern is drawn in first, with the finer lines and dots filled in afterwards. In the Kaili area the fabric is folded in half, right sides outwards, before dyeing. This gives a paler wrong side to the fabric, as the dye does not penetrate right through the material. Alternatively the fabric is covered with a starch paste to give a smooth surface which prevents the wax from penetrating right through the cloth, resulting in a more definite resist.

A completely different type of indigo-dyed pattern is found in other areas of South-West China, including Guizhou and Yunnan provinces, where members of the Bouyi tribe live. It is said that these tribes may be descended from the Dong Son culture people, as their spiral and circular patterns are similar to those found on the famous bronze drums. The spiral designs are waxed on to cotton cloth in a series of closely worked fine lines – testimony to the expertise of these talented artists. In some villages, parts of the design are filled using a yellow dye,

enhanced with darker brown lines. Bands of batik-patterned cloth are applied to the sleeves and cuffs of indigo-dyed jackets, as well as down the front lapels.

The Gejia women of Guizhou Province prefer more naturalistic patterns to decorate panels for tourist sale. The floral motives with leaves and trailing stems are probably influenced by traditional Chinese embroidery designs. However, spiral and geometric patterns are used to decorate their helmet-like caps, jackets, short pleated skirts and little aprons. In this instance the cloth may be stretched on to a frame, or laid on to a board. A Gejia girl demonstrated the process, starting with orientation dots placed on to the white fabric and gradually building up the design in stages with the heated wax tool.

The girls who live in Loujia Zhuang village near the city of Anshun also choose floral patterns. The firm cotton cloth is spread on to a low table so that two girls can work together, sitting on stools placed at either side. The fabric is not fixed down, which allows different parts of the design to be reached by moving the fabric. The finer outlines are worked first, using the triangular tool, and then thicker waxed lines are added afterwards. A tin can holds the wax, set into an iron pot of smouldering sawdust. When completed, the cloth is dyed in indigo and the wax removed to reveal the blue and white design. Sections of floral batik pattern outline the cuffs of the girl's brightly coloured jackets, as well as the shoulders, back collar and front bands.

Painting with Additional Colours

A more precise method of colouring the wax-resist fabric with fabric paints is used in Guizhou Province. A commercial artist demonstrated her pictorial work in the city of Guiyang. She outlined the designs of naturalistic flowers and butterflies with a deep brown-coloured wax that was not intended to be removed or boiled out. She drew a series of very fine lines with the triangular tool, giving the effect of a wood etching. Certain parts of the design were coloured in, leaving other areas bare and the background fabric of white cotton untouched. The result was delicate and quite unlike traditional batiks or paintings.

This is similar to the Indian technique known as *coletan*, where synthetic dyes are painted into waxed outlines. However, the design motifs are then covered with wax, both back and front, so they can be immersed in the dyebath and the wax finally removed by boiling. This speedy method is used by the Javanese commercial workshops. A different method, used in Anshun in Guizhou Province, is to add brightly coloured synthetic dyes to areas of the design after the wax has been removed.

Batik Wax Methods in Indonesia and the Islands

There are several distinct types of wax batik work in this area. Diane Gaffney has made a study of Javanese batik methods and produced a useful collection of cloth samples. The simplest one is a white pattern on a blue background. The white cotton fabric is patterned with wax using the spouted canting tool, and then dipped into an indigo dye. This blue and white cloth was produced in a small workshop in Jogjakarta in central Java, thought to be the place where the batik process originated.

Javanese 'Batik Tulis'

The hand-applied batik differs from that of the northern parts of South-East Asia in that the design is waxed on both sides of the fabric. This requires great precision. The fabric is not laid flat, but is hung over a horizontal frame or rod, and the worker picks up the free-hanging cloth and waxes a section at a time. The canting spout does not touch the actual fabric, thereby allowing delicate freehand patterns to be drawn. When one side is finished, the reverse side is held up to the light and waxed to match. A brush is used to make thicker lines or to fill in larger spaces. A cloth can take several months to complete, and initially this time-consuming technique was reserved for royal and aristocratic long-cloth sarongs and *selendang* shawls.

Stamped or 'Cap' Batik

In areas of central Java during the nineteenth century, a method of stamping wax patterns on to the cloth was developed from European block-print stamps. Although quicker than traditional tulis work, a high degree of expertise is needed to produce the best results. The *'cap'* or *'tjap'* (pronounced 'chap') is a metal stamp made of thin copper strips which are soldered upright to an iron framework supported by a metal handle. The pattern outlines are formed from double strips of copper, folded and twisted to form the design. Flower and leaf shapes are filled with folded loops and thin slices of copper to make delicate veins and fronds. Other spaces are filled with 'dots' made by inserting a series of upright, closely packed copper wires. All is then filed level to provide a completely flat surface.

The fabric is stretched on to a padded table and the cap is used to pick up wax from a covered pad placed on a perforated copper filter set into a pan of hot wax. It is then stamped on to the cloth with a repeat pattern designed to fit together. Double-sided batik was worked with a pair of mirror-image copper caps stamped on both sides of the

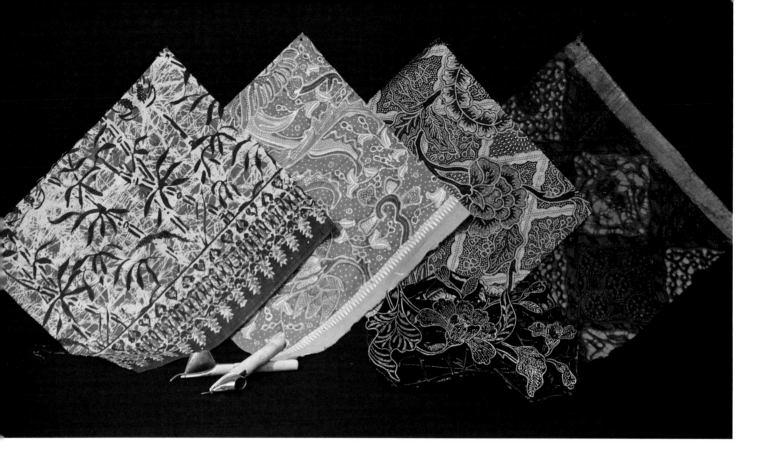

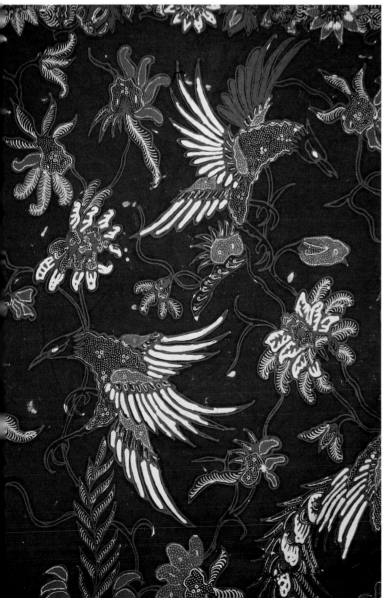

Indonesian wax resist samples from Java and Bali. FROM LEFT TO RIGHT: *Balinese 'combination' batik: waxed background with block prints superimposed; batik Tulis, hand-waxed using a canting tool; north coast batik, from Pekalongan – floral patterns show Dutch influence; cap batik waxed with a copper stamp from Solo in Central Java.* LEFT FRONT: *Two batik wax canting tools.* RIGHT FRONT: *A copper cap for printed batik. Samples from Diane Gaffney of 'Textile Techniques'*

LEFT: *Detail from an antique sarong from Java, worked by hand in the batik tulis technique, shows a design of exotic birds in a floral setting. Gift, Janice Williams, 1995*

fabric. The town of Solo in central Java has long been famous for this copper stamp work, used to decorate the sarongs worn by the upper classes.

North Coast Batik

The area around the town of Pekalongan on the north coast of Java has always been open to influences from surrounding countries, or those connected by sea trade, especially the Arab merchants and Chinese settlers. It was the colonial Dutch who were responsible for a highly decorative influence in the batik patterns. The colourful melange of flowers, birds and butterflies utilized as patterning on the sarongs resulted in a much brighter version of the normal stamped work. The copper cap was the ideal tool to produce these intricate designs, formed of leaf-vein lines and a

myriad of little dots, which both filled and outlined a pattern in shades of blue, cream, brown, purple, red and black.

The Dutch traders soon realized the importance of batik fabrics to the people of Java, especially to their workers in the plantations. This led to Swiss and Dutch manufacturers in Europe producing vast quantities of machine-printed 'batik-patterned' fabrics, which before the American Civil War of 1861 were of imported American cotton. When this was no longer obtainable, Chinese, Arab and Eurasian merchants set up batik businesses on the north Java coast, using the traditional stamped and drawn wax methods. Local craftswomen worked the popular 'Indische' designs, adapted from Dutch botanical books and floral paintings.

Pekalongan in Java was famous for a number of Indo-European women designers, including Eliza van Zuylen who worked from the late nineteenth century until the 1940s. She became known for her 'floral bouquet and ribbon' designs, worked in the traditional batik-tulis method. Colourful Javanese patterns were provided for the local people, and Japanese-inspired patterns developed for export to Japan.

Malaysia and Singapore

This area is well known for the block-printed batiks that show large floral designs, including the popular 'flowering tree' derived from the Indian painted cloths. The background area is filled with wax, which is then 'crackled' to give added interest, and unlike Javanese batiks, colours are allowed to overlap. Block-printed patterns were used on sarongs and women's head-cloths during the early twentieth century, probably influenced by naturalistic wood carvings. By the 1920s wax cap-printing was introduced, followed by wax screen printing, called batik *kotak*, where the pattern is waxed on to the reusable gauze screen, not the cloth. This acts like a stencil, and the dye is painted through on to the cloth beneath, thus saving time and labour, but giving a different look to the finished product.

Balinese Batik

Although the batik methods were not indigenous to Bali, the Balinese workers adopted the Javanese technique to produce batik textiles for local sale and for export. They

originated a 'combination batik' that consisted of waxed and 'crackled' backgrounds with a block print design superimposed on top. The result is quite different, as it is obvious that the dark, indigo block-printed pattern has no connection with the crackle background. This does not detract from the liveliness of the designs, but provides yet another instance of the creative adaptability of these island people. The Indonesian workers in Bali became famous for their batik-painted wall hangings. To save time after waxing, the colour is painted or sprayed on, and the resulting 'pictures' are bright and vibrant. They are sold as tourist items.

Javanese and Sumatran Batik: the Importance of Pattern

In a society where the decoration of cloth was more important than weaving or embroidery, there was bound to

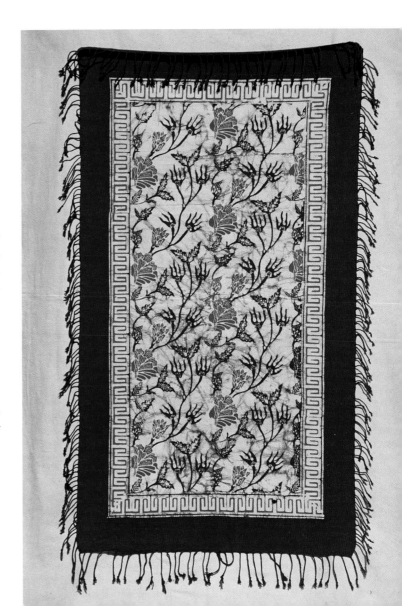

A fringed shawl has a 'tree-of-life' motif worked as a repeat pattern in wax resist with a heavily crackled surface. Singapore, 1989

be a hierarchy where patterning became the defining instrument of class structure. Certain patterns were 'forbidden', reserved for royalty and with severe penalties for misuse by the common people. The main patterning was on the sarongs and *selendangs*, but is also found on headcloths and sashes. The sarongs were divided into sections, with each section decorated in a different manner. The main body, or *badan*, was interrupted by a broad band called the *kepala* or head, containing rows of *tumpal* triangles, which faced in mirror image.

Examples of old Javanese batik fabrics are combined to make a patchwork coverlet. Designs include the diagonal Garis Miring, the Kawung elliptical shapes, Ceplok flowers and fruit, and several examples of Garuda wings, single or in pairs. From Diane Gaffney of 'Textile Techniques'

Motifs

The patterns feature the floral and popular motifs such as birds and elephants, sea creatures, insects and butterflies. These are freely interpreted within the design, often forming parts of repeated elements coming under the category of the 'tendril' or *semen* pattern. These include vegetation, flowers, rice fields and mountains, interspersed with small animals and birds.

The *garuda*, a Hindu mythical man-eagle, may appear in entirety, or just the wings are shown. A single wing is a *lar*, a pair of wings is called *mirong*, while wings alone with a fan-shaped tail are referred to as the *sawat*. Other mythical creatures include the Naga serpent and the *Peksi Kingkin*, or sad bird.

Patterns

The *Kawung*, one of the principle 'forbidden patterns', has circular and elliptical shapes that overlap, forming a geometric grid pattern with the units varying in size.

The *Ceplok* pattern is a repetition of geometric shapes based loosely on flowers, fruit and leaves.

Ancient *Banji* patterns, which date to the Hindu-Buddhist period, are formed of interlocking geometric shapes, based on joined swastikas.

Garis Miring is the name given to a series of patterns that run diagonally across the fabric. The most important are called Parang Rusak, meaning 'broken knives'. These royal patterns show a series of interrupted curves, set in diagonal rows.

Nitik patterns are purely geometric, formed of circular motifs alternated with inverse shapes delineated with rows of dots and short stripes, resembling brocade weaving.

Puppets and Wall Hangings

The traditional Javanese wayang, or shadow-puppets, are made from perforated and elaborately painted leather. They had their origins in the leather puppets of southern India, and the art of shadow play is said to have spread to Java together with the Hindu religion. The plays feature episodes from the Hindu epics of the *Ramayana* and *Mahabharata*, with performances sometimes lasting from midnight to dawn. These puppets are worked from behind

the screen, and normally viewed from the front as a shadow play performance.

Painted designs on antique wayang puppets may show some of the classic batik patterns in use at the time, some dating back to the eighteenth century. Oval screen fans are also made from parchment leather, using the same method as that for the wayang puppets. These fans are used by dancers throughout Indonesia, and are decorated with scalloped edges and patterns similar to those on the puppets.

Rod puppets, called *wayang golek*, are meant to be seen. They are worked from below by the puppeteers, who are frequently on view themselves – which does not detract from the performance. In many instances these rod puppets are dressed in fabrics cut from old batik sarongs, which was one way of preserving precious scraps saved from worn clothing. The puppets have a certain elegance, partly due to their beautifully painted faces and partly to their expressive, rod-controlled hands. These decorative puppets frequently form the subject matter of batik pictures and wall hangings, normally made for the tourist market.

Painted and Printed Cloths

Some of the finest cotton painting came from the Coromandel coast, as this area of eastern India was well placed geographically for trade with the rest of South-East Asia. The painted cloths of India held a status and importance that could hardly have been visualized by the weavers and dyers who made them for export to the coasts of Malaya, Java and eventually into Indonesia and the islands of the archipelago. Even the painted designs attained a talismanic status and were copied by local workers in the hope that the patterns themselves would still be effective, even in translation to other media.

The very fact that these cloths had to be imported meant that they were costly and thus the preserve of the royal families and their aristocratic followers. They became a source of wealth, and were exchanged within their adopted countries, taking the place of gold or silver, and were even used as booty in warfare. Their rarity gave them value, and in Myanmar and Thailand they became an alternative currency for official tribute, gifts, marriage payments and even bribes. Gifts of imported Indian painted cloths were presented to the monks and nuns in the monasteries in Thailand. These were never worn, but were used as wrappers for the Buddhist holy texts written on palm-leaf sections. They could also wrap the monastic saffron robes when these were not in use, or be turned into the monk's shoulder bags. These gifts, however they were used, would bring merit to the donor, evidence of the great expense that had been incurred.

In Indonesia, long after they were used for prestigious clothing, the painted cloths were preserved as sacred heirlooms, kept in woven rattan baskets in the roofs of the huts. They would be brought out on special occasions: puberty ceremonies, marriage alliances, or used in healing and religious rituals. Although the people of Sulawesi used the actual Indian painted cloths as funeral shrouds, they also painted their own funeral cloths and banners. These sacred cloths, called *ma'a*, could be copies of the Indian cloth designs, but other patterns were used as well.

Both Balinese and Javanese textiles are decorated by painting the cloth. In the past, colours were obtained from

A political banner advertising the United Nations Seminar on Population Problems in Asia and the Far East, 1955. The batik background shows the diagonal Garis Miring pattern. Gift, Janice Williams, 1995

mineral dyestuffs including soot, which was used to make black, while iron-rich clays produced a series of reds and browns. Today, acrylic paints are more likely to be used. After the designs had been drawn with a pencil or charcoal stick, a paintbrush or a chewed twig was used to add the paint. Painted cloths from the Maranao weaving groups in the western Philippines, collected during the late nineteenth century, are in American museum collections. Designs that have a mixture of Javanese and Islamic sources are painted on to abaca cloth which has been pounded to make it soft, intended for use as bed-covers.

Political Batik

Batik has been used to convey a political or world health message. A printed cloth in the author's collection celebrates the United Nations Seminar on Population Problems in Asia and the Far East, held at Bandung, Indonesia, in 1955. The website for the Population Award Ceremony tells us: '... the governments realized that the prevailing rising population growth rates largely negated and even retarded the effects of national socio-economic

programmes.' The lettering on the batik panel, together with the United Nations logo showing the world surrounded with laurel leaves, is superimposed on top of a ready block-printed cloth, and does not show through on to the reverse side.

Bali and Java: Gilded Prada Cloths

Egg-white albumen formed a glue-base for the gilding that outlined the block-printed patterns in both southern Bali and on the north coast of Java. The technique was probably imported from India where a similar egg-white paste has been used for many centuries as gilding glue, although in Java a mixture of vegetable oil and earth mineral was an alternative solution. Wooden print blocks are smeared with the glue and then stamped on to the already printed cloth. Chinese gold leaf is applied to fabric in central Java, while gold dust is scattered over the glue-printed motifs on the northern coast. In both instances, the excess gold is gathered up carefully and re-used. In Bali, block-printed motifs are decorated with gold-leaf powder, but using a fish-glue solution rather than egg white.

Prada cloths with designs in tulis work of leaves and birds called 'Virgin Forest' were worn in Java, but floral patterns on a geometric background were exported to Bali, where tulis work did not exist. Cap-printed cotton with gold leaf decoration was exported to southern Malaysia for the folded and stiffened head-cloths worn by the men. Today, screen-printed versions of the block-printed cloths are made for the Balinese market where the prada fabric is made into sarongs, worn for temple ceremonies and dance festivals. First the cloth is screen-printed, and then the synthetic gold outlines are added. Normally the gilding follows the outlines of the printed motifs, but a different pattern may be superimposed on top. The golden outlines look very effective, and glitter in the sunlight as the women slowly twirl around in the traditional sequences of the Balinese national dance.

Apart from the traditional Chinese gold leaf that was imported into Indonesia, gold leaf is produced today in other mainland countries, including India and Myanmar.

Gilded prada cloth samples from Java. Cloths are screen printed with batik designs, then stamped with gold outlines using wooden hand-print blocks. Samples from Diane Gaffney of 'Textile Techniques'

Both Thailand and former Burma used gold leaf as decoration for temple and palace walls, while the devoted still attach pieces to statues of the Buddha. A modern gold-leaf workshop in Mandalay demonstrates the various stages of production – a traditional method that has not changed over many hundreds of years. Approximately 50g (2oz) of gold bullion is stretched to make a ribbon about 2cm (³⁄₄in) wide by 6m (20ft) long. This is cut into four equal lengths, and each length is cut into 200 equal pieces that are separated by interleaving them in a stack of bamboo paper.

This unit of 200 wrapped pieces is hammered with a 6lb hammer for half an hour. The enlarged gold flakes are then cut into six pieces, and these 1,200 pieces of gold are hammered again for half an hour. Three young men, standing side by side, hammer three separate packs of gold leaf, setting up a rhythmic sequence of synchronized blows. The number of 'blows' is counted, then the men have a rest, and then start up again. Each set of five flakes is reduced to three, and the 720 flakes are wrapped and hammered again.

These repeated processes take five hours, and the end product is wafer-thin gold leaf cut into sizes ranging from 5cm (2in) to 4cm (1¹⁄₂in) square, packed by interleafing in hand-made paper.

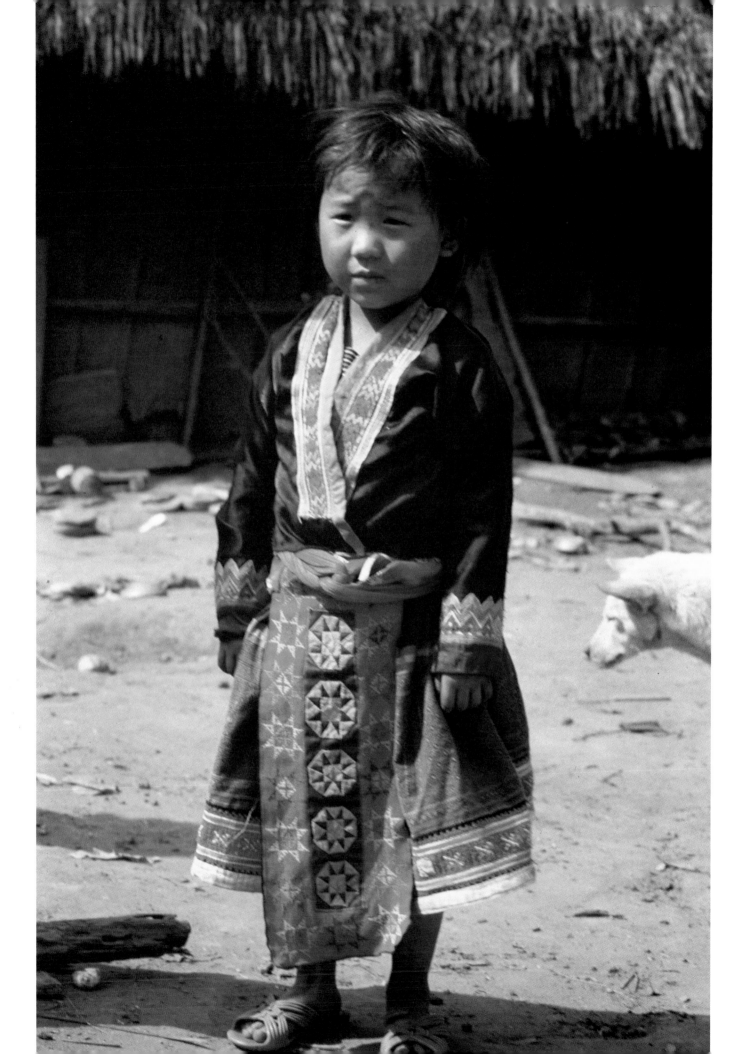

Embroidery and Appliqué

Geographical Variations

It is often said that embroidery evolved as a simpler method of decorating already woven textiles, but it is frequently more time-consuming to work detailed stitchery than it is to weave inlay or brocade patterning on the loom. A tube skirt or long-cloth already decorated with woven patterning required little or no further ornamentation. Rather than embroidery replacing woven patterns, it was the embroidery that gradually deteriorated in quality. Urbanized societies had little time to spend on craftwork, and less importance was given to the wearing of tribal costume. Tourists who purchased embroidered items were not very discerning, going for bright colours and an 'ethnic' look to the textiles. The embroiderers soon realized that they need not spend the amount of time and expertise once used in a former tribal context, where the quality of embroidery determined a girl's status and suitability for marriage.

Some of the tribes who entered the northern areas of South-East Asia from China and the Yunnan Province, brought with them a long tradition of stitched embroidery techniques. They stated their identity and allegiances, not by patterned weaving, but by the type of embroidery and decoration on their garments. Many of these people wore a closed version of dress, the women as well as the men in trousers with over-blouses or tunics, rather than the wrapped tube skirt found in the warmer southern regions.

Lengths of plain cloth were made by specialist weavers in the villages, or were purchased from markets or itinerant traders.

The Influences of Migrating Populations

China has a long history of embroidered textiles. Court embroiderers were employed to produce sumptuous robes for the emperors, their wives, concubines and members of the court. The damask-patterned silk fabrics were embroidered with fine silken threads using shaded satin stitch and the so-called 'forbidden stitch' or 'Pekin' knot, while couched threads in gold and silver added richness to the cloth. Rulers in northern Thailand, Myanmar, Laos and Vietnam aped their Chinese overlords, and where possible, obtained embroidered garments as gifts, or seized slave workers who were skilled in the art. Shamans and priests adopted Chinese embroidered tunics as talismanic garments to set themselves above their fellow tribesmen.

The practice of embroidery gradually filtered down to the level of the ordinary people, where the various types of stitchery flourished, although some tribes preferred to use a single technique rather than to diversify. Others combined various kinds of embroidery and appliqué, while beadwork and decorations were frequently added. Those tribes who came originally from China did not necessarily stay in any one place for long: wars, famine, loss of land, the threat of slavery, all drove the people to find new territories, and they naturally took their embroidery and decorative skills with them. Sometimes it is difficult to determine where these overlapping influences come from, at others the styles, stitches and motifs used, all point to a common ancestry.

OPPOSITE PAGE:
A little girl from the White Meo hill tribe of Doi Suthep, in North-West Thailand, wearing her best embroidered apron and an indigo-dyed jacket with embroidered revers.

The Influences of Foreign Trade, by Sea and by Land

The Chinese merchants sailed down the eastern coast of Vietnam, and then on south to the Malay peninsula, the area of the Malacca Straits, Sumatra and the northern shores of Java. Although their influence in Indonesia was more one of patterning than of embroidery, their textiles were much sought after and often formed part of royal regalia.

India had an early influence on embroidery designs when the Hindu religion was brought to Indonesia. This was overtaken by the Muslims when non-figurative patterns were adopted by the followers of Islam. It is possible that the chain-stitch embroidery found throughout Indonesia and into the Philippines came from India. Gujarat is famous for *Ari* chain stitchery – also called tambour work – which is stitched through the cloth with a tool resembling a fine crochet hook. The tambour embroidery frame, which originates in Turkey, takes its name from the circular drum shaped like a small tambourine. A similar technique is found in Sri Lanka (formerly Ceylon), where it is still worked today. Both needle chain-stitching and tambour chain stitch were used to decorate clothing and wall hangings.

Embroidered bed canopies (*ol-ol*) and curtains (*kulambo*) formed part of the royal regalia of the Muslim sultans of Maranao, in the southern Philippines. The beds were used as thrones from which to conduct audiences, and the textiles were embroidered with Islamic emblems and tales from the lives of the Prophet. From the age of three, the daughters of the Sultan were confined until they were married, in separate *lamin* towers or special quarters in the *torogan*, or royal family residence. They spent their time working embroideries, waited on by slaves and women of lower caste.

It was the Dutch colonials who brought European-style embroidery to Indonesia. The Netherlands had long been the source of fine lace and embroidery, and the home-produced even-weave linen fabric lent itself to counted work and pattern darning. These embroidery techniques were exported to the Dutch territories, but were carried out in local fabrics and threads. Imported threads and materials are used in Indonesia today, with cross-stitch and satin-stitch embroidery decorating the neckline and cuffs of the women's kebaya jackets and the lower borders of their sarong skirts.

Needle-weaving is a traditional embroidery technique found in Denmark and the Netherlands. Weft threads are withdrawn from the fabric and pattern-darning is inserted into the warp with a needle to make decorative borders, either self-coloured or using dyed threads. The Minangkabau women of West Sumatra embroider ceremonial cover cloths with central areas of satin-stitch embroidery using Chinese inspired designs. This central area is surrounded by deep bands of needle-weave stitchery in bright colours, depicting geometric patterns of animals and birds. Further bands of satin stitch and lace borders add to the richness of these textiles.

The Spanish nuns who came to the Philippines made use of the fine white fabric made from pineapple fibres, called *piña* cloth. This provided an excellent foundation for the whitework embroidery of chalice covers, napkins, altar cloths and the religious vestments worn by the Catholic priests. The converted Filipino women were taught the art of detailed embroidery, cut work and the lacy effects of pulled and drawn threadwork. Some of the nuns had originally come to the islands via the convents in Mexico, and through their expert tutelage the art of hand embroidery in the Philippines was to form the basis of a continuing export trade. During the earlier part of the twentieth century, tablecloths, tray-cloths and napkins had a definite Chinese influence in design, with dragons and other oriental motifs worked in raised and padded satin stitch. Today, embroidery on cotton fabrics is still taught in the convents, with the embroidered articles exported to North America.

South-West China and the Golden Triangle

Counted and Cross Stitch

Cross-stitch embroidery has always been regarded as a protection against evil and the sign of good luck. The mystic symbol of the cross is found in many of our cultures throughout the world. A straight line on its own barely makes a statement; but cross that line at right angles with another and immediately the strength of the symbol is evident. An upright cross-stitch method, called *Tiaohua* (picking pattern) or *Tiaoluo* (stitching in gauze) has been used in China since ancient times. It is worked as a row of single crosses, or as a variation called 'Chinese cross stitch', where a wider horizontal stitch is crossed at intervals.

It is thought that diagonal cross stitch may have come from the West to the areas of the Golden Triangle and then north into Yunnan Province, rather than the other way round. The art is highly developed in Afghanistan and the Karakoram mountain areas of North-West Pakistan. This remote area has a history of invaders and migrants from other lands, each bringing their own culture. The Persians established early settlements, and later the Greek military

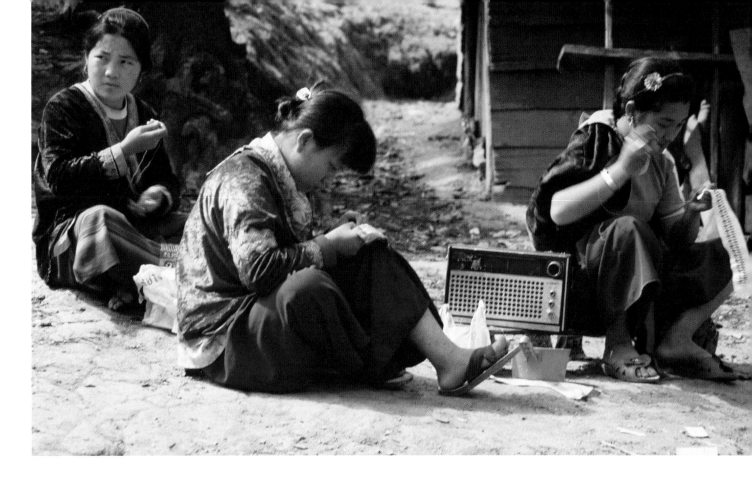

Women of Doi Suthep sit working at their hand-stitched embroidery.

expeditions of Alexander the Great reached this area, with subsequent Greek migrations through Afghanistan. Ottoman embroideries from the seventeenth to the eighteenth centuries, worked in double running stitch, were the inspiration for North-West Persian embroideries, called West Caspian. These designs, worked in cross stitch by the people of Pamir in the north of Pakistan, were copied by the people of Karakoram. Arranged marriages between noble families brought designs from outside the area. Thus a Hunza bride, returning home after her husband took a second wife, is said to have brought the Iraqi cross stitch to the Karakoram area where there is a definite resemblance to some of the Greek patterns.

Bands of cross-stitch embroidery, worked on to indigo-dyed hemp fabric, are inserted into the pleated skirts of the women of Guizhou and Yunnan provinces, as well as those of the Golden Triangle. Similar cross-stitch bands outline necklines and hemlines, are inserted into sleeves and form panels on the backs of jackets. A variation of the simple diagonal cross is worked by taking a long, slanting stitch from left to right and then crossing back at intervals, in a 45-degree angle from right to left. The patterns are all geometric, based on the grid formed by the intersection of warp and weft threads of the ground fabric; they have nothing to do with the 'paint-by-numbers' cross-stitch kits available in the Western world and popular even in modern Japan. Patterns, sometimes difficult to decipher, include the symbols and motifs that represent the iconography of the particular tribe or area.

Today, the difference is mainly one of scale. Antique pieces, such as the lapel bands from Nan in north-western Thailand, include cross stitches that are incredibly fine. Commercial workshops in the same area produce coarse hand stitchery on strips of 'aida' double-thread fabric. This cross-stitched band, several metres (yards) long, is wound up like a fire hose, ready to be cut into lengths and applied to indigo jackets and bags for export and tourist sale. In both northern Thailand and the Miao provinces of South-West China, the cross-stitch embroidery is worked from the wrong side of the fabric. It is not known whether this is to keep the fabric clean, or is a tradition imported from outside areas such as North-East Pakistan where the Pulkhari surface satin stitch is sewn in a similar way. The fine cross-stitch patterns on the Thai lapel bands are frequently outlined with contrasting backstitches or several rows of chain stitch. The close-worked designs on the small aprons worn by the Gejia girls in Guizhou Province are treated in a similar manner, and there is evidence of the technique throughout South-East Asia.

Cross stitch is used to decorate single-sided articles such as hats and hat bands, aprons, collars and cuffs, baby carriers, clothing and domestic furnishings. It forms the entire design on the Yunnan head-cloths. All-over geometric designs are first set out as a grid of cross stitches, with the internal sections filled in afterwards. If the pattern does not fit exactly, it does not seem to matter, adding to the liveliness of the finished article.

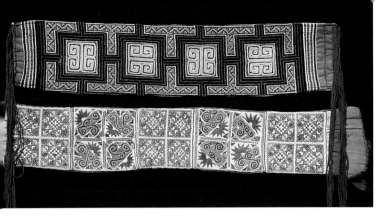

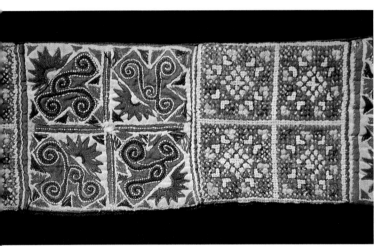

Cross stitch delineates the patterns on twentieth-century blue-and-white embroideries of rural South-West China, worked on cotton in indigo-dyed thread. Patterns showing motifs of animals and mythical beasts dating from as far back as the Tang Dynasty (618–906AD) were researched by Dr Carl Schuster during the 1930s. He collected tribal embroideries from isolated areas of Yunnan, Laos and Vietnam, looking for symbols handed down from ancient times. These motifs and medallions are still worked in these areas today. Eventually, the Schuster textile collection was divided and deposited in the Museum für Völherkunder, Basel, Switzerland and in the Field Museum of Natural History in Chicago. An oblong panel, purchased in Guizhou Province in 2001, shows typical patterns in blue cross stitch, similar in size and shape to one worked earlier in the twentieth century by the Miao Zhenfeng women of Xingyi County. Both panels include stylized peacock birds and flowers, temples and pagodas with ancestor figures. One border has a repeat pattern of fish and lion dogs, and both pieces contain the swastika symbol.

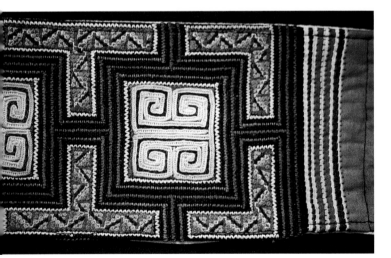

BELOW: Panel from a pair of Iu Mien woman's trousers showing geometric designs worked in cross-stitch. The upper border of yantra *motifs is embroidered in double running stitches.*

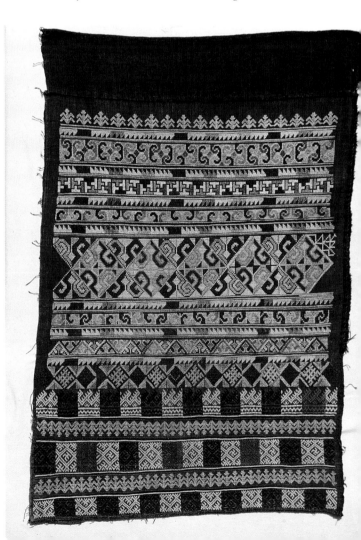

TOP: *Two embroidered belts: the top one is from the Sapa tribes of northern Vietnam, the lower one from the hill tribes of North-West Thailand.*

MIDDLE: *Detail of the belt from Thailand. Cross-stitch and double run outlines fill the alternating square grids. Satin stitch is worked over reverse appliqué motifs, combined with chain-stitch scrolls outlined with backstitch.*

BOTTOM: *Detail of the belt from Sapa. This is embroidered as a double running stitch worked as a minute triangle. Motifs are outlined with zigzag stitch, and the ram's horn motifs are in open chain, worked closely.*

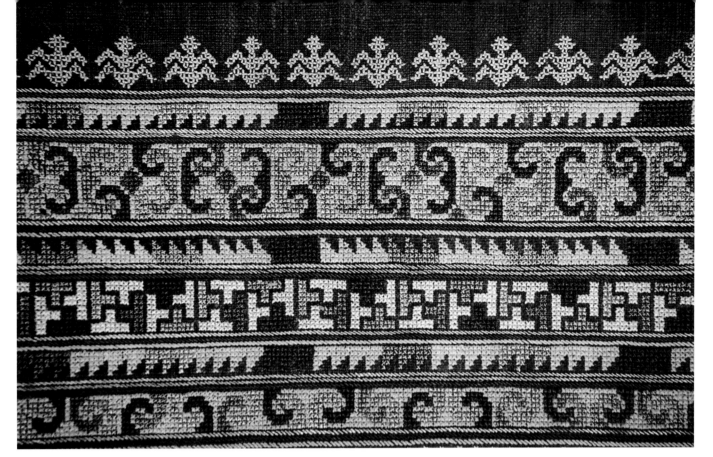

ABOVE: *Detail of the Iu Mien woman's trousers.*

RIGHT: *Detail of a Yao-Mien woman's trouser panel.*
A grid pattern of double running stitches forms a series
of cross shapes that interlock to form larger motifs.
(The trousers are illustrated on page 85.)

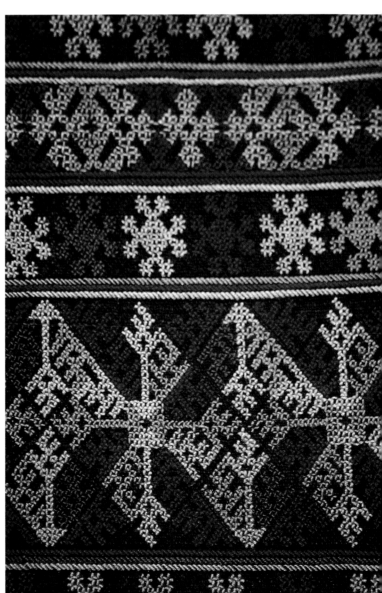

Double Running Stitch

In Europe, double running is called 'Holbein' stitch after
the blackwork embroidery on shirt fronts and cuffs,
depicted in Tudor portraits. The evenly spaced, straight
stitches are worked in and out of the fabric around the
motif. On the return journey the alternate spaces are filled
in, resulting in a pattern which is the same on both sides of
the fabric. This method was practised throughout Europe,
the Middle East and in the Hunza valleys of northern Pak-
istan, where it is used to depict geometric floral patterns
and other motifs in dark thread on a white ground. It has
even reached areas of Guizhou Province, where beautifully
worked panels decorate tying bands, shirt cuffs and sleeve
borders.

Double running is used by the Yao-Mien and Mun tribes
in northern Thailand and Vietnam to decorate the legs of
their indigo-dyed trousers. The patterns are generally
referred to as 'grid stitch', without any explanation of the
technique. An analysis of the grid-stitch patterns shows the
path that the double running takes. The basic motif is
cross-shaped – a central square with an extra square on

each side, making five squares in all. The stitches outline the squares in a sequence that fills in the spaces back and front, never repeating itself and always finishing at the starting point. The starting point can change, and additional cross-shaped motifs, or half motifs, can be added at will. These patterns, which are combined with bands of pattern darning divided by lines of stem stitch, frequently cover most of the outer trouser-leg area. Textile dealers often cut the legs away from the wide inset and sell them separately, thus destroying the meaning of the garment. Today, these trousers are embroidered with cross stitch, which is much quicker to do, but the previous fine-scale work was proof of the girl's embroidery expertise, showing both diligence and patience. These qualities would help her to give the right impression when seeking a marriage partner.

Pattern Darning

Double darning is a form of double running stitch, worked in close or spaced rows to form reversible blocks of colour. It is of oriental origin, found in Turkey and Central Asia, and it reached Europe by the sixteenth century, via the Ottoman Empire. The Dutch, who were experts in sampler making, brought the technique back east to Indonesia, where long, straight darning stitches are found in embroidery from the island of Sumbawa. Pattern darning is also used by the Miao people of South-West China to form geometric patterns in parallel rows of running stitch. This type of pattern darning is similar to woven brocade patterns, at times making identification difficult.

Counted satin stitch is used to produce diaper patterns covering both sides of the fabric – normally viewed from the right side only. The Bouyei women of South-West China embroider bands of close-woven cotton fabric with intricate geometric and lattice designs in vibrant colours. These bands are later applied to apron hems and jackets, or used double for belt ends that show on both sides. In many areas the stitches form borders or outlines for cross-stitch patterns, or become an intrinsic part of geometric designs. Surface satin stitch uses less thread, showing only a small stitch on the fabric back, and is reserved for single-sided embroidery.

In Myanmar, the Chin tribes use a type of darned stitchery on their wraparound skirts. A woven diaper pattern of red weft threads on a black warp is formed in the top shed only. These supplementary red threads do not show on the back. When the fabric is taken off the loom, fine scale stitches in yellow, white and green are darned through and around the exposed black warp threads which form the inverse of the diaper pattern. This embroidery is not easy to decipher, but the fact that the designs go backwards as well as forwards, rules out an inlay method. Nothing shows on the back.

Free Stitchery

Shaded Embroidery and Filling Stitches

Chinese classical embroidery was the inspiration for a rich folk embroidery tradition. The shaded satin stitch worked on the imperial robes in subtle colours was interpreted in bright cotton-thread embroidery, with flowers, leaves, birds and the full repertoire of mythical motifs decorating items of clothing, hats, shoes and accessories. Baby carriers are especially ornamental, the iconography frequently acting as protection for the infant. In societies where pushchairs and prams were unheard of, the baby carrier also acted as a status symbol. The women are both dexterous and creative

This baby carrier from Dali, near Lake Erhai in Yunnan Province, is embroidered in satin stitch, featuring a large floral spray, birds and a pair of little fish – emblems intended to protect the infant.

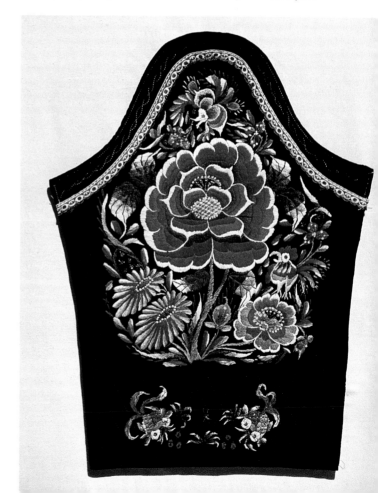

and the type of stitch used is not always apparent until analysed. Satin stitch is not the only filling stitch. Closely worked long herringbone stitch in silken threads forms the floral petals in circular motifs in Yunnan Province. In South-West China, close rows of chain stitch, long button-hole stitch and various looped stitches can also form a filling.

The Sgaw women of the Karen tribes in North-West Thailand use fishbone stitch in fine red cotton to fill the grid squares that cover the surface of their tunic tops. These are further decorated with long chain stitches and seed beads. On the high plateau of eastern Myanmar, the Shan tribal women embroider their jacket and tube-skirt borders. Lines of tucks are sewn parallel with the skirt hem, while the deep band above is filled with repeat patterns of zigzags in double running stitch. Motifs are outlined with split stitch and filled with a close buttonhole stitch.

In the late nineteenth century, the women of the Lamung region of south Sumatra embroidered the upper and lower sections of their ceremonial sarongs, known as *tapis inuh*. The freely worked filling stitches were embroidered in cotton and silk, together with couched metallic threads, sequins and flecks of mica. Designs show stylized figures, ships, spirals and buffalo horn motifs. Embroidery stitches decorate a twentieth-century jacket from western Sumatra, with chain stitch, straight and satin stitch covering the entire surface.

Double-sided and Silk Embroidery: Vietnam

The influence in northern Vietnam was classical Chinese, but from the tenth century onwards an embroidery tradition developed that had origins in the past history of the country. By the seventeenth century the art was concentrated in the Hué area, when the imperial palace fostered the technique of European embroidery combined with Asian expertise. The practice of stitchery by young girls was considered to be character forming, and at an early age they were taught to embroider in preference to learning how to read and write. Motifs and symbols were sewn on to costumes for the Vietnamese emperor and his family, with themes based on mythology and scenes from nature. Certain styles, still in use today, were first developed by a court official named Le Cong Hanh. He died in June 1661, and his name is still honoured in an annual commemoration ceremony by the XQ Hand Embroidery Company, whose workshops still produce the beautiful double-sided embroidery.

Young Vietnamese girls work exquisite embroidery in shaded satin stitch at the Hué workshop of the XQ Hand Embroidery company. Silk threads and embroidery frame sides are kept covered for cleanliness.

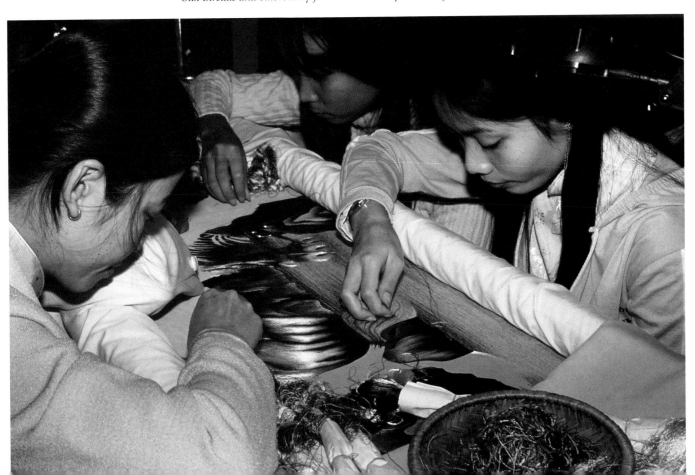

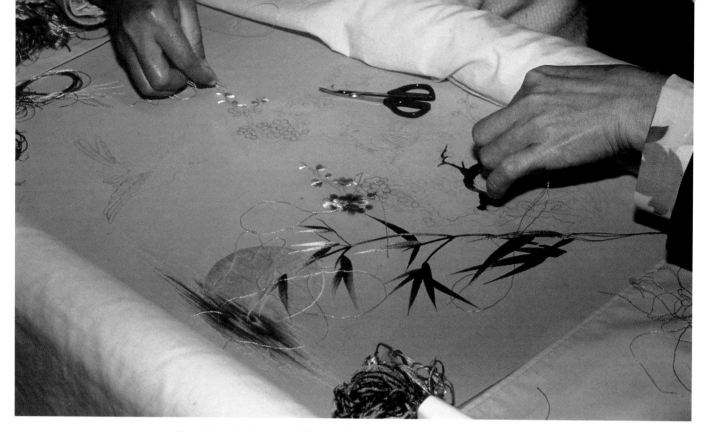

Two girls embroider a special picture showing bamboo stems and a full moon.

Embroidery in silk threads, using encroaching satin stitch, gives a shaded effect to floral embroidery and a naturalistic look to butterflies, birds, animal fur, flowers and foliage. Designs are drawn by an artist on to paper. Next, the pencilled outlines are pricked with a needle, the average embroidery requiring several thousand holes. The pricked drawing is laid on top of the background fabric, and a powdered dye is rubbed through the holes to transfer the design; in Europe this technique was known as 'prick and pounce'. The embroiderer has a choice of up to thirty coloured threads, in silk for highlights and 'DMC' cotton thread for other areas. The threads produced by 'Dofus, Mieg et Cie', a French firm of historical repute, were possibly introduced during the 1930s in French colonial times.

The average single-sided embroidered picture takes up to three months to make, but very large ones made for display areas can take a year or more. Twelve types of stitching are used, with as many as 400 stitches per 3cm square (just over 1in). The fabric is stretched and laced into horizontal frames, and up to four girls may work on the same piece. Single designs worked by senior girls are signed and certificated. Many pictures show landscapes, flowers and exotic animals, but occasionally the girls work from their own choice. Elderly people are looked up to in this culture, and wrinkled old men and women feature in many of the designs – subjects less acceptable in our Western society. Pictures are commissioned from catalogues or repeated to order, with exact copies of the originals produced, time and again.

The double-sided embroidery is worked on to silk gauze, in a satin stitch that covers both sides of the fabric. This is not the same as the Chinese double-sided embroidery, where two girls sit, one on each side of an upright frame, taking it in turns to take a stitch that barely shows on the 'reverse', enabling two different pictures to be worked at the same time. The girl embroiderers wear a uniform of the Vietnamese long dress, and the same Ao Dai dress is worn by the sales girls in the prestigious emporiums in Hanoi and Saigon, where these pictures are sold. A video produced by the XQ Hand Embroidery Company shows the girls working in an idealized setting, with gardens reminiscent of the imperial palace compound at Hué. They are shown wearing their long white dresses and cone-shaped hats, gently sweeping the paths with besom brooms and listening to poetry, possibly to indicate that the girls are inspired by a benevolent organization to produce even better and more meticulous embroidery.

Metal Threadwork

The application of gold or silver metallic thread to a luxurious fabric adds both to the value of the fabric, and the way in which it is regarded. Golden threads are applied to clothing and furnishings that are intended to show the wealth and status of a person. Metal threads are easily

abraded, and their delicate nature makes them unsuitable for use on working garments. Religious devotees present metal-embroidered gifts to the temples, either for the apparel of statues and deities, or to use as covers for relics and holy items, or as clothing for priests and temple dancers.

Embroidery

Metal-thread embroidery is found in all parts of China, in former Burma and Siam, in Laos, Vietnam, coastal Malaya and parts of Indonesia. Elaborate garments embroidered with the five-clawed imperial dragon were reserved for the Chinese emperor and his family; while Mandarin courtiers wore rank badges with bird designs, which changed according to status; animal designs were reserved for the military. Susan Conway tells us that although ceremonial embroidery was imported from China to the Lan Na Courts of former Siam, the ladies of the court enjoyed embroidering small domestic items, dress trimmings, and covers for the religious manuscripts with metal sequins and gold and silver wire. In Burma, the gold embroidery, called '*shwe-chi-doe*', formed a stiff embellishment on royal court costume,

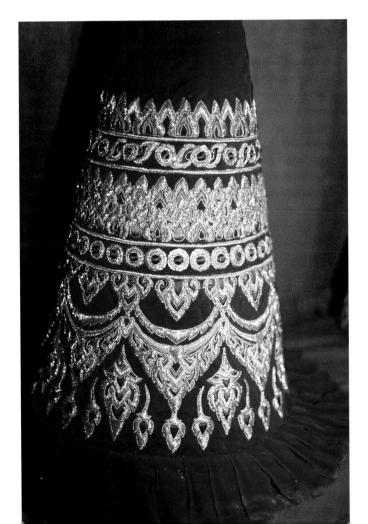

with the cut-out layers overlapping like reptilian scales. Examples are on display in Yangon National Museum, and the designs are reflected today in the costumes of the popular puppet shows.

In the past, embroidered articles were valued by the amount of gold present in the actual thread. Several ways of turning precious metal into a thread suitable for embroidery were devised, with the Chinese among the first to perfect a method. Their goldsmiths hammered flat the malleable ingots to form a thin sheet of gold; this was sliced into very narrow strips that were wound in a spiral round a core of silk threads. A cheaper method was to paint the gold on to paper, and in the nineteenth century the Japanese flooded a thin layer of gold on to rice paper that was cut into strips to form the famous 'Japanese gold thread'. Unfortunately the rice paper could deteriorate in damp weather.

Today, substitute 'Jap gold' is made from synthetic lurex sandwiched between two layers of transparent plastic. This is bright and does not tarnish, and looks best when used together with the older, mellow threads. The availability of cheaper metallic thread led to an aristocratic fashion for lavishly decorated textiles, often of a completely impractical nature. The ordinary people used lower grade threads, or yellow silk to imitate the gold. In Myanmar, tinsel-wound metal threads are produced in the villages today, to decorate embroideries for tourist sale. The tinsel-wrapped cord is made in the traditional way, by a girl twisting a length of plied thread with a wheel, while a boy walks away, adding and incorporating the tinsel as he goes. He returns to the girl, keeping the thread at tension, and the tinsel cord is wound up, ready to start the process again.

India

In India a completely different method of thread making evolved from the art of wire drawing. A candle-shaped silver bar about 4cm (1½in) in diameter and up to 102cm (40in) in length was covered with a layer of gold leaf by rolling on a flat table, allowing the gold leaf to adhere to the surface. The bar is then drawn through a series of holes, each smaller than the last. This gold-coated 'silver-gilt' wire could be drawn out to a length of up to 4 miles (6.5km), with the wire gradually becoming narrower and, miraculously, with a thin layer of gold still remaining on the surface. The wire was hammered flat and wound round a thread core, first by hand, later by machine. This fine

An offering cover in Chomthong Temple, Northern Thailand, is embroidered in couched metallic threads and padded silver leather, combined with emerald green gemstones.

thread can be taken through the fabric surface to form stitches.

India is famous for the production of gold and silver *purls*. Here, the drawn-out wire is wound round a spindle to form a tiny hollow spring. These pliable purls are cut into pieces and couched or applied like long bugle beads. The purls can be shiny and smooth, dulled to 'rough' purl, or wound round a triangular spindle to form 'check' purl. These Indian threads were in high demand and were exported throughout the area. The purls were cut into tiny segments, picked up with a threaded needle and sewn down flat, singly or in groups. They can be overlapped, or sewn in spirals. These tubular coils of wire are slightly flexible, and a curve is formed by sewing a shorter stitch length. Gilded leather or fabric was sometimes added, sewn to the background as appliqué, and padded to make a rounded shape.

Couching

Chinese embroidery is based on the surface couching of the precious metal thread, used to surround applied patterns and motifs. The threads are couched on top of the fabric by sewing in place at predetermined intervals with a finer thread. This may tone with the gold or silver, or contrast with the couched threads. Two lines of thin gold thread are couched down as a single thread: this is easier to control, especially at sharp corner points. Thicker metallic threads and cords are sewn down singly by opening up the ply and inserting the needle through the gap. The Chinese call the various types of outline couching by descriptive names. If a double or single gold thread is used, it is called *Quanjin* or 'encircling with gold'; and if the design is filled with laid and couched metalwork, it is called *Panjin* or 'filling with gold'.

Quilted and Machine Work

Although little pincushions and tribal 'courtship tokens' are padded to make a firm article, in hot countries quilting is seldom used as an embroidery technique. The exception is in body armour, where a stitched and padded garment helps to deflect arrows and spear points. Quilted clothing is used mainly in China and the colder mountain areas. Line-stitched patterns are worked in white thread on to backed or padded plain cloth items such as bags or baby carriers,

A young boy prepares metallic cord ready for couching round the motifs on kalaga embroidery. Mandalay, Myanmar.

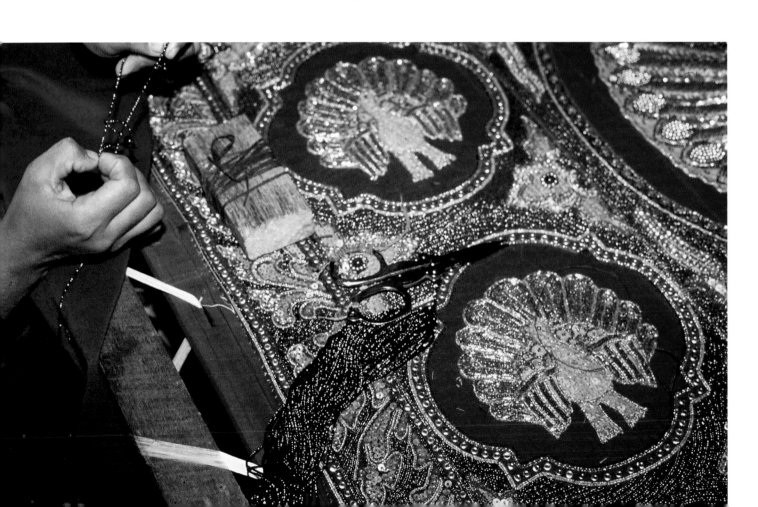

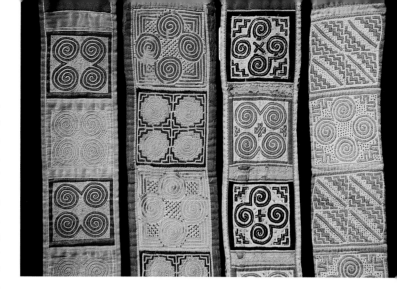

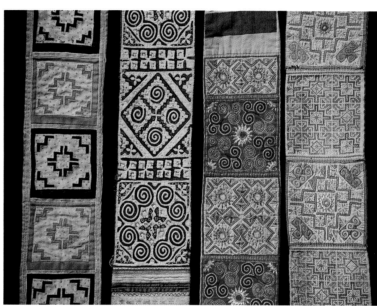

frequently by the men, using a treadle sewing machine or occasionally an electric straight-stitch machine. In many areas machines are considered to be masculine, so this is men's work. By the same token, men insert heavy metal zip-fasteners into beautifully embroidered purses, with little heed to neatness or placing.

Simple hand-sewing machines are frequently used for garment construction, even in remote villages in the highlands of Thailand. Applied cords are sewn under the straight-stitch foot by feeding the cord from above, tensioned over the shoulder. One hand is used to guide the cord in place on the fabric surface, while the other hand turns the machine handle. Commercial machine embroidery is normally practised in town workshops. It was interesting to see the prestigious *Luntaya acheik* tapestry woven pattern copied by machine embroidery on to the hem of a tube skirt worn by a Burmese air hostess.

In Indonesia, commercial machines are used to produce luxury fabrics for the women's *kebaya* jackets worn above the sarong skirt. Floral designs in machine satin stitch are combined with cutwork areas to produce lacy patterns. Well designed machine work helps to carry on an embroidery tradition that might otherwise be lost in a lifestyle which allows only a limited time for decorative handcrafts.

Appliqué and Patchwork

The decoration of cloth by applying a cut piece of fabric on top of another one to make a new design may have developed from the mending of a torn garment. Buddhist monks, although not allowed to cut up their monastic robes for fear of desecrating them, as a mark of humility may wear clothing formed from pieces of rag sewn together. Holy men and hermits wore these patched garments, which became more ragged with the passing of time. These revered patches were even copied in batik designs in Java, and scraps of special old fabrics were applied to new in the island of Sumba, possibly to preserve their potency.

TOP: Hmong lapel and belt bands. The fine workmanship of the reverse appliqué patterns dates them to the mid-twentieth century or earlier. FROM LEFT TO RIGHT: Luang Prabang, Laos – run stitches and seeding dots; North-West Thailand – satin and backstitch; North-West Thailand, Nan area – satin and backstitch; Luang Prabang, Laos – satin and backstitch.

BOTTOM: Hmong lapel and belt bands. FROM LEFT TO RIGHT: Luang Prabang, Laos – satin-stitch dots; North-West Thailand – reverse appliqué and satin stitch; North-West Thailand – satin, chain and backstitch; North-West Thailand – very fine cross stitch.

Techniques

Appliqué as an embroidery technique was practised in most areas of South-East Asia, including South-West China where it is combined with stitchery and metal-thread work. The methods used to hold the cut edges of the fabric vary, as does the treatment and design area of the applied cloth. The women of the mountain villages in Guizhou Province decorate the indigo-dyed resist patterns on their pleated skirts with tiny segments of yellow silkworm cocoon, cut into shape. These are alternated with strips of red fabric, turned under and hemmed to form part of the batik pattern.

Applied patterns are used in Thailand to decorate bags, aprons and the backs of garments. Cut-out patterns in red cloth applied to tourist-sale bags are not hemmed, but held on top with a white cord, machine stitched in

place. This is in complete contrast to finely worked appliqué on the antique sleeve bands, where the edges are turned under and stitched by hand. In southern Sumatra, floral designs of leaf and flower motifs are applied to a background fabric, with joining stems couched with metal threads.

A different form of modern appliqué is worked in areas of Bangkok, where large-scale motifs feature dragons, lion dogs and mythical creatures. These are cut from appropriately patterned fabric, applied to a coloured background and outlined with chain stitch. Further embroidery stitches, including stem and running, are used, together with decorative buttons. Appliqué with Buddhist symbols is found in Myanmar, together with the padded appliqué that is a feature of the Burmese traditional kalaga wall hangings, which have a preponderance of beads and sequins.

Machine Patchwork

A superb example of machine-sewn 'cathedral window' patchwork in the form of a baby carrier, was purchased in Kunming, Yunnan Province in 1987. The oval sections of the circular design are normally hemstitched by hand, but here, accurate machine work outlines the oval segments of

the pattern. The ovals contain a variety of coloured cloth insets with little silver baubles sewn into the centres. Satin-stitch embroidery and braid-work surround the pattern area, and the fabric ties of the baby carrier are machine stitched in white on blue.

Paper Cut-outs

Paper cutting is a Chinese folk-art tradition, used on festive occasions. Home-made or purchased paper-cuts were glued to silk fabric and embroidered over to make little shoes and purses. Even as far back as the Ming dynasty (1368–1644), gilded leather cut-outs were applied to fabric and covered with different densities of stitchery to expose more or less of the gold below. In many areas of South-West China today, patterns cut from paper are applied to fabric and

Heavily decorated baby carrier from Kunming, Yunnan Province, 1987. Raised satin-stitch embroidery is worked over a card cut-out. Motif curves are outlined with plaited braids.

Detail showing the 'cathedral window' patchwork pattern at the carrier base. This is worked by straight-stitch machine, and round silver beads are added to the intersections.

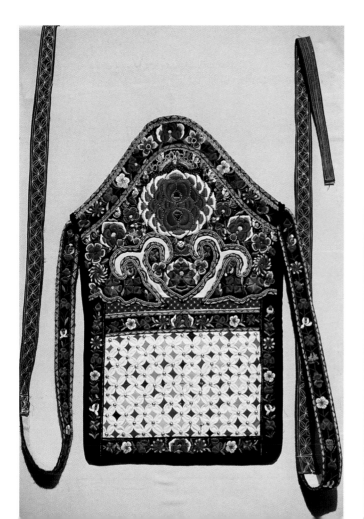

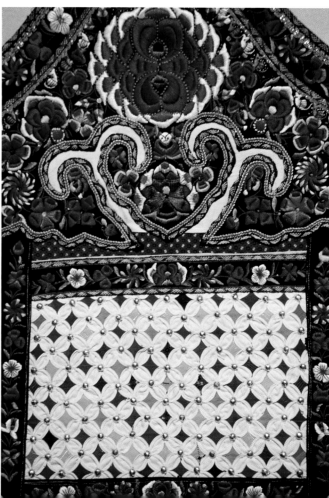

completely covered with close stitchery. This gives precision to the outlines of the motifs, at times enhanced with the addition of decorative couching threads. Differently coloured fabrics are glued behind certain design areas, which are worked and applied separately. A similar stitching technique has long been used in Europe and the Middle East for metal-thread embroidery, but with parchment or vellum as a substitute for the paper.

This process has been adapted by the minorities people to make appliqué patterns formed by cutting a shape from folded paper. The paper shape is glued to the back of indigo-dyed fabric, using a rice-paste or starch-based glue. In Shaui village, in the Loudian area of Guizhou Province, a woman was cutting out the pattern with blue-stained fingers, working deftly with the scissors, turning the piece this way and that to form the curves. This paper-backed, fabric cut-out was placed on to a contrasting background material and glued in place. When dry, coloured cotton threads were added to the outer edges of the pattern and couched to hold all in position. Metallic threads are used to outline the cut-out patterns on festive aprons, and a similar technique is worked on to stiffened baby carriers, worn strapped to the mother's back. These designs are also found on bags, oval fans, mirror surrounds, children's hats – anything that will support a stiffened surface. The paper cut-out can form a pattern for applied fabric designs where the paper is removed before stitching around the outlines, giving a softer feel to the work.

Today, some, though not all, Hawaiian quilt workers first cut the design for their reverse appliqué designs from folded paper, and use this as a pattern. Robert Shaw, writing in *Quilt Masterpieces*, puts forward the theory that missionaries may have brought the technique from Pennsylvania, where the German settlers practised '*scherenschnitte*', the central European art of folded paper pattern cutting. This poses the question as to whether folded paper cutting was the precursor of the folded fabric cutting method for reverse appliqué in Hawaii, Tahiti and the Philippines. Exactly the same folded fabric technique is practised by the Hmong tribes, although to a smaller scale. Either the folding and cutting method gradually worked its way westwards up into the Golden Triangle, or the Chinese method was taken eastwards by traders into the archipelago. Originally, the Orang Ulu from central Borneo incised pattern guides into flat pieces of wood for their intricate beadwork designs. Nowadays the wood is replaced with folded paper cut-outs, placed beneath the bead network – yet another link in the island chain.

Applied Patchwork

The definitions of patchwork and applied patchwork tend to be fluid, as the methods frequently combine. Technically, patchwork is a new fabric constructed from smaller pieces of fabric joined together by seaming. Applied patchwork may first be seamed and then applied to another fabric, as a whole, or in sections. If individual pieces of fabric are attached to the surface of a larger background, then it is appliqué.

The Akha and Lisu tribes of northern Thailand both use applied patchwork to decorate their clothing. The Black Lisu use applied patchwork alone, without the addition of cross-stitch embroidery. They are known for the bands of fabric that border their pleated skirts, jackets and tunics. The bands are made from joined strips of cloth that are cut up and rejoined to make chequerboard patterns, including one called the 'double eye'. These patterned strips are combined with applied bands of fabric that have been cut to form little hand-hemmed triangles along one edge. They are inverted and mirror-imaged to make saw-tooth patterns, occasionally with the addition of borders made from

Blue Hmong baby carrier, northern Thailand, mid-twentieth century. Machine sewing and hand stitchery.

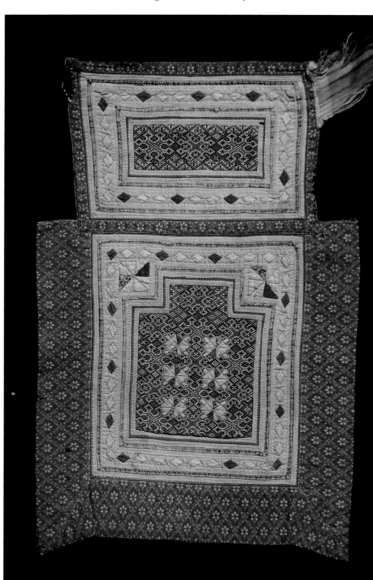

strips of narrow, machine-stitched cloth. Some tribes add little red pom-poms made of cotton thread, or windmill triangles of red fabric, sewn at intervals to an indigo-dyed, resist-patterned fabric.

Larger scale versions of the chequerboard patterns are made to form simple items for tourist sale, such as pin-cushions, mats and pot-holders, or padded 'good luck' tokens with thread tassels at the corners. These may have additional embroidery or couched outlines to the saw-tooth triangles. Circular designs of overlapping triangles in coloured patchwork are made by cutting narrow strips of fabric into oblong pieces. The fabric is turned under on the upper edge, folded at the centre point with the ends turned down, and joined together as a little triangle. This is attached to the background fabric with hidden stitches. The Chinese use a similar method to produce little triangles that are applied and overlapped like pantiles or animal scales. Geometric patterns are formed by the overlapping rows, and the dragon and fish are popular motifs.

Narrow bands of folded fabric are applied by machine to the zigzag outlines of the distinctive collars and the hat shapes of the Blue Hmong. These borders surround a grid pattern, where tiny applied fabric squares alternate with plain ones, both decorated with satin-stitch triangles and curved patterns in chain stitch. Another example of the combined use of machine sewing and hand stitchery is shown in a Blue Hmong baby carrier from northern Thailand, dating to the mid-twentieth century. Little triangles of pink, blue and green fabric are hemmed to yellow cloth bands inserted as surrounds to finely worked cross stitch bordered by the machined strips of applied cloth.

In the Philippines, a circular pattern of saw-tooth triangles decorates the fabric cover of a woman's conical straw hat, while similar patterns are worked on to the blouses and full skirts of the Bukidnon women of coastal Mindano. Appliqué triangles even form the main design element on the men's fabric-covered head-crowns. On a larger scale, Samal outrigger canoes, with patchwork sails featuring stripes and saw-tooth designs made from brightly coloured trade-cloth, sail around the coasts of western Mindano and the Sulu islands.

Reverse Appliqué

The Hmong People

The majority of patterns on antique sleeve bands are

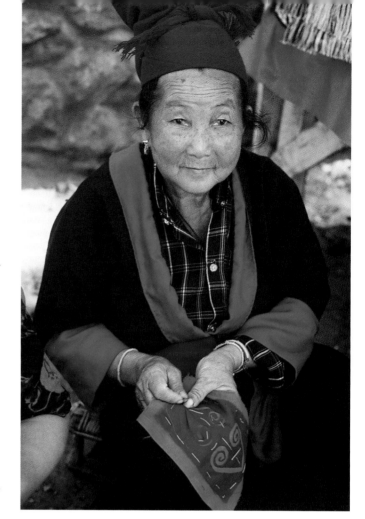

A Blue Hmong woman sits sewing in the Hmong market in Luang Prabang, Northern Laos, in 2001.

worked in reverse appliqué. Today, this technique is prac-tised by the Hmong people of the Golden Triangle, but worked to a much larger scale. These people were always fiercely independent, continually fighting against subjuga-tion. Their ancestor legends feature ice and snow, and in the distant past, they may originally have come to China from Tibet or Mongolia. During the nineteenth century they migrated from South-West China down to the north-ern areas of Laos, Thailand and Vietnam, seeking better conditions and release from a repressive regime. They brought with them their embroidery arts, expressed in geo-metric and spiral designs embellished with cross and other embroidery stitches together with the reverse appliqué, which they call 'Pa nDau' (pronounced 'pond-ouw') mean-ing 'flower cloth'. This refers to all their embroidery, whether or not there are flowers in the design.

The reverse appliqué motifs used in *Pa nDau* include the Elephant's Foot, Ram's Head, Pinwheel, Snailhouses, Stars, Sunshine, Circles and many more. All of these designs feature spirals, sometimes as an element standing on its own, but more often as mirror images of a pattern repeat, such as the curved ram's horn motif. The modern work is normally left plain, but the antique sleeve bands are further

decorated with embroidery stitches, backstitch, chain stitch and satin stitch, all to a minute scale. The curved incisions on the fabric are reminiscent of the spiral designs of the Dong Son culture, and these may have been the initial inspiration for the reverse appliqué patterns.

In reverse appliqué, an upper piece of coloured fabric is placed on top of the contrasting background material, with both pieces of a similar size. Design shapes are cut into the top layer, and the design lines are turned under and hemmed to reveal the colour underneath. The method of cutting the designs is based on folded cut-paper techniques, quite unlike the Mola patterns of Central America which have the design drawn on top. The upper fabric is folded in half twice, horizontally and vertically, with the creases marked with the finger nails. This may be folded again, on the diagonal, or with flaps turned back, all according to the chosen pattern. This multi-folded section is tacked (basted) round the edge and into the middle. Design lines are marked with the fingernail and cut part way only, but through all the layers. The marked piece is opened out and tacked to the background. Only in Snail-house pattern is the entire spiral cut in stages beforehand.

The central line between the curves of a spiral pattern is cut a section at a time with sharp, pointed scissors. The free edges of the cut fabric are teased under with the needle and carefully hemmed in place on either side to make a contrasting channel of the base fabric colour. When secure, the next section is cut and the process repeated. It requires skill to keep these curved lines even, whatever the scale of the work. Zigzag lines, called 'Dragon's Tail', are included on the inner curves by snipping triangles out of the cloth and hemming the turned edges in place.

The Philippines

The Tausug people, a dominant group from the Sulu archipelago of the Philippines, are justly famed for their appliqué wall hangings (*luhol*) and the decorative patterns that embellish flags, banners and the sails of their boats. Officials of the Sulu sultanate all had their own individual flag and pennant designs. This type of appliqué is similar to that worked in Hawaii and Tahiti, where intricate designs are cut whole from the folded cloth and worked in two contrasting colours only. The favourites are snow flake and floral patterns, and the tree-of-life design which is made for weddings and festivals. Animals and figures, seen on Tausug pennants, may hark back to pre-Islamic times.

There is evidence of patterning on the local abaca cloth, before imported cotton cloth was available during the nineteenth century, when the designs were worked on to fabric. The working method is similar to that in Hawaii and

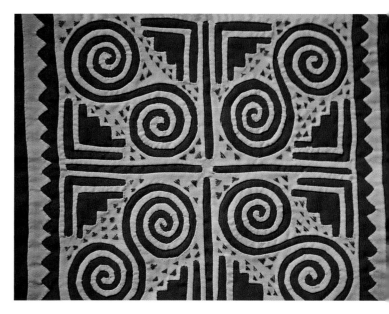

ABOVE: *Hmong reverse appliqué, called* Pa nDau, *uses spiral patterns reminiscent of the Dong Son culture motifs.*

BELOW: *The wrong side of the reverse appliqué, showing the stitchery methods.*

Tahiti, where the fabric for quilts was folded first longitudinally from side to side, then in half laterally, and finally a triangle is formed by folding the top right corner to the bottom left. Each fold is ironed flat, and the pencilled design is drawn on top of the final eight-fold section. All eight fabric layers are cut at the same time, the cut top is opened out, placed on to the contrasting base fabric, and tacked (basted) into position. Fabric for single mirror-image designs, such as the tree-of-life and various reptiles,

was folded once longitudinally before cutting the fabric. The design lines are then hemmed in place, working from the centre outwards.

Influences Resulting from War and Persecution

A second set of migrations took place during the Vietnam War, when the Hmong allied themselves to the American troops and their military intelligence services. Some of the Hmong acted as secret agents in enemy territory and became involved in sabotage and the supplying of resistance fighters. After 1975, when the Communists came to power, the Hmong collaboration led to persecution and retaliation, forcing many to flee north into Laos and others to refugee camps in Thailand. Various charitable institutions set up workshops to help market the embroidered goods produced by the womenfolk. Examples of the Hmong craftwork and embroidery have spread across the world, and are now available in many Western and USA ethnic textile shops.

Refugee Work: Hmong Story Cloths

The 'story cloth', sometimes referred to as a 'story blanket', is a narrative embroidery worked originally by a people who could not read or write. Embroidered pictures of village life have become one of the main sources of income for Hmong women, both in the settlements of northern Laos and the former Thai refugee camps. The women, used to the repetition of losing their homelands, feared that their stories and embroidery traditions would become lost to future generations. At first, pictorial embroideries worked in simple stitches such as satin, stem, herringbone and chain, dealt with the horror of the recent atrocities. Pictures depicting the flight of refugees over the Mekong River once showed Thai border guards with rifles aimed at the people. Since the 1970s these political embroideries have been altered, and sections showing scenes such as the gunmen have been unpicked — although occasionally, the original pencil pattern outlines still show.

During the early 1980s in the Thai refugee camps the men, who were not used to being unoccupied, started to draw the designs for the pictures, and some ended up doing the actual embroidery. The Hmong have settled in northern Laos, and in the early years the women decorated their clothing which they wore at the yearly festival in Vientiane. Later they adapted the designs for saleable items, and

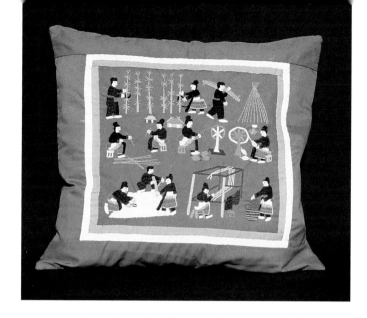

ABOVE: *A Hmong 'story cloth' forms the design embroidered on to a modern cushion cover. Little people are depicted harvesting fibres, spinning and weaving on a frame loom.*

BELOW: *A second cushion cover shows an agricultural scene with villagers pounding grain, feeding chickens and harvesting the corn.*

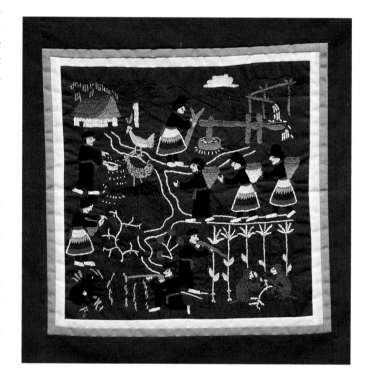

the women can be seen in the market in Luang Prabang, stitching story cloths as well as the reverse appliqué. The many Hmong people who emigrated to the USA set up groups to make all the different kinds of *pa ndhau*, including the reverse appliqué as well as the story cloths. These embroideries are now found in craft outlets and quilting exhibitions.

Today, these embroideries, which all go under the encompassing name of *pa ndhau*, are intended to preserve

The embroidery workshop for the disabled, Hanoi area, Vietnam, 2006. The young people are interpreting pictorial designs in straight-stitch embroidery, using mainly cotton threads. 'The True, the Good and the Beautiful Company.'

the culture of tribal life in a pictorial form. Large versions, big enough to form wall hangings, are on sale in the Night Market in Vientiane, capital city of Laos. The market is open all day, and the Hmong women sit at stalls with the larger embroideries pinned to the rear walls and the tables piled high with cushion covers, bags and jackets. Any surface capable of decoration is adorned with the embroidery, to some extent lessening the original story behind the 'blankets'. In spite of this, these pictures are delightful, showing scenes of rural life, where little people cultivate the land or practise the crafts of spinning, weaving and dyeing. They also show stories of heroism, and the myths and legends of the distant past. Festivals and New Year celebrations, marriage feasts and rites of passage, all are now preserved for future generations and for our delight.

Embroidery by the Disabled in Vietnam

In a craft workshop set up for disabled children in northern Vietnam, a section was devoted to the production of embroidered pictures. We were told that these children had been affected genetically, or by continued exposure to the chemicals used in the so-called 'Agent Orange' defoliant used by the Americans during the Vietnam War. This mixture of herbicides was sprayed by the US in Vietnam from 1962 to 1971 for the purpose of defoliating forest areas that might conceal Viet Cong and North Vietnamese forces, and for destroying any crops that might feed the enemy. Unfortunately these chemicals had a continuing effect, causing birth defects and congenital malformations from the 1970s onwards.

Although some of the young people in the workshop were deaf and dumb, a surprisingly happy atmosphere surrounded the tables where they sat in rows, all busy at their embroidery frames. Both the boys and the girls were only too pleased to show us their work, how they used photographs, drawings or picture postcards as a source for the designs drawn on to the white fabric background. This fabric was stretched and laced into an embroidery frame. The embroidery, in a multitude of coloured threads, was all executed in straight stitches used freely in the manner of single brushstrokes on a painting.

The design of each picture was repeated over and over again, like the silk embroidery from the professional workshops, but to a coarser scale. The accuracy was amazing, and a pile of finished pictures appeared identical, as though produced by a computerized machine. Many showed designs based on local scenery, with thatched huts, palm trees and rice paddies, while boatmen, all wearing conical straw hats, ply their craft through the rivers and watery inlets.

A typical scene of the area, showing boatmen carrying crops through the village waterways. Worked by the disabled children.

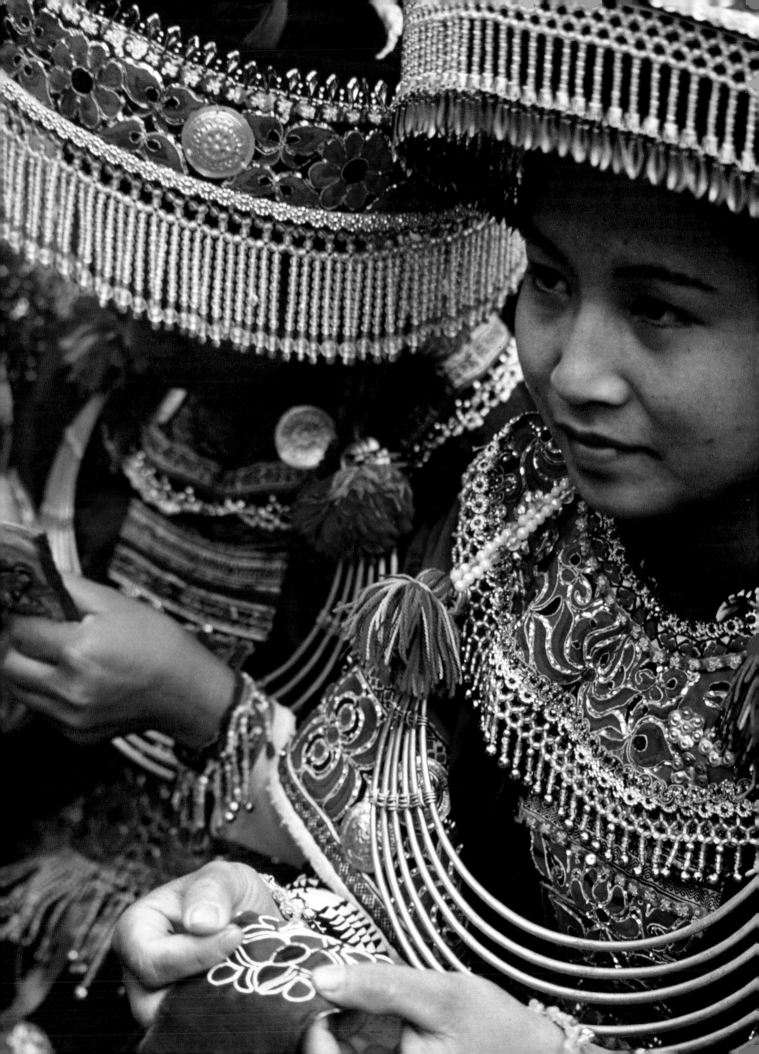

Beadwork and Bead Embroidery

Bead Types and Origins

Shell Beads

Decorative shells have always held a fascination for both men and women from ancient times even to the present day. Nature is so profligate with shape, colouring and pattern that the observer is impelled to gather them, collect them and in many instances, to string and wear them. Cowrie shells are valued as wealth, and in many societies they are also regarded as a fertility symbol. Inland and mountainous countries are driven to import cowrie shells from a great distance, as they are only found in the coastal waters of the Indian and Pacific oceans. There are several varieties of these marine snail gastropods, but the smaller ones are the most desirable. According to *Britannica*, the 10cm (4in) golden cowrie (*C. aurantium*) was traditionally worn by royalty in Pacific islands, and the money cowrie (*C. moneta*), a 2.5cm (1in) yellow species, has served as currency in a number of countries. The cowrie shell is a feature of the embroidered textiles of South-East Asia, as well as of India, Pakistan and areas of Central Asia.

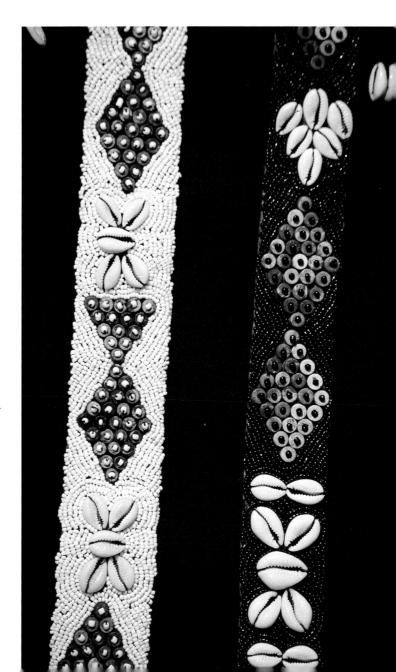

OPPOSITE PAGE:
Young women from Gaozhai village near Anshun in South-West China, wearing beadwork finery while working at their embroidery.

RIGHT: Black-and-white trade beads contrast with cowrie shells and little cane discs on these belts from Borneo.

A range of smaller shells from the Pacific Ocean and the areas around the Philippines, together with corals of different colours, were drilled and used for the embellishment of clothing as well as for personal decoration, while larger flat shell discs were strung as neck ornaments. Shells were local currency in Papua New Guinea until 1933, when their use was abolished. However, in some places local customs persisted and golden-edged clam shells continued to be part of the 'bride price' paid by the groom. In other areas, strings of 'shell' money and livestock formed the bride price.

Mother-of-Pearl and Abalone

The nacre, or mother-of-pearl, occurs as an inner layer in the shells of some gastropods and bivalves. The shell layers, composed largely of calcium carbonate, are secreted by different parts of the mantle, a skin-like tissue in the mollusc's body wall. These iridescent shell linings have long been used throughout Europe and Asia to make mother-of-pearl buttons and small cut-outs of jewellery, both for wearing and sewing on to fabric. Both bone and mother-of-pearl buttons are included on garments worn by the Akha tribes from Thailand. Another gastropod is the abalone, known as *paua* in New Zealand, whose shell has a row of holes on its outer surface. The colours range from greens to mauve-

Detail of a child's hooded cap from the Akha tribes of North-West Thailand, showing the use of buttons combined with embroidery.

blues, and the shell's lustrous interior is used in the manufacture of ornaments. The iridescent lining of the Australian pearl oyster is carved into pendants, as well as providing a source for bead-making.

Pearls

Natural pearls are formed from many layers of nacreous secretion around pieces of irritant grit in both the sea oyster and the freshwater mussel shell. Natural pearls have long been valued, and divers frequently risked their lives when lowered with ropes from small boats down to the sea-bed to gather the pearl oysters. The freshwater pearls are called 'seed' pearls, and today, 'cultured' pearls are made by deliberately inserting an irritant into the sea oyster. These are examined at intervals and harvested when ready. The Chinese called natural pearls the 'brains of the dragon', and they were traded from the seas around Japan, finding eager buyers as far south as the Philippines and west into Indonesia.

The art of using pearls for embroidery spread from India into South-East Asia. During the nineteenth century, Indian rulers in Lucknow began to wear European-type crowns, embroidered with glass beads, sequins and seed pearls. These pearls had to be pierced with a bow-drill for stringing or for sewing, a delicate operation; wax was used to hold a stack of pearls in position while the drilling took place. The gatherers of freshwater pearls held them in their mouths for about two hours, after which they were wrapped in a damp cloth. Smaller pearls were used for embroidery and were sewn singly on to the cloth, combined with other gems, or strung into a network and applied to the fabric.

Seed Beads

The hill tribes of northern Thailand, which include the six main groups of the Akha, the Hmong (or Miao), the Karen, Lahu, Lisu and Yao, all share a love of silver jewellery and beadwork, much of it used to decorate their various head-dresses, which are bedizened with metal coins, dyed chicken-feather tassels and long loops of Job's tear seed beads. These little white seeds are also used by the Akha tribe to decorate their distinctive indigo-dyed jackets, and they are combined with stitchery in red cotton threads to embellish the front and back of the tunic blouses worn by the Sgaw women of the Karen tribes who live near the Burma border. The same design of beads and stitchery is seen on their shoulder bags and baby carriers, and has now

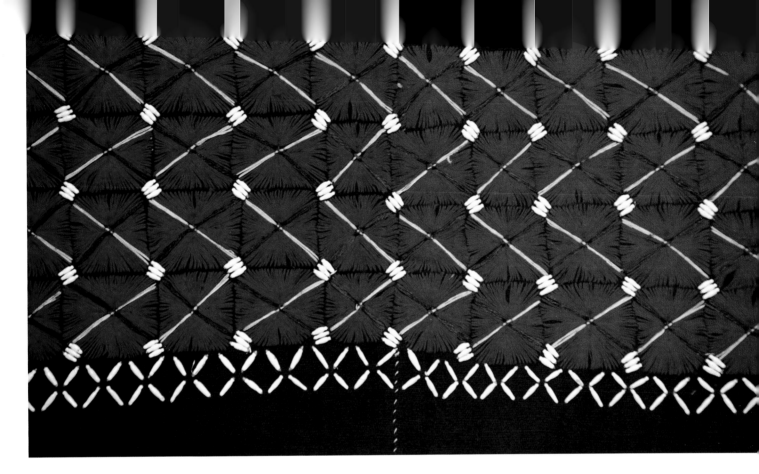

been adapted for use on embroidered items sold at tourist outlets.

The Job's tear seeds, so called because they resemble a tear-drop, are also known as Saint Mary's tears and occasionally as David's tears, all names reflecting the various tears shed in the Bible stories. Locally they are called 'rice beads', as the domesticated variety is cooked and eaten as a cereal grain. The origin of the plant – botanical name *Coix lacryma-jobi* – is disputed, some saying it developed many centuries ago in the Indonesian islands, others believing it originated in North-East India where archaeological excavations have revealed Job's tear seeds together with steatite beads in a workshop, dating from about 2000BC. These seeds flourish in many areas, so both theories may be correct.

This tall, ornamental grass has a rare type of 'seed' head which forms a hard, shiny pearl-like outer casing from which eventually the pollinated female flower-head will emerge. The protruding end of the seed breaks off when removed from the plant stem, to leave a ready-made hole above the soft interior that can easily be pierced for threading. Job's tears are a greyish white in colour, but can be dyed after drying. They grow in the tropical zones of many countries throughout the world and are cultivated in marshy areas of China where the inner kernel is said to have medicinal values. The *monilifer* variety produces small, round seed cases, and these are incorporated as a decorative element in many forms of textiles.

However, the original oval-shaped Job's tear bead remains the most popular, and has become an integral part

ABOVE: Detail of the blouse showing the close-worked fishbone stitch in red thread, combined with Job's tear seed beads.

BELOW: Sgaw women from the Karen tribes in the mountains on the Thai-Burma border wear tunic blouses together with sarong skirts.

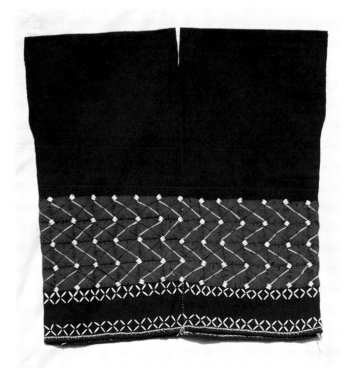

of the rich, decorative traditions of the hill tribe people of north-western Thailand. These seed beads are equally popular in Myanmar, and are used to decorate the headdresses of the tribes who live along the mountain ridges of the eastern areas. A tribal hat, purchased in Yangon, has strings of round seed beads looped on either side of the front, sewn in conjunction with close-packed rows of domed metallic 'half balls'. These seeds are a natural brown in colour, and contrast with the silver ornaments, an unexpectedly successful juxtaposition.

In Indonesia and the islands of the archipelago, seeds of many kinds were used to decorate clothing and accessories as well as being strung into neck ornaments. The seeds were frequently combined with pierced shells, animal teeth and tusks. These were traded with the Chinese for glass beads, which were more durable than the seeds or carved wooden beads.

Glass Beads

Glass beads are said to have originated in Egypt, but there was a thriving glass and bead production in southern India, dating from over 2,000 years ago. Egyptian *faience* was made before glass was discovered. It was used to imitate the mineral turquoise by adding copper to powdered quartz and lime, giving the beads a blue colour, while black and purple shades were obtained with the addition of manganese. The first true glass is said to have been manufactured in Mesopotamia in about 3000BC, while the Egyptians did not discover glass making until much later, in about 1500BC. Glass is made from a fusion of sand (silica) and an alkali such as soda or potash. A good supply of timber was required to heat the furnaces, as the glass would only fuse at very high temperatures.

GLASS BEAD MAKING

There are two types of glass bead made by hand: those made from a hollow tube of blown glass, and the 'wound' beads made from a molten glass rod. Wound beads are made singly by letting the molten glass wind round a heated metal rod, which is held in a clamp and rotated by hand. Additional colours and glass decoration can be added after reheating. When cold, the beads are removed from the metal rod by dipping into an acid bath, leaving a bead with a large central hole. It is not possible to mass produce these beads, and they are used less frequently.

'Drawn' glass beads are formed from a 'gather' of molten glass taken from the furnace with a blowing iron. Two separate blown bubbles of molten glass are joined together by two men, who then draw the combined bubble into a tube by walking away from each other, thus lengthening and extruding the glass at the same time. Tubes of over 30m (35yd) are made in this way. A second method, common to both the workshops of Europe and the villages of southern India, is to introduce a hollow metal rod into a conical bubble of glass so that the glass bubble closes around it. An assistant grasps the rod and runs rapidly down the workshop, drawing out the thin tube of glass. The canes of fine glass tubing are cut into manageable lengths, and when cold, are bundled and chopped into small pieces.

The cut edges are sharp, so all the little tube beads are put into metal cylinders together with sand and charcoal, and the cylinders are rotated and heated until the beads are

Hand-made spangles and applied beads decorate this double kalaga, portraying on the right a princess in traditional Burmese dress, and on the left a 'celestial being' called a deva. Possibly late nineteenth to early twentieth century. Lent by: Bobby Britnall

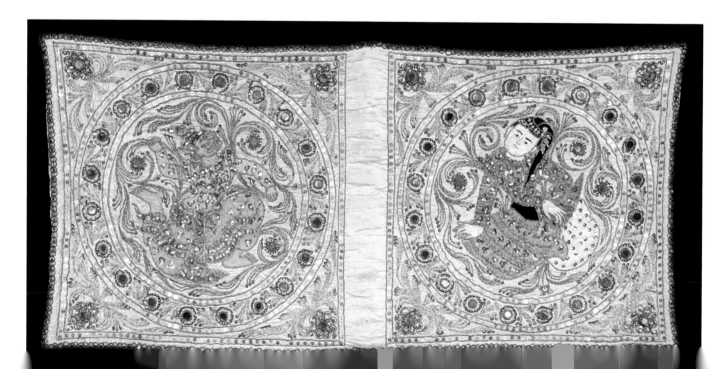

smooth and rounded. Methods for smoothing and polishing these small beads vary from place to place, some using heated clay pots filled with cow-dung and ash, but the general principle is the same. In Europe, the little round beads are called *rocailles* from the French, meaning 'little rocks'. Longer cut cane pieces, like small cylinders, are known as *bugle* beads; small sized, round beads are known as 'seed beads' – not to be confused with beads made from natural seeds.

In Myanmar, bead making for the embroidered kalaga wall hangings is equally labour intensive. Coloured glass is frequently made by sorting broken or discarded glass and melting it in a high temperature furnace. This recovered glass is made into glass tiles, which are cut into small cubes. Each little cube is glued on to a rod to form a temporary holding handle to enable it to be ground down and polished on a grinding wheel, turning the cube into a round bead. Young boys perform this arduous task, and when the bead is spherical, the glue is melted and the bead removed from the rod. These beads are like small glass marbles and do not have holes pierced through them. A different boy glues each separated bead on to a final, small square of glass.

Sequins, Paillettes *and Spangles*

In commercial Europe, the little flat disc with a hole in the middle, stamped from silver or golden-coloured metal, was traditionally called a *paillette*. If the disc was cup-shaped, it was called a *couvette*. Any other stamped or cut-out shape with one or more small holes near the outer edge was called a 'sequin'. Nowadays, any little metallic or plastic round disc is referred to as a sequin, although the name, which originally referred to golden coins minted in northern Italy during the thirteenth century, was not used before the nineteenth century. Since then the term 'sequin' has come into common usage, with most contemporary publications, including those of the countries in question, using this name. From the seventeenth century onwards, sequins were imported from India to Burma. According to Noel F. Singer, the Burmese *Shwe-taik* (royal treasury) struck (in this case meaning 'stamped') a vast number of sequins for the robes of the royal family and court officials. Both flat and cupped sequins were made from gold and silver foil.

A 'spangle' was in use from Elizabethan times and is a small, metal ring flattened to retain a tiny hole in the middle. Joan Edwards, in research for *Bead Embroidery*, says that the spangle originated from the tiny metal eyelets called 'oes', used for trimming items of clothing and theatrical costumes. In records of the late sixteenth century, both spangles and 'oes' are grouped together and listed as being made of copper and gold. In the modern jewellery trade, little metal 'jump rings' are made by winding wire round a thin metal rod and cutting down the length to free the rings. These split rings can be opened up and used to join earring sections together and necklace ends to ring fasteners.

In the workshops of Myanmar today, the spangle-making process is similar to the method still used in India and other parts of the world. A drawn wire, made of silver-covered base metal, is closely wound round a rod. A cutter slits the wire longitudinally, which allows the separated rings of wire to be pushed off by drawing the rod through a notched hole. The resulting pile of little wire rings, each with a cut join, is passed to a group of young girls who hammer each one flat, thus forming a sequin. These hand-made 'spangles' can be identified by observing the split join, still visible with good eyesight or a magnifying glass.

Silver Beads and Ornaments

In a society where commercial banks do not exist, where housing is insubstantial and individuals are constantly on the move, it is natural that worldly wealth should be carried and worn on the person. This is especially true of a woman's dowry, both before and after marriage. A superior set of silver jewellery and ornaments displayed at courtship time, will demonstrate the dependability of the girl's parents, and eventually will ensure that the bride has at least something of her own to rely on. The type of ornament and the way in which it is worn will vary from tribe to tribe and country to country, but the same ethos lies behind the display, giving not only a standing within the community, but a sense of pride to the fortunate wearer.

A modern bag from Myanmar shows the use of 'silver' beads and ornaments, a feature of many of the Golden Triangle tribal costumes.

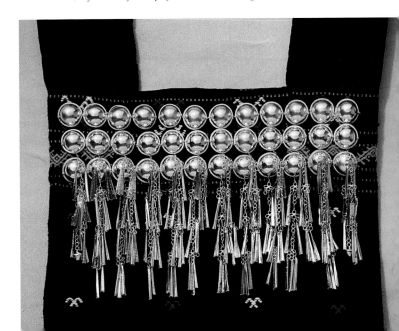

THE GOLDEN TRIANGLE AND SOUTH-WEST CHINA

Metal beads were made by the tribal smiths from an early date. A bronze necklace from Burma dates back to over 1500BC, with beads resembling seed pods. Gold and silver beads found in central Thailand date from the first centuries AD when there was a definite Indian influence in mainland South-East Asia. Even today, the tribes of the Golden Triangle and South-West China do not trust ordinary money, and they are especially rich in their silver jewellery displays. According to Paul and Elaine Lewis, writing in *Peoples of the Golden Triangle*, the Hmong and Mien women were in favour of massive silver ornaments, the

Lisu covered themselves with overlapping layers, and the Akha attached the jewellery to their garments. Brass, copper and aluminium are also used, but to a lesser extent. Domed silver buckles, solid or hollow bracelets, anklets and neck torques, flat neck-rings, lock-shaped and hanging pendants, dangling earrings and solid earplugs, finger rings and hair ornaments together form a wealth of silver jewellery that is impressive in every way.

The Mien and Mun Yao of South-West China, northern Vietnam, Laos and Thailand have an equal love of wealth display and silver jewellery. Their jewellery is very similar in construction to the Hmong, but there is a preponderance of long chain pendants, giving a lighter feel to the necklaces and earrings. As in most areas, silver coins are attached to head decorations and silver belts. Silver disc clasps on jacket fronts are ornamental rather than utilitarian.

The Miao people of South-West China decorate their tribal headdresses with intricate shapes stamped from thin silver combined with a profusion of silver chains and pendants. Each tribe can be recognized by the headdress and the way in which the silver jewellery is worn. In Leishan County of Guizhou Province, horn-shaped silver headpieces are set on to a cap adorned with a forest of silver filigree and a frontal fringe of silver dangles. Sometimes a veritable armoury of silver is worn around the neck and as a type of breast-plate medallion. This finery is on display at times of ceremony and during the festivals that mark different occasions throughout the year, although much is worn on an everyday basis, even when a woman is working in the fields.

INDONESIA AND THE ISLANDS

Gold ornaments were worn by the Raja rulers of the Ngada Regency of Flores Island. A golden headpiece is accompanied with a necklace with pendant beads in the form of golden cowrie shells, copying the cowrie necklaces worn by the ordinary people. Women wear silver earrings and hairpins, as well as gold discs and neck pendants during special ceremonies. This gold jewellery is a male gift, part of the bride-wealth transaction of the marriage ritual.

In areas stretching from Indonesia to the Philippines, jewellery was considered to be an ancestral treasure, imbued with layers of meaning that defined a person's status within the community, their kinship and tribal allegiance. Certain beads retained special significance and were

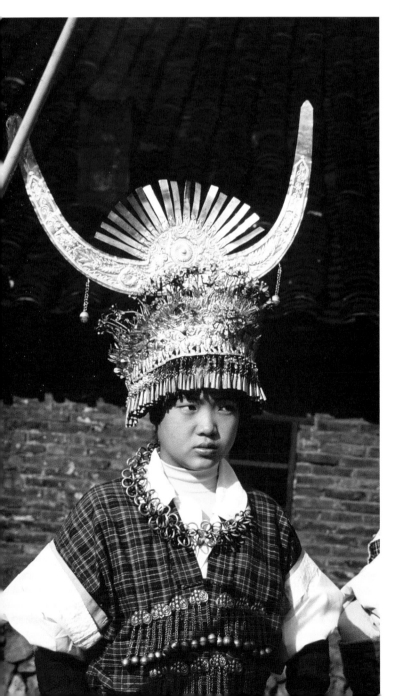

This girl from the 'Small Horned Miao' tribe, living in Shiquing village, Guizhou Province, is wearing her traditional silver head-dress and ornaments for a dance display.

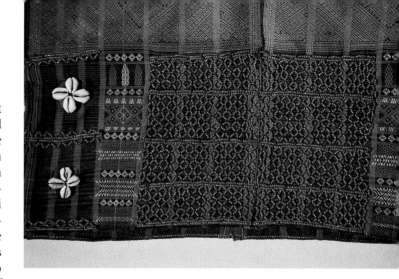

Detail of red beads worked on to the front of a tunic blouse from the Chin States, Myanmar, possibly dating to the 1970s.

used in marriage and religious ceremonies. The different types were held in high regard, each having a name and purpose, giving protection to babies, warriors and those embarking on a journey. Red beads were combined with shell 'trophies' in the Trobian Islands of New Guinea. In his study of the island culture during 1915 to 1918, the Polish-born British anthropologist Bronislaw Malinowski established his *Theory of Functionalism*, believing that people's actions and interactions all have a purpose. In the annual 'Kula Ring Exchange', elders and men of high status made dangerous journeys across the seas in order to exchange bead and shell decorations with individuals of similar rank from other islands. In themselves these objects were worthless, but gained value in the act of exchange and the sequence of ownership, rather like a silver competition cup with the list of winners' names engraved in annual order.

Ceremonial exchange is still very important, whether in the form of shells or special bird feathers. In Papua New Guinea today, the 'Kula Exchange' of arm shell decorations and necklaces continues. The villagers travel along the rivers and across to the islands by canoe, but some professional people and even politicians make exchanges through the medium of air travel.

Beads Added to the Fabric Surface

Myanmar

A tunic blouse from the Chin states, dating from the 1970s, is decorated with what is sometimes called 'lazy stitch' beadwork, commonly found in native North American tribal beadwork. There are only so many methods of sewing on beads, and this technique, where several beads are threaded on to the needle at a time to make a long beaded stitch, is found in many areas of the world. The tunic is decorated with fine supplementary weft patterns laid into the top shed only, but worked over a striped warp that shows on both sides of the fabric. Little round red beads are sewn in groups to decorate the striped surface of the lower part of the tunic. On the back of the fabric it is possible to see the spaced stitches, worked in a thicker black cotton thread, that secure the bead groups in place. At times, a careful examination is necessary to determine the method used for adding beaded decoration. On the front, a trellis pattern of the red beads is worked like a grid

between double rows of the strung bead groups. The horizontal groups include between nine and ten beads, while the grid pattern is formed of strings of three beads only. A cross shape, made from four large-sized cowrie shells, is repeated and stitched to the panels at the sides.

The *mutisalah*, an opaque red glass bead known colloquially as 'Indian reds', was found in megalithic sites in southern India dating from about 200BC. These beads were made in the area until as late as the sixteenth century, and antique beads are still highly prized. They were traded far and wide, and are found in archaeological sites of the pre-European era in mainland parts of South-East Asia and the islands of the archipelago. Today, red-coloured beads are still very popular. They bedeck the headdresses of women from the Golden Triangle, and are combined with other colours in beaded network throughout the area.

In common with areas of Afghanistan, Pakistan and India, tribal textiles from northern Myanmar are decorated with little round *rocailles* sewn in clusters to the hems and edges of garments. They decorate the upper and lower hems of the narrow Chin tube skirt, sewn in close groups of eight to ten tiny beads in white, yellow, green, red and blue, but with the white predominating. White 'seed beads', in an even smaller size, are strung in looped groups of up to twenty beads along the remainder of the hems. These little beaded groups are also found on bags, headgear, and other items of costume in this and the surrounding areas.

Kalaga Wall Hangings of Myanmar

The art of making the bead and metal-thread embroidered kalaga pictures has been practised in Myanmar for well over two hundred years. Workshops in the city of Mandalay still flourish, providing pieces for tourist outlets and for sale abroad. Mandalay was established in the country once known as 'Burma' when King Mindon moved the capital

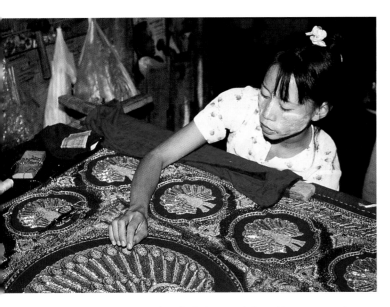

ABOVE: *A young girl in the kalaga workshop, Myanmar, sewing sequins on to the tail of a peacock.*

BELOW: *Couched, metallic threads outline the areas of the design filled by beads and sequins.*

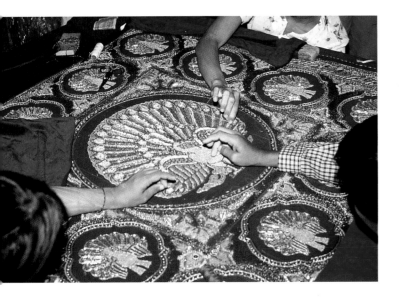

from Amarapura and set up his court here in the 1850s. There was already a long tradition of gold embroidery decorated with gem stones and pearls dating back to over a thousand years, influenced by the Thai peoples. It was during the late eighteenth century that the kalagas, meaning 'foreign curtain', became more detailed, culminating in a veritable feast of decoration during the reign of King Mindon. The word 'foreign' referred to embroidery imported from Thailand, rather than from countries beyond the immediate borders of former Burma.

Originally the kalagas were used to decorate the walls of the palaces and the temples, and subjects included scenes from the last ten lives of the Buddha – the Buddhist *Jataka* tales, as well as the Hindu shorter epic poem, the *Ramayana*. The signs of the Zodiac, animals and auspicious motifs were familiar choices. In a different context, the decorated fabric was used to make coffin palls and the funeral canopies reserved for distinguished priests and high-ranking men.

Early nineteenth-century designs were superior in concept, but with less embroidery and little padding, and sadly there are few of these rare antique kalagas still in existence. They were superseded by more elaborate pieces with extra sequins and beadwork, together with three-dimensional stuffing of the appliqué sections. The import of goods during the British occupation and trade with nearby China provided a choice of new fabrics and metallic threads.

In a Mandalay workshop during 2005, several young girls and one boy sat on low seats, three or four to each frame, each with one hand working from the top and the other guiding the needle from beneath. The base fabric for the kalaga – which would be of cotton if it is to be completely covered by the embroidery, or velvet if part of the background is to be exposed – was stretched on to the frame by lacing over rods inserted into casings on all four sides of the fabric. This provided a very taut surface. The design areas are tacked with cotton or drawn out in charcoal. Tinsel-covered thread is couched down in parallel rows to outline the borders of the motifs. The children worked with speed, later filling in the pattern areas with rows of overlapping sequins.

The main figures, motifs or animals that are to form the central parts of the design are worked separately on to cotton cloth, outlined with metal threads, and filled with sequin layers. These are then stiffened on the back and cut out of the cloth, to be applied later to the final backing. The cut motifs are sewn down, and the outlines covered with more applied metal threads. Spaces are left open for the kapok stuffing to be prodded in with a pointed stick – it is amazing how much it can take to give a smooth, padded form to the motif. Certain background areas are selected to be painted and the faces are drawn, later to be incorporated into the embroidery. The final embellishment is of glass beads, each one glued to a glass square; these are not pierced, but threads are tacked over the corners and metal threads are couched around to hold them in position.

The kalaga tradition has survived through the export of these popular hangings to both neighbouring Thailand and Laos, and further afield to Europe and the United States. These padded pictures are now included on bags and purses, and even articles of clothing. The workshops are often run as family businesses, and still use the labour-intensive methods from the past. This often results in a freer interpretation of the old designs, and a less rigid

approach to the embroidery. There is nothing machine-made about a kalaga.

Puppet Costume

The kalaga workshop included displays of traditional puppets. These hang in groups from hooks in the walls, each puppet with a wooden cross that holds the controlling strings. The carved wood and painted heads of the characters are diverse, with males and females in the form of kings, princesses, nobles and the various divinities from the *Ramayana* and other legends. These puppet heads were even copied as painted faces to 'beautify' young novice monks taking part in Buddhist rituals. The fabric for the puppet costumes follows the patterning on court regalia of the past, with surfaces worked using the same techniques as for the kalagas. Monsters, clowns and animals, including monkeys and horses – depicting both good and evil elements – are all clothed in appropriate garments, and the trappings enlivened with couched tinsel, beads and sequins.

Puppet figures are still used in the traditional Burmese puppet theatres. Costumes follow royal court costume, enlivened with metal threads and beadwork. (Lent by Jane Davies)

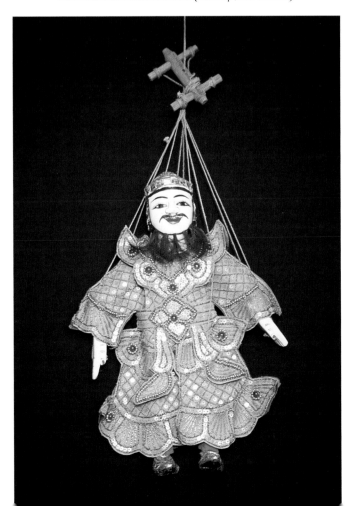

Puppet shows, still very popular today, have long been a part of the cultural life of the country, in both urban and rural areas.

Court Costume, Myanmar

The royal costumes in former Burma were like stiff suits of armour, weighing several kilos (pounds) – it is hardly surprising that royal personages are nearly always shown sitting down. The overlapping layers of flared cloth are embroidered with double lines of couched gold or silver threads, groups of check and rough *purls*, all with added beadwork, sewn jewels, layered sequins and spangles. The nineteenth-century costumes in the Ethnographic Museum in Yangon look dulled with age, but originally must have echoed the splendour of the surrounding court decorations. Bright versions are worn by the national dancers, giving us at least an idea of past glories. According to Noel F. Singer, high-ranking queens and princesses wore a ceremonial skirt called a *keik htamein*, covered with jewels and thin gold discs decorated with embossed patterns. A plain fabric piece, starting at the ankles, was added to the lower skirt edge to make the obligatory long train.

Cambodia and Thailand

Although upper garments were not worn above the long skirts during the Angkorian period, jewelled neck ornaments, long dangling earrings and bracelets formed the costume of the women who performed the court rituals. Siamese influence introduced the wearing of decorative tops, and over a period of time, elaboration crept in. This is seen today in the costume of the various national dance troupes, both in Cambodia and Thailand, with bejewelled sashes worn by the women over their tight-fitting silk blouses. These wide brocaded sashes, called *spai*, are heavily embroidered and embellished with beads and sequins. They are also worn by brides on their wedding day, draped across the shoulders to hang down over the back to cover the upper part of the brocade skirt. A beaded fringe hangs down from the ends of the spai, adding to the sumptuous effect.

South-Western China

As one of the poorest provinces in China, Guizhou was not open to foreign tourists until 1997. In a country that is dominated by the beautiful Karst mountain scenery, there

is very little flat land in the valleys between the mountains, and it is here that the subsistence farmers carve terraces from the slopes to grow rice and maize. A hard life was enlivened at intervals by wedding celebrations, feasts and festivals. In the past, the beadwork costumes worn by the womenfolk of Guizhou Province were not quite so elaborate. The present Chinese government has encouraged dance festivals, where many villagers join to compete and win prizes for the best dances and costumes.

In Gaozhai village in the Anshun area, men and the elder women wore the traditional dark blue cotton tunics and black trousers still favoured by the older generation. This was in complete contrast to the highly decorated costumes of the dancers. The young girls wore elaborate beaded crowns, with a deep fringe of threaded and networked pearl beads hanging down from the circular headpiece. More beads decorated the circular collar, which extended over the shoulders. A bib front was in part obscured by silver

hoops that formed a deep neck ornament embellished with thread tassels. A short apron, beautifully embroidered with cerise silk threads, was also decorated with the pearl bead and network fringe. The front bib extended over the shoulders to form a back collar, also embroidered and beaded. Not only were the young girl dancers in costume, but four baby girls, all dressed exactly like their mothers in beaded costumes, were doing their very best to follow the steps of the dancing.

Beadwork from Malaysia, Indonesia, Borneo and the Islands

This area is particularly rich in beadwork. The importation of European trade beads was merely a continuation of a tradition dating back several thousand years. Early beads were made from pierced shells, animal and fish teeth, carved stone, moulded and fired clay, iron and bronze and later, precious metals. Roman mosaic glass beads have been found in Sarawak, thought to have been imported by Arab traders. Beads imported from India included the 'Indian Red' *mutisalah* as well as semi-precious stones – agate, amethyst, carnelian and crystal. Even the early versions of glass beads were much preferred to those made of seeds or pierced shell as they were more decorative, longer lasting and could be traded as currency. They were used for ornamentation in ceremonies stressing the 'eternal' element of ancestor and spirit worship, as they would seemingly last for ever.

The women of Sumatra decorate their *tapis* sarongs and ceremonial jackets with embroidery combined with cowrie shells and *cermuk* mirror-work, showing the influence of Indian *shisha* work. In India, large bubbles of glass are blown and then filled with a silver mercury solution to coat the inside. The glass is broken into pieces, which are then cut to shape with special scissors. The resulting little discs of mirror glass are slightly uneven, never completely round, and devoid of sewing holes. They are fastened to the fabric with a network of threads which are then embroidered into, to form a holding ring.

Beadwork is important as a decorative technique throughout the archipelago, many tribes choosing to combine beads with woven textiles as well as incorporating them with embroidery stitches. In the island of Sumba, shell and bead embroidery decorates the women's sarongs with designs similar to the beadwork headbands. The Nggela women of Flores Island work 'octopus' motifs in

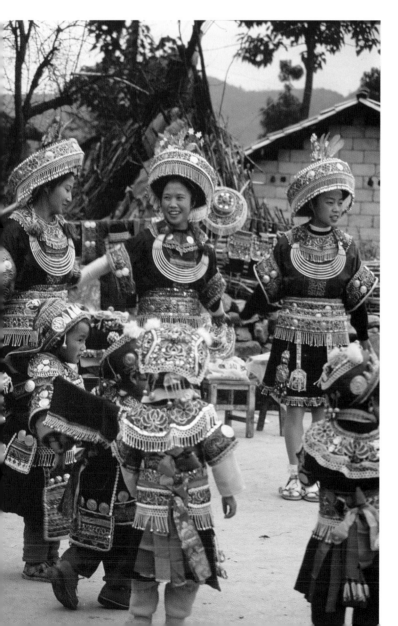

Little girls are bedecked in beaded costumes, just like their mothers, ready for the dance display in Gaozhai village, South-West China.

embroidery and beadwork on to the hems of their sarongs. These are sacred cloths used in the rain dance, and when 'roof renewal' rituals are performed. A lavish use of beads is an important part of ceremonial costume in parts of the Philippines, with the addition of necklaces and rare shell bracelets. The Bagabo men wear beaded jackets, head-cloth, sash and trousers, while the women wear beads on their head ornaments, sashes and the bell-shaped sleeves of their blouses.

Netted Beadwork

The art of stringing beads into necklaces, bracelets and ornaments, common to many societies throughout the world, soon led to the joining together of the strung elements to form a network of beads. Netted beadwork tends to look similar wherever it is made, as there are limited ways of forming the bead mesh using a continuous thread. This presupposes that fine enough needles are available to go through the holes of the beads several times, as the meshes of the netting are joined by linking together sets of threaded beads.

In network, beads are strung together in staggered rows, with the working thread going in turn through a bead in the previous row above. This method, which is often called Peyote stitch after the North American native beadwork, is referred to as 'one-bead' netting by Caroline Crabtree, which is a more descriptive name. All beads will sit

Beadwork belt from Borneo. Horniman Museum number 5.522. Photo: Heini Schneebeli

between the ones in the row above, like the staggered seats in a theatre, with the bead holes facing horizontally across the work. This 'one-drop' netting can be extended by adding a second bead on each stitch to make 'two-drop' netting, or more if desired. If the bead holes lie vertically, then it is called 'brick stitch', as the bead formation resembles that of the alternating bricks in a wall. The designs will of necessity be geometric, with curves worked as a series of steps. There are many variations, depending on the number of beads picked up between links and how they are joined. Netted beadwork, in one form or another, is used extensively by many of the people of Malaysia and the islands.

The Straits Chinese, Malaya

The 'Straits Chinese' is the name given to the community of Chinese settlers who occupied the Malacca Straits during the nineteenth century. Caroline Crabtree in her book *Beadwork – a World Guide*, tells us that the extensive use of brightly coloured beadwork with ornate floral designs was influenced by the Malays, as this type of netted beadwork did not exist in mainland China. Closely formed bead-netted bands show patterns of undulating flowers and opposing bird motifs, finished with elaborate bead fringes. These bands were used to decorate wedding chambers and the doorway of the marital bedroom, but usually were not worn. We are told that the small round glass and metal beads were purchased from a travelling salesman called a *jarong* man, who made his deliveries on a tricycle. Bead-netted pieces are worked in the Gujarati areas of North-West India – featuring different design types – but the actual techniques may have been transported to these coastal areas of Malaya.

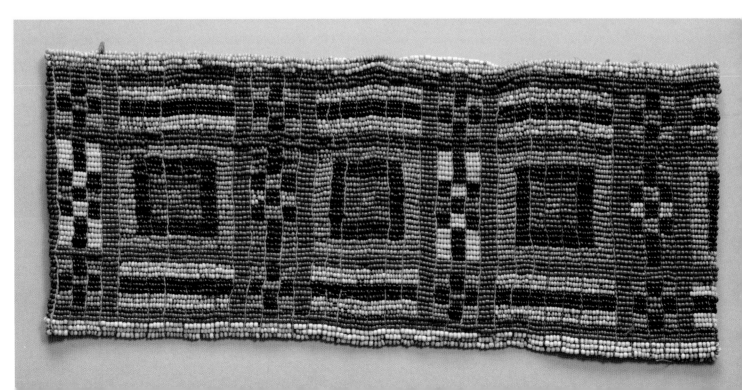

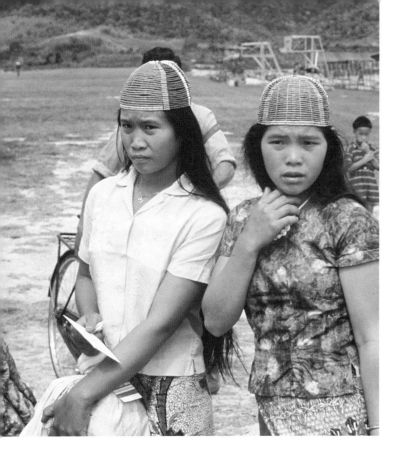

Two girls from the Kelabit tribe wear their distinctive beadwork caps at Bario, Sarawak, a forward army base near the Kalimantan border during the 1960s. Lent by: Geoffrey Bradshaw

Borneo

This tropical island, situated on the equator, is divided into sections with Sarawak in the west and Sabah in the north forming part of Malaysia. Kalimantan, the larger eastern part, belongs to Indonesia. The island numbers a series of ethnic groups including the 'Land Dyak' and the 'Sea Dyak' (Dyak meaning non-Muslim). The Kayan and Kenyah tribes of central Borneo are named the *Orang Ulu*, or upriver people, known for their 'longhouse' type of communal living. They are renowned for their ornamental wood carving, basketry and beadwork. Their inherited iconography of Dong Son hooked and spiral motifs finds its way into every craft, whether decoration on tomb poles, plaited basketry, wall paintings or beadwork.

The bead technique used in Borneo differs from single-thread network in that a series of separate bead threads are linked together, rather than one continuous linking thread. The reason for this is utilitarian, as the thread is obtained from creepers or pineapple fibre. These fibres can be threaded through beads without the use of a needle, but are not strong enough to be sewn through fabric. When imported needles became available, some beads were embroidered on to cloth and some were strung as network, but the main decoration was worked in the traditional method.

The pattern for the beadwork is incised into a flat piece of wood, although nowadays, a cut paper pattern can take its place. A regular number of bead pairs are strung on to a holding cord which is tied around the top of the pattern board. A series of working strings is attached to the holding cord using half hitches, alternating between the pairs of beads. A single bead is threaded on to each fibre string for the initial row. On subsequent rows, two strings will go through a single bead, thus joining the strings together. A linked network in colour pattern order is formed, working downwards. The small glass *rocaille* or seed beads are used, as they are constant in size. The favourite colours, originally derived from early beads made from hornbill beaks, are red, white, yellow and black.

The Dyak and Iban women of Kalimantan wear knee-length *bidang* tube skirts – heavy with intricate beadwork designs – while their fringed jackets are adorned with shells and geometric beadwork patterns. In the past, a longer tube sarong was worn. In one example, the vertical centre join was covered with a beadwork band, bordered with cowrie shells and sequins. A deep horizontal band of beadwork lies across the middle, with a central theme of anthropomorphic figures, bordered with close rows of cowrie shells. Lazy-stitch beads, sequins and pendant beads are sewn to the hem. There is nothing static in design; fashions change with the passing of time, and influences from other areas are assimilated. Circular patterns are worked from a central ring and frequently form the decoration on the large, shallow conical 'sunhats' worn by the Kenyah tribes. Other patterns are worked on to back-held baskets and baby slings. The designs are important, with talismanic properties employed to protect the baby, and certain motifs reserved to display rank and status. It was believed that misuse of these motifs would incur the wrath of the spirits, resulting in dire consequences.

A similar type of beadwork is made in Sumba, and there is evidence of examples imported from southern Sumatra. The Sumba women are famous for their *katipa* beadwork headbands, which show anthropomorphic, animal and bird designs. Late nineteenth-century examples are worked using imported glass beads and cotton thread. A narrow beadwork band is attached to the top sides of an oblong beaded panel, which is finished with a bead fringe. It is possible that the vertical strung-bead method may have given way to threaded beadwork with the availability of cotton thread and steel needles. Whichever method was used, these headbands are distinctive, many showing intricate geometric patterns.

Bead Hats and Caps: Sarawak

A different type of bead is used for the distinctive bead hats

worn by tribal women from western Sarawak. Opaque glass and semi-precious stone beads, cylindrical in shape, are strung together to form the close-fitting caps of Kelabit women. These are worn to control the long mane of hair, which is swathed around the head, all kept in place by the cap. The beadwork can take the form of a fitted band, a close cap, or a tall, conical hat with a rattan framework. The colouring of the beads changes with fashion, but antique caps are considered valuable by elderly wearers, the different bead types having symbolic associations. These caps are worn less frequently nowadays, but during the 1960s, when British air bases were situated on the island, local tribes would visit incoming transport planes – their source of supplies in a difficult terrain. The women, many with extended ear-lobes, wore the caps together with sarong-type skirts.

Beads Incorporated within the Weave Structure

While the majority of bead decoration is formed by sewing beads on to the surface of the fabric, beads may be incorporated as part of the weave structure. Normally, this requires that the beads are first threaded on to a separate weft thread, which will be passed across the open shed of the weft together with the beads. If beads of different colours are used, then they have to be threaded in the correct pattern order. Beads threaded on to the warp threads are used less frequently, and are more likely to be included on the edges of narrow widths. In this technique, beads are brought down from the upper section of the warp and incorporated within the weave structure by securing with a weft pick.

Bow looms used by the Akha tribes of north-western Thailand. The detail on the left shows bead weaving in progress; on the right is feather tassel making.

Bead Bow-Looms for Braids: North-West Thailand

The Akha people use a simple bow-loom to weave a narrow band where round seed beads are threaded on to the outer warp threads and pushed down one at a time on each side as the work progresses. The plain weft pick holds the seeds in place so that they make a continuous beaded border along the outer edges of the band. These bead-decorated bands are used to form chin straps and borders for the elaborate hats, as well as applied decoration for jackets and bags. The 'bow' is made from a piece of cut cane, notched at either end to hold the warp threads. These measure about 40cm (24in) in length, and hold the longer bow in tension. On an actual bow-loom there are fourteen cotton warp threads, apart from the two outer ones where the round seed beads are threaded. The weft is formed of a length of synthetic yarn in bright cerise red.

Backstrap Bead Weaving: Boloven Plateau, Laos

There is a tradition of backstrap loom weaving in the highland area of southern Laos, using the foot-braced loom.

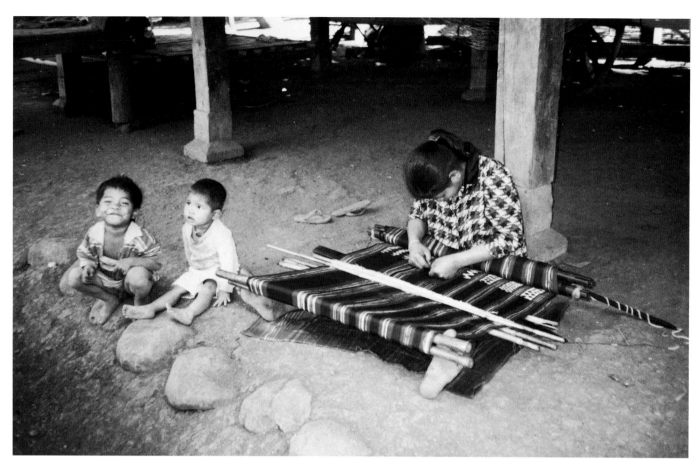

A woman backstrap loom weaver from Ban Houey Houne on the Boloven plateau, Laos, inserts beads to decorate a sarong skirt.
A rod carrying the beaded weft thread is seen on the right.

During the late 1990s, an increase in weaving trade brought prosperity to the village of Ban Houey Houne, and the women gained in social standing. In other villages, the women use heavy sticks to pound the grain in hollow tree trunks, but here the men have constructed water-driven rice-pounding machines down by the river. This gives the wives more time for their lucrative type of weaving, which includes the incorporation of beads within the weaving process.

The beaded weft-thread technique is similar to bead-weaving on a small loom where the beads are incorporated into the weave structure – frequently used for necklaces and belts. On a bead loom, there is always one more warp thread than the number of beads used so that a single bead will sit between each of the warp threads. In this construction the beads are picked up in pattern order on a threaded needle and passed beneath the warp. On the return journey, the needle is taken over the top of the warp and back through the beads, so that they lie fixed between the warp threads. The result is a bead structure held by the hidden warp and weft threads.

The wooden houses of the village are raised on stilts, providing areas of shade where the women sit with their looms. They normally work in pairs: one to weave and the other to adjust the beads, which are strung in pattern order on to a long black thread that is wound around a stick. When the weaver arrives at a pattern section, the second woman pushes up a counted group of beads, and these are incorporated one at a time by the first woman, between every second warp thread. Finally, all is held in position by the next weft thread pick. Thus the bead decoration becomes an integral part of the cloth and shows equally on both sides of the fabric.

All the village women were wearing their own particular beaded version of these warp-striped cotton skirts. The wide red stripes include colourful areas of pattern, and alternate with bands of plain black for the beadwork. The unseamed skirts are worn wrapped around the waist, lapped in front to form a pleat and held in place by a woven belt. The two selvedges form the top and bottom of the skirts with the stripes running horizontally in wear. The beads are arranged in geometric patterns which include a

diamond lattice grid, rows of inverted triangles, opposing triangles joined at the points, single diamonds, and triangles combined to make windmill sails. The women purchase the beads from traders in the local market, little rocailles in colours of white, green, red and blue. In the past, the beads were originally made of silver and formed part of a woman's dowry wealth.

This type of beaded weaving is found in other areas of mainland South-East Asia and Indonesia. Woven beadwork, with beads incorporated into the weft, is worked by the Batak people of Sumatra. Little white seed beads on the weft thread form geometric patterns on the striped cotton warp. Any method that produces a successful outcome is bound to spread and be copied by other weaving communities, made all the easier with the availability of even-sized, little round beads.

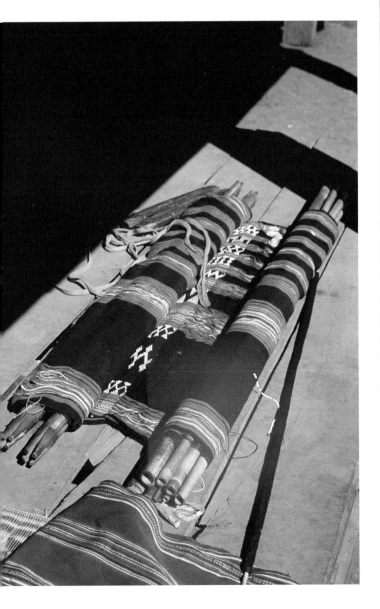

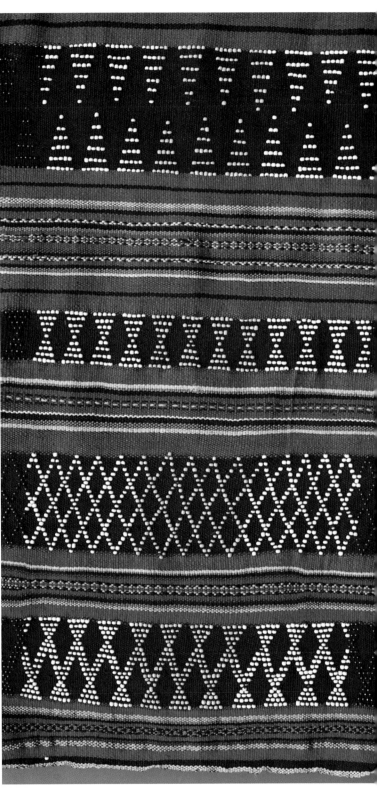

ABOVE: *Detail showing the beads inserted into the weft of the sarong skirt.*

LEFT: *The backstrap loom is rolled up when not in use.*

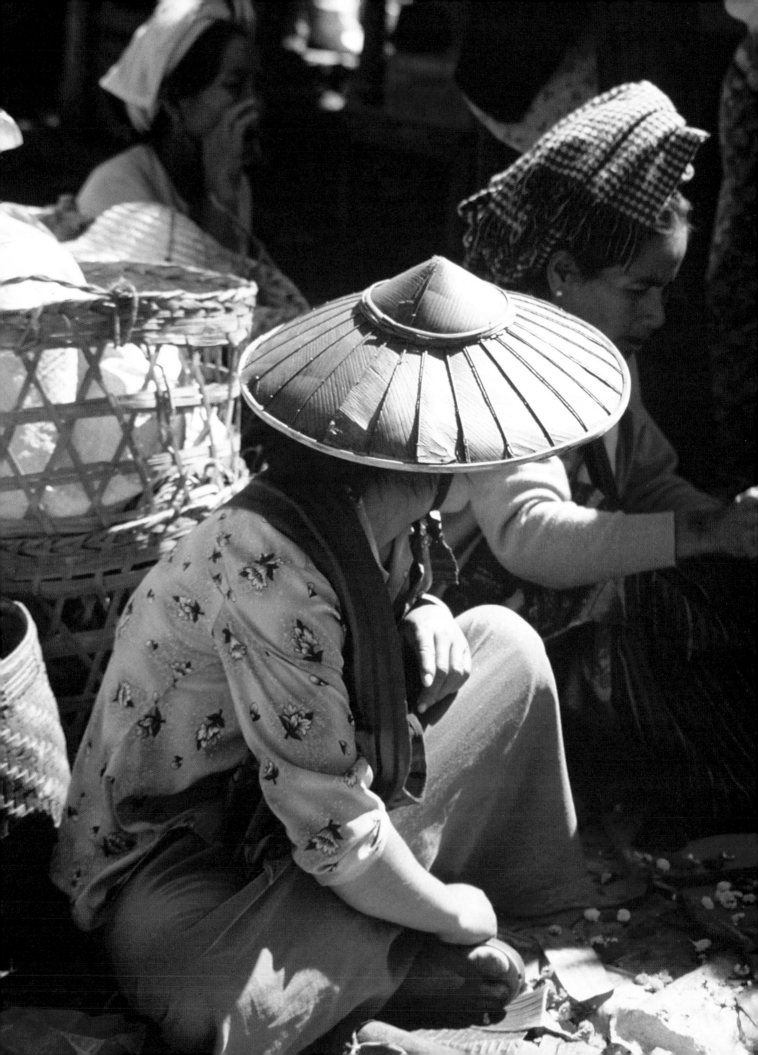

Thread and Fibre Crafts

Braids

Technically, a braid is a narrow band formed of interlaced threads, but in common usage, even a woven tape is referred to as a braid. A plaited braid has the advantage of being pliable, which means that when stretched it becomes narrower in width, and when tension is released, increases in width. It can be applied to curved edges or design outlines, and adapts easily to fill the shapes. It can act as a bias binding if folded over along the length, or be folded to make a decorative edging resembling flower petals. It will stretch and fit to shape when bound round the lower legs as puttees or gaiters. A true braid is plaited by hand, varying in shape from flat to round, with the number of threads used defining the width and the type of patterning available.

Plaited Braids

It is easier to plait a group of threads if the ends are weighted in some way. This is true of heavy braids or of the fine threads used in plaited laces. Bobbins hold the threads as well as acting as weights in bobbin lace, and similar devices are used in the braid techniques of South-West China. Bobbin lace is worked on to a padded pillow where pins hold the completed work in place, with the surface of the pillow supporting the bobbins and allowing them to be kept in order. The braid makers use special braid stands or braid tables, where a semi-circle of smoothed wood is supported on four legs, looking rather like a

truncated stool. A small framework at the rear, straight end of the table supports a roller on to which the completed braid is wound. The plait-thread group is tied to this framework when work commences. The semi-circular shape allows the weighted bobbins to hang down in order over the curved edge of the table. If a braid stand is not available, an upturned basket or similar domestic item may be used; in one instance a woman converted her shopping basket, with the handle acting as a frame on which to tie the starting threads.

Rodrick Owen, writing in the *Braid Society Newsletter 2006*, quotes from a paper written by Dr Krystyna Chabros, published in the *Central Asiatic Journal*. The theory is put forward that the braiding table (called a *zoos širee* from the Chinese for 'coin table') possibly came to China from Mongolia, as it was well known among the herdsmen of the Gobi desert. Their table, made in two parts with a circular top resting on a bobbin box, is very similar to the one used by the Miao braid workers. It could be dismantled, was easy to transport, and the girl herders worked braids while tending their sheep. Braids of up to sixty-three bobbins could be made, all weighted with coins, and as some square-holed coins date to the first century AD, it is surmised that table braiding may have started at an early date.

The bobbins, some of which have a hooked top to hold the thread, are made from wood, bamboo, animal bones or any other material that is suitable. The weights are equally varied: some are made from fired clay, or of small stones with holes in. Metal washers, coins and even fishing weights are used, anything that will give the right amount of tension to the working threads. The number of threads used differs, in even or uneven numbers, depending on the width and complexity of the braid. The order in which they are crossed will determine the pattern, so that in an eight-thread plait, sections of two colours can alternate, or be confined to either side. The worker lifts the bobbins from above, using both hands, always keeping to the correct pattern sequence.

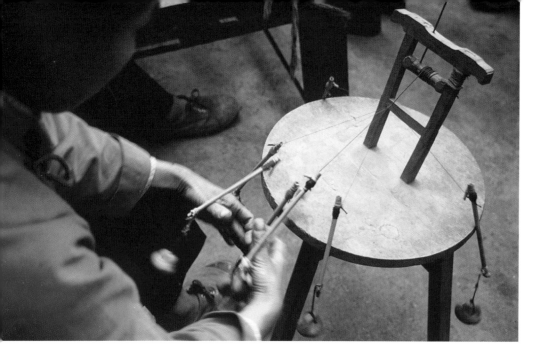

Applied Braids as Decoration and Use in Costume

Flat braids have been used in China for several centuries. They outline the purses and tabs that held various items to the belt, and have now become collectable items. Today they are stitched around the cut-out fabric motifs applied to bags, baby carriers, aprons and hats. In Yunnan and Guizhou provinces of South-West China, applied braid-work has become an embroidery art. Narrow, plaited braids are an intrinsic part of embroidery design on festival garments, and the art is practised in Kaili, Leishan and Tai-jiang County. A fine, silk thread is chosen for the narrow 3mm (¹/₈in) braids which may be applied flat, gathered or pleated.

The 'Pleated Braid' Miao women stitch their close-worked designs on to panels of satin fabric, with red as a preferred colour. Designs of dragons and fabulous beasts are worked in shades of dark blue and green coloured braids. These panels are then sewn on to garments, forming sleeve panels, jacket collars and lapel borders. Decorative braids are sewn to the sides of the skirts worn by Cham women in Vietnam. These are worked on the horizontal sideways loom and include designs of peacocks, dragons and twisting vines.

Woven Tapes

A woven tape keeps its shape, however much it is stretched. This can be useful if a firm edge or binding is necessary. Tapes form bag handles, harness girths, sword bands, head-bands for holding loads carried on the back, tapes for baby carriers, bindings for closing cloth bundles, and innumerable other domestic uses. A woven tape is made on a loom. It is possible to make a tape on a large floor loom, but this is a waste of resources and a small, designated loom is normally used. The simplest is in the form of a small backstrap loom, with one end of the warp tied around the weaver's waist, and the other tensioned on the foot or a convenient peg or post.

In South-West China, Vietnam and areas of the Golden Triangle, the sideways loom is frequently used to make narrow tapes. This loom can vary from one with foot pedals to

A fixed heddle is used to make woven braids in Bai Jia Po village, Guizhou Province, China. In use, the heddle is suspended in the warp of a backstrap loom.

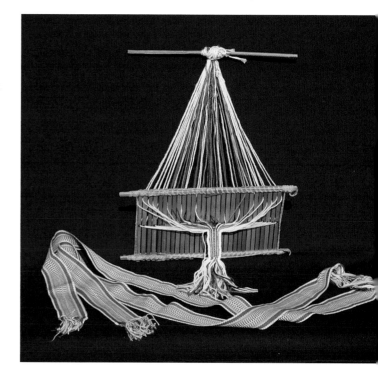

a smaller version where the weave shed is changed by lifting the string heddles by hand. A shed stick or sword keeps a selected shed open, and a continuous string heddle attached to a wooden rod is normally used to lift the alternate shed. In some areas a rigid heddle is used to make braids and narrow waist sashes, in preference to the string heddle method. In Guizhou Province, a folding loom is used, rather like a deckchair with an extension piece fixed in the middle. The frame holds the circular warp, with the extension piece controlling the amount of tension needed. When not in use, this loom can be folded up and stored, or moved to another location.

Occasionally the loom framework is done away with altogether, and the seated weaver slots the group of continuous warp threads around her knees, once again working from the side. The tension on the warp is controlled by the weaver opening or closing her legs, so that as the warp is taken up, her knees get closer together. This is an excellent way of providing a 'framework' for simple woven bands. When the weaver has a break from weaving, the circular warp is removed and wound up to keep it in the correct order. In a combination of the knee and frame methods, an upright wooden frame supported on two short posts is also used to hold the circular warp. The weaver squats to one side, with the circular warp stretched between horizontal pegs set into the two posts. One lowered knee controls the excess of the continuous warp from below – a position which must be difficult to maintain. There would appear to be no end to the ingenuity of these dedicated weavers.

Tablet Weaving

The technique of tablet weaving dates back to at least 200BC in Europe, and was known in other parts of the world. Many of the historic bands have a woven text, which among others can include examples of Greek, Latin, Arabic or Persian, worked in double-faced weave. Ceremonial belts were woven using the tablet-weave process in southern Sulawesi. The texts were in the Arabic script and considered to be magical. It is probable that Arab traders brought the art to this area and to neighbouring Java. Double-faced weave provides a choice of two colours for the weaver – for instance, allowing white lettering on red, or white lettering on blue. The colours will become the opposite on the reverse side, thus mirror-image red lettering on white, or blue on a

white background. The early examples were worked in natural cotton with a ground thread of red-brown, resembling the coloured robes of the monks. The nineteenth-century work is normally blue on white, followed by red on white. In the early twentieth century, up to six different colours were included, made possible by the introduction of hard-spun machine threads. This resulted in more complicated work, and the script became less legible.

Burma

It is thought that the art of double-faced tablet weaving may have come to the Arakan coast of western Burma from India during the eighteenth century. Today, markets on the shores of Inle Lake attract many different tribes. The mixture of costumes, the piles of vegetables, fabrics, tourist trinkets, hats, jewellery, cloth bags and bundles of firewood all combine to make a kaleidoscope of colour and textures. Rough trestle tables are set up on either side of the paved pathway that leads to the monastery, perched on a

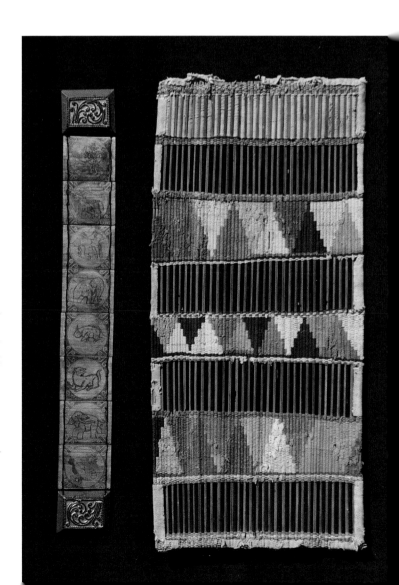

This pliable cover to wrap the palm-leaf holy texts is woven in a tapestry technique on to a 'warp' of thin canes. A reproduction folding palm-leaf 'book' shows incised drawings of fabulous beasts and other animals. From the market stalls, Inle Lake, Myanmar.

convenient hilltop. Here, wooden carvings, jewellery and textiles are offered for sale, including the tablet-woven bands that are used to bind around the palm-leaf segments inscribed with holy scriptures.

These prestigious Burmese woven texts, called *sazigyo*, are highly regarded, both for their religious connection and for the amount of 'merit' gained by the donors, often a devout Theravada Buddhist couple. Their names and deeds will always be associated with the textile, as they are included in the script that forms a record, together with the main section of devout verses. Ralph Isaacs has given a detailed description of these tablet-woven bands in an article written for *Newsletter No. 34* of the Oxford Asian Textile Group. The literal translation of the word sazigyo is 'cord for tying manuscript leaves into bundles'. After discovering his first sazigyo in Burma during 1991, Ralph Isaacs started a collection and began to decipher the texts. Eventually, he and his wife gave their collection to the 'James Green Centre for World Art' in the Brighton Museum. The museum commissioned Peter Collingwood, author of *Tablet Weaving*, to produce a detailed analysis of the techniques used by the Burmese weavers. This is available for research.

As many as twenty-eight to fifty-two tablets are used for the bands. The tablets are small rectangles of thin wood, bone, lacquered leather or, nowadays, moulded plastic with four holes drilled, one into each corner. The tablets can measure anything from 5cm (2in) up to 10cm (4in),

but sizes vary. All tablets for a project must be of the same size. A hard-spun cotton warp yarn is threaded through each hole and turned on each pattern row to bring another warp thread into play. The tablets can be turned the same way, or reversed when needed. This may appear easy in concept, but a considerable amount of expertise is needed to make even a simple type of lettering, let alone several metres of complicated Burmese script.

The tablet loom is formed of a simple wooden plank about 1.5m (5ft) long with a peg in a block at one end and a roller set into a moveable block at the other. The end loops of the tablet-warp fit over the round peg, and the portion nearest to the weaver, who sits alongside the loom, is wound round the end roller as work progresses. A small shuttle is used for the cotton weft thread that is passed across each time the tablets are rotated, and the thread is firmly beaten into place. This weft hardly shows. Each sazigyo band starts with a loop and finishes with a cord for tying round the palm-leaf manuscript bundles. In common with many examples, a sazigyo in the author's collection has lost both the beginning and the end, but otherwise is perfectly legible.

The sazigyo bands were worked by specially trained weavers. A tablet-band commissioned by a donor could take up to a week or more to produce, and was a costly item. Ralph Isaacs tells us that the verses in the woven text praise both the donor and members of his family. The words open with 'May this donation succeed!' followed by the main text, some 5m (18ft) long, composed of four-syllable verses. The text ends with praise for the donor, together with the date and sometimes the name of the weaver. Many sazigyo have pictorial motifs showing animals and birds which have associations with rituals performed in the Buddhist temples. The benevolent donor hoped his donation would help him to seek Nirvana, and invited all to share in his merit.

A tablet woven band, called a sazigyo, is wound round a sheet of glass to display both sides of the text, with the inverse colours showing on the wrong side. The beginning and end ties are missing. Central Myanmar, 2005.

Thread Crafts

Lace Work – The Philippines

Several types of lace and fine embroidery were introduced to the Philippines during the early seventeenth century. Sisterhoods of nuns arrived from Spain at various times and set up convents in the islands: thus nuns from the Order of Saint Clara founded a convent in Manila in the early 1620s. It is said that designs worked on to mantillas, handkerchiefs and linen during the seventeenth century were

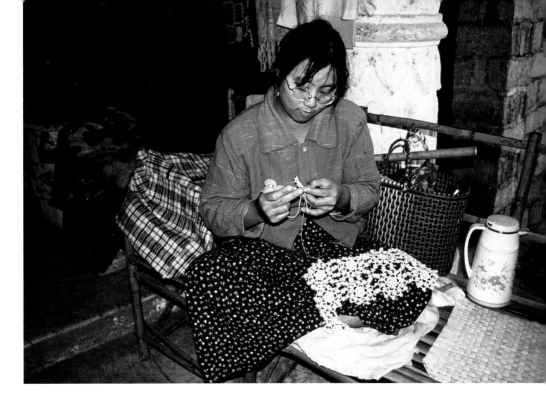

RIGHT: A girl from the shores of Inle lake demonstrates her tatting skills at a stall outside the 'Thousand Pagoda' Monastery, Myanmar.

BELOW RIGHT: Two tatted mats, purchased from the girl, show the use of decorative picot loops.

copied from designs fashionable in Spain and France at that date. The mission schools in the islands taught lace making well into the twentieth century, and out-workers were employed in the industry. Although much of the work took the form of fine sewing and embroidery in drawn thread work, the circular spider-web designs of Paraguayan *ñandutí* lace were made in the delicate *piña* cloth.

Fabric made from pineapple fibre is slightly transparent and has a pale cream tinge, which is the natural colour. The ñandutí lace was worked on to fine fabric stretched on to a rectangular frame, using woven wheel, needle-weave and needle-lace stitches. When a motif was complete, the fabric was cut away from behind to reveal the lacy pattern. The word *ñandutí* means 'web', and the craft was probably introduced into Paraguay by Portuguese Jesuit missionaries. It was also worked by the Spanish, who introduced a similar lace to Tenerife, the largest of the Canary Islands. This lace, known as Teneriffe, is made on a web of threads wound backwards and forwards on a circle of pins set into a pillow, or latched around notches in a circular base, not sewn on to a fabric background.

It is interesting to find an instance of the European lace called 'Battenburg', which is formed from tapes sewn to pattern outlines with spaces filled with needle-lace stitches, incorporated with Indonesian costume. A postcard shows a woman dressed in finery and with an elaborate silver head-dress, wearing a deep cape collar in Battenburg lace above her breast cover and gold-brocaded sarong skirt. Elaborate necklaces and long dangling ear-rings complete the outfit. This is no doubt a modern version of the bobbin-lace introduced into West Sumatra by the Dutch in the late nineteenth century. Small bolster pillows supported the pattern and the inserted pins held the lace threads in place as the plaiting stitches were formed. Bobbins, made from wood or bamboo, both held and weighted the threads. The

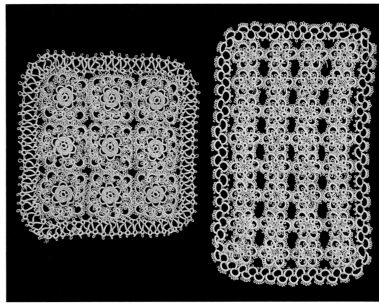

Minangkabau women of the highlands make tape-lace following traditional European patterns, as well as the geometric torchon laces and the European-inspired Cluny laces. Gold-wrapped thread lace frequently forms the borders of ceremonial cloths and head-dresses.

Tatting: Burma

The sight of festoons of tatted mats, jackets, doilies and other articles hanging on stalls outside the Burmese monasteries and tourist shops in Myanmar in 2005, was

quite unexpected. Tatting, which is decorative knotting on a running thread, is a very European craft, thought to have originated in France during the eighteenth century where it is called *frivolité*. Crochet, although far more common, was nowhere to be seen. Unlike tatting, crochet is worked as a series of continuous loops with a hook. Tatting is not an indigenous craft, and in spite of enquiries, it was not possible to determine how tatting had come to central Myanmar and the Inle lake area. There is a large Catholic cathedral in Yangon, and tatting may have been brought by French nuns, as this type of lace decoration is used on altar cloths and church vestments.

Tatting is worked with a continuous thread, knotted on itself to produce a series of little joined rings. The thread is wound on to a small oval shuttle, pointed at both ends. A circle of thread is formed around the fingers, and the shuttle is used to make the tatting knot by passing the working end of the thread through and around the thread circle. The knot, worked in two stages, is formed of a half hitch and a reversed half hitch joined together to make a 'cow hitch'. It is possible to move this knot into position along the holding thread. If a space is left between two sets of knots, a picot loop is formed, an essential part of the decoration. A series of knots are worked and pushed together to form a ring. Rings are joined at the base, and a series of loops or bars are worked by knotting on to straight threads, rather than into the circle. These bars help to form and extend the pattern.

There was evidence of tatting being worked locally in central Myanmar. Even in a mulberry paper-making and parasol workshop a young boy was busy tatting, while on the walkway up to a monastery on the shores of Inle Lake, two young girls were making tatted mats while minding their stalls. The thread was synthetic, slightly less smooth than the normal cotton thread used for most tatted items. One girl worked with two shuttles to make a more complicated pattern, and was happy to display the finished results. The mat looked decorative, as all the little rings were outlined with a profusion of picots, which are not easy to work evenly.

Net-Making

No one knows the origin of the craft of net-making, for its use is universal. The fact that nets have been found in the tombs of ancient Egypt is the result of a dry climate that preserves the textiles, rather than an indication that they were not made elsewhere at an early date. Apart from the use of netting as a means of catching fish in rivers, lakes and the coastal waters, inland communities used nets as snares to catch small animals. Netted bags of all shapes and sizes were popular, as the network construction adapted to

the shape of the items carried. The threads used varied from twine made from sisal or other natural fibre for heavy duty nets, to cotton threads for utilitarian mosquito nets and hammocks, or silk for decorative nets that adorned costume and furnishings.

Netting is formed of a series of knotted meshes, worked to size over a flat wooden or metal gauge similar to a ruler, so that each diamond-shaped mesh is of an equal size. The continuous working thread is wound on to a long flat 'needle' of the correct width to go through the chosen mesh size. The working thread is looped round the gauge from below and knotted in place after passing the pointed needle through the mesh above. Each new mesh is linked into the one above, and the 'netting knots' hold the completed mesh in place without slipping. Large netting needles are made from a flat piece of wood or similar natural material, with the central portion cut as a pronged slot around which the thread is wound in a figure-of-eight formation. The needle holds the thread and at the same time allows it to unwind as the netting proceeds. Needles are also made of twisted wire or shaped metal.

Most nets are worked horizontally from a holding cord or bar, but in South-West China, heavyweight circular nets are made to form the base of a cylindrical net basket. A looped starting plait, formed of six cords composed of several strands, is plaited together for several centimetres (a few inches). The thick plait is then divided into the six parts and each part is plaited until it reaches about 20cm (8in). The six long plaits are splayed out like a starfish, with the looped starting plait standing free in the middle. (This is the centre of the basket base, and the loop forms a hanger when not in use.) Segments of netting are worked between the angles of the 'starfish' sections, latching on to the folds of the plaits. When the circular base is finished, the net cylinder shape is worked until at about 50cm (20in) the top is reached, where a drawstring is threaded through the final loops.

Fishing Nets

Conical fishing nets were adapted for use with the leg-rower boats of Inle Lake in Myanmar. The fisherman stands upright at the end of the long, narrow boat and manipulates the conical bamboo framework that holds the gill net. This net is open at the base and attached to the struts of the frame by moveable rings. The contraption is thrust down to the 3m (10ft) deep lake bed, over an unsuspecting fish. The fisherman releases the ring that holds the net and traps the fish by securing the net with a forked trident spear. The closed net and trapped fish are then drawn to the surface together with the conical frame, ready to start again.

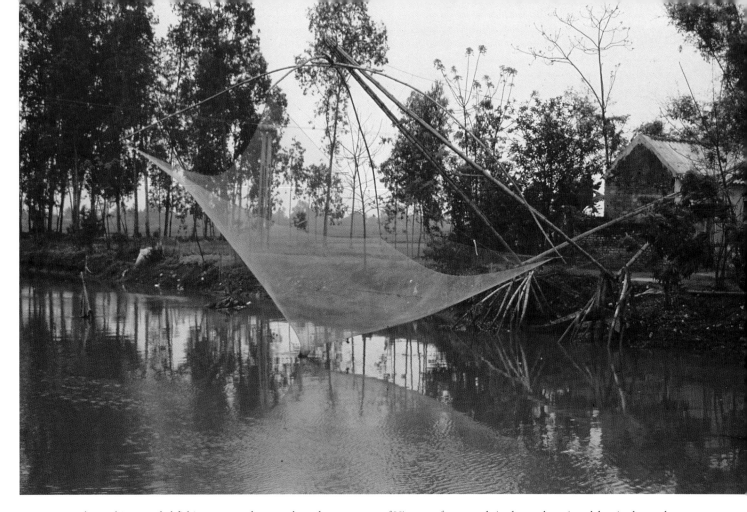

ABOVE: *The Kochi suspended fishing nets can be seen along the waterways of Vietnam, from canals in the north to river deltas in the south.*

BELOW: *A descriptive embroidery from the 'Gold Hand Silk' workshop, Bâi Chay, Halong Bay, northern Vietnam, shows a Kochi net suspended high above the waterway.*

Some of the embroideries by the disabled people in northern Vietnam showed local scenes of the rivers, with little boats and the *Kochi* fishing nets as favourite subjects. These baited nets, which are stretched on poles and dipped into the river, are a smaller version of the coastal nets with bamboo frameworks several metres (yards) high. Although called *Cheena vala*, meaning 'Chinese fishing nets', they are also named after the southern Indian city of Kerala, formerly known as Cochin. It is thought these nets may have been introduced by the Chinese explorer, Zheng He, but it is more likely that their use spread south with the coastal spice trade. The nets make an intriguing subject for embroidery, with the netting, worked on top of the background stitchery, giving a three-dimensional effect.

Hammocks

In hot and humid countries, the sleeping hammock is a necessity, allowing cool air to flow around the sleeper. The hammock can be slung between two trees, or between the posts that support the main floors of the wooden houses. They are used for daytime 'siestas' as well as for night-time sleeping, and provide extra sitting places or a cradle for the baby. These hammocks are netted, not *Sprang* – the art of

interlinking stretched threads – as is common in Central and South America. In the weaving village on Koh Dah Island in the Mekong river, Cambodia, the villagers still made their own netted hammocks, though machine-made hammocks were available in the market in Phnom Penh. Linked meshes in synthetic threads were worked in a large-scale version of machine-knit lace. These brightly coloured hammocks could be seen in many of the villages, either slung under the houses or in the shade of the front verandahs. Purchased hammocks were an obvious ready-made preference to the labour-intensive hand-made versions.

Fine-Scale Nets

Fine-scale netting is worked with correspondingly fine gauges and netting needles. For example, tiny hairnets are made by the Gejia tribes of Guizhou Province, South-West China, to go over the small round bun that forms a close knot on the top of the woman's head. The decorative head-dress goes over this and, in common with several other tribes, the bun protrudes through a hole in the headdress top. The little net is made flat, but is drawn into shape with a drawstring cord.

Hammocks with large-scale net meshes are hung from the area beneath the houses on Koh Dah Island, the Mekong river, Cambodia. The side bar of a 'long loom' is visible in the shadow behind the hammock.

In the Imperial Palace at Hué, Vietnam, a deep red-coloured silk net formed a valance around the canopy of the nineteenth-century royal sedan chair. The scalloped edging was finished with rows of red silk tassels. Also on display were royal garments that followed the style of the Chinese imperial robes, but with sections of decorative netting applied to areas above the cloud, and wave patterns on the hem and on the sleeve borders. Another use of netting in costume is as a base over a background fabric for metal thread embroidery, with motifs cut out and applied. This is similar to, but not the same as, the eastern Mediterranean technique of decorating net with thin strips of silver, hammered flat to form small repeat patterns.

Fibre Crafts

In many areas, split palm, cane and leaf fibres form the basis of small baskets, woven mats, hats and sitting cloths. Producers of palm sugar syrup in rural areas of Myanmar weave little baskets from the split palm leaves; these are used to hold sugar candy sweets, forming an ecologically viable container. Split cane is used in Cambodia for baskets and little souvenirs for tourist sale, exact scale models of the open fishing baskets used to trap fish in the shallow water of the rice paddies.

Weaving Fibre Mats and Bed Covers: Vietnam

In the riverside city of Hoi An in central Vietnam, a weave workshop produced mats made from strips of sedge reed – a plant of the family *Cyperaceae* – dyed with bright colours. The mats were made to sit on, or as undercovers for the traditional bed bases that are built into the houses as a raised wooden platform. The horizontal loom width was too wide for the weaver to pass the strips through at one go, so an assistant sat to one side of the loom and deftly slotted the sedge end into a cleft, cut into the top of a long bamboo stick. This was passed through the open warp shed, and the weaver unhooked the sedge strip at the far side as the assistant withdrew the stick, ready to re-thread it. The weaver sat cross-legged on the completed part of the mat, and raised or lowered the rigid heddle to alter the weaving shed openings for the sedge strips to pass through. The warp was made from natural fibre or strong cotton threads, held at either end of the horizontal floor loom by looping over the front and back beams. These were secured with ropes to wooden peg-posts, fixed to the floor.

A bed alcove in the eighteenth-century Tan Ky merchant's house in Hoi An showed one of these bed mats in position on the bed base. The reed mat formed the under layer over which other covers, neatly rolled to one side during the daytime, would be placed. The Tan Ky family, who dealt in silks and other imports, arrived from China in the sixteenth century. The 'old house', now a museum, reflects the assimilation of Vietnamese architectural styles by the later generations of these prosperous Chinese merchants.

ABOVE: *The Gejia girls of Guizhou Province, South-West China, use a tiny shuttle to make little hairnets to cover their buns, worn protruding through a hole in the headdress.*

BELOW: *The actual nets, purchased from the girl. The netting shuttle is still attached to the work. A finished bun-net in brown, on the right, is padded for display.*

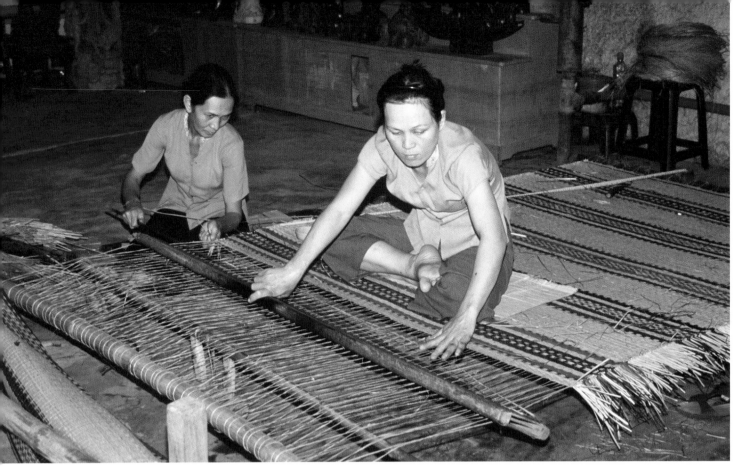

ABOVE: *Rush mats are woven on a horizontal floor loom in a workshop in Hoi An, central Vietnam. A woman assists the weaver by pushing the reeds across the open shed with a bamboo stick.*

BELOW: *The weaver lifts the fixed heddle to change the 'shed' opening, ready for the next reed insertion.*

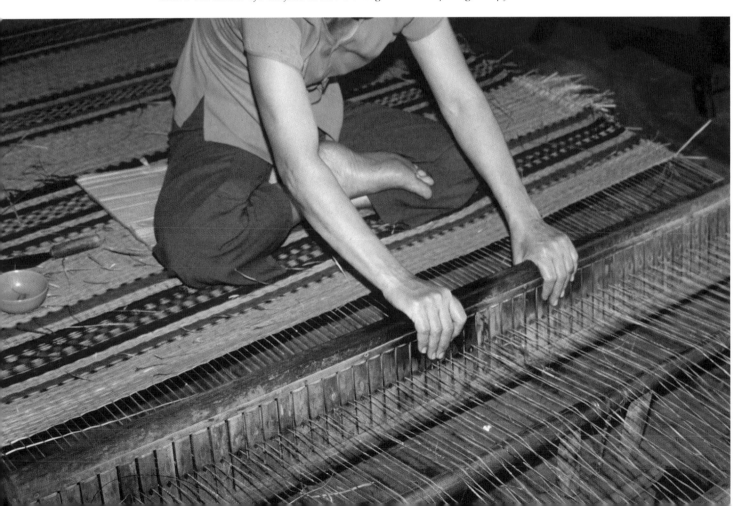

Woven Mats: Sarawak

Split rattan (rotan) cane is used by the Kayan, Kenyah and Kelabit tribes to make durable floor mats in this area of western Borneo. These split canes can be woven in the usual way, but a different technique, called *tikai lampit*, requires that the canes are first drilled with equidistant holes. According to Heidi Munan in Sarawak Crafts, the split rattan canes are laid side by side, marked with a gauge and drilled with an awl so that all the holes line up. These drilled canes are threaded together with creepers that are bruised at the ends to expose the fibres, which are then plaited to form an edging.

Many mats are woven using a diagonal technique, starting from one corner and using pairs of rattan strands to form the under and over pattern. Patterned mats are woven using cane dyed with natural substances such as soot, minerals and the boiled rattan seeds that produce a red colour known as 'dragon's blood'. Heidi Munan describes the mats and baskets woven by the Penan women, who are famous for their closely plaited rattan work. Their finely worked baskets are virtually waterproof. The Orang Ulu feature anthropomorphic and animal designs on their mats, while other tribes prefer geometric patterns. An unusual feature is the man's 'seat mat', nowadays less in evidence. This primarily utilitarian mat hung from the man's waist at the back and provided a ready-made 'seat', wherever the wearer happened to stop for a rest.

Twining

Twining is an interlacing technique, a transitional stage towards plaiting. A set of passive threads, in the form of a warp, are linked together by interlacing (or twining) a pair of active threads around them. This pair of active threads is divided to go over and under a passive thread, and then divided again to go under and over the next passive thread, thus linking all the passives together with a series of twists. The active threads can go over pairs of passives, change direction on alternate rows, or stagger rows on double threads.

Twining is often related to basketry, when it is worked in the round, but some tribes use this technique to make garment sections, later sewn together. The men of the Ndora region of the Flores Islands wore twined ramie vests, painted with geometric and animist designs that are still similar to ones worked today. The end threads of the twining process, which is worked on a frame with two shuttles, are formed into groups to make an end fringe. These vests are considered to be 'magical' and have associations with masculinity. As they were only made in this region, the vests formed part of a complicated exchange system. The

ABOVE: This plaited palm straw hat, made for the tourist market in Mandalay, Myanmar, is worked in segments joined with a fabric braid. It is light, easy to wear, and folds flat.

BELOW: The conical Non Lá *straw hats are made throughout Vietnam. In Chuong Mai village, Hanoi area, cane rings are prepared ready for the latania leaves – seen in a pile on the left – to be stitched in place.*

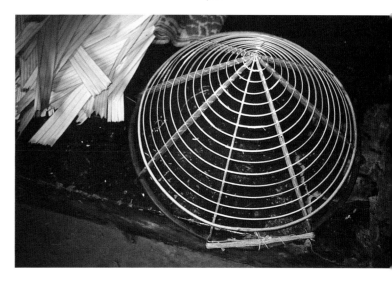

weavers of Sumba occasionally use a twining technique to finish the hems of their *hinngi* sarongs, and twining is also found in some of the braiding techniques.

Plaiting and Interlacing

Plaited straw hats, very like the traditional Panama hat, were made in Java for export, during the latter days of the Dutch administration. Woven straw hats, worked in twill patterns similar to the ones used for table mats, are worn by locals in Myanmar as well as being sold to tourists. One

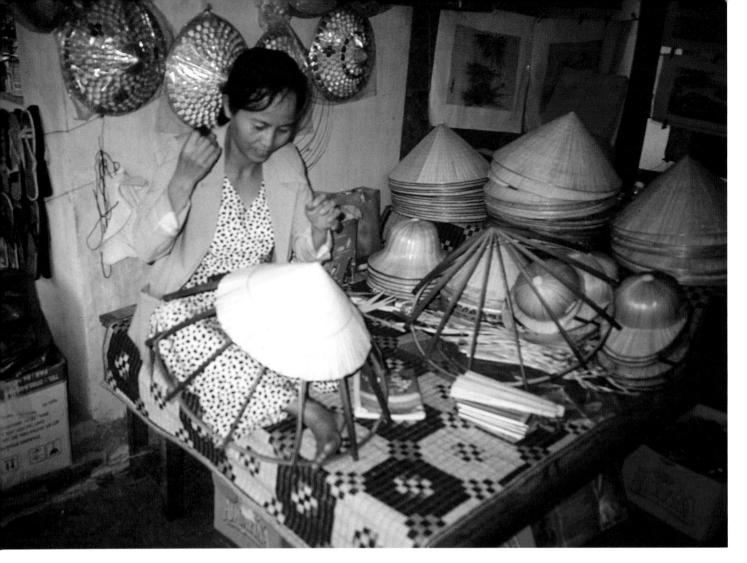

ABOVE: *In a Hué area workshop,* latania *leaves are sewn on to a framework of cane rings. When completed, ribbon ties are added underneath.*

BELOW: *Rows of Burmese-style palm-leaf hats are on display by the Ayeyarwady riverbank at Minguin, Myanmar.*

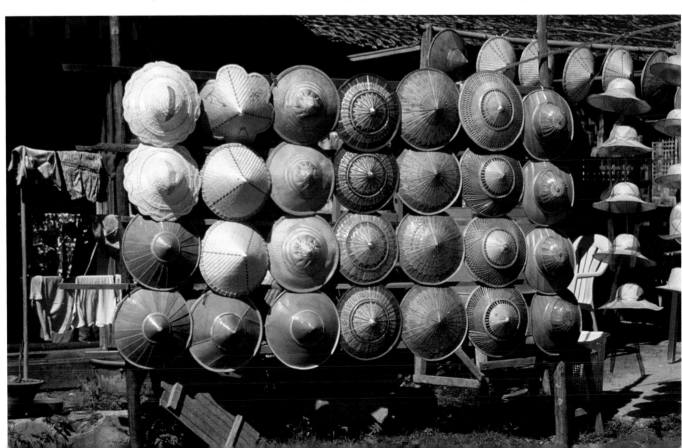

that was purchased in the Mandalay area is in segments joined by fabric bindings, and neatly folds flat when not in use. Domed and cone-shaped hats in a diversity of styles are also worn in Myanmar. Leaf segments are held in place by cane ribs and rings, some the shape of the original 'pith helmet' worn by Europeans in the tropics.

Conical Hat Making: Vietnam

Certain areas specialize in the making of these *Non Lá* conical hats. In the countryside outside Hanoi, villagers divide the stages in hat making between several workshops. The *latania* leaves used for the hat covering are naturally ribbed along the sections. They are cut to form elongated wedges that fit perfectly on to the cone-shaped framework, with the narrow points meeting at the top. The foundation of the hat is a continuous spiral of thin cane, or a series of cane rings diminishing in size. These are ledged on to grooves in a wooden former while the hat is being assembled. Each ring is stitched in place by hand from underneath, with equidistant rows of stitches showing on the outside. To finish off, a firmer ring is stitched to the outer rim. Ribbon ties are linked into sections of interlaced thread placed at either side of the hat interior. The coloured threads are anchored by looping under the lower inside rings, and look like a version of plaited God's Eye patterns. These hats not only keep off the sun, they are a shelter from rain, and can double up as baskets or even water carriers.

Bases for Lacquer Ware

In Vietnam, workshops for the disabled are set up in Saigon where lacquer-ware (son mai) of all kinds is made, including boxes with lids and picture panels. It is said that the art was introduced into Vietnam from China as long ago as the fifteenth century. The lacquer resin is obtained from the 'son' tree (*Rhus succedanea or R. vernicifera*). Up to eleven coats of resin are applied to bases of teakwood, leather, metal or porcelain in a sequence of hardened layers. After polishing, the piece is decorated with incised patterns, painted or inlaid with mother-of-pearl. In the Myanmar lacquer-ware industry, split cane is used to make the formers. Pliable strips are wound in circular formation and glued in position to make bases for beakers, bowls, dishes and vases. These shapes are later smoothed on a foot-operated lathe with the use of a chisel, then sanded down before the black lacquer is painted on.

A more unusual use of split palm is employed to make base shapes for beakers or vases, woven from the palm and human hair. The girls sit on the floor of the workshop, each girl with an inverted cylindrical pattern block in front of her. A switch of thick black hair lies ready beside the strips of split palm. Two or three strands of the long black hair are taken and woven in and out of the palm strips to make a pliable shape. The start of the technique is the same as in basket weaving, where several palm strands are crossed over on to the upturned pattern block, and woven in and out of each other to make the circular base.

More strands are added, forming the warp threads that are turned down at right angles from the circular base to form the beaker sides. Once the sides are reached, the hair is added and the girls deftly weave it in and out of the palm strands, with the hair becoming the woven weft. The completed cylinder is reasonably firm when removed from the former, and springs back into shape when compressed. The top is finished off with more split palm, ready for the layers of black lacquer to be painted on. Even when all the lacquer layers are completed, the beaker is still slightly supple.

This girl worker in a lacquer workshop near Bagan, Myanmar, is weaving a base for a lacquer pot out of palm straw and human hair. A part-completed pot former and a switch of hair are displayed on the right.

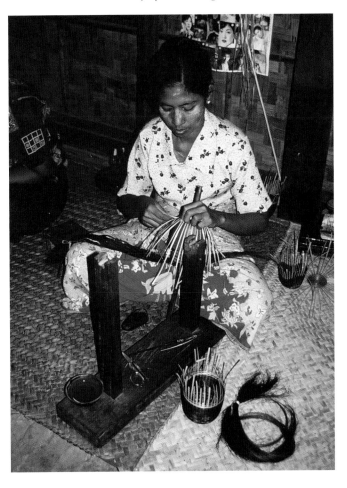

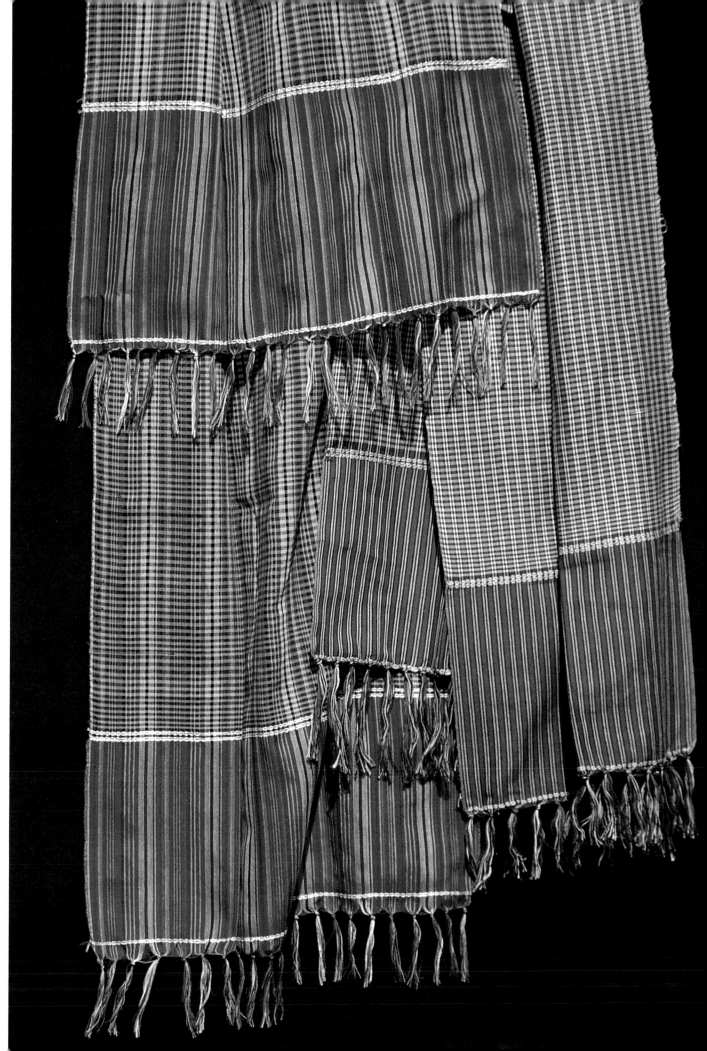

Fringes, Tassels, Pompoms and Feathers

In societies throughout the world, there is an innate desire to add decoration to clothing, accessories and even to the human body. These adornments can take the form of jewellery, whether worn as a separate item, inserted as body piercing, or attached as precious items to the actual garments. In many instances, beadwork takes the place of expensive jewels, and the decorative element of the craft results in the addition of fringes and ornamental edges. Embroidered fringes and tassels are a natural extension of thread crafts, and the warp ends of finished weaving form another area for manipulation. Those tribes associated with beadwork and embroidery tend to add more ornamentation, whereas the weavers whose skill is interpreted in superbly woven cloth would appear to be more restrained in their decorative additions. Possibly they do not wish to detract from the art of brocade and inlay weaving, with skills acquired through a long apprenticeship lasting from childhood to adult status.

Tribes in remote areas of the island archipelago, where clothing is not necessary in a tropical climate, tend to use the natural substances around them to add decoration to body painting, scarification and tattooing. Shells, feathers, fur, beads of all kinds, pierced bones and animal teeth, items carved from nuts, seeds, wood and vegetable fibre, all are called into colourful display. Decoration can take the form of cult regalia and accessories, whether to emphasize the local animistic and spirit ceremonies, or to embellish the priestly garb of imported religions.

OPPOSITE PAGE:
Fringed Kramer *turban scarves from the Siem Reap area, Cambodia.*

Fringes and Decorative Edges

Fringed Weaving

All weavers have the problem of dealing with the warp ends when the finished piece of cloth is removed from the loom. At times, these ends may be cut off at the bottom and left without any finishing process, though in this case the threads need to be long enough to form a simple fringe that will not unravel in use. It is far more common for the weaver to divide the end threads into manageable groups and tie them in an overhand knot pushed up to hold the final weft threads securely in place. This knotted fringe may be further embellished by dividing the thread groups once again, and joining them together with overhand knots to form a lattice pattern. The embroidered, cream-coloured Chinese silk shawls, made during the late nineteenth century for export to Europe, have decorative fringes made with rows of joined overhand knots. Several centimetres (inches) of unknotted silk threads form a further fringe at the bottom.

Another technique used to make decorative fringes was *macramé* knotting, an Arabian craft. The Arab weavers found this an excellent way of finishing the warp ends, and the practice spread to other areas. The two basic knots, the overhand knot and the half-hitch, are combined to form the various macramé working knots. All of the vertical threads are linked together by one or other of these knots, to form a close-worked lattice or a more open mesh. This linking will vary according to the chosen pattern.

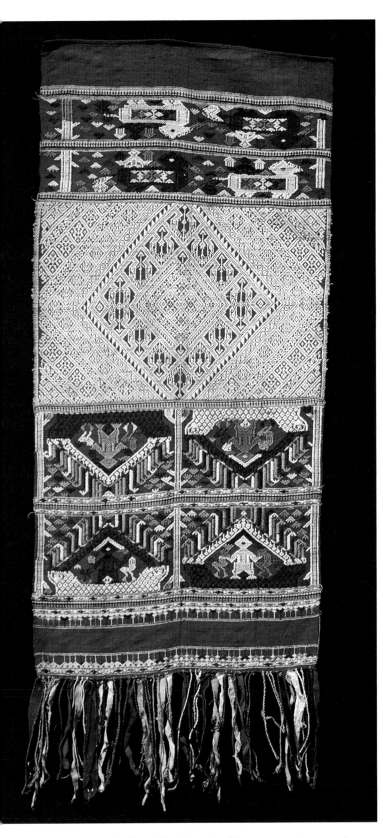

Strips of coloured cloth form the fringe on an antique temple shawl end from Sam Nuea, Houa Phan Province, North-East Laos. Provenance: Mrs Chanthone Thattanakham, Vientiane

Twisting the thread ends to make plied fringe ends is a common practice. If the warp is not cut from the loom, but removed with the end loops still intact, it is easy to manipulate the threads by poking a finger or a thin rod through the loop and twisting. A rough thread will stay plied, but if the twisting is continued, the loop will ply back on to itself, and the top end can then be sewn or attached back up to the final weft thread row. An alternative is to roll these end threads across the thigh, thus imparting a twist – a method used by many tribes.

A twisting method is used by the weavers of Sumba as part of a process to finish off the hems of their *hinggi* sarongs and mantles. When the ikat-woven fabric is finished, it is removed from the loom with the warp end loops hanging free. A small, side-operated backstrap loom is set up alongside the base of the hinggi cloth. A narrow braid pattern is woven by taking groups of the end loops from the hinggi fabric through the warp of the narrow loom, using them as weft threads to work the pattern. These end borders, known as kabakil, are sometimes twined instead of being woven. In this case the decorative braid threads are worked in and out of the free end loops of the hinggi cloth by hand. The hinggi warp loop threads protrude along the outer side of the woven braid, with their ends measuring 20cm (8in) or more, according to the required length. Afterwards, these ends are twisted to form plied fringes, and the ends of the sideways-woven braid are treated in the same way. This is an excellent way of utilizing the free warp ends to make a decorative edging.

Woven Fringes

Separate fringes are woven on a narrow-width loom, or one designed solely for the purpose. The warp is set on as a series of close threads at the left-hand side to form the heading, while a free space the width of the fringe is left before the selvedge threads are set on at the right-hand side. This leaves an unwarped section near the right, so that the weft threads will cross the empty space, before they are held at the right-hand selvedge. These horizontal weft threads will form the fringe when taken off the loom and are cut free from the right-hand selvedge. The left-hand holding section can be woven as a decorative braid or heading.

The scale of the fringe will alter with the type of thread used. Highly twisted silk threads were used to finish embroidered items in Chinese embroidery, but nowadays the threads are more likely to be rayon or synthetic. Bright red fringes feature on many of the ethnic Chinese hats. An embroidered version of a close-fitting scholar hat with a flat top was purchased in Kunming during the late 1970s. A lozenge of cross-stitch embroidery decorates the top, fancy

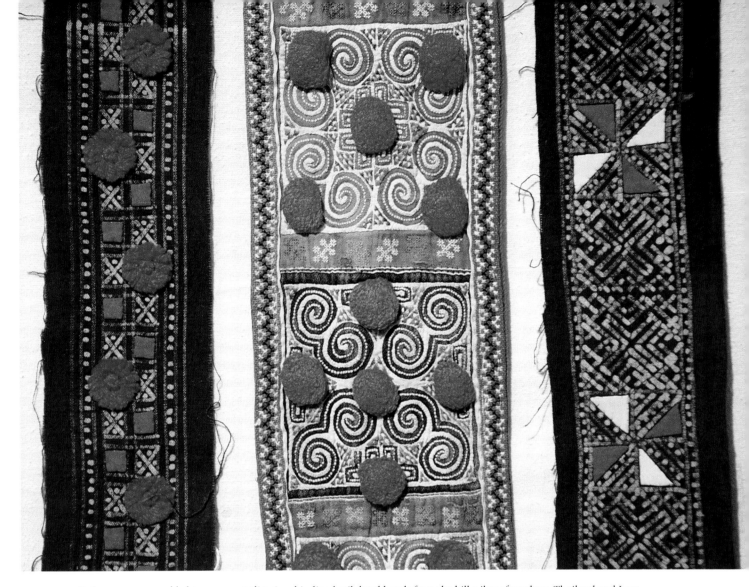

Red pompoms are added to reverse appliqué and indigo-batik lapel bands from the hill tribes of northern Thailand and Laos.

braids are stitched to the outlines of the cap, and the square top is bordered with a deep fringe in bright red threads.

Several tribes in north-east Myanmar, near to the Chinese border, wear similar fringe-decorated headdresses to those worn in Yunnan and Guizhou provinces. In *The National Ethnic Groups of Myanmar*, an Aikswe woman of the Wa-Palaung group in the Kunlong region is depicted wearing a fringed crown similar in shape to the ones worn by the Anshun dancers in Guizhou Province, while Wa-fringed turbans echo those worn by weaving groups in northern Laos.

Many of the Miao tribes decorate their costumes with beaded fringes. No two are alike, and their costume is evolving all the time. The advent of tourism, which brings money to the villages, together with the competitive element of the dance festivals, promotes a continuing elaboration, especially in beadwork and metal jewellery. Aprons, sash ends, back panels and shoulder bags are all finished with beads and tassels. Even longer bead strings and deco-

rative pompoms hang from the bases of baby carriers. Headdresses are especially decorative, with wide ones giving even more scope to pendant bead strings and tassels.

Pompoms and Tassels

Decoration on Thai Hats

The Lisu girls of North-West Thailand are especially fond of long tassels made from brightly coloured synthetic threads. Multicoloured threads are gathered together to form thick bundles, which are secured in a variety of ways to their indigo-dyed cloth turbans. A thread bundle, about 1.5m

ends, some decorated with round thread pompoms in several colours. A young man's 'courting' bag is vibrant, with a long, multicoloured thread fringe on the lower end, combined with silver dangles placed along the top opening and the hem borders of the coloured straps.

Akha

Long thread tassels adorn the sides of the Akha tribal hats, which are already covered with silver-domed discs, beads and strings of silver coins. The decoration of the hat varies from tribe to tribe, but the basic shape is that of a fitted cap, barely discernible beneath the additions and embellishments. The back of the cap may have a flat upright section, shaped like a trapezoid that is narrower at the top

A bead-, seed- and feather-decorated hat of the U Lo-Akha women is frequently worn perched on top of a coin-decorated cap. Strings of seed beads and long feather tassels hang from the sides, while a tuft of fur is at the top.

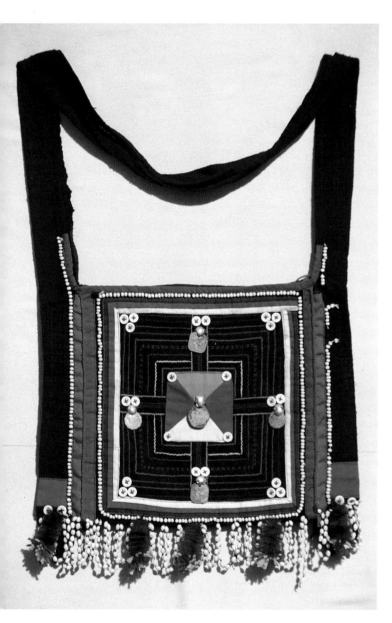

A shoulder bag, carried by the Akha people from North-West Thailand, is decorated with seeds, beads and coins. The fringe at the base is formed of loops of Job's tear seeds, alternated with feather tassels.

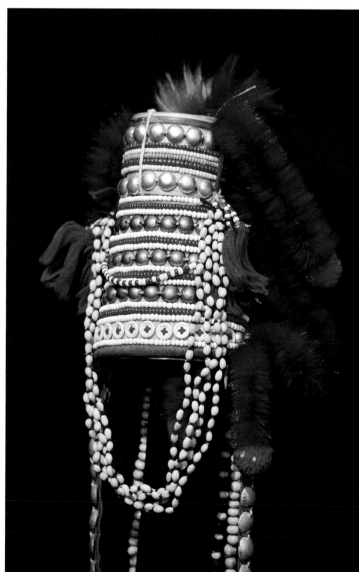

(5ft) in length, is held with a pair of decorative bindings placed at the front of the turban. The tassel ends are divided and brought round to the back, with the longer end draped over the turban top. The tassel is joined at the back with a beaded string attached to a triangular pad of cloth, itself embroidered and beaded. The triangle has its own multicoloured fringe, and hangs down to join the cascade of threads from over the turban. Occasionally, strings of coloured beads are combined with the turban threads. Equally thick thread tassels hang down from the tunic belt

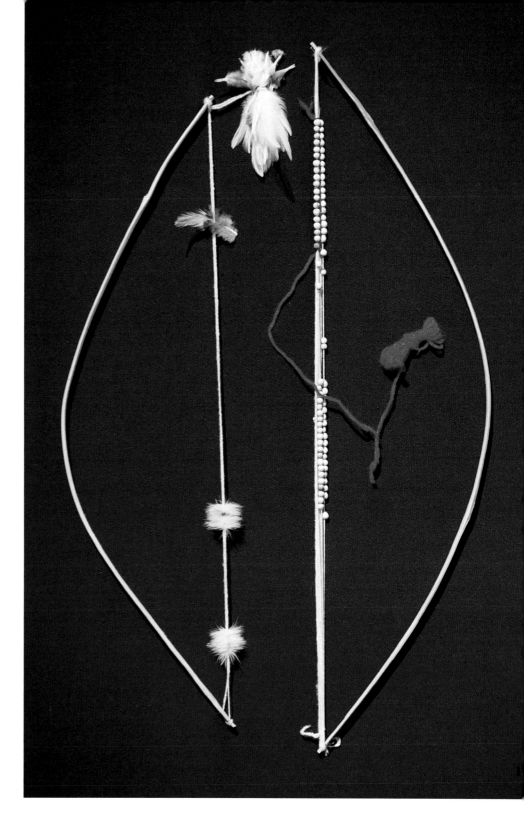

than the base. It is made from embossed silver or a fabric-covered stiffener, and helps to hold in place the extra thread pompoms, tassels, bead strings and feathers that decorate the headdress top.

The U Lo-Akha women wear an extra, narrow cylindrical cap on top of the normal one. Apart from the usual silver beads, this may have the addition of gibbon fur, either its natural colour or dyed red, together with sections of feathered bird wing. This is accompanied by loops and dangling tassels made of wild bird feathers or dyed chicken feathers. These resemble a thick chenille thread, or a miniature version of the padded end of a bell-pull. The tassels are made on a version of the bow-loom, adapted to take the feathers. The split cane bow is threaded with a single pair of shorter warp threads, so that the bow is kept in tension. The dyed feathers, approximately 9cm (3½in) in length,

are threaded one at a time into the double warp threads. No weft thread is used, and each feather is secured by weaving it several times in and out of the warps until the length is used up. The feathers protrude at the sides, and are held firmly in position by the sequence of twists.

The Loimi-Akha women also sew long, decorative tassels on to their embroidered and applied patchwork jackets. Red threads are combined with small Job's tear seeds, cut

A detail of the back of the Akha jacket illustrated on page 86, showing the strings of Job's tear seeds that form the long tassels.

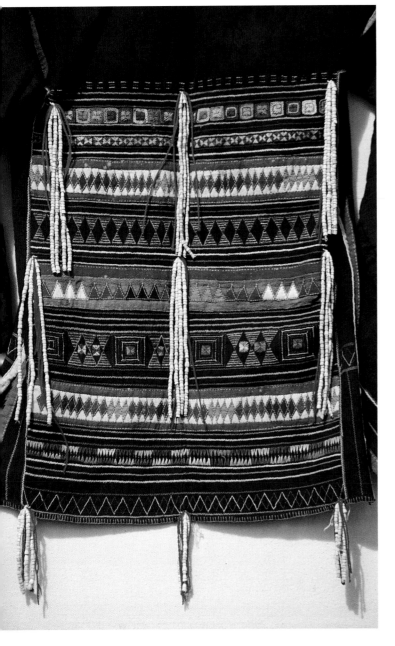

in half and threaded in the same orientation so that the seeds slot downwards into each other, making a smooth tassel. Round Job's tear seeds decorate their caps in combination with silver dome-beads. In one instance, three 'bronze' coins are sewn on to the front of a Loimi cap. A quarter Anna 'India' coin piece is dated 1901, with Queen Victoria's head on the obverse surrounded by the letters 'Victoria Empress', accompanied by one dated 1905, King Edward VII, 'King and Emperor' and King George V, dated 1940. These must have been highly regarded for their intrinsic rather than their actual value. Strings of the round grey-white seed beads hang at either side, together with the dyed feather tassels, pompoms and a topknot of gibbon fur.

Myanmar

In Myanmar, the Akha tribes wear costumes that are very similar to those worn over the border in North-West Thailand. A cap of the Kaw-Akha tribes in eastern Myanmar has a decoration of Job's tear-seed tassels, but in a natural brown colour. Two bead strands are joined so that they form a loop under the chin. This is a common beaded decoration and echoes the silver earrings that are attached to each other by silver chains hanging beneath the chin. The upright cap back has dyed feather tassels at either side, ending with tassels made from brightly coloured synthetic threads.

Some tribes choose long tassels made of white threads rather than red. Long fringes hang from sporran-type aprons worn at the front of the short skirt, and swathes of the threads are slung across the shoulders and chest like a bandoleer. The women of the Black Yin tribes, also known as the Black Kayin, wear black dresses reaching to their knees, plus an extra cloth like a skirt. Rows of red tassels are sewn in layers to the front of the dresses, starting at armpit level and reaching to just above the waist, where a binding sash holds all in place. Both men and women of the northern Lisu tribes wear long tassels to decorate sash ends, and the men have long thread tassels dangling from their sword scabbards.

Karen

Karen girls from the tribes on the Thai-Myanmar border add long red fringes to their embroidered shift dresses at ceremonial times, including funerals. The red cotton fringes are added to the already embroidered garment, just below the arm openings, and reach down to cover half of the chenille thread-embroidered hem band.

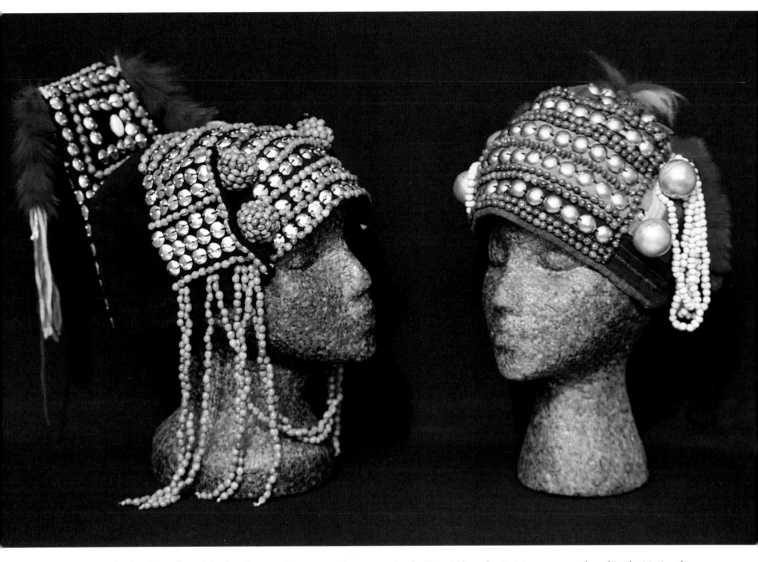

Two very similar bead-, seed- and feather-decorated caps. LEFT: *A cap worn by the Kaw-Akha tribe, in Myanmar, purchased in the National Museum, Yangon.* RIGHT: *A cap worn by the Loimi-Akha tribes came from the night market, Chiang Mai, North-West Thailand.*

Mien and Mun Yao

This love of thread tassels is spread right across the areas of the Golden Triangle, from Myanmar in the west, across northern Thailand to the Mien and Mun Yao people in Laos, Yunnan and northern Vietnam. The Mien women from Laos wear ceremonial tassel pendants. Thick red wool tassels are fitted to the ends of silk cords wrapped with silver thread along the length, to make a parti-coloured pattern. These silk tassels hang from silver bells and pendants, giving a particularly rich effect. Both the Mien and the Mun tribes have long red thread tassels to decorate the sides of their shoulder bags, singly or in pairs, and sometimes with the addition of red pompoms.

Older versions of women's purses dating back to the 1940s show a series of red pompoms, sewn around and across the surface in a grid formation. These are formed from dyed feathers or from natural fibres, not from modern synthetic yarns. The Red Yao women from the Sapa area of northern Vietnam cover the backs of their headdresses with a series of strung pompoms combined with silver jewellery. These ball-shaped pompoms match those that outline the sides of their front aprons and tasselled belts, all in brightest red to match their turbans. Today the pompoms are made of synthetic threads, predominantly in red, but with some other colours added.

A simple method for pompom making is to take two same-size flat discs, each with a hole in the middle. These

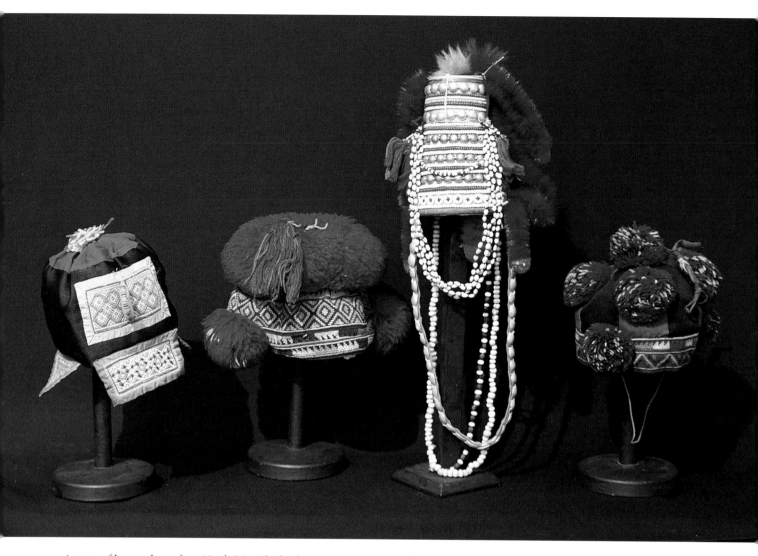

A group of hats and caps from North-West Thailand. FROM LEFT TO RIGHT: *A Hmong boy's embroidered cap with front and back flaps; a Mien-Yao woman's cap with circular pompom top; full-length view of the U Lo-Akha cap; a Mien-Yao boy's cap with pompoms round the sides.*

discs are placed together and the pompom thread is wound through the hole and over the outer edges, to completely cover the discs with several layers of thread. When finished, the layers of thread are cut through along the circumference of the discs, and the two discs are prised slightly apart, allowing a binding thread to secure the pompom in the middle. When the discs are removed, the pompom is eased into shape and trimmed to make a spherical ball. The central binding thread is used to secure the pompom to the garment or bag.

Thread pompoms are a frequent decoration for the caps worn by the Mien tribes of North-West Thailand. A Mien-Yao woman's cap from the Nan area is made from a joined oblong of indigo-dyed cloth, with rows of red and blue tape sewn along the top. This is sewn to a lining cloth, and all is gathered together to form a pleated centre to the crown. The sides are embellished with geometric cross-stitch patterns, and a circle of red pompoms surrounds the top, revealing the pleated braid in the middle. This circular pompom is made from a series of smaller pompoms, stitched closely together so that they meet to form a continuous ring. A large red pompom is sewn on to the embroidered band at either side. Little boys' caps have separate pompoms, with a central one perched on the top of a segmented cap, surrounded with four separate equidistant pompoms. Two pompoms, one on each side, are attached to the cross-stitch embroidered sideband, similar to the women's caps.

Thread pompoms decorate the ends of a woman's phaa piao head-cloth from Ban Tai Dam, an animist village, Luang Prabang area, northern Laos.

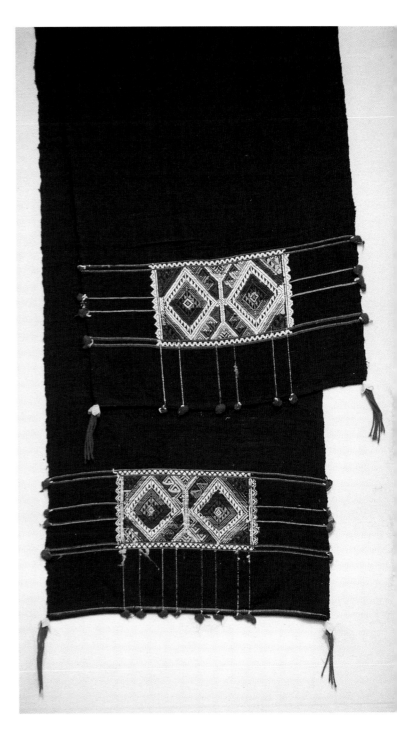

Disc Pompoms

In the northern Lao-Thai areas, women of the Tai Dam and Tai Waat tribes at one time wore special head-cloths, called *phaa piao*. These are long, indigo-dyed cotton cloths embroidered on both ends with diamond and hook designs that differ according to the particular tribe. The fabric ends and lower sides are bound with strips of applied red cotton cloth, on the straight grain of the fabric. A series of small, thread-covered circular discs with holes in the middle are attached to the base and sides of the fabric hem. According to Patricia Cheesman, the Tai Dam married women wore these head-cloths with the embroidered front end over the forehead, and the long end going over the raised hair-bun to hang down at the back. The number of rings worn, generally odd in number, showed the marital status of the woman.

The flat disc-rings are first covered with the red fabric and then closely stitched all round with segments of different coloured silk threads. This is achieved by taking a stitch into the red fabric on the outer circumference of the ring, then wrapping the coloured thread round through the hole in the middle, before taking the next stitch. This leaves a narrow band of red fabric showing on the outside rim, only possible to see in detail with a magnifying glass. It would appear that the red covering fabric is first cut into narrow strips, more than twice the disc radius in width and slightly longer than the circumference. This strip, which is folded and placed around the circumference of the ring, is held in place with tacking stitches taken through the central hole. The excess in the fabric width is ruched up on both sides of the ring, giving the finished disc a padded appearance. The cut fabric edges on the inner circle are completely covered by the closely packed silk binding threads, and the 'tail' of protruding red fabric is used to sew the completed ring in place on to the border. The finished disc measures 8mm (½in) in diameter, and as all the discs are uniform in size, they may have been formed from metal washers.

The old head-cloths are used occasionally by other local groups, but many are offered for sale. This explains the structure of a modern 'ethnic' jacket purchased from a dealer by the author. The mysterious applied sections of cloth, decorated with pattern-darned triangles surrounded by lines embroidered in fine chain stitch, had borders of red cloth with the addition of little multicoloured rings.

Once their origin was understood, the applied panels stood out as being the lower sections of the *phaa piao* head-cloths. The embroidery designs would suggest they might belong to the late Sipsong Tjao Tai style illustrated by Patricia Cheesman in her *Lao-Tai Textiles* book. It is a pity that these head-cloths have been cut, but at the same time they are preserved for reference, allowing the structure of the rings to be examined closely.

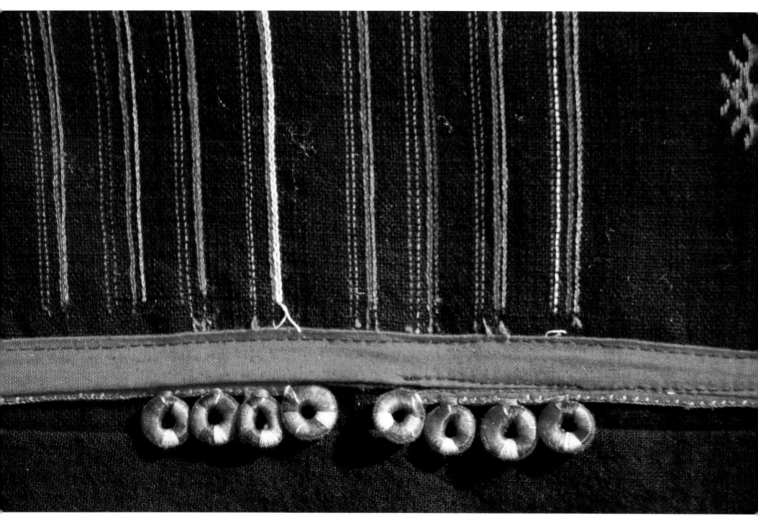

Detail shows the supplementary weft decoration and thread-covered rings on the end of a phaa piao head-cloth, worn by the Tai Dam married women, northern Laos.

God's Eye Tassels and Decorations

Little tassel and thread-laced decorations are imported into Western countries from Thailand. In their simplest form they consist of groups of round thread pompoms attached in groups to small diamond shapes covered with interlaced threads. These groups are attached to a main circular shape, often covered with crochet in equally bright colours. These are sold as 'courtship tokens', said to be thrown over balconies by the Thai maidens to a group of would-be suitors below; whichever young men caught the tokens could 'court' the appropriate maiden. However, although this custom was originally practised in some areas, these are not true courtship tokens and are made purely for tourist sale. Even so, they are very decorative.

More complicated versions have a series of indented diamond shapes covered with the thread patterns known as 'God's Eye'. The 'diamond' is made from three triangles of wood, glued together at the longer bases so they make three equal sections. These are covered with paper and then wound with coloured threads in a continuous sequence to form indented diamond shapes within each of the three sections. Red, white, green and yellow threads make striped patterns that interlace where they meet. Smaller, threaded diamonds are added to the five points of the large shape, and each one is decorated with groups of the small coloured pompoms. There are many versions of these decorations, but the basic principle is always the same.

Long strings of God's Eye squares are made by first fixing together two small flat rods of wood so that they meet at

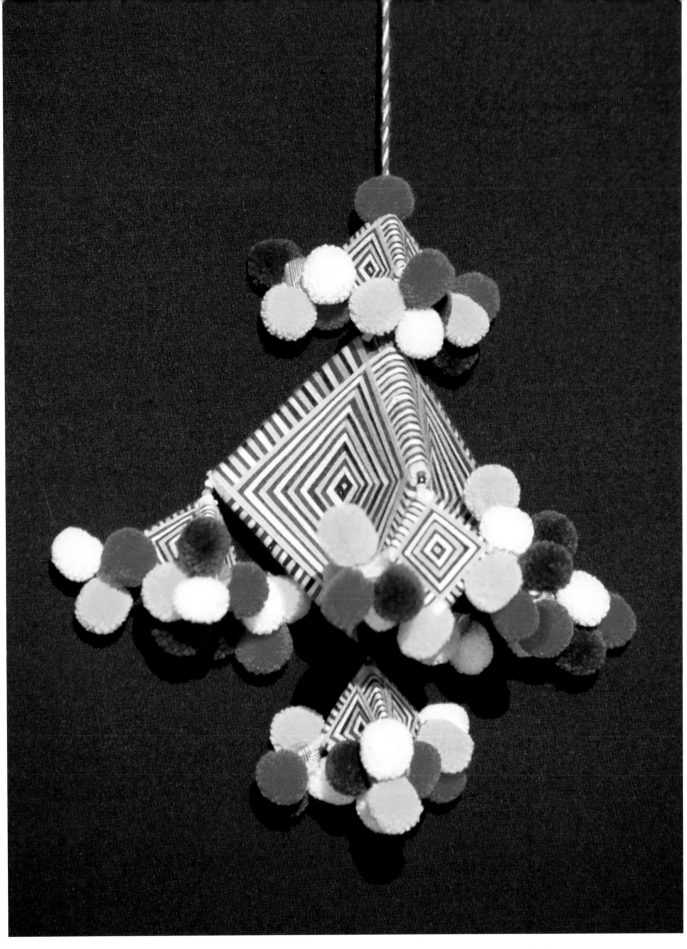

God's Eye patterns on a pompom-embellished mobile hanging, from North-West Thailand.

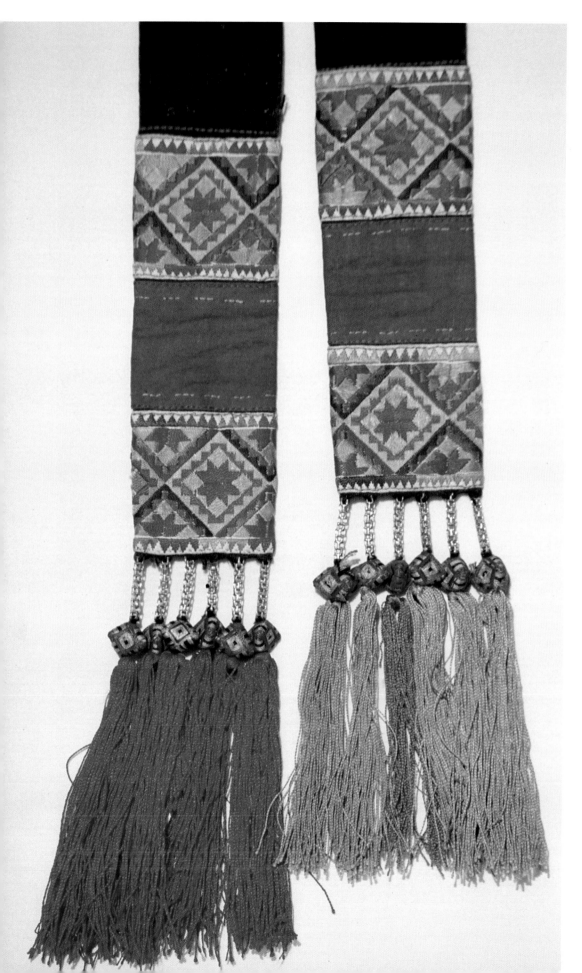

A series of little God's Eye triangles hang from silver chains to support the tassels on an embroidered belt-end worn by the Bouyei women from Yunnan Province, late twentieth century.

Mobile decorations in the Chomthong Buddhist temple, northern Thailand, are made from thread, paper, beads and tinsel.

right angles in the middle. This makes four equidistant arms that are laced around, working from the middle outwards. The winding thread is taken around each arm in turn, forming a raised cross on one side and a flat surface on the other. A series of these wound shapes are strung together, with smaller ones hanging from the arms of the cross. The tourist hangings are developed from the original ones found as religious decorations in the Buddhist temples in Thailand. These strung mobiles, called *tung yai*, look especially lovely hanging in the dim light of the temple, or silhouetted against an open doorway. God's Eye hangings are found in many areas of the world, as the interlacing patterns are formed automatically, provided the correct route is taken. It is not known if the shape is the reason for the name, or if the wound thread pattern – which follows the laws of geometry and mathematics – is thought to produce a magical effect. Similar constructions, called 'spirit houses', are placed on the roofs to give protection to the buildings.

Feather Decorations

Male birds use their iridescent feathers and exotic plumage

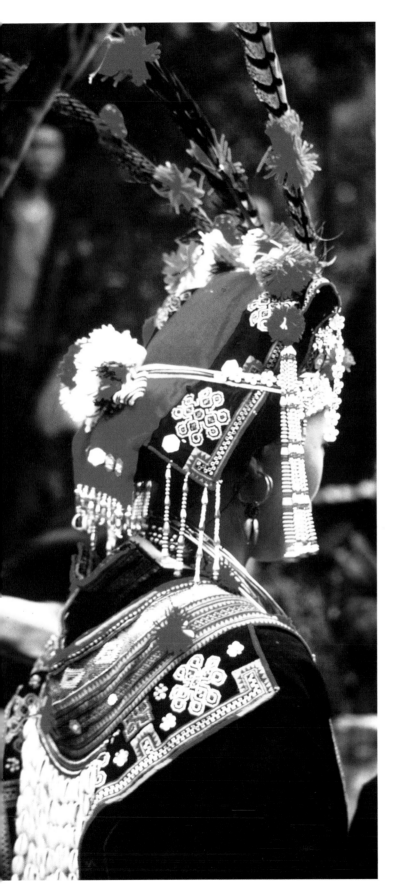

A 'Pheasant Miao' girl from Guizhou Province wearing an elaborate costume bedecked with beads, cowrie shells and strings of feathers. Her bead-tasselled headdress is embellished with three pheasant feathers, each one decorated with pompom tassels.

to attract their mates, and although the females are usually of a plainer hue to aid camouflage when nesting, some are also very decorative. Feathers have been used by mankind throughout the ages, either as an addition to costume, or to form the main ingredients of the costume itself. The feathers can form headdresses and hair decorations, be attached to bags, weapons and accessories, or integrated into tassels and beadwork. Peacock feathers were prized for their beauty and included as feather fans, as part of royal regalia, and added to costume and accessories. The design of these feathers was expressed in other media, too: for example, the famous gilded Peacock Throne from India, representing two open peacock tails inset with diamonds, rubies and other precious stones, was frequently copied. The original throne was built for the Mughal emperor Shah Jahan in the early seventeenth century; it was seized by the Persians in 1739 who took it back to Iran, where it was later plundered by the Kurds who dismantled it for the precious gemstones.

Myanmar

The Naga tribes belonging to the Tibeto-Burman group that in the past migrated across the Patkoi mountain ranges, can be found on both sides of the India-Myanmar border. This is the remotest part of the Union of Myanmar, and these people live in the densely forested areas on the western banks of the Chindwin River. According to the booklet *National Ethnic Groups of Myanmar*, the Naga are 'stout and sturdy', normally wearing little else than a circle of polished cane over the genitals. The females also wear the bare minimum, just enough to preserve 'female modesty'. It is at festival and ceremonial time that the Naga warrior 'comes into his own'. At the *Kaing Bi* New Year Festival, the man will wear a cane helmet decorated with wild boar tusks, bird feathers, bear fur and human hair. Large feathers adorn the helmet top, and matching pairs of fluffy feathers sprout from the sides. Feather tassels, placed halfway down, embellish the large warrior spear, and a sword is worn on a belt decorated with goatskins, lacquered bamboo and beads. A Tanghkun Naga man is shown in full ceremonial dress wearing an immense headdress formed of three cane discs and a face bib, all decorated with hair and feathers hanging below and an array of spectacular feathers above.

South-West China

Although elaborate feather headdresses would appear to be the prerogative of tribes in tropical countries, many of the ethnic Miao women decorate their distinctive headdresses with feathers. Festival costume from Sandu County consists of a headdress cap decorated with silver ornaments and curved extensions ending in chicken feather bunches. Similar chicken feathers form a fringe attached to the lower hems of intricately embroidered jackets, reaching down to ankle length.

Pheasant feathers are popular, and the women of one tribe from Guizhou Province, called the Pheasant Miao, wear the long tail feathers attached to their elaborate headdresses at festival and dance times. Six or more pheasant feathers are attached to the top of the bead-fringed and embroidered cap. Each feather is decorated at intervals with several brightly coloured thread pompoms in red, yellow and blue, but with red predominating. Although these are small pompoms, the weighted feathers are heavy enough to bounce to and fro as the dancers twist and turn. There is an exuberance of decoration, and similar pompoms embellish other parts of the costume. Back bib panels are covered with threaded tassels of cowrie shells that sway as the girls move. A series of embroidered handkerchiefs, also decorated with red pompoms, hang from the belt, and longer red thread tassels fixed to silver pendants are strung at the sides. In the year 2001, the village men, unlike the exotically feathered male birds, wore plain blue trousers and jackets, but in their relative dullness were a perfect foil for the girls.

Indonesia and the Islands

Women from the Ngada Regency of the Flores Islands wear cascades of tall feathers attached to their headdress, made from large gourds over which they wrap their hair. In contrast, the men wear a plain turban of dyed indigo cloth. The men of the Ndora region carry special feather-decorated trophy poles, associated with the deer hunt. When seated on horseback, a successful hunter is allowed to show his status with a long rattan pole set up behind him, decorated with chicken feathers. This ornamental pole, called a *lado manu*, may stand free or be attached to the back of the twined rattan vest – another status symbol worn by the hunter. The pole has white feathers slotted up the stem, where it branches into two sections at the top; each curve is decorated with the feathers. Spears also had feather decorations on the ends, which may have aided them in flight, in a similar way to fletched arrows. These feathered devices are no longer used at hunting times, but remain a symbol of bravery in the chase.

New Guinea

Although the island of New Guinea is divided in half, with Irian Jaya in the west and independent Papua New Guinea in the east, it is still a single geographic island, surrounded by many smaller islands. The terrain is mainly mountainous, but there are wetland river areas in the south and low-lying tropical rainforests in the north, which support rubber plantations, as well as sago and coconut trees. Most people of Irian Jaya are engaged in agriculture, but crafts such as wood carving, leather tanning, basket, mat and handloom weaving, still thrive. In many areas, Indonesian-type costumes are worn on a day-to-day basis, but decorative costumes are worn at celebrations and festival times. Although there are some Muslims and Christians, indigenous animism still prevails, and the costumes reflect the spirit beliefs with the use of natural objects as decoration.

Anthropologists believe that some highland tribes still exist in Papua New Guinea, who have never had contact

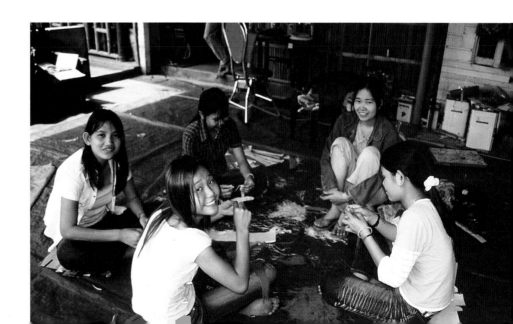

In the agricultural area outside Hoi An, Vietnam, young girls sit making tassels to decorate the fabric lanterns made in the lantern workshop.

The finished lanterns make a decorative display in a craft shop in Hoi An, Vietnam.

with outside societies. Commercial teak-logging enterprises, and the search for copper and gold, makes this less likely as time goes on. Even those tribes who have already been contacted continue to practise rituals, many based on spirit beliefs where they dress up in costumes of feathers and animal skins to represent the forest, animal and mountain spirits. They also enact legendary battles and perform musical 'sing sings' as part of the ceremony. Dancing is used to display the costumes and the decorated bodies of the dancers, emphasizing the strength of the collective group to which they belong.

Colourful body painting is accompanied by elaborate shell and feather headdresses; tribes from the island of Bago-bago to the south-east wear particularly distinctive costumes. Bird of paradise feathers sprout from animal teeth crowns, surrounded with tusks and yet more feathers. Additional feathers are woven into the neck ornaments and form arm-bands and anklets. Some tribes wear little clothing except for a penis sheath, and at festival times, a cascade of large feathers attached to the back of the belt.

The Philippines

In the western area of the island of Mindanao, young girls celebrate cultural dance festivals wearing embroidered appliqué on their costumes and elaborate feather headdresses. Bright yellow fluffy feathers, with red sections near the quill base, are attached to sticks set on to a close-fitting cap to form a fan-shaped arc above the head. Yellow threads are secured behind the 'fan sticks', with the excess hanging down as tassels either side. The girls wear beaded choker necklaces with strands of beads hanging down in front, ending in a series of silver coins. Feather 'cockades', sprouting from a bead- and tassel-decorated headdress, are worn by the young women during some of the cultural festivals held in capital Davao City. It is not known if these festival costumes are a modern innovation, or if they stem from some earlier tradition.

Bead fringes border the corners of the square cloths covering the wide-brimmed hats worn by the T'boli women from the state of Cotabato, when attending communal gatherings. A Bagobo couple, illustrated in *Textiles from the Southern Philippines*, are shown wearing ceremonial costume; both feathers and beads form an important part of the woman's ceremonial headdress. A beaded headband

holds the contraption in place, with beaded tassels hanging down to shoulder level at either side. The Bagobo woman has a bead and shell necklace, and both she and her husband are wearing rare shell bracelets, possibly part of the Kula Ring Exchange. The Bagobo tribes also make backpack bags to hold betel nuts for chewing. As these nuts were offered to their gods, the bags and equipment gained an added significance. Bags were made of various materials, including the locally available banana fibre. The bags were decorated with beads, and fringes of horsehair were added to the beaded panels.

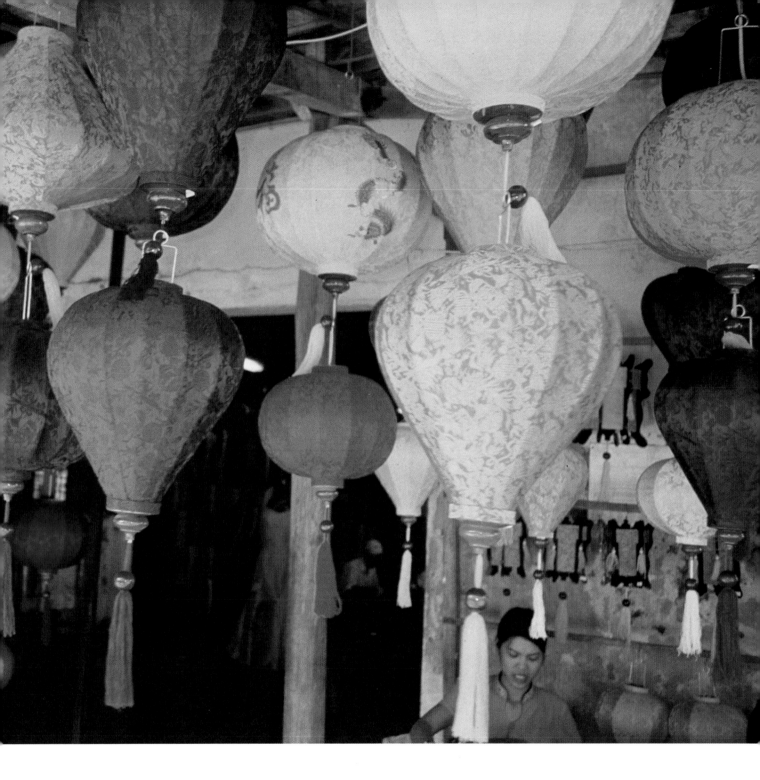

Tasselled Lanterns, Vietnam

The Vietnamese are famous for their colourful fabric lanterns, a legacy from neighbouring China. Among other places, these are made in rural workshops near the port of Hoi An on the Thu Bon river. A wooden frame-work, made from split cane, is covered with brightly coloured damask-weave fabric. Men split the cane to make the ribs for the circular, oval-shaped frames that are made to fold up, thus taking up less room for storage and transport. Young girls glue fabric sections on to the segments formed by the framework, centring each one carefully and making sure the fabric is quite taut. Another group of girls sits on a floor mat under an open veranda, making the tassels from silk threads. The threads are wound on to a former, removed, and the completed bundle of threads secured by winding together at the top. When lit, these tasselled lanterns look delightful in display, and sum up the spirit of these colourful people, who have adapted techniques from far and wide to become part of their very own craft repertoire.

Glossary

Spelling can vary from country to country, as many of the words are adapted from the indigenous languages. Most weaving and embroidery terms are dealt with fully in the relevant chapters.

Amrita The elixir of immortality

Aida Trade name for double-thread embroidery fabric

Andung The skull tree, island of Sumba

Ao Dai National 'long dress' worn in Vietnam

Apsaras Celestial dancers, Angkor Wat

Asura Hindu demons

Badan The main 'body' of a Javanese sarong

Bhagavata A Hindu religious poem

Bidang Beaded knee-length tube skirts of the Dyak women, Kalimantan

Bugles Small cylindrical bead

Canting or tjanting Batik wax drawing tool

Cap or tjap A metal stamp to print wax patterns

Cermuk Sumatran mirror-work similar to Shisha embroidery, India

Charka Spinning wheel, India

Chinthe or singha Mythical lion

Chong san Traditional Chinese tunic dress

Chong kraben Wrapped loincloth breeches, Thailand

Couvette Cup-shaped sequin

Deva-Raja Hindu god-king

Devata A celestial goddess of great beauty

Erawan Seven-headed elephant, ridden by the Hindu deity Indra

Feng huang The double phoenix symbol, China

Frivolité Original French name for tatting

Galon Mythical creature, part man and part bird

Garuda A Hindu mythical man-eagle

Geringsing Double-ikat woven cloth, Tenganan Pegeringsingan village, Bali

God's Eye Plaited thread patterns for mobile spirit hangings

Hamsa Mythical duck-like bird

Hinggi cloth Sumba Island man's knotted waistcloth

Hintha Mythical bird, resembles a goose

Hol weave 3/1 uneven twill patterning, Thailand and Cambodia

Hong or suwannahong Mythical swan-like bird

Ikat Tie-dyed warp or weft threads for weave patterning

Jamdani Patterned inlay weaving from East Bengal, now Bangladesh

Jarong man Travelling salesman, Malaya

Jataka Tales of the last ten lives of the Buddha

Ketadu Musical instrument made of a lontar palm leaf

Kain Panjang Open-ended 'long-cloth' skirt, worn in Malaysia and Indonesia

Kalagas Sequin-embroidered and padded wall hangings

Katipa Beadwork headbands worn by Sumba women

Kebaya Close-fitting women's jackets worn with sarong skirts, Indonesia

Keik Htamein Jewel-covered ceremonial skirt worn by royal ladies, Burma

Kepala Broad 'head' band on a sarong, containing 'tumpal' triangles

Khlongs Water transport canals in Bangkok, Thailand

Kiet The silk head-cloths worn by Cham women of Cambodia

Kochi Baited fishing nets suspended from frames erected over water

Kosa-sing Long-nosed mythical creature resembling a squat elephant

Kotak Wax screen printing, also called 'batik kotak'

Kramer Oblong checked cotton scarf or turban cloth, Cambodia

Kulambo Embroidered royal curtains, Maranao, southern Philippines

Lakmee Wooden ikat-tying frame, Thailand

Lar Single garuda wing

Lau pahudu Warp pattern stored on a string model

Linga Symbolic male organ

Longyi or lunghi Wrapped tube skirt

Luhol Appliqué wall hangings of the Tausug people, the Philippines

Luntaya acheik 100 shuttle tapestry weave patterns

Macramé Decorative knotting, originally an Arabian threadcraft

Mahabharata Longest known Hindu epic poem

Makuta Headdress crown worn by the devata statues

Manusiha A composite mythical man-lion creature

Mirong Pair of garuda wings

Mordant A fixative for natural dyes that helps fabric and thread keep its colour

Muangs A group of people who owed allegiance to over-lords

Mukena Islamic woman's long veil

Mutisalah Opaque red glass bead known as 'Indian red'

Mutmi or **matmi** Thai term for ikat tie-dye

Naga Mythical serpent, part dragon, part snake with cobra-like hoods.

Nak Mythological snake, Thailand and Laos

Nats Spirits of Nature

Non Lá Conical straw hat, Vietnam

Ñandutí Circular needle-lace patterns worked into cloth, Paraguay

Oes Tiny metal eyelets

Ol-ol Embroidered royal bed canopies, Maranao, southern Philippines

Orang asli Malaysian word for 'aborigine people'

Orang ulu Malaysian word for 'river people'

PanDau Reverse appliqué embroidery of the Hmong women

Paillette Original name for sequin

Pakhikung Supplementary warp weaving, Sumba

Palampores Indian painted 'Chintz' cloths

Pamn muk Separate pleated additions to the sampot chang kbin

Panjin Filling stitches for gold thread embroidery, China

Paso Burmese man's extended-cloth wrapped lungyi

Patola Prestigious double-ikat weave from Northwest India

Paua Abalone shell, New Zealand

Peksi kingkin A sad bird

Pensarupa A composite mythical creature

Peranakan 'King's Chinese', immigrants to the Straits of Malacca

Phatuum Blanket cloth, northern Laos. Elephant head-cloth, Thailand

Pha sarong Man's wrapped tube skirt, Thailand

Phaa piao Special head-cloths worn by married women, northern Lao-Thai

Phasin Woman's wrapped tube skirt, Thailand

Pidan Sacred wall hangings in Buddhist temples

Piña Pineapple-fibre cloth

Pirn Thread holder fitted inside the central hollow of the shuttle

Pis cloths Tapestry-woven fabrics, Philippines

Plangi or pelangi Tie-dye on cloth, meaning 'rainbow'

Prada Gilded, block-printed batik cloths

Purls Gold wire wound as a tiny hollow spring, used for embroidery

Qi lin Mythical beast with a dragon's head, hooves of a deer and a lion's tail

Quanjin 'Encircling with gold' – couched gold embroidery, China

Qutan or **kotn** Arabic word for 'cotton'

Ramayana Second of the great Hindu epic poems

Rocailles Little round beads

Sampot chuok Rectangular piece of cloth worn folded in front

Sampot bat Finely pleated skirt folded across the body

Sampot chang kbin A man's short wrapped loincloth

Sampots Wrapped skirts worn by devata goddesses

Sarong Wrapped tube skirt

Sarungs Another word for sarong

Sawat Fan-shaped tail wings of a garuda

Sazigyo Tablet-woven religious texts, Burma

Scherenschnitte Central European folded paper pattern cutting

Selendang Long narrow shawls, Indonesia

Semen Background 'tendril' pattern on batik sarongs, Java

Sequin Formerly a stamped shape with one or more small edge-holes; nowadays a little round disc with a central hole for sewing

Sericin A sticky substance covering filaments extruded by silkworms

Shin-pyu Initiation ceremony before a novice monk enters a monastery

Singha Mythical lion

Son mai Lacquerware

Spangle Small metal ring flattened to retain a tiny hole in the middle

Snoeng Frame for tying ikat threads for hol cloth, Cambodia

Sprang Interwining or interlinking of adjacent threads on a fixed warp

Story cloth Narrative embroidery worked by the Hmong women

Suwannahong or **hong** Mythical swan-like bird

Tapis inuh Women's embroidered ceremonial sarongs, south Sumatra

Tatting Knotting on a running thread to form lace designs

Teneriffe-lace Spider-web circular designs in fine thread

Tiaohua An upright cross stitch, also called 'Chinese cross stitch'

Tiaoluo Stitching in gauze, China

Tikai lampit Woven mats from drilled split cane, western Borneo

Tjanting or **Canting** A batik wax drawing tool

Tjap or **Cap** A metal stamp to print wax patterns

Tritik or **Teritik** Sewn tie-dye

Tulis Hand-applied Javanese batik, also called 'Batik tulis'

Tumpal Mirror-image triangle patterns on Javanese sarongs

Ulos ragidup 'Pattern of life cloth' – Batak people, northern Sumatra

VOC (Vereenigde Oost-Indische Compagnie) Dutch East India Company

Wat Buddhist temple

Wayang golek Rod puppets

Yantra Three-pronged symbol

Yin-yang Male and female principles in Chinese cosmology

Yoni Symbolic female genitalia

Zoos Širee Chinese braiding table

Bibliography

Mainland South-East Asia

Cheesman, Patricia, *Lao–Thai Textiles: The Textiles of Xam Nuea and Muang Phuan* (Studio Naenna Co. Ltd, Thailand, 2004)

Connors, Mary F., *Lao Textiles and Traditions* (Oxford University Press, 1996)

Conway, Susan, *Thai Textiles* (British Museum Press, London, 1992)

Conway, Susan, *Silken Threads and Lacquer Thrones, Lan Na Court Textiles* (River Books Co. Ltd, Thailand, 2002)

Conway, Susan, *The Shan: Culture, Arts and Crafts* (River Books Co. Ltd, Bangkok, 2006)

(ed) *China's Minority Nationalities* (Published by CHINA RECONSTRUCTS, Beijing, 1984)

Fraser, David W. & Barbara G., *Mantles of Merit, Chin Textiles from Myanmar, India and Bangladesh* (River Books Co. Ltd, Thailand, 2005)

Freeman, Michael, and Jacques, Claude, *Ancient Angkor* (River Books Co. Ltd, Bangkok, 1999)

Garrett, Valery M., *Mandarin Squares* (Oxford University Press, 1990)

Green, Gillian, *Traditional Textiles of Cambodia, Cultural Threads and Material Heritage* (River Books Co. Ltd, Thailand, 2003)

Hla, Kyi Kyi, *A Myanmar Tapestry, A Collection of Articles on Myanmar* (Taw Win Publishing House, Yangon, Myanmar, 2004)

Labbé, Armand J., *Ban Chiang: Art and Prehistory of Northeast Thailand* (Bowers Museum, Santa Ana, California, USA, 1985)

Lewis, Paul and Elaine, *Peoples of the Golden Triangle* (Thames and Hudson Ltd, London, 1984)

Naing, U Min, *National Ethnic Groups of Myanmar* (Daw Moe Kay Khaing, Yangon, Myanmar, 2000)

Pourret, Jess G. *The Yao, The Mien and Mun Yao in China, Vietnam, Laos and Thailand* (River Books Co. Ltd, Thailand 2002)

Prangwatthanakum, Nongsak and Naenna, Patricia, *Lan Na Textiles – Yuan, Lue, Lao* (Center for the Promotion of Arts and Culture, Chiang Mai University, Thailand, 1990)

Samen, Khun, *Preah Neang Tevi, National Museum Collections, Phnom Penh*, (Department of Museums, Phnom Penh, Cambodia, 2005)

Singer, Noel F., *Burmese Puppets* (Oxford University Press, 1992)

Stanislaw, Mary Anne, *Kalagas, The Wall Hangings of Southeast Asia* (Ainslie's, California, USA, 1987)

Westphal, Katherine, *Dragons and Other Creatures, Chinese Embroidery of the Ch'ing Dynasty* (Lancaster-Miller Inc., 1979)

Xiu, Zhong, *Yunnan Travelogue – 100 days in Southwest China* (New World Press, Beijing, China, 1983)

Yuchi, Zhao and Shizhao, Kuang (senior editors), *Clothes and Ornaments of China's Miao People* (The Nationality Press, Beijing, 1985)

Indonesia and the Islands

Duggan, Geneviève, *Ikats of Savu: Women Weaving History in Eastern Indonesia* (White Lotus, 2001)

Forman, Bedrich, *Indonesian Batik & Ikat* (The Hamlyn Publishing Group Limited, a division of the Octopus Publishing Group, London, 1988)

Gillow, John, *Traditional Indonesian Textiles* (Thames and Hudson Ltd., London, 1992)

Guy, John, *Woven Cargoes, Indian Textiles in the East* (Thames and Hudson, London, 1998)

Hamilton, Roy, W. (ed.), *From the Rainbow's Varied Hue – Textiles of the Southern Philippines* (UCLA Fowler Museum of Cultural History, Los Angeles, 1998)

Hamilton, Roy, W. (ed.), *Gift of the Cotton Maiden, Textiles of Flores and the Solor Islands* (UCLA Fowler Museum of Cultural History, Los Angeles, 1994)

Hitchcock, Michael, *Indonesian Textile Techniques* (Shire Ethnography, 1985)

Hitchcock, Michael, *Indonesian Textiles* (British Museum Press, 1991)

Munan, Heidi, *Sarawak Crafts, Methods, Materials and Motifs* (Oxford University Press, Singapore, New York, 1989)

Purananda, Jane (ed.), *Through the Threads of Time, Southeast Asian Textiles* (River Books, James H. W. Thompson Foundation, Bangkok, 2004)

Reedjik, Hein (ed.), *Decorative Arts of Sumba* (The Pepin Press BV, Amsterdam and Singapore, 1999)

Roojen, Pepin Van, *Batik Design* (The Pepin Press BV, Amsterdam and Singapore, 1993, 1994, 1998)

Severin, Tim, *The Spice Islands Voyage, In Search of Wallace* (Little, Brown and Company, UK, 1997)

Summer, Christina, with Osborne, Milton, *Arts of Southeast Asia* (Powerhouse Publishing, Sydney, 2001)

Summerfield, Anne and John, *Walk in Splendor, Ceremonial Dress and the Minangkabau* (UCLA Fowler Museum of Cultural History, Los Angles, 1999)

Victoria and Albert Museum, *Batiks* (Her Majesty's Stationery Office, London, 1969)

General

Balfour-Paul, Jenny, *Indigo* (British Museum Press, London, 1998; reprinted: Archetype, 2006)

Burnard, Joyce, *Chintz and Cotton, India's Textile Gift to the World* (Kangaroo Press Pty Ltd, Australia, 1994)

Crabtree, Caroline, *World Embroidery* (David and Charles, 1993)

Crabtree, Caroline and Stallebrass, Pam, *Beadwork, a World Guide* (Thames & Hudson Ltd, London, 2002)

Dubin, Lois Sherr, *The History of Beads from 30,000 BC to the Present* (Harry N. Abrams, Incorporated, New York, 1987)

Edwards, Joan, *Bead Embroidery* (BT Batsford Ltd, London, 1966)

Gillow, John and Sentance, Brian, *World Textiles, a Visual Guide to Traditional Techniques* (Thames and Hudson Ltd, 1999 and 2000)

Hamre, Ida and Meedom, Hanne, *Making Simple Clothes, the Structure and Development of Clothes from other Cultures* (Adam & Charles Black, London, 1980)

Marsh, Henry, *Slavery and Race, the Story of Slavery and its Legacy for Today* (David & Charles (Holdings) Ltd, Devon, UK, 1974)

Paine, Sheila, *Embroidered Textiles: Traditional Patterns from Five Continents* (Thames and Hudson, London, 1990)

Paine, Sheila, *Amulets, a World of Secret Powers, Charms and Magic* (Thames and Hudson, London, 2004)

Scott, Philippa, *The Book of Silk* (Thames and Hudson Ltd, London, 1993)

Summer, Christina with Osborne, Milton, *Arts of Southeast Asia* (Powerhouse Publishing, Sydney, 2001)

Fibres, Threads and Textile Techniques

Askari, Nasreen and Arthur, Liz, *Uncut Cloth, Saris, Shawls and Sashes* (Merrell Holberton Publishers Ltd, London, 1999)

Baines, Patricia, *Spinning Wheels, Spinners and Spinning* (Charles Scribner's Sons, New York, 1977 and 1979)

Bertin-Guest, Josiane, *Chinese Embroidery, Traditional Techniques* (BT Batsford Ltd, London, 2003)

Burnham, Dorothy K., *A Textile Terminology, Warp and Weft* (Routledge and Kegan Paul, London and Henley, 1964)

Chatterton, Jocelyn, *Chinese Silks and Sewing Tools* (Jocelyn Chatterton, London, 2002)

Chung, Young Y., *The Art of Oriental Embroidery* (Bell & Hyman – London, in association with Charles Scribner's Sons, New York, 1979)

Collier, Ann M., *A Handbook of Textiles* (Pergamon Press Ltd, Oxford, 1974)

Collingwood, Peter, *The Techniques of Tablet Weaving* (Robin and Russ, 1996)

Emery, Irene, *The Primary Structures of Fabric* (The Textile Museum, Washington, 1980)

Goodwin, Jill, *A Dyer's Manual* (Pelham Books/Green Press, London, 1982)

Hardingham, Martin, *The Illustrated Dictionary of Fabrics* (The Bookclub Associates, London by arrangement with Cassell Ltd, 1978)

Hassel, Carla J., *Creating with Pa nDau Appliqué* (Wallace-Homestead Book Company, Greensboro, N.C., 1984)

Hecht, Ann, *The Art of the Loom – Weaving, Spinning & Dyeing Across the World* (British Museum Publications Ltd, 1989)

Miller, Edward, *Textiles, Properties and Behaviour in Clothing Use* (B T Batsford Ltd, London, 1968 and 1983)

Poggioli, Vicki, *Patterns from Paradise, the Art of Tahitian Quilting* (The Main Street Press Inc., New Jersey, USA, 1988)

Sandberg, Gösta, *Indigo Textiles, Technique and History* (A & C Black Ltd, London, 1989)

Sandberg, Gösta, *The Red Dyes, Cochineal, Madder and Murex Purple* (Lark Books, USA, 1997)

Seiler-Baldinger, Annemarie, *Textiles, a Classification of Techniques* (Crawford House Press Pty Ltd, 1994)

Shaw, Robert, *Hawaiian Quilt Masterpieces* (Hugh Lauter Levin Associates, Inc., USA, 1996)

Smith, Ruth, *Miao Embroidery from South West China, Textiles from the Gina Corrigan Collection* (Gina Corrigan, Occidor Ltd, Bognor Regis, West Sussex, UK, 2005)

Stillwell, Alexandra, *The Technique of Teneriffe Lace* (B T Batsford Ltd, London, 1980)

Sutton, Anne, Collingwood, Peter and St Aubyn Hubbard, Geraldine, *The Craft of the Weaver, a Practical Guide to Spinning, Weaving and Dyeing* (British Broadcasting Corporation, UK, 1982)

Tacker, Harold and Sylvia, *Band Weaving, The Techniques, Looms and Uses for Woven Bands* (Studio Vista, 1974)

Thomas, Mary, *Dictionary of Embroidery Stitches* (Hodder and Stoughton Ltd, London, 1934)

Thomas, Mary and Eaton, Jan (compiler) *Mary Thomas's Dictionary of Embroidery Stitches* (Trafalgar Square Books, 1998)

Waller, Irene, *Tatting* (Studio Vista, Cassel and Collier Macmillan Publishers, Ltd, 1974)

Catalogues, Journals and Pamphlets

Carey, Jacqui (designer and curator), *Braids and Beyond, a Broad Look at Narrow Wares* (Braid Society Exhibition, 2003)

Catalogue, *Spiritual Fabric* (Anshun, Guizhou Province, China, 2000)

Corrigan, Gina, 'Search and Research – the Pleated Skirts of the Miao', *The World of Embroidery, Volume 49 No. 1* (January 1988)

Dryad Leaflet No. 111, *Tablet Weaving* (Dryad Handicrafts, Leicester)

Duggan, Geneviève, 'Indonesian Textiles – Woven Blossoms, Seeds of History. Ikats of Savu as Time Markers', *Hali, 143* (May/June, 2004)

Exhibition Catalogue, *Tai Textiles in the Mekong Region, Continuity and Change* (Vietnam Museum of Ethnology, Hanoi, 2000)

Exhibition Catalogue, Hong Kong Museum of History, *Ethnic Costumes of the Miao People in China* (Urban Council, Hong Kong, October 1985)

Hughes, Jennifer, 'Costume, Needlework and the Evil Eye – The Lisu of Thailand', *The World of Embroidery, Volume 51, No. 1* (January 2000)

Isaacs, Ralph, 'Sazigyo: Textile Texts', *Oxford Asian Textile Group, Newsletter No. 34* (June 2006)

Keo, Pich, *Khmer Art in Stone* (National Museum of Cambodia, 1994)

Munan, Heidi, 'Beads from Cradle to Grave', *The Beadworkers' Guild Journal, No. 12* (March 2002)

O'Connor, Deryn, *Miao Costumes from Guizhou Province, South West China* (Exhibition Catalogue, James Hockey Gallery, WSCAD, Farnham, UK, 1994)

Owen, Rodrick, 'Interlaced Braids – An Overview', *Strands Issue 13*, (The Braid Society, 2006)

Guide Books

Bell, Brian, project editor, *Malaysia* (Insight Guide, 2003)

Colet, John, *Footprint, Vietnam*, (Footprint, Bath, UK, 4th edition, 2006)

Corrigan, Gina, *Odyssey Illustrated Guide to GUIZHOU, China Guizhou Overseas Travel Co.*, (The Guidebook Company Ltd, Hong Kong, 1995)

Cummings, Jo, *Laos*, (Lonely Planet, 3rd edition)

Doral, Francis, Project Editor, *Burma, Myanmar* (Insight Guides, updated 2005)

Editors, *Indonesia* (Lonely Planet, 2006)

Editors, *Malaysia, Singapore and Brunei*, (Insight Guides, 10th edition, 2007)

McCarta, Robertson, *Thailand*, (Nelles Guides, 1st edition, 1991)

Muller, Kal, *East of Bali, from Lombok to Timor, 2nd edition* (Periplus Editions (HK) Ltd., 1995)

Wulf, Annalese, *Cambodia, Laos, 2nd revised edition* (Nelles Guide, 1996)

Reference

Encyclopaedia Britannica, 2003

Craft Video Films and CDs

Willoughby, Janet, Ends of the Earth Ltd

Kalagas, Burmese Embroidered Tapestries
The Ikats of Sumba
Traditional Silk Weaving in Thailand

Museums and Textile Collections

United Kingdom

Ashmolean Museum, Oxford
Bankfield Museum, Halifax
Birmingham Museum and Art Gallery, Birmingham
Bristol City Museum, Bristol
British Museum, London
Gulbenkian Museum of Oriental Art, University of Durham
Horniman Museum, London
James Green Centre, Brighton Museum
Leicestershire Museum and Art Gallery, Leicester
Nottingham Museum of Costumes and Textiles, Nottingham
Pitt Rivers Museum, Oxford
Royal Scottish Museum, Edinburgh
The Whitworth Art Gallery, University of Manchester
University of Leeds International Textiles Archive, Leeds
University Museum of Archaeology and Anthropology, Cambridge

Europe

Germany

Völkerkunde Museum, Frankfurt

Netherlands

Museum of Geography and Ethnology, Rotterdam
Museum of the Royal Tropical Institute, Amsterdam
Nusan Tara Ethnographical Museum, Delft

Poland

Asia and Pacific Museum, Warsaw

Portugal

Museum of Overseas Ethnography, Lisbon

Sweden

Ethnographic Museum, Göthenburg

Switzerland

Völkerkunde Museum, Basle
Völkerkunde Museum der Universität, Zurich
Völkerkundliche Sammlung, St Gallen

USA

Boston Museum of Fine Arts
Brooklyn Museum, New York
Los Angeles County Museum of Art, C A
Metropolitan Museum of Art, New York
National Museum of Natural History, Smithsonian Institution, Washington
The Textile Museum, Washington DC
UCLA Fowler Museum of Cultural History, Los Angeles

Australia

Museum of Applied Arts and Sciences, Powerhouse Collection, Sydney

South-East Asia

Cambodia

National Centre for Sericulture, Siem Reap
National Museum of Cambodia, Phnom Penh, Cambodia
Royal Palace Compound, Phnom Penh

Indonesia and the Philippines

Bali Museum, Denpasar, Bali
Central Museum, Jakarta
National Museum of the Philippines, Manila
Sarawak Museum, Sarawak, Borneo
West Java Museum, Bandung, Java

Laos

Royal Palace, National Museum, Luang Prabang

Malaya and Singapore

Museum of Asian Art, University of Malaya, Kuala Lumpur,
 Malaya
National Museum, Singapore

Myanmar (Burma)

National Museum, Yangon

Thailand

Jim Thompson House (old wooden house and textiles),
 Bangkok
National Museum, Bangkok
Suan Pak Kard Palace (Cabbage Patch Museum), Bangkok

Vietnam

Historical Museum of Vietnam, Ho Chi Minh City
 (Saigon)
Hoi An Museum of History and Culture, Hoi An
Hué Museum of Royal Fine Arts, Long An Palace, Hué
Museum of Ethnology, Hanoi
Tan Ky Merchant's House, Hoi An

Index

Page numbers in bold italic refer to illustrations.

aida fabric 153
Akha 86, 87, 93, 99, 163, 170, 181, 202–204
amrita 43
amulets 43, 44
andung 45
animals 32, 46, 47, 55, 154, 158, 165, 176, 177, 180, *187*, 195
Angkor 7, 8, 11, 20, *21*, 37, 41, 53, 59, 60, 61–64, 70, *109*
Ao Dai 80, *81*, 158
applied patchwork 163, 164
appliqué *84*, 151, 161–164
 Hmong 161, *164*
 reverse *84*, *161*, 164–166, *165*
aprons *30*, *76*, 80, *83*, 84, *150*, 153, 161, 178
Apsaras 8, 49, 60, *61*, 62, *63*, 70
Arab 22, 26, 40, 96, 144, 145, 189, 199
ari chain stitch 152
Asura 43
Ayeyarwady River 16, 18, 196
Ayutthaya 17–19, 64

Babbage, Charles 119
baby carrier 93, 153, *156*, *162*, *163*, 170, 201
badan 146
Bagan 18
bags 93, 122, 160, 161, 170, *173*, 175, 187, 190, *202*, 214
Bali 25–27, 109, 136, 139, 147, 149
Bangkok 12, 17, 20, 67
Bansiddhi, Saeng-da, Mrs 113, 114, *121*, 124, *125*, 135
batik 29, 49, 51, 70, 86, 140–149
 canting 141, *144*
 cap 143, *144*, 145
 double-sided 143
 dyes 140
 indigo 142, 143
 North Coast 144
 patterns 146
 pen tools *141*, *142*, 143
 Prada gilding 148, *149*
 screen-print *149*
 tulis 143, *144*, 145, 149
 wax 140, 141, 143, 145
beads 34, 86, 87, 89, 160, 162, 169–183
 animal teeth, tusks 172, 178, 199, 212
 bugles 160, 173
 glass 172, 178, 179
 metal (silver, gold) 173, 174, 178
 mother-of-pearl 170, 197
 Mutisalah red 175, 178
 pearl 170, 176, 178
 rocailles 173, 175, 183
 seeds 87, 170, 199, *202*, 204, *205*
 shell 32, 169–170, 172, 174, 175, 178, 214
 wood 172, 199
beadwork
 bow-loom *181*
 embroidery 175–179
 netted 175, 178, 179–181
 weaving 181, *182*, 183
Bhagavata 43
bidang 180
birds 28, 32, *33*, 45, *46*, *51*, 53, *54*, 55, *144*, *156*, 158, *176*, 180, 203, 212, 213
boats *53*, 55, 165, *167*, *191*
Borneo 25, 34, 37, 55, 70, 104, 163, 169, *179*, 180, 181
Bouchon, Basile 119
braids 142, 181, 185–187, 200, 201
British 19, 22–24
Buddhism 14, 18, *19*, 22, 26, *27*, 35–37, 44, 48, 49, 52, 55, 58, 75, 89, 108, 109, 113, 147, 162, 176, 177, 188, 211
Burma 11, 13, 14, 16–18, 20, 46, 49, 64, 67, 72, 73, 78, 87, 90, 159, 161, 172, 174–177, 188
butterflies *48*, 49 138, 143, 144, 158
buttons 162, *170*

Cambodia 7, 11, 12, 19–23, 29, 35, 38, 43–46, 48, 51, 55, 58, 59, 62, 63, 65, 66, 75, 80, 83, 90, 92, 96, 102, 103, 108, 110, 117–120, 124, 132, 135, 138, 177, 192, 193
canting or tjanting 141, *144*
Cao Daism 39, 40
cap or tjap 143, *144*, 145
cermuk or shisha 178

Cham 138, 139
Champa 21, 63
chang kbin 65, 66, 90
Chao Phraya River 17, 19
charka wheel 100
Chenla 20
Chin, Burma 67, 69, 73, 78, 123, 156, 175
China 12–15, 17, 19, 21, 22, 32, 44, 46, 49, 52, 69, 78–81, 92, 96, 101, 116, 129, 140, 142, 145, 151–153, 156, 159, 160, *168*, 171, 174, 177, 179, 186, 192, 193, 213
China grass 105
chinthe *50*, 52
Chindits 52
chong kraben *65*, 66, *67*
chongsan 81
Christian 26, 35, 36, 40, 52, 71, 213
chwang kbun 65, 108
coletan – India 143
Confucianism 38, 39, 55
cotton 9, 23, 29, 51, 61, 66, 67, 75, 95, *96*, *97*, *98*, *99*, 100, 113, 133, 140, 143, 145
 carding 98
 fluffing *98*
 ginning 97, *98*
 rolags *97*, 98, *99*
 spinning 98, *99*
 swift-winding *99*
couvette 173
cowrie shells 87, *169*, 174, 178, 180, 212, 213
cut-work 161–163

Darwin, Charles 26
deva-raja 20, *172*
devata *10*, 60, 62
Dong Son culture 12, 13, 21, 27, 52, 55, 71, 127, 165, 180
dragon 41, 49, *50*, *51*, 52, 53, 55, 89, 116, 136, 138, 152, 159, 162, 164, 165, 186, 195
Dutch 11, 19, 22–24, 27, 40, 46, 49, 70, 96, 140, 144, 152, 156, 189, 195
dyeing cotton 109
dyeing silk *108*
dyes 108–11
 bark 110
 chemical *111*, 140
 indigo 110, 111
 insect – stick-lac 110
 insect – cochineal 110
 plant 109, 113
 root 109, 136
 shells 108, 111
 synthetic 111

East India Company (British) 23, 95
East Timor 11
Elephant River 16
elephants 24, *47*, 48, 52, 53, 74, *134*, 135, 164
embroidery 151–162, 166, 167
 ari-chain 152
 chain stitch 154, 157, 161, 166
 couching 160
 cross stitch 84, 142, 153, 154, 156, 161
 double-run 153, 154, *155*, 156
 double-sided 157, 158
 free stitchery 156–158
 metal thread 65, 157–160, *159*, 160
 pattern darning 156
 Pekin knot 151
 running stitch 153
 satin stitch 152–154, 156, *157*, 161, 162
 tambour 152
Erawan 48

feathers 170, 175, 181, 199, *202*, *203*, 204, *205*, 211, *212*, 213, 214
Feng Huang 53
fish *48*, 49, 52, 154, *156*, 164, 190
Flores 59, 71, 98, 136, 178, 195, 213
French 20, 23, 96
fringes 93, *168*, 177, *198*, 199, *200*, 201, 213
frivolité 190
Funan 20, 21

galon 53
Gandhi, Mahatma 100
garuda 53, 146
geringsing cloth 138
ginning cotton *97*, 98
God's Eye 197, 208, *209*, *210*, *211*

gold 32, 34, 37, 53, 147, 148, 149, 158–160, 174, 177, 214
Golden Triangle 13, 78, 85, 86, 142, 152, 153, 164, 173, 174, 186, 205
Guizhou 7, 13, 174, 186

Halong Bay *13*
hammock *192*
hamsa bird *46*, *50*
hats 92–93, 153, 163, *196*, 200, 201, *205*, *206*
 beaded *34*, 93, *180*, 181
 latania leaf 92
 Non Lá 92,*195*
 palm leaf *185*
 straw 92, *195*
Hindu 21, 22, 23, 26, 37, 45, 46, 48, 49, 53, 96,138, 152
hinggi 70, 136, *137*, 200
hintha bird 46
Hmong 81–83, *84*, 87, 88, *111*, 161, 163, *164*, *165*, 170, 174
hol weave *133*, *134*, *135*
hong bird 46
horses 25, 27, *38*, 48,49, *50*, 70, *75*, *134*, 177

Indo-China 11, 22, 139
Indonesia 11, 13, 22, 24–26, 35, 38, 40, 51–53, 55, 57, 59, 69, 74, 95–97, 106, 107, 109, 113, 115, 126, 136, 139, 141, 143, 159, 170, 172, 183
Inle Lake *16*, 73, 88, 103, 105, 120, 133, 185, 189, 190
Irian Jaya 27, 213
Islam 22, 26, 40, 71, 148, 152, 165
India 17, 21, 22, 26, 29, 48, 61, 69, 95, 96, 109, 137, 152, 159, 160, 169, 175, 187
indigo 57, 70, 91, 110, *111*, 113, 133, 141, 142, 143, *150*, 153, 161
ikat 27, 34, 46, 71, 131–138
 binding 131, *132*
 double-*ikat* *137*, 138
 hol pattern *133*, *134*, *135*
 warp-*ikat* 135, *136*, *137*
 weft-*ikat* 133–135, *136*, *137*

jamdani weave 62
Japan 17, 28, 137, 138, 145
Jaquard, Joseph Marie 119
Jaquard loom 119
Jars, Plain of *20*
jarong man 179
Jataka tales 176
Java 23, 24, 37, 38, 49, 53, 70, 106, 139, 143, 144–146, 148, 161, 195
Job's tears *86*, 170, *171*, *202*, *203*

kain pankjang 70
kalagas 37, *38*, 46, *47*, *50*, *160*, *172*, 175–177
Kalimantan 139, 180
kambut 129
Karen 13, 67, *72*, 74, 87, 88, 157, 170, 171, 204
katipa 180
kebaya 91,161
keik htamein 177
kepala 146
ketadu *71*
khlong 17
Khmer 12, 19–21, 37, 52, 60–64, 96, 138
Khmer Rouge 21
kiet 138, *139*
Kochi net *191*, 192
Korea 38
kosa-sing *51*, *54*, 55
kotak batik 145
kramer 74, 118, *198*
Kula Ring Exchange 175, 214
kulambo curtain 152

lace 82, 91, 188–190
lakmee frame 133
Lan Na 19, *65*, 66, 159
lanterns *215*
Laos 12, 13, 16, 19, 20, 29, 37, 51–55, 68, 72, 80, 82, 83, 85, 89, 92, 96–98, 117, 122, 123, 132, 134, 151, 159, 164, 166, 181–183, 200
lar 146
lau pahudu 126, 127
linga 42, 43
lion-dog *50*, 52, 154, 162
loin-cloths 63–67, 70
Lombok 136

longyi **56**, 59, **90**
loom types 115–119
 backstrap 96, 113, **115**, **116**, 123, **182**, **183**, 186
 bow-loom **181**, **203**
 Cambodian long-loom 116, 117, **120**
 Dobby 119
 draw-loom 118, 119
 flying-shuttle *118*
 frame-loom 116, **117**, 120
 horizontal floor-loom 118, **194**
 Jaquard 119
 Malay frame-loom 117
 side-operated *117*, 118, 186
 tablet-loom 188
lotus cloth **105**, **106**
Luang Prabang 20, 133, 161
luhol appliqué 165
lungyi **69**, 72
luntaya acheik **66**, **90**, **127**, **128**, 161

ma'a 147
machine sewing 160–162
macramé 199
Mahabarata 37, 38, 43, 49
makuta 62
Malacca, Straits of 22, 24, 69, 152, 179
Malay Peninsula 19, 22, 24, 152
Malaya 11, 14, 20, 22, 23, 64, 138, 147, 159, 179
Malaysia 14, 23, 24, 25, 41, 57, 58, 69, 95, 104, 105, 138, 149
Malinowski, Bronislaw 175
manuisha 52
Mekong River 16, 20, 59, 96, 115, 120, 124, 132, 166, 192
mica 157
mirong 146
monks 14, **37**, 75, **109**, 147, 187
mordant 95, 109, 110, 111
muang 14, 32
mukena prayer veil 91
Muslim 26, 27, 55, 74, 213
mutisalah 'Indian Red' beads 175, 178
Myanmar 13, 16, 18, 36, 44, 50, 58, 59, 73, 86, 88, 92, 99, 106, 122, 125, 196, 201, 212

naga **27**, 43, 45, **50**, **51**, 52, **53**, 59, 60
nak **54**, 55, 138
Nan La 7, 65
Nats 36
Netherlands East Indies 11
netting 190, **191**, 192, **193**
Non Lá conical hat 7, 104, **195**, **196**, 197
nuns **8**, 75, 152
ñandutí lace 189

Orang Asli 22, 41
Orang Ulu 163, 180, 195
quanjin encircling stitch 160
ol-ol canopies 152
oes 173

Pa nDau 164, **165**, 166, 176
Padaung long-necks 88, **89**, **99**
Pagan Dynasty 18
paillette 173
painted cloths 147, 148
pakhikung 127
pamn muk 63, **64**
panjin filling stitch 160
Papua New Guinea 11, 27, 170, 175, 213
Peranakans 24
paso 72
patchwork **162**, 163–165, 204
patola cloth 71, **137**, 138
patola ratu 138
paua shell 170
pearls 34, 170, 176, 178
Pekalongan 144, 145
peksi kingpin 146
pensarua 45
Perfume River 17
Perkin, William 111
pha tuum 74
pha sarong 67, 68
phaa piao **207**, **208**
phasin 65, 67, 68, 91, **133**
Philippines 27, 40, 55, 104, 105, 107, 122, 123, 128, 129, 148, 152, 163, 188, 163–165, 170, 214
Phnom Penh 21, **41**, 59, 60, 114, 124, 134, 139
phoenix 53
pidan 134
piña 40, 104, 152, 189
pirn **114**, **115**
pis cloths 128, **129**

plangi, pelangi 138, 139
pleated skirts **76**, 78, **79**, 82, 84, **87**, 161
Polo, Marco 100
pom-pom **83**, 199, **201**, 202, 205, **206**, 207, **209**
Portuguese 11, 19, 22, 40
priests 89, 106, 109, 151, 152, 159
puppets **130**, 146, 147, **177**
purls 160

qi lin 52
quanjin filling stitch 160
quilting 64, 160, 161
qutan 96

Raffles, Sir Stanford 22, 70
Ramayana 37, 38, **41**, 43, 49, 146, 176, 177
rank badges 23, 32, **33**, 45, 47, 53, 159
Red River 12, 14, 17, 21, 84
rice 15, 16, 19, 18, **22**, 25, 26, 27, **37**, 84, 120, 167, 178, 182
rimpu 91
rocailles 173, 175
Roman Catholic 27, 40, 152

salempang 72
salendang 72
sampot **61**, 62, 63, 64
Sapa 84, 85, **154**
Sarawak 23, **25**, 71, 104, 107, **115**, 122, **180**
sarong 59, **69**, **70**, 71, 86, 136, **144**, 145 147, 152, 161, 182, **183**
Savu 55, 110, 113
Sawat 146
Sea of Milk 43, 52
scherenschnitte 163
selendang 122, 146
semen pattern 146
sequins 34, 37, **47**, 65, 159, 162, 173
serpent **51**, 136
shaman 44, 45, 89, 151
Shan States 67, 86
shells 111, 169, 170–172, 178, 199, 214
Shin-pyu 35
ships 55, 157
Shiva 20
shuttles 114, 115
 boat **115**
 cylindrical **114**
 flying-shuttle *118*
 netting **193**
 tatting **189**, 190
 wood or bamboo 115
Siam 18, 19, 64, 66, 90
Siem Reap 60, 64, 101, 103, 134, 198
silk 9, 24, 29, 40, **51**, 59, 62, 75, 89, **94**, **100**, **102**, **108**, 118, 132, 133, 138, 139, 140, 215
 de-gumming **103**
 mulberry trees 100, 101
 reeling 102, **103**
 silk-moth cocoons 100, **101**, **103**
 silk-moth eggs 101, 102
 silk-moths 100–102
 silk-worms 100, **101**, 102
 winding **103**
Silk Road 24, 100
silver 34, 89, 93, 147, 158, 160, **173**, **174**, 183, 202, **210**, 213
Singapore 11, 22, 23, 145
singha lion **50**, 52
skull tree 44, 45
slaves 14, 23, 24, 26–28, 40, 151, 152
snoeng **132**
son-mai 197
spangle **172**, 173
Spanish 19, 27
Spice Islands 23, 26, 27, 29
spinning 98–100
 cotton **97**, 98
 spindle **97**
 spindle-whorls 98
 wheels 98, **99**, 99–100
sprang .192
Sri Lanka 14, 152
story-cloths, Hmong **166**, 167
Sukhothai 19
Sulawesi 109, 139, 147, 187
Sumatra 11, 22, 26, **34**, 71, 72, 104, 136, 145, 152, 157, 178, 183, 189
Sumba 34, 42, 43, 45, 46, 49, 52, 71, 110, 126, 127, 136, **137**, 161, 180, 195
Sumbawa 139, 156
sungit 122
suwannahong bird 46
swastika 44, 154
swift **99**, **103**, 119

tablet-weave 188, 187
talismans **42**, 43, 44, 151
Taoism 39, 40
tape-braids **186**
tapis inuh 157
tassels **83**, 93, 170, 199, 201, **202**, **204**, 205, 208, **210**, **212**, 213, 214, **215**
tatting **189**, 190
tattoo **56**, 65
teen-bok **133**
Thai 46, 91, 166
Thailand 19, 20, 21, **30**, 37, 38, 40, 44, 52, 55, 56, 74, 79, 86, 88, 93, 97, 99, 102, 107, 123, 132, 133, 135, 142, 147, 151, **159**, 164, 170, 177, 181, 201–207
Thu Bon River **17**, 25
tiaohua 152
tiaoluo 152
Tibet 16, 17, 214
tie-dye 138–40
 plangi, pelangi 138, **139**
 tritik **138**
tikai lampit 195
tjanting 141
tjap 143
Tonkin, Gulf of 13, 17
Tonlé Sap 16
tree-of-life 134, **145**
trousers **83**, **85**, 77, 154, **155**
tulis-batik 143–145
tumpal 146
turbans **73**, 74, 85, **93**, **198**, 205, 213

ulos ragidup 136
United States 20–22, **83**, 126, 166, 167, 176

vegetable fibres 104–108
 abaca 165
 agave 104
 bamboo 104, **181**, 212, **194**, 210
 bark-cloth 107, **108**
 coconut 106, 213
 hemp 153
 kapok 105, **107**, **197**
 latania leaf 104, **195**, **196**, 197
 lotus flower stem **105**, **106**
 palm leaf **185**, **187**, 193, 195, **196**, **197**
 pineapple 104, 139, 152, 180, 189
 plant and leaf 104, 193
 ramie 105
 rattan 97, 98, 106, 107, **115**, **184**, **195**, 213
 sedge reed 193, **194**
Vietcong 20
Vietnam 11–14, 16, 20, 27, 38, **43**, 44, 49, 51, 52, 58–60, 63, 64, 69, 80, 84–86, 89, 92, 96, 102, 151, 155, 157, 167, 197, 205
VOC 23, 24

Wallace, Alfred Russell 25, 26
wayang golek 147
weaving 113–115, 119–129, 213
 heddle-frame 118, **125**
 heddle-strings 114, 115, 117, 120, **123**, **124**, **125**, 126, 187
 rigid-heddle 118, **186**, **194**
 shed-sticks 114
 warp-board **120**
 warp-shed 114, 115, 116
 warping **119**, 120, 121
 warping-mill 120
 weft-shed 114
weave types 121–129
 brocade 121, 124, 199
 damask **94**, 95, 151
 supplementary-warp 125, **126**
 supplementary-weft **94**, **112**, 121, **122**, 124
 tapestry 121, 127, 128, **129**, **187**
 twill 121, 127
 twining 195, 213
Wingate, Orde Charles, General 52

Yangon 18
Yangtze River 14
yantra 44, **154**
yin-yang 45, 52
yoni 43
Yunnan 7, 11, 14, 49, 69, 82, 85, 116, **138**, 142, 151–153, 162, 201, **210**

Zheng He 24, 192
Zhou Dagan 64, 74, 75, 96
zodiac 44, 176
zoos širee 185, **186**
Zuylen, Elisa van 145